STORY OF A MURDER

Also by Hallie Rubenhold

Story of a Murder

The Wives, the Mistress, and Dr. Crippen

HALLIE RUBENHOLD

DUTTON

DUTTON

An imprint of Penguin Random House LLC
1745 Broadway, New York, NY 10019
penguinrandomhouse.com

LIBRARY OF CONGRESS CATALOGING-IN-PUBLICATION DATA
has been applied for.

ISBN 9780593184615 (hardcover)
ISBN 9780593184622 (ebook)

Printed in the United States of America
1st Printing

The authorized representative in the EU for product safety and compliance is Penguin Random House Ireland, Morrison Chambers, 32 Nassau Street, Dublin D02 YH68, Ireland, https://eu-contact.penguin.ie.

In memory of my mother,
Marsha Rubenhold, who taught me to love books.
June 21, 1942–August 23, 2023

Contents

Cast

PRINCIPALS

Charlotte Bell	Teacher, nurse, the 1ˢᵗ Mrs. Crippen
Kunegunde Mackamotzki/ Corinne Turner/Cora Crippen/Belle Elmore	Music hall performer, the 2ⁿᵈ Mrs. Crippen
Ethel Le Neve	"Typist," mistress, aspirant 3ʳᵈ Mrs. Crippen
Hawley Harvey Crippen	Homeopath, fraudster, murderer

SUPPORTING CAST

THE BELL FAMILY

Susan Bell (née Madden)	Charlotte's mother
Arthur Bell	Charlotte's father
Susan Rebecca Bell	Charlotte's older sister
Selina Leary (née Bell)	Charlotte's younger sister
Madden Arthur Bell	Charlotte's older brother
William Bell	Charlotte's older brother
Charles de Hauteville Bell	Charlotte's younger brother

THE CRIPPEN FAMILY

Ardesee Crippen (née Skinner)	Hawley's mother
Myron Augustus Crippen	Hawley's father
Philo H. Crippen	Hawley's grandfather
Hawley Otto Crippen	Hawley and Charlotte's only child

Cast

THE MACKAMOTZKI / MERSINGER FAMILY

Mary Mackamotzki Mersinger (also Schmidt, née Wolf)	Belle's mother (married 3 times)
Joseph Mackamotzki	Belle's father
Frederick Mersinger	Belle's stepfather
Teresa Hunn or Hahn (née Mackamotzki)	Belle's younger (full) sister
Kate "Katie" Mersinger	Belle's younger (half-) sister
Louise Mills (née Mersinger)	Belle's younger (half-) sister

Walk-on role in Belle's early life

Charles Cushing Lincoln	Belle's employer and lover

THE NEAVE AND BROCK FAMILIES

Walter Neave (aka Le Neve)	Ethel's father
Charlotte Neave (née Jones)	Ethel's mother
Adine "Nina" Brock (née Neave)	Ethel's younger sister
Claude Neave	Ethel's brother
Bernard Neave	Ethel's brother
Wilfred Neave	Ethel's brother
Sidney Neave	Ethel's youngest brother
Horace Brock	Nina's husband
Ronald Brock	Nina's son
Ivy Ethel Brock	Nina's daughter

CRIPPEN'S MENTORS IN HOMEOPATHY, EMPLOYERS AND BUSINESS PARTNERS

Dr. Edwin Breyfogle	Early mentor
Dr. Phil Porter	Ob-gyn specialist, mentor
Dr. James Dart	Friend and doctor, Salt Lake City
Dr. George Clinton Jeffrey	Ob-gyn, New York
"Professor" James Monroe Munyon	Patent medicine millionaire, owner of Munyon's Remedies

Cast

Monsieur J. Carré	Manager of the Drouet Institute, fraudster
Edward Marr	Medical and financial fraudster, partner
William E. Scott	Advertising and financial fraudster, partner
F. Sinclair Kennedy/Forrester Kennedy	Medical and financial fraudster, partner

At Albion House

Gilbert Rylance	Dentist, business partner in Yale Tooth Specialists
Marion Louisa Curnow	Bookkeeper at Munyon's Remedies
William Long	Assistant and "technician," married to:
Flora Long	His wife

FRIENDS OF BELLE ELMORE AND H. H. CRIPPEN

Adeline Harrison	Journalist, playwright, Belle's "frenemy"
Dr. John Herbert Burroughs and his wife, Maud Burroughs	Neighbors on Store Street
Bruce Miller	Belle's extramarital love interest

Music Hall Ladies' Guild friends

Lottie Albert (also Osborn)	Performer
Annie Stratton (née Moore)	Retired "blackface" performer, daughter of George Washington "Pony" Moore, married to:
Eugene Stratton	American celebrity "blackface" performer

Cast

Isabel Ginnett (née Mayer)	Equestrian performer, wife of superstar circus equestrian performer Frederick Ginnett, President of the MHLG
Clara Martinetti (née Engler)	Retired mime artist, married to:
Paul Martinetti	Retired American celebrity mime artist
Lillian Nash (Lil Hawthorne)	Internationally famous American singer, married to:
John Nash	Her manager
Melinda May	Retired singer-dancer, Secretary of the MHLG
Louise Smythson (née Hodgson)	Former dancer and professional female football player, Vice President of the MHLG
Louise "Louie" Davis	Dancer, part of a duo with Howard Ward

FRIENDS AND ASSOCIATES OF ETHEL LE NEVE

Emily Jackson	Ethel's landlady and friend, married to:
Robert Jackson	Mineral-water salesman
Dr. Ethel Vernon	Eminent "women's doctor" who tended to Ethel
Lydia Rose	Ethel's childhood friend from Hampstead
Lydia Rose (senior)	Lydia's mother
Mrs. Alice Benstead	Ethel's paternal aunt in Brighton, married to:
Richard Benstead	Boarding-house keeper
Caroline Elsmore	Ethel's dressmaker
John Stonehouse	Ethel's suitor, lodger at Mrs. Jackson's

Cast

Cast

On board the Montrose

Captain Henry Kendall	Captain of HMS *Montrose*
Freida Heer	Stewardess guarding Ethel

Quebec

Chief Officer McCarthy	Chief Officer of the Quebec Police, married to:
Mrs. McCarthy	Host to Ethel
Inspector Denis	Assistant to Chief Officer McCarthy
Sarah Stone and Julia Foster	Holloway Prison wardresses, Ethel's escorts on the *Megantic*

TRIALS

Sir Albert de Rutzen	Magistrate presiding at Crippen and Ethel's committal hearing
Lord Chief Justice Alverstone	Judge in *Rex* v *Crippen* and *Rex* v *Le Neve*
Winston Churchill	Home Secretary in 1910
Charles Willie Matthews	Director of Public Prosecutions

Lawyers

Defense

Arthur Newton	Crippen and Ethel's solicitor
Alfred Tobin, KC	Lead counsel for Crippen's defense (barrister)
Huntley Jenkins	Junior defense counsel (barrister)
Henry Delacombe Roome	Junior defense counsel (barrister)
Frederick Edwin "F. E." Smith	Ethel's defense counsel (barrister)

Prosecution

Sir Richard Muir	Treasury counsel, lead counsel for the Crown (barrister)
Travers Humphreys	Junior counsel for the Crown (barrister)

Cast

Samuel Ingleby Oddie	Junior counsel for the Crown (barrister)
Cecil Mercer	"Devil" to junior counsel (barrister)

Expert witnesses

Dr. William Willcox	Senior Scientific Analyst at the Home Office
Dr. Bernard Spilsbury	Pathologist, St. Mary's Hospital
Dr. Arthur Pearson Luff	Physician, St. Mary's Hospital, Honorary Scientific Adviser to the Home Office
Dr. Gilbert Turnbull	Witness for the defense, Director of the Pathological Institute at the London Hospital
Dr. Reginald Wall	Witness for the defense, physician at the London Hospital
Charles Hetherington	Dispensing chemist at Lewis & Burrows

JOURNALISTS

Evan Yellon	Investigative journalist and editor of *Albion*, a magazine for the deaf
Henry Labouchère	MP and editor of *Truth* magazine
Horatio Bottomley	MP and owner of *John Bull* newspaper
Joseph Meaney	Journalist who covered Belle's funeral
Philip Gibbs and J. P. Eddy	Journalists hired to write Ethel's 1910 life story

IN PRISON

Major Owen Mytton-Davies	Governor of Pentonville Prison
Ada Alice Fricker, aka "Lady Mercia Somerset"	Con artist

Cast

THE SMITH FAMILY AND FRIENDS

Stanley Smith	Ethel's husband
Stanley Robert "Bob" Smith	Ethel's son
Nina Margaret Campbell (née Smith)	Ethel's daughter, married to:
Colin Campbell	Her husband
Rex Manning	Ethel's best friend, married to:
Doris Manning	His wife
Ursula Bloom	Novelist who wrote about Ethel

CHORUS

Marie Lloyd	Famous music hall personality
Joe Elvin	Famous music hall personality
Wal Pink	Famous music hall producer, friend of Mrs. Ginnett and Belle Elmore
"Charles Pooter"	Comedic character from Holloway, the protagonist in *Diary of a Nobody* by George and Weedon Grossmith
Alexander Bell Filson Young	Editor of *The Trial of Hawley Harvey Crippen*

Prologue

N O MURDERER SHOULD EVER be the guardian of their victim's story, and yet this is the role that Hawley Harvey Crippen has always held.

For weeks in 1910 he stood sphinx-like and imperturbable under the public gaze. The police and the press marveled at his fixed expression, at how it remained unyielding to questioning and cross-examination. Not even the sudden bursts of photographers' flashes rattled him. He never flinched or buckled under the pressure. He gave one account of events from which he never deviated. So long as he held that narrative close, he also controlled Belle Elmore's story, all the elements of her tale, all the experiences and opinions of the wife he had killed.

Although he was recognized as a proven liar, his version of the ordeal, his assertions about her, would be what endured. The events of the North London Cellar Murder would be remembered as Dr. Crippen's tale—a sensationalized story of a murderer.

Until relatively recently, murderer's tales would jump directly from the newspapers into cultural legend. Once they were ballads with block-printed portraits, then penny dreadfuls and cheap paperbacks stuffed full of chilling exploits. Long ago, murderers became celebrity monsters, terrifying aberrations of humanity whose waxwork likenesses inspired an uneasy mix of revulsion and reverence among those who visited chambers of horrors. Like most myths, stories of murderers and their crimes made for great entertainment. The veracity of these often-repeated narratives, whether sung or

1

whispered around campfires, was rarely probed. When a killer is placed at the center of the drama, there is no opportunity to contemplate anything else. They own the story entirely; their deeds are of prime importance. Everyone else is just a supporting character.

This book pulls apart the traditional framework of the North London Cellar Murder and removes Hawley Harvey Crippen from his usual role as the story's star. He will be one character among an ensemble cast brought together to tell a more panoramic and human version of one of the most infamous crimes of the early twentieth century. This is the story of a murder, not a murderer, and as such there is space for nuance, for moral ambiguity, for understanding the context of the crime, the lives of those it touched and the setting in which it occurred. Room has been created to consider the perceptions and contributions of a range of individuals who were previously dismissed as peripheral.

Since 1910, the wardens of Dr. Crippen's story have been a corps of male narrators. Chief Inspector Walter Dew, Captain Henry Kendall, the barristers Richard Muir, F. E. Smith, Travers Humphreys, Cecil Mercer and Samuel Ingleby Oddie, and the scientists William Willcox and Bernard Spilsbury, along with a collection of music hall performers and journalists, have each, in their own way, propped up Crippen's story with their memoirs and biographies. Bound into these volumes are the tales of masterful, clever and brave men whose shrewd observations, expertise or decisive action enabled them to help capture a killer and bring him to justice. These men could not be heroes if Hawley Crippen were not a villain.

Standing behind them is another group whose contributions have been allowed to fade away with the passage of time. The North London Cellar Murder is a story predominantly about women but told almost exclusively by men. So many of its female players were vocal and active participants in events. Aside from Belle Elmore and the femme fatale, Ethel Le Neve, whose stories are woven into the case, an entire company of women—sisters, friends and colleagues—all occupied roles of varying importance in the discovery and prosecution of the crime. Some of them were even involved in

changing the law. While Ethel Le Neve's story was extensively chronicled by the press, only Adeline Harrison, a journalist, was given significant space in the papers to air her views. Unlike her male counterparts, the secretary of the Music Hall Ladies' Guild, Melinda May, was the sole woman to have her first-hand account published in a book. It is the women's version of events, what they saw and did, as documented in newspapers and archival records, that I will be fully restoring to this history.

Murders are horrific events—devastating, squalid and vicious. There is nothing that can mitigate the destructive impact of a life deliberately extinguished. However, what such a crime does leave in its wake is an opportunity to pause and to examine the human condition. On its most basic level a murder is a story about people and their emotions, about their vehement desires, their tumultuous anger, their raging jealousy, their corrosive frustrations. It is about what these forces wreak on families, friends, communities and societies. In some cases, it is about the imprint these events leave on history.

It was through this lens that I came, almost by accident, to the subject of murder. As a social historian, my interests lie in the mundane and unspoken aspects of daily human existence: the grubby and unmentionable, the inner dialogues, the fears, the shame and the expectations harbored by the long dead, who like us yearned and ached and loved. While the wealthy and educated often recorded their experiences, the majority of men and women who inhabited centuries past were not granted this privilege. Instead, traces of their life journeys can frequently be found in the documentation of crime.

As any member of the modern police force or the criminal justice system will attest, a murder creates an enormous amount of paperwork. It was no different in the past. Where the historian is concerned, these forms and statements, the interviews with witnesses, the inventories of confiscated property and even the newspaper reports are like gold dust. A crime creates a fixed snapshot of an era at a particular moment in a particular place. It also presents an oppor-

tunity to take a core sample of that society. The documentation surrounding a crime allows historians to drill into a period and to examine the realities of life that lurk beneath the publicly espoused values and beliefs. How people claim to have lived and how they actually lived rarely ever aligns.

Truth is a slippery substance. No account, even one written into historical record, is ever entirely reliable. Everyone will see or experience an event differently from someone else, which is not to suggest one or the other is incorrect, but rather that history offers us an ever-shifting kaleidoscope of possible answers. In the context of a historical crime, the personal motives of those providing the accounts must also be considered. Not everyone is forthcoming with information and sometimes that which is offered is presented in fragments. Everyone involved in the North London Cellar Murder harbored their own set of imperatives. Some wanted justice for their friend or family member; others wished to protect the defendant or themselves from punishment or public censure. The police wanted to demonstrate that they were diligent. Reporters wanted to produce good copy and smoothed and trimmed their interviews accordingly. Occasionally, they colored the dull spots with their imagination.

All these participants and their array of accounts contribute to the multi-act drama you are about to experience—but be warned: this ensemble cast is comprised of many unreliable narrators. If at times certain stories seem inconsistent, it is because they are formed of stratified lies—layer upon layer of them. You will never be left to navigate these alone, as the contexts will be made clear. In the course of this saga, perspectives will shift; you will be introduced to one side of the story and then to another. Between these multiple versions, a broader understanding of this episode in history will emerge, even though it is bereft of the most important first-hand account of all—that of Belle Elmore. One of the most unfortunate aspects of any story of a murder is that the victim can never speak for themselves.

ACT I

The First Wife

Charlotte

I T MUST HAVE BEEN a terrible shock to see his name in the news-paper. It appeared not just in one, but in all of them. His un-mistakable face was everywhere—those bulging eyes behind the spectacles, the drooping mustache. As they read the grisly details of what he had done to his wife it would have been impossible for them not to think of Charlotte. What might he have done to her?

Selina Leary knew it was only a matter of time before the jour-nalists came calling at 225 West 120th Street. She was prepared for them when they knocked on the door of her Harlem apartment. The *New York American* had already been to see her brother, William Bell, in Long Island. Selina was less forthcoming than he was. Wil-liam spat out angry words; she chose hers carefully. She was asked about Belle Elmore, but Selina "did not care to say anything about the slain woman" or about Dr. Hawley Harvey Crippen, beyond admitting that she once "knew him well" and that she would be able to identify him should he be caught.[1]

William had told the journalist about Charlotte's letters. He had told them that Charlotte's former husband had insisted she submit to "unnecessary operations." The reporter asked Selina if she wished to confirm this, but she said nothing.

The *New York American* wanted a photograph of the first Mrs. Crippen to print in their publication alongside that of the second Mrs. Crippen, and so someone, most likely Selina, went and re-trieved one from an album or a frame or a drawer. It had been taken on a day sometime between 1882 and 1884, not long after Charlotte

Jane Bell, her mother Susan and Selina had arrived in New York from England. Charlotte had gone to the fashionable studio of the French-born photographer Marc Gambier, who took portraits of famous actresses and middle-class Manhattanites. It cost $5 for a dozen 10 x 7-inch prints of one's own face. Charlotte had her dark hair pulled back into a bun and her fringe curled loosely on her forehead. She had the clearest of blue eyes, a small, firm mouth and a square, full face. She was neither beautiful nor unattractive by late-nineteenth-century standards. As might be expected of an unmarried, educated young woman in her mid-twenties, she had dressed modestly in what appears to be a dark-colored taffeta bodice with a high lace neck. She also chose to wear a large plain gold locket. These were the early days of Charlotte's new life in America, and it is difficult not to spot a glint of optimism in her distant, pensive look.

To most Americans who were unfamiliar with the realities of life for the Irish "gentry," Charlotte's description of her upbringing at Bellview House, in Abbeyleix, County Laois, must have sounded like a romantic tale. She was born on April 20, 1858 to Arthur Bell, a gentleman farmer and a Justice of the Peace, who had studied Classics at Trinity College, Dublin. Bellview, with its seven bedrooms, its drawing room, parlor, dining room and library, all richly appointed with mahogany furniture, sat on the rise of a hill, in the middle of 90 acres of pasture, meadow and woodland. Its stable was filled with horses. Its farms produced hay, wheat, oats and potatoes, and reared pigs, turkeys, chickens, geese and dairy cattle. Charlotte, with her elder siblings, Susan Rebecca, Madden and William, and her younger siblings, Charles and Selina, used to travel about the countryside, to Abbeyleix and Kilkenny, in the Bells' polished open-top brougham. Her father rode with the local hunt, and the family attended balls and charity events at Abbeyleix House, the home of the Viscount de Vesci, for whom her grandfather acted as a land agent. Arthur had married Susan, the daughter of Reverend Samuel Madden, the Prebendary of Kilmanagh, an educated woman who strongly believed in the promotion of literacy. The Bells were a family drawn to science, medicine and technology. In 1862, Arthur in-

vented a new type of sawmill which required a fraction of the horsepower normally used by such machines.[2] Susan encouraged the family's servants to read, and regularly lent her employees books from her own collection.[3] The Bells were Protestants in an Ireland whose English-made laws were not designed to favor the Catholic majority. For generations, their faith conferred on them political and social advantages which allowed them to enter the fringes of elite life.

On the surface, they seemed to enjoy an existence no different from that of the English gentry, but the Bells' perceived prosperity, their comfortable chairs and French drapery, their schooling, servants and manners were merely the trappings of a life they could not actually afford. For centuries, in Great Britain and Ireland, true enduring wealth was predicated on landownership, which offered security of tenure and a guaranteed income. Its inheritance might ensure a family's position, economically, politically and socially, for years to come. Unfortunately, the Bells, like the majority of Irish families, from those of their class down to the poorest of cottier farmers, were tenants. The Bells had leased their land from the Viscounts de Vesci since the eighteenth century, pouring their resources into developing their holdings, subdividing their property among family members and subletting to smaller tenants. Money was borrowed and usually repaid against the value of the land's income, but in 1852, after seven years of crop failures during the Great Famine, the Bells were increasingly unable to make good on their debts. Around the time of his marriage, Arthur had agreed to take over the lease of Bellview from his father and to pay off some of the encumbrance with Susan's dowry. This only partially cleared the burden and, upon his father William's death in 1860, a further encumbrance against the property came to light. The Bells, with their growing family, began to struggle and Bellview House was in urgent need of repairs to its roof. It had originally been Arthur's plan to hand back the lease to de Vesci, sell his goods and emigrate with his young family to New Zealand, but his father's ill health kept him in Ireland. "My means are so small (only amounting to £46 per

annum besides what I can make by my own industry in Bellview) and so crippled that it is not in my power to do the work myself . . ." Arthur wrote in a lengthy pleading letter to the Viscount in May 1860.[4] He asked to borrow £50 for the costs of maintaining a property which, in effect, belonged to the Viscount, not to him. "If your Lordship should have any opportunity of giving me or procuring me employment, I trust you should find me not only deeply grateful, but most anxious to attend to your Lordship's interest, or do credit to your patronage . . ." he added, in what must have been a mortifying request.

Arthur was granted the loan, but when in 1867 his financial circumstances had still not improved and the floorboards had begun to rot beneath his family's feet, he was forced to borrow a further £50 from his lordship.[5] The Bells were hardly able to keep their heads above the rising tide of their debts when, in the following summer, typhoid fever came to Bellview. While Charlotte and her younger siblings recovered, Arthur did not. He died on August 20, 1868 and was followed to his grave in October by Charlotte's elder sister, Susan Rebecca. After this blow, her mother struggled to maintain the estate. She sold the farm equipment in order to repay her husband's debts, and by 1871, her brother-in-law Reverend William Jacob and her sister Rebecca had taken on a share of the lease, but neither of these remedies staunched the bleed of money from Bellview. Arthur had written to Lord de Vesci as early as 1860 that he knew his "prospects of getting on in this country were very slight."[6] After the catastrophic impact of the Great Famine on the Irish population and economy, no one wanted to assume a lease encumbered with debt for land which barely yielded enough income on which to live. The events of 1845–51 drove roughly 1 million Irish to emigrate, and in the years that followed a scarcity of work or opportunities to build a future would push the numbers of those leaving the country higher still.[7] Ultimately, by 1877, Susan could no longer manage what remained of the Bells' family home. She and her children would now have to look overseas for any promise of prosperity.

There would always be opportunities for her boys. In 1877, an uncle placed Charlotte's younger brother, Charles de Hauteville Bell, into an apprenticeship with the merchant navy in England. Madden Arthur Bell emigrated to Australia to seek his fortune in the gold fields, and William Oscar Robert Bell bought a passage to New York in 1881 and became an engineer. The women of the family had two choices, the most preferable of which would have been to marry. The least favorable would have been to go forth into the menacing world and earn an income. In 1877, Charlotte was a marriageable nineteen, but a well-bred, educated young woman without a penny in her pocket was unlikely to have attracted the right sort of suitors. However, it did make her a perfect candidate to become a governess or a teacher, the only jobs considered appropriate for a young woman of her station in life.

When and under what circumstances Charlotte was hired to teach at Brackley Grammar School in Northamptonshire are unknown. She appears on the 1881 census as a "teacher." The word "governess" had originally been written into the column designated for "occupation," but someone mindfully amended it. A governess required no professional training to shepherd and instruct young children, usually within the household of a relatively wealthy man, but by 1881, the role of a teacher increasingly did. Adverts for "certified teachers" filled the wanted columns of the newspapers in the early 1880s, and church-sponsored teacher training colleges for women, such as Whitelands College and Maria Grey College in London, were offering rigorous one- and two-year courses which prepared students to become schoolmistresses. Qualified female teachers hired by schools might be expected to offer instruction in English, foreign languages, music, history, mathematics, "moral" and natural sciences. There is no indication which of these Charlotte offered the seventeen male pupils at Brackley Grammar. The school, with its affiliations to Magdalen College, Oxford, had grand aspirations to make itself "a middle-class school of the first order" and "a very important center of education."[8] It was headed by the Reverend John William Boyd, who appears to have preferred Irish

Protestant teachers; the colleague with whom Charlotte shared her instructional duties, Dudley McLeish, had, like her father, studied at Trinity College, Dublin. Both she and Mr. McLeish, along with Reverend Boyd's wife and six children, two boarding pupils and four servants, shared his large but "damp and unsanitary" home.[9] It was suggested that these conditions led to an outbreak of typhoid which would claim the life of Boyd's son later that year. Boyd would leave the school shortly after this, as it seems so too would Charlotte, whose life had already been devastated by the unfortunately familiar disease.

So little is recorded about the lives of Arthur Bell's widow and daughters after his death that the circumstances which finally compelled them to emigrate to the United States remain a mystery. While Charlotte was employed in Northamptonshire, Susan had found a position in Wales working at the National School in Holyhead, where she and Selina also lived. Evidently, this arrangement had proved unsatisfactory, or perhaps letters from her son William in New York encouraged her to join him there. Holyhead, poised on the windblown tip of Wales, the port from where the ships set sail and returned from Ireland, must have seemed a transient place in which to station their lives: somewhere between the past and the untried future. It is difficult to believe that leaving did not feel inevitable. Susan and Selina departed for New York in 1882, with Charlotte either accompanying them or following soon after.

Until their arrival in New York, the Bells had lived a mostly rural existence, with visits to Dublin, Kilkenny and other cities and towns in Ireland and Great Britain. Nothing they would have seen, smelt and heard prior to their arrival in the United States would have prepared them for the sensory assault that awaited them in the screeching, belching, snarling, sprawling American metropolis. In 1882, the Statue of Liberty was not yet in place to greet them, and the incomplete Brooklyn Bridge sat like a partially strung harp in the middle of the East River. Laborers working for Thomas Edison's Illuminating Company were digging the streets of Lower Manhattan and laying electrical cable through the otherwise gaslit city. Above them

rose gargantuan buildings which spread along entire city blocks. Inside they contained the highest ceilings and the widest cathedral-like windows. There were rumbling, rattling trains cantilevered over streets, held in place with forests of criss-crossed, riveted, rusting iron girders. The roads were as wide as rivers, and two and three deep on either bank with wagons and carts, carriages, horses, barrels—and people. The city bulged with roughly 2 million of them in the early 1880s. They were of every country, every language, every description, dark skin and light skin, speaking in languages the Bells had only seen mentioned in books. They wore colored shawls and brightly embroidered headscarves and waistcoats, Chinese silk robes and slippers with curled toes, beads and braids and hats: flat or triangular or little skullcaps. Oscar Wilde, another native of Ireland who visited New York in that year, commented on the frenetic pace of life and that everybody seemed "in a hurry to catch a train." The city fizzed with ideas and industry and business. There were streets of clothiers, haberdashers, bookstores and furniture sellers that seemed to run for miles. The entire place felt like "one huge Whiteley's shop," Wilde marveled, while also remarking on the infernal noise of it all: "One is waked up in the morning, not by the singing of the nightingale, but by the steam whistle . . ."[10]

Susan, Charlotte and Selina cast themselves into this vast ocean of a city. Where they landed first is unknown, but by 1885 Susan and Selina are recorded as living at 411 West 40th Street, right in the rotting heart of an area known as Hell's Kitchen, the Irish settlement. Few New York neighborhoods were as notorious as that bounded by 34th Street to the south and 59th Street to the north. From there its reputation ran down to the docks, west from 8th Avenue. The waterfront and the Hudson River Railroad attracted heavy industry into the area; distilleries, stockyards and slaughterhouses with tanning and fat-rendering facilities. These, along with milk sheds, carpet mills, wallpaper factories, gasworks and ironworks, all provided jobs for poorly paid, unskilled laborers, the majority of whom were Irish immigrants. Cheap tenement housing sprang up to accommo-

date the area's population, who also built themselves shanties along the vacant lots between 37th and 50th. Drinking establishments and brothels plugged the gaps between the factories and the ramshackle homes. The area's housing quickly became overcrowded. Residents shared their squalid quarters with chickens, goats and geese. The thick stink and effluent of industry was an all-pervasive, hanging, drifting presence. Sanitation was poor and diseases such as cholera, typhus and diphtheria would sweep through the community. Criminality bred as easily; barefoot children as well as adults turned to violence and theft, pickpocketing and robbery, the sale of sex and stolen goods. According to the journalists who ventured into the area, peering into the infamous buildings—the Barracks, the House of Blazes and the place which lent its name to the entire locality, Hell's Kitchen on 40th Street—everywhere was a scene of human misery, intoxication, lethargy, vice, filth and illness.[11] Guns blew out neighbors' brains, drunken men beat their wives unconscious, bodies were found sunk into the fetid mud and shit pudding of the streets. Newspapers of the 1880s liked to heighten the worst of these tropes for their readers, but rarely mention that Hell's Kitchen was also populated by people who ran shops and provided services, those who merely wanted to get on with their lives: carpenters, seamstresses and grocers.

It is a puzzle how Susan and Selina Bell found themselves here, having fallen from the mahogany-filled rooms of Bellview and the company of Lady de Vesci. Four hundred and eleven West 40th was a five-story brick building, where in the late 1880s two heated double rooms without board could be rented for $2 a week.[12] Among Susan's neighbors in 1886 were several other widows, a piano maker, a bartender and a fireman.[13] Perhaps one clue to the Bells' presence there lies in the building that almost abuts theirs: the Rose Memorial Chapel, a Protestant Episcopal church at 418 West 41[st] Street. Like many deprived areas, Hell's Kitchen was a magnet for social reformers and church missionaries who, like the Baptist minister and activist Walter Rauschenbusch, lived and worked among the downtrodden there in the 1880s. As the daughter of a high-ranking

clergyman, it is possible that Susan too may have occupied her time with similar work within the community.

If the Bell women had dedicated themselves to missionary work and social reform, this may have contributed to Charlotte's decision to train as a nurse when she arrived in New York. Ministering to the sick and the dying was only half of what nursing would entail in an enormous, unequal city. Charlotte would be throwing herself directly into the cauldron of social problems; she would come face to face with New York's destitute: the malnourished, the diseased, those whose limbs and digits were caught in machine gears and factory looms, single mothers, alcoholics and opium addicts. For the devout who wanted to serve the lost sheep of their community, hospitals were one of the worthiest places to start, and as a single, educated woman in her mid-twenties, Charlotte would have made an ideal candidate for a nursing college.

In the 1880s, the training of women as nurses was still a relatively modern development. The Civil War had demonstrated to Americans the great and urgent need for skilled professionals who could assist both patients and doctors. In the decades that followed the war, many training programs were established across the country; however, colleges were selective about the type of woman they sought for their two-year residential courses. The "noble" and "useful" calling of a trained nurse required "a peculiarly sympathetic, mature and brave heart," commented Mrs. Seth Low, the president of the Brooklyn School of Nursing, in 1889. A nurse needed to be "honest, trustworthy, punctual, quiet, orderly, gentle but firm, cleanly and neat, patient, cheerful and kindly."[14] Students were expected to have "a common school education and be able to read well" but a preference was given for better educated women, who may have received training in other fields, such as teaching.[15] Most importantly, all candidates needed to "be of sound physical and good moral character."[16] To prove this, colleges required two letters of reference: one usually from a clergyman, and the other from a doctor testifying to a woman's physical fitness. Candidates could not be married or caring for children and were usually required to

be between the ages of twenty-five and thirty-five. Nursing was not thought to be a suitable occupation for teenaged girls, or privileged young ladies of delicate dispositions.

Once accepted on to the program, a trainee moved into the nurses' quarters or dormitories, often attached to the hospital. Candidates were given their uniforms, usually a starched white cap, a white pinafore and a long-sleeved, high-necked, modest dress. They were also entitled to a financial stipend for the duration of their training, roughly $7 to $10 per month in their first year, and $10 to $15 per month in their second. The advantages of pay and room and board would offer some recompense for the grueling regime of work and study ahead of them.

In New York, most nursing courses were modeled on that innovated by Bellevue Hospital. Pupils were assigned textbooks to read, and sat examinations throughout the year. They attended lectures given by hospital physicians, but the bulk of the learning occurred in the wards and was imparted through observation and practice at the bedsides and in the operating theaters. They learned how to make and apply bandages, line splints, change linens, provide sponge baths, make "beef tea" and restorative meals, as well as how to administer drugs and hypodermic injections. They were instructed on how to watch for changes in vital signs, sleep, appetite or thirst and how to convey this critical information to the doctors. Work in the wards was exhausting and relentless. Listening to suffering and screaming, contending with bleeding and vomiting, cleaning patients of excrement, urine, phlegm and pus, bearing witness to the brokenness of the human body and observing life expire before them was all in a day's labor. Hospitals contained "all the tragedy in the world under one roof," wrote Mary Roberts Rinehart, who began her training in 1893.[17] Years later she would recall her first introduction to the blood-splattered operating room and how she was required to dispose of a human foot.[18] She commended herself for not being sick. Nurses were supposed to be sympathetic, but never fragile.

Military-like regimentation and strict daily schedules helped to

ensure that nurses did not lose their nerve or their focus. Shifts were split between staff, with nurses' days usually beginning at 6:30 a.m. and ending between 8 and 10 p.m., when her colleagues on night duty arrived. In the first year, every trainee nurse was expected to give three months of her time to night duty, which often made it difficult to stay awake during afternoon lectures. All nurses were allowed two hours of leisure in the afternoons and were granted two weeks of vacation leave each year. Occasionally trainees were permitted to go to the theater in the evenings but were "never allowed to receive a gentleman friend at the school."[19]

Once they had completed their initial training, most nurses went on to secure jobs or to acquire a specialism in a particular field of medicine. After achieving her nursing qualifications, Charlotte was drawn to work in a homeopathic institution. Her brother William would later state that he thought it was the Hahnemann Hospital on the Upper West Side "at 62nd Street and 9th Avenue," but the Hahnemann had never been located in the area, nor did it offer training for female nursing pupils.[20] Instead, the homeopathic hospital to which he referred was almost certainly the Deaconess Institute of the Methodist Episcopal Church at 129 West 61st Street. It had officially opened its doors in 1887 "to patients of all ages who require medical or surgical treatment."[21] In April of that year, there were thirteen doctors and surgeons on staff, and the Institute was actively seeking nurses to hire and to train, as well as medical interns hoping to hone their skills. Among the latter was an eager and confident young man from Michigan, who had great plans for his future.

2

The Crippens

I T IS UNLIKELY THAT anyone in San Jose, California, knew the truth about Ardesee Crippen's circumstances. Her neighbors and the ladies for whom she stitched elegant gowns may have speculated among themselves, but as long as she referred to herself as a married woman, no one would dare suggest otherwise. She had been playing this game for roughly twenty years, and knew precisely what to say in 1880, when the census taker came knocking on the doors of Santa Clara Street. When she was asked to provide the name of the head of her household, Ardesee made it clear that she was that person. Her "husband" Myron, who had at various times called himself a clerk, a farmer, a salesman and a merchant, was presently nowhere to be found. It was just her, "keeping house," and her seventeen-year-old boy, Hawley Harvey Crippen. No one ever need know that he was illegitimate. In 1880, he was finishing high school and working part-time in a fruit cannery, raising money for his further studies. Home for Mrs. Crippen and her son was a couple of rooms above a row of shops in the commercial center of town, which consisted of a handful of dusty streets traversed by a horse-drawn trolley car.

There is no explanation for how Ardesee and Hawley came to be in Northern California, at the southern tip of San Francisco Bay. The surrounding hills were brilliant green in the springtime, the climate calm and sunny, if not occasionally damp: perfect for growing the fruit, nuts and berries which made its farmers rich. But, like

the peach and plum trees, the Crippens were imports from else-
where.

Ardesee had given birth to her only son in the year that followed
the death of her only daughter, Ella. Hawley Crippen entered the
world in Coldwater, Michigan, sometime in the second half of 1862.
Some sources say it was July, while others suggest it was September 11.
Hawley Crippen's life would be riddled with such mysteries and
gaps—this would be but the first of them. How Ardesee Skinner of
Damascus, Pennsylvania, a tiny settlement tucked into the wilder-
ness, crossed paths with Myron Augustus Crippen is another. At
some point, the residents of Coldwater started to call Ardesee Mrs.
Myron Crippen, but the couple would not actually marry until 1891,
when they were both fifty-six.[1] The deception must have been no
mean feat; the Crippens were people of consequence in Coldwater.
Myron's father, Philo H. Crippen, was one of the early settlers in the
town. He owned a substantial farm, a mill and a general store. He
had interests in the town's bank and in the sale of local real estate.
The Crippens were founding members of Coldwater's Methodist
Episcopal Church and were conspicuously pious. Philo Crippen was
"a strong temperance man" and had built his family a proud clap-
board home adorned with a Greek revival-style portico.[2]

Although the details of the family dynamics are only ever hinted
at in documents, Myron seems to have been something of a prodi-
gal son. There is a restlessness to his life. In 1860 he and Ardesee are
living on a farm, but by 1870 Myron, at thirty-five, is calling himself
a "retired merchant" with property worth $5,000. He signs the Civil
War draft register in 1863 but manages to avoid the conflict. Five
years later, Ardesee is listed as a sewing machine sales agent for the
Home Machine Company, and by 1874, Myron is operating the busi-
ness on a larger scale from the center of Coldwater. Then the family
disappears.

There are faint suggestions of what may have occurred. Many
years later, after Myron's death, "friends" mentioned that he had
once been "worth $100,000 . . . but . . . crooks did him out of it."[3] The

Crippens left Coldwater, but where exactly they went is uncertain. Ardesee and Myron appear to have gone in opposite directions. Hawley Crippen would say he was educated in Indiana, but his father claimed he left his hometown in 1875 and went to Florida (Titusville and Jacksonville) and then to Toronto, Canada.[4] What enticed him to the far southern tip of the United States before sending him rebounding north across the border makes for curious speculation. Eventually, he turns up in San Jose in 1880, works as a dry goods merchant, disappears to New York, and returns in 1883. In the meantime, his son had grown up.

As a boy, Hawley Crippen had displayed distinct signs of promise. "He showed an unusual mind, a disposition to overcome all obstacles, to attain every object he sought," his father would one day recall:

> He was always fond of music and when but a child he clamored for a violin. We thought him too young to care for one and learn to play it, whereupon he set to work and made one out of a wooden box and was soon playing snatches of several popular tunes on the instrument of his own manufacture.[5]

According to Myron, Hawley had also "fixed his mind on taking up the profession of medicine" while he was still in school.[6] Fortunately for his son, a doctor, Edwin S. Breyfogle, practiced on the ground floor of the building where he and Ardesee lived. Whether it was one of the Crippens who had solicited some training for their child, or the inquisitive boy himself, Breyfogle was to take Hawley under his wing as an unofficial part-time pupil.

Edwin Breyfogle had come to San Jose in the 1870s from Ohio to practice as a homeopathic physician and surgeon, at a time when homeopathic medicine, though controversial, was rapidly gaining favor as an alternative to orthodox medicine. Homeopathy as a system of healing was innovated by the German physician Samuel Hahnemann in the late eighteenth century, when medicine bore little resemblance to its modern incarnation. At the time, there was

no understanding of germs or viruses, no antibiotics or anesthetics. Most cures relied on blood-letting or purgatives which made patients violently ill. Surgery was performed without antiseptic and while those on the operating table were conscious. Medicine was seen as brutal and invasive and not especially effective. With homeopathy, Hahnemann offered something gentler: cures for ailments which were prescribed after careful study of a patient's symptoms and circumstances, not only their age, sex, their social class and racial characteristics, but their likes and dislikes, and even their moods. Remedies were created according to homeopathy's defining principle that "like cures like"; in other words, that which makes a patient ill can also heal them. Hahnemann had alighted upon this notion while experimenting with cinchona bark, used for curing malaria. He found if he took enough of it, the bark would produce the same symptoms as the disease itself. However, in order for this principle to work, Hahnemann believed these potentially harmful substances needed to be diluted, as a large dose would only worsen an illness. This "law of infinitesimals" maintained that as a substance was diluted, its therapeutic properties were enhanced, and its harmful effects were reduced. The more diluted the substance, the stronger the remedy. During the process of preparation, dilutions were given extra effectiveness through "potentization," or vigorous shaking. Although the patient would enjoy the full benefit of the medication, virtually nothing of any active ingredient would remain in the remedy itself.

Perhaps homeopathy's greatest appeal among the general public was that, unlike "allopathy" (the community's name for orthodox medicine), it was not seen to contribute to the death or injury of patients. Remedies were designed to assist a person's "vital force" to heal the body. This "kinder" and more "sympathetic" method of curing illness was cited as the reason for its appeal to women and the devoutly religious. The discovery of antiseptics and the acceptance of germ theory also led many practitioners to combine homeopathic remedies with regular medical procedures, which appeared to increase positive outcomes. By the mid-nineteenth century, homeopathy felt

like an exciting and progressive development in medicine. It had become as popular in America as it had in Europe, so that between 1860 and the 1880s, the United States could boast of fifty-six homeopathic hospitals, thirteen mental asylums, nine children's hospitals and fifteen sanatoriums.[7] In the meantime, rivalries and disagreements raged between orthodox medicine and homeopathy; medical societies expelled or ostracized homeopaths, and orthodox instructors refused to teach students who professed a desire to practice it.[8] All the while, homeopathists argued among each other as to whether they should adopt aspects of orthodox medicine or remain entirely faithful to Hahnemann's principles.

Whether Hawley Crippen had specifically set out to become a homeopathist, or was influenced in his choice by Edwin Breyfogle, by 1881 he had applied to the University of Michigan Homeopathic Medical College in Ann Arbor. Although there were no entrance exams for students holding high school diplomas, candidates were required to demonstrate that they had gained some experience from a respectable physician in the field, prior to application. Dr. Breyfogle had agreed to be Crippen's preceptor, and by working shifts in the local cannery during his summer holidays, he had earned some of the $35 fee needed for the first year of his three-year college education. There were no college dormitories in Ann Arbor so pupils were expected to board with private families for a further $3 to $5 per week. In addition to this, there would be laboratory fees and textbook costs to consider. It would be an expensive undertaking, and it fell to Ardesee to make up the difference. According to a local newspaper, it was her "great personal sacrifice" working long hours as "a fashionable dressmaker . . . who designed and constructed the party gowns for the elite of the city . . ." that enabled her (rather than Myron) to send her son to Michigan.[9]

In September 1882, Hawley Crippen took his first steps toward a career in medicine. His days would be filled with laboratory demonstrations and practical work, as well as lectures. Among the number of subjects homeopathic medical students were required to study in their first year were histology (or microscopic anatomy), chemistry,

minor surgery, botany, the *Materia Medica* (homeopathy's "bible"), and of course practical anatomy. According to the University of Michigan's course catalog for 1882–83, first-year pupils were required to spend "from 10 to 12 weeks of afternoon work in the dissecting rooms in which all the structures are to be worked out by each student."[10] Michigan's Homeopathic College did not differ from conventional medical training in that it demanded students acquire hands-on experience with actual human cadavers. Even for a homeopathic practitioner, familiarity with every aspect and function of the body was considered fundamental to a doctor's knowledge.

While in Michigan, Crippen appears to have made the acquaintance of Dr. Phil Porter, who, like Edwin Breyfogle, would become instrumental in shaping his career. As an esteemed practitioner in gynecological and obstetric medicine, as well as the editor of both journals in the field, Porter was regarded as one of homeopathy's most preeminent specialists. His influence was felt everywhere—on homeopathic committees, in medical colleges and at conferences. "Thoroughness is his specialty and ovariotomy is his pastime," a colleague once joked, with all the humor of 1885.[11]

It says much about Hawley Crippen's promise as a medical student that he came to Porter's notice while still in his first year of education. The physician would become his mentor and in 1883 offered him an opportunity to assist in an oophorectomy.[12] Yet in spite of this, and for reasons unknown, Crippen would withdraw from the University of Michigan at the end of his first year. He chose instead to continue his studies at Breyfogle's alma mater, the Cleveland Homeopathic Hospital College, in Ohio. So begins a pattern of constant movement that would come to characterize the entirety of Crippen's early career. Compelled by eagerness or impatience, boredom or disillusionment, he would never be content to linger anywhere for long.

It was with the encouragement of Phil Porter that the newly qualified Dr. Crippen embarked on a study tour of Europe in the summer of 1884.[13] Porter himself had only just made a trip across the Atlantic to visit various homeopathic institutions and training

centers. His introductions would help procure opportunities for his pupil overseas. He also invited Crippen to contribute scholarly articles and insights from his travels to one of his publications, the *American Homeopathic Journal of Obstetrics and Gynaecology.*

This would be a thrilling adventure for the 23-year-old doctor, a rare chance to journey around the continent and acquire an urbane polish, while increasing his medical knowledge. He would hone his (admittedly poor) French linguistic skills, dabble in German, admire the architecture, absorb the culture, and sample the food and wine so exalted by nineteenth-century Americans as the height of sophistication. As the journal's "special correspondent," Crippen, who harbored ambitions as a writer, often strays from his scientific observations into poetic musings. "A delightfully Spring-like morning last week tempted your correspondent to brave the dangers of seasickness and cross the English Channel to France," he wrote.

Preparations were hastily made, and after farewells to a few friends and a consumptive shriek from the engine, the train was soon rolling through the suburbs of London out into a splendid farming country toward Newhaven. From the window of the car, the ever-varying panorama could be seen, long stretches of green fields dotted here and there, with quaint old-fashioned houses against a background of brown hills, almost leading one to believe it a bit of landscape taken from our own Pacific Coast.[14]

Crippen had traveled to Paris from London, where he had attended lectures at the Hospital for Women in Soho Square and visited the city's Homeopathic Hospital and Medical School. In the French capital he observed the workings of the famous Salpêtrière Hospital, which was then at the center of early psychological studies into female hysteria, before moving on to Berlin. In Germany, the birthplace of homeopathy, he was disappointed to find that medics had to acquire their training through allopathic institutions before practicing in the field, though he was especially impressed by the "rigid adherence" to Joseph Lister's teachings on antiseptic within

operating theaters.[15] However, for the better part of his year abroad, Crippen had been based at London's Royal Bethlehem Hospital, the notorious "Bedlam" mental institute.

His time there was spent exploring the intersection between mental illness in women and gynecological "irregularities." Within the context of modern medicine, Crippen's work and observations at "Bedlam" and the "scientific" conclusions he draws make for profoundly disturbing reading. Like many of his contemporaries in the medical world, he believed women were susceptible to periods of insanity throughout their reproductive lives, first at the onset of maturity, the next during pregnancy and postpartum, and finally at menopause. "Young ladies whose childhood has been devoted to exercising the mental faculties . . . the girl of precocious education, the slave of fashion and late hours, with implements of torture to keep the shoulders straight and the waist within bounds" run the risk of "enfeebling" their bodies and bringing on "excessive or irregular and painful menstruation," he writes in his article "Diseases of Women as a Case of Insanity."[16] He also believed that mental illness in women was caused by their reproductive systems. Anything from heavy periods to the position of a woman's uterus and cervix might bring about "mental derangement." A fifteen-year-old patient who had not yet menstruated, but who had a family history of mental illness, was thought cured of her paranoia by the onset of her periods. More unsettling still was the case of a 61-year-old laundress who had been suffering from mania and had tried to kill herself. Upon inspection of her vagina, they found evidence of ulceration and infection, before removing "a child's toy; a *wooden trumpet*" from near the cervix. It was concluded that the presence of this foreign object had been the cause of her psychological disorder. With its removal she was pronounced cured and was discharged.[17]

Porter was impressed with Crippen's work and upon his return in the summer of 1885, took him on as an assistant at his practice in Detroit. Here, Crippen continued to develop his theories about disorders of the female reproductive system and their effects on other parts of the body, this time focusing on the ear and "hysterical deafness."[18]

From the ear, Crippen turned to the eye and embarked upon a further course of study at the New York Ophthalmic Hospital in 1886. Leapfrogging from one city to the next, the following year he was back in Detroit working at the practice of an ophthalmologist, Dr. D. J. McGuire, before his attention was drawn to a residency position at the newly founded Deaconess Hospital in New York.[19]

As a hospital intern, Crippen's routine would have been grueling. Young doctors were usually assigned to what was called "ambulance service," or the emergency ward. He, like the nurses, would have been on call, living on site and dealing with a range of urgent cases; fevers, infections, injuries and attempted suicides. In the middle of the night, when patients in the wards began to sink, an intern was always the first doctor to be summoned. He would be shaken from his bed and appear "in a dressing gown over his pajamas, with rumpled hair and heavy eyes."[20]

Although the Deaconess, like most hospitals, would have attempted to keep male and female staff isolated during their leisure time in gender-separate sitting rooms, Dr. Crippen and Nurse Bell would have been frequently thrown together in the wards. Hospital matrons were known to complain that many nurses seemed "to regard the hospital as a matrimonial agency where flirting with young doctors is the first consideration and nursing a secondary matter."[21] It is difficult to imagine any other scenario while society insisted that marriage for a woman was always preferable to a career. Nevertheless, relationships between male and female staff members—which in some hospitals included women doctors as well as nurses—while discouraged, were grudgingly accepted as a natural occurrence.[22]

The early story of Hawley Crippen and Charlotte Bell's romance does not seem to have been recorded by family members. What drew them to one another will probably never be known. A photo of Hawley Crippen taken in Vermont in the early 1880s shows a thin young man with a full head of neatly combed strawberry-blond hair, his trademark mustache already in place and drooping over the corners of his wide mouth.[23] One day, his large blue eyes would be covered with heavy, magnifying spectacles, but at this early stage

he seemed capable of sight without them. People would later describe Dr. Crippen as charming, gentle, kind and always eager to be of assistance, especially to ladies. He was also intensely, unstoppably driven, focused and calculating, and perhaps it was a combination of these characteristics which Charlotte believed would make for a good husband. Although almost nothing is known about her personality, Nurse Bell, who had endured the loss of her father and sister, who had learned to earn her own income and had trained for not one but two careers while still in her twenties, who had left behind the country of her birth for the dangers and promises of a new land, and who had daily balanced life and death in her hands, would have been a woman of remarkable resolve and considerable mental and physical strength. She was also four years his senior and would have just turned twenty-nine at the time they had met. Perhaps she reminded Hawley Crippen of his mother, the only determined and stable influence in his life.

Charlotte and Hawley were married on December 13 in the year that they met, 1887. Crippen had returned to Detroit prior to their wedding, and his fiancée had resigned her nursing position and joined him there. The groom had arranged for the union to take place at the home of Dr. Porter, who, in the absence of Crippen's own father, appears to have assumed that role in his life. The choice of venue may have served another purpose for Crippen too; several years earlier he had proposed marriage to Mrs. Porter's niece, whose mother had forbidden the match.[24] Such performative and symbolic gestures would hold great significance to the doctor for much of his life. Being seen, recognized and admired for his success drove his ambition. He made certain to announce his marriage to "Miss. Charlotte J. Bell of Dublin, Ireland" in a number of medical journals in which he described his bride as "the niece of the late Dr. John Butler," a celebrated homeopathist, a pioneer of electrotherapy and the developer of "the vibrator."[25] It appeared to be an auspicious match for the homeopathic community, though whether it augured as well for the couple personally is questionable. There is nothing to suggest that either of their families were present at the wedding. Dr.

Porter and his wife Isabel acted as the witnesses, and years later, Charlotte's brother William would admit that he never learned where or when his sister had married.

Along with the announcement of their marriage, the newly wedded Dr. and Mrs. Crippen made it known that they intended to start their life together out west, in San Diego, California. The couple departed the day after their wedding and traveled across the Midwest to Texas, where, in mid-December, Hawley stopped to collect mistletoe (also used in homeopathic preparations) from alongside the tracks of the Southern Pacific Railroad.[26] By the 20th, they had arrived amid the dry, green and beige hills of Los Angeles, where they were welcomed by a local newspaper as a party of 189 passengers from the east "who have declared their intention to locate in this state."[27] For the Crippens, this journey was undertaken not only to commence an adventurous new chapter in their lives, but also to enjoy a luxurious honeymoon, appropriate to the aspirations of a young medic and his refined wife.

A few days before Christmas, Hawley Crippen inscribed their names into the ledger of the Hotel Josephine on Coronado Island, in San Diego Bay.[28] Described as "a first-class family hotel," the Josephine was a dazzlingly elegant beach resort with a veranda and private balconies, as well as viewing towers where guests might watch the ferries and pleasure boats glide across the calm water.[29] As they strolled along the shore of the glittering Pacific, the Crippens must have felt liberated from whatever challenges they may have faced in New York. Here, in the warm December sun, was hope, promise and a respite from the cold—if only for a while.

3

Paralysis of the Sympathetic

T HE DECISION TO COME to San Diego was a bold roll of the
dice. In the 1880s the city was in the grip of a property boom,
which drew speculators from around the country. The sunshine en-
ticed growers of citrus, grapes and soft fruit. The port called to
those hoping to create shipping and trade empires with Asia and
South America. In the hills that ringed the city, prospectors mined
for gold and silver. The medical community too flocked to San Di-
ego, which had been declared "the Italy of Southern California" and
lauded as the finest health resort in the state.[1] In spite of this, the
thriving young city, which clung to the outer edge of the American
frontier, had yet to throw off its lawless, "western" character. Fifth
Street, the main street, ran like a seam of vice through its middle,
decorated with saloons, brothels, opium flops, gambling halls and
thieves' dens. Shootouts were common and Wyatt Earp, a lawman
whose name was synonymous with some of the most legendary of
them, had recently become one of San Diego's more prominent
business owners.

Hawley Crippen saw an opportunity to prosper here as a homeo-
pathist, amid a community in need of medical care. In the year the
Crippens arrived, fundraising had begun for San Diego's first ho-
meopathic public hospital, the Good Samaritan. Until that time pa-
tients were treated in a variety of private homes, boarding houses
and hotels, with doctors based in offices around the city. Crippen
managed to cobble together a patchwork practice as an "eye, ear
and nose" specialist operating from several addresses at the more

salubrious end of 5th Street. This included a position as the resident oculist at the "San Diego Optical Institute," which in reality was a jewelry shop that sold spectacles, opera glasses and binoculars.[2] Like those who mined for gold or sunk orange trees into the rich soil, the Crippens were prospectors. As such, they had arrived with modest resources and intended to live humbly until they found their fortune. They had made their home in a set of rooms further up 5th Street in the Gilbert Block, above a row of shops.[3] With shared toilets down the hall, there was little luxury or convenience to be enjoyed, which would have been spread thinner still with the arrival of Ardesee, who had come to join the married couple when Charlotte found herself pregnant at the beginning of 1889.[4]

A baby, while certainly not unanticipated, would change everything. For the first time in his life, the man who had dedicated his career to researching the reproductive organs of women was living in his own scientific study: observing his wife's abdomen grow, her body transform, and her desires and moods rise and fall. Given his expertise, it would be surprising if it were not Crippen who delivered his son, Hawley Otto, on August 19. Charlotte pushed him out in the middle of San Diego's sticky monsoon season, with Ardesee on hand to assist.

It is unlikely to be a coincidence that one of Crippen's most prolific periods of writing for Phil Porter's *Homeopathic Journal of Obstetrics, Gynaecology and Paedology* corresponded with the period of Charlotte's pregnancy and the birth of their child. During this time, a series of articles entitled "The Insanity of Pregnancy" appeared. Crippen explained in a preface that he had intended to publish his work as a book, but instead he decided that it "might reach a greater number of readers" if it appeared in Dr. Porter's periodical.[5] This was the consolidation of all Crippen's research undertaken at Bethlehem Hospital in London and under the auspices of Phil Porter in Detroit. In it he expanded on his understanding of the connections between female mental illness and the state of "pregnancy, parturition and lactation." He had discovered that of the 561 cases of female insanity at Bethlehem Hospital, fifty-eight were "due to causes re-

lating to pregnancy," with most women's "mania" presenting in the period following birth. He would go on to say that the majority of women during the period of pregnancy experience changes in "tastes, habits and temperament" which lie on "the borderland of insanity" and that the "tendency to insanity increases with age." However, insanity in pregnancy might be treated with kindness, at home by a skilled nurse or family member, and if the need for institutionalization arose, the cruel physical restraints of previous decades were not called for, only the gentle expedient of a padded cell. For the most part, Crippen's unpalatable theories adhere to those of his contemporaries, including his inclination toward eugenics: he firmly discouraged "marriage in families that have . . . [a] strongly marked neurotic tendency" and unions between the blind "as the duty we owe to the state." The only truly eyebrow-raising aspect of his writings is the disconcertingly suspicious timing of their publication.

While Crippen's true interests lay in gynecology and obstetrics, he seemed convinced that he could only earn a living as an eye and ear specialist. It required slightly more than a year and a half to establish a niche for himself in San Diego. After the opening of the Good Samaritan Hospital in 1889, he was describing himself as the "Eye and Ear Surgeon" to this institution as well as to the San Diego Dispensary. However, whether on account of frustration or discontent, at the start of 1890, he, Charlotte, Otto and Ardesee had packed their belongings and returned to New York. Whatever gold he had hoped to strike in California had not been forthcoming.

The Crippens had come full circle, quite literally. There is no indication that a job had pulled the doctor back to the metropolis, either. In fact, William Bell suggests the opposite was true. He recalled that his sister and her husband entered a precarious period where they moved from one address to the next: from the Upper West Side (at 62nd and 10th Avenue) "to a house somewhere near the Armory at 62nd Street and Columbus Avenue."[6] Bell seemed to think his brother-in-law was practicing as a dentist, but an oculist was more likely. Oddly, given their recent move and the absence of

steady employment, the Crippens did not seem to be short of money. In the spring, Hawley had taken his family, including his mother, on a rather extravagant trip by ship from New York to New Orleans, where they stayed at the fashionable Hotel Vonderbank, before proceeding to Memphis, Tennessee.[7] Here they took lodgings at the plush Gaston's Hotel, frequented by the city's "men of commerce" and celebrities such as Oscar Wilde. The purpose of this visit was professional; at the time, Crippen was seeking a permanent position at one of the homeopathic colleges and hospitals, something he would not succeed in securing until the autumn when he was appointed a surgeon and specialist in practical refraction at the New York Ophthalmic Hospital.[8]

Such a prestigious position within a respected institution might well have established the Crippens' fortunes. They were at last able to afford more comfortable and spacious housing in a modern block of apartments not far from the Ophthalmic Hospital, at 148 East 30th Street.[9] The Smithsonian, as it was called, offered units of six and seven rooms with hot water, and bathrooms, a dining room, a sitting room and quarters for a maid, for upward of $35 per month.[10] William Bell recalled this change of address, as he did his sister's other relocations. "They moved to 30th Street, near Lexington Avenue," he said, but this occasion had lodged in his memory more precisely because it coincided with Crippen getting himself into "some kind of trouble."[11]

Throughout his life, Hawley Crippen would cultivate a penchant for living beyond his means. It may have been a habit he had acquired from his father, who in turn had been indulged by Philo Crippen, the family's wealthy patriarch. Philo was willing to fund his descendants' follies, whether it was travel, or establishing a business, so long as the loans he gave them were repaid with interest. However, when he died in March 1890, it was revealed that neither Myron nor Hawley had done what they had promised. Worse still, Philo himself was mired in debt. His entire estate had to be liquidated by his creditors, which included not only the gas company and the doctor who had tended him in his final illness, but various

shopkeepers, the bank, and the city to whom he owed tax.[12] It came to light that Hawley Crippen owed his grandfather more than $500, roughly equivalent to $156,000 today.[13] The bank, which was far less forgiving than his relation, decided to pursue the entire amount at exactly the moment when Crippen had accepted his post at the hospital.[14]

In a desperate pinch, the doctor looked to his wife for assistance. It is difficult to know just how much of Charlotte's life in Ireland, or her family's financial circumstances, Crippen actually understood. As Irish Protestants born into the privileged class, the Bells would have regarded themselves in a caste apart from the flood of conspicuously poor Catholic immigrants who had poured into the United States during the famine. Although they did not possess wealth, they would have presented as if they did. Charlotte's manners, her education and even her English-sounding accent would have suggested to Americans, unfamiliar with the complexities of the Irish class system, that the Bells were conventional landowners, who could find capital or secure loans, if necessary. Charlotte's stories of her upbringing and her aristocratic associations, even her decision to describe herself as being from Bellview, the family estate, rather than from the town of Abbeyleix, would have contributed to her husband's conviction that the Bells were sitting on money in Ireland.

In June 1891, Crippen bought a second-class passage to England with the intention of visiting his mother-in-law in Dublin.[15] Like many Irish immigrants to the United States, Susan had chosen to return to her homeland in 1888, after her daughters had wed. According to William Bell, the nature of Crippen's errand was to claim "certain small valuables," or jewelry that he or perhaps Charlotte believed were owed to her. Surely whatever treasure Hawley expected to find would have exceeded the sum he had spent on the expensive excursion overseas. To his disappointment, Susan refused to give him anything and sent him away.[16] It appears that Crippen also paid a call on Charlotte's younger brother, Charles de Hauteville Bell, who had built a successful career as a captain in the merchant

navy. Conveniently, Charles lived in Liverpool, the port into which Hawley's ship arrived, which enabled the affable American doctor to ingratiate himself with his brother-in-law. As part of his charm offensive, Crippen seems to have entertained Captain Bell with an invented tale of his first encounter with Charlotte, which he claimed occurred "mid-Atlantic on a boat bound for New York." He and Miss. Bell "became immediately fond of one another" and were married soon after landing, he lied.[7] Charles Bell liked him. His impression was that Dr. and Mrs. Crippen were happy in their marriage. Bell never mentioned whether Charlotte's husband asked to borrow money.

Crippen returned home at the beginning of August. A new academic term at the hospital's college was about to start and Hawley could look forward to steady employment and the prospect of recovering his financial position. Instead, two months later he resigned his post, gave up their comfortable apartment and moved his family across the country to Salt Lake City, Utah. Not unlike the prior occasions when he had uprooted their lives, no job awaited him at the end of the railway line. He and Charlotte had to begin again.

The most logical explanation is that Crippen was attempting to throw his debt collectors off his scent. The United States was vast enough for a man or a woman to ruin themselves in one town and rebuild their lives in another, without a single soul ever knowing anything about their past. The trick was to keep moving, to shed mistakes, spouses, creditors and even names along the trail. After vanishing from New York, Hawley Crippen walked into the offices of the *Salt Lake Tribune* on November 7 and announced his presence in the city. Within a short while, the doctor had established himself as "an ear and eye surgeon."[18] He was Salt Lake City's sole practitioner in the field, which certainly would have attracted the notice of Dr. James Dart, the President of the Utah Homeopathic Medical Association. Dart, a Civil War veteran, had come to Utah in 1881 and brought his homeopathic skills with him from New Jersey. Much like the Breyfogles in San Jose and Phil Porter in Detroit, James Dart placed himself at the center of his profession and opened

his home to social gatherings.[19] The Crippens rented a small wooden house between the train depot and the as yet unfinished spires of the Mormon Salt Lake Temple, not far from his welcoming parlor.

Even with the support of Dr. Dart, Crippen struggled to establish a thriving practice. Nevertheless, he seems to have procured the funds to pay for the rent on his home as well as on an office in the center of town where he spent his afternoons writing and editing content for medical journals. Finances were already stretched when, like a pair of camp followers, Ardesee and later Myron made their way from New York to join the household.

Although the Crippens were unaware of the eyes that followed them along their street, their neighbors appear to have formulated opinions about the nature of what occurred behind their front door. It would not be until the summer of 1910, after they had read the newspaper headlines, that any of these thoughts were publicly disclosed. By then it had been eighteen years since anyone had seen the Crippens and the neighbors' assorted recollections were a tangle of fraying memories. One resident incorrectly remembered Crippen as "a tall man, rather muscular, with a black mustache" but also clearly recalled Ardesee, "who made her livelihood doing plain sewing," coming to live with the family. "During his residence here, it was supposed he had an income from some source other than his practice of medicine," the former neighbor added. "The family was in straitened circumstances, but Dr. Crippen was uncommunicative," which prevented the neighbors from learning much about his financial affairs.[20]

The most intriguing of these accounts came from a man named William Tanner who stated that he and his wife lived in a cottage in Salt Lake City that was immediately adjoined by "another house which was occupied by a family called Crippen." Tanner's wife was friendly with Mrs. Crippen, but the man who "was commonly known as Dr. Crippen throughout the neighborhood" was not very popular. He had a "quiet and at times almost insulting demeanor," Tanner recalled. He also made it clear that the doctor's wife lived in fear of her husband, who did not like her to be "a neighborin' with

those in the vicinity." The Tanners grew suspicious and kept watch on the family. "Gradually the impression grew that Mrs. Crippen was being maltreated by her husband." One night, in the early part of 1892, the Tanners had just finished dinner when through the window of the front room, Mrs. Tanner witnessed Dr. Crippen throw "a heavy book at his wife" which "struck her in the back of the neck." She had seen Mrs. Crippen stagger and then "fall to the floor."[21] Dr. Crippen eventually lifted his wife from the ground and carried her into the lounge.

No one knows for certain the nature of Charlotte and Hawley's marriage, or how sound the ties that bound them were. It is difficult to imagine a woman of Charlotte's courage and independence satisfied to sit silently in a back room while her husband drafted their life's plan. Was she content to meander from one city to the next, tending to their little boy, sharing her small space with her mother-in-law? Was she happy with her lot, or, when she sailed for America, had she hoped for more than this?

At the end of 1891, the Crippens had been married for four years. In that time, there had been only one child brought to term. In 1910, William Bell suggested that there was a disturbing and sinister reason for this. He claimed that Charlotte had been writing letters to her family complaining that her husband was making her undergo abortions, on account of "certain ordinary and to-be-expected circumstances." He had been "taking advantage of his medical and surgical knowledge and was compelling her," Bell insisted. Charlotte had confided that she had already submitted to "two dangerous cuttings" and wrote fearfully that "My husband is about to force me to the knife again, and I feel that this will be the last time. I want my relatives to know that if I die it will be his fault."[22]

The weather in Salt Lake City had turned bitterly cold at the end of January 1892. The *Salt Lake Tribune* said the thermometer had dropped to 12 degrees Fahrenheit. Snow was expected, but until then the

clouds left gaping holes of bright blue in the high desert sky. Dr. Dart wrapped himself warmly before venturing out on his terrible errand. It was the 24th of the month, a quiet Sunday in the Mormon city.

He was shown into the Crippens' house and taken to where Charlotte lay. It all would have been conducted with the utmost solemnity and professionalism. Dart would write down the words "apoplexy" (a stroke) as a result of "Paralysis of the Sympathetic," a homeopathic term implying a complete shutdown of the sympathetic nervous system. Then he signed the death certificate.

How an otherwise healthy 33-year-old woman came to suddenly suffer a stroke is a mystery. Equally perplexing is why her husband told members of his professional brotherhood that "the sad event occurred . . . from heart disease."[23] Was William Bell's aggrieved tale about his sister entirely true or enhanced by an over-zealous, headline-chasing newspaper editor?[24] Then there is William Tanner's account. Although his memory of events may not have been the sharpest (or the most genuine), Tanner recalled the Crippens' "little boy" knocking on their door. It was the day after they had seen their neighbor throw a book at his wife. The child "asked Mrs. Tanner to come to his home as his mother was very sick." When his wife arrived there "she found that Mrs. Crippen was dead and that a big dark bruise, nearly the size of a butter chip, was apparent just at the base of the brain." He went on to say that Crippen's wife had been "ill for many months" prior to that.[25]

In this situation, there is an itch that is difficult not to scratch, a conclusion that wants to be drawn. In 1910, everyone believed it possible that Hawley Harvey Crippen killed his first wife, but it is impossible to prove that he did.

What remains to be told of this episode does nothing to salve the urge to pick at this possibility.

There were seventy-two hours between Charlotte's final breath and her burial. On the day following her death, Crippen placed a notice in the *Salt Lake Tribune*: "Died: Crippen—on January 24th, Charlotte J., beloved wife of Dr. H. H. Crippen. Funeral from residence, 565 South First West at 10 o'clock a.m. Tuesday."

Everything was concluded very quickly, very neatly. The under-takers, William Skewes & Son, took her coffin up the hill, east out of town, to the Mount Olivet Cemetery. Crippen would not have wanted mourners to witness that he was relinquishing his wife to a pauper's grave. Charlotte was lowered into the patch of land re-served for those who had nothing: the drunks, the vagrants, the destitute and the shunned. There was not even enough money for a headstone.

Was he truly this impoverished? Could he not have solicited assis-tance from his associates or from Charlotte's family? Certainly, if the chagrin of this act was too great to bear, there were always moneylenders. He had never been ashamed to resort to them in the past—nor would he be in future.

Neighbors who lived in the vicinity of South First West Street remained "suspicious." "There was something that did not appear right about the death—an air of secrecy seemed to surround it—but the case was never investigated, and it is a question if there were sufficient grounds at that time to order an investigation," wrote the *Salt Lake Tribune*.[26]

Hawley Crippen gave up the house where he and Charlotte had lived as a family and moved to a more central address in the city. He decided that he could not manage to raise two-and-a-half-year-old Otto alone and so handed his child into the care of Ardesee, who had plenty of experience raising a boy on her own. She and Myron would spend the next several years blowing around the country like tumbleweeds, sometimes together, sometimes in opposite direc-tions, through Houston, New York, St. Louis and Portland, before finally coming to rest in Los Angeles.

William Bell swore he was furious when he received Charlotte's letters. "It was in my mind to go West and kill this man who was maltreating my sister," but he "restrained" himself. However, after word reached him of Charlotte's death, he claimed he did go to Salt Lake City. Unfortunately, when he got there "Dr. Crippen had van-ished."[27] He must have waited a good many months before setting out, if he truly ever did go. It would have been too shameful to ad-

mit that he had let the matter, the anger and the questions slip away, that he had allowed his sister to fade into the dust of the desert.

Dr. Crippen remained in Salt Lake City through May of that year—he had two papers to present at the meeting of the first annual Utah Homeopathic Medical Association. Then, finding nothing else to keep him there, he turned his sights east. He would never look back, nor would he wish to remember how he had left his wife, nameless on a hillside.

ACT II

*"I never expected
anything like this"*

4

Kunegunde

I N 1873, ON SEPTEMBER 3, a tiny baby came screaming into the
world. She was born in a brick tenement on the shores that lie
opposite Manhattan, amid the smokestacks and factories, the sugar
refineries and breweries. This Brooklyn girl, who would grow up
with few trees to climb or fields from which to gather flowers, was
instead to collect a bouquet of different names. Some were inher-
ited from the forests and pastures of Germany and Poland: Kune-
gunde and Concordia. Others were home-grown and made her feel
American: Konney, Cora, Corinne. One was picked to express her
ambitions: Cora Turner; another was full-blown in its flamboyance:
Belle Elmore. She wore them at various times in her life, pinned to
her identity.

The first of these was handed to her at birth. She was called Ku-
negunde after her German maternal grandmother. Her surname,
Mackamotzki, belonged to her father, Joseph, a maker of nails who
had emigrated to New York from a region referred to as Russian
Poland, and sometimes as Prussia. Kunegunde was not quite two
years old when she underwent her first change of name. She is re-
corded as Concordia Mackinack on the 1875 census. Her family
would later admit that the moniker assigned to the little girl was
too unwieldy for American mouths. No one could pronounce it, let
alone remember it. Her mother, Mary, would choose a simpler name
for the couple's next child, Teresa, though the girl's father would
never get the opportunity to call her that. A few months before her
birth, Joseph died, leaving his heavily pregnant wife to support herself

and their young daughters through her dressmaking skills. Fortunately for the widow Mackamotzki, her husband's friend, a German immigrant named Frederick Mersinger, agreed to marry her and take in her children. Mary gave birth ten days after her nuptials, when all of them, including Concordia, became Mersingers.

The Mersinger family, with its two transplants, put down roots and began to grow. In 1880, they were living at 154 Union Avenue, at the center of the Brooklyn neighborhood of Williamsburg. At the time, Brooklyn's population of roughly 600,000 was already as diverse as that of Manhattan. Although Williamsburg was the center of the area's German-speaking community, its streets were also home to Eastern European Slavs, Irish and a growing number of Italian immigrants. Catholics, Lutherans and Jews built businesses and houses of worship on opposing blocks. Cultures and languages swirled together in America's reluctant melting pot, no ethnicity trusting the other entirely, but dependent on their bakeries, their delivery carts and their butcher's shops. Each set of streets, whether the mainly German ones on which the Mersingers lived, or the Italian or Jewish neighborhoods, had their individual sights and smells: sauerkraut, caramelizing sugar, vinegar, coffee, boiling honey, strong beer. Organ grinders played their jaunty tunes, surrounded by gangs of ragged-clothed children. Sad-eyed elders watched from their open windows. Drying laundry flapped like sails in the breeze, collecting particles of coal dust. The author Theodore Dreiser commented that, with its small wooden houses and poorly paved streets, "Brooklyn looked actually poor and hard-up."[1]

The Mersingers' home on Union Avenue was no different from those which surrounded it. The family would have occupied one floor of the two-story tenement, their lives decanted into a few interconnected rooms adjoining a small kitchen. It was here, around a warm stove, that Concordia's family, her mother and stepfather, her sister Teresa, her half-sister Katie and her mother's youngest brother Antoin would have gathered. Money was exceptionally tight and would continue to be, so long as the family expanded. When Concordia was a young child, both of her parents worked.

Frederick brought home an income delivering newspapers, while her mother continued at her trade as a dressmaker. At eleven years old, even Mary's brother was sent out to earn his keep as a paperboy. Three sets of wages put food on the table, though meals would have been meager and concocted from anything affordable or at hand: scraps of meat, an onion, some bread, a bit of egg, thin slices of apple, which might be chopped and mixed into meatballs (*Frikadellen*), or made into *Weg Geschnissen*, a type of bread pudding.[2] Nothing, no crumb of the edible, no offcut of fabric, no pencil nub, chip of coal or sliver of soap would have ever been discarded.

Poverty and the urban landscape would have been the dual forces that shaped Concordia's earliest understanding of the world. In the yard behind their building, beyond the foul-smelling outhouse, was a fish smokery which puffed out thick, reeking clouds. There was a musky-smelling stable next door and a noisy wire-manufacturing plant across the road. Childhood experiences were to be snatched wherever they could be had, in the wasteland between warehouses and industrial buildings and on the stoops of the overcrowded brownstones. Boys gathered for a game of baseball, girls minded their younger siblings, children nimbly wove between the moving wheels of wagons and carts and horse traffic on their routes to and from school.

Despite the difficulties that such a life brought, the devoutly Catholic Mersingers appear to have provided their children with a kind and gentle upbringing.[3] Frederick proved to be an affectionate stepfather, and generous to the two girls who had been placed in his charge.[4] "I raised her as my own child," Mersinger would one day recollect about Concordia, whom he called "the best little girl I ever knew."[5] From an early age, his stepdaughter had begun to display a talent for performance and used to make the family laugh "with her imitations of the animals."[6] Mersinger also claimed to have introduced the child to music and taught her to play the zither. According to the family, she soon developed a fine singing voice and used to dream about going on the stage.

Music and singing were an integral part of German immigrant

life and the streets that cross-hatched Williamsburg were home to numerous venues and societies that promoted performance. Within blocks of the Mersingers' building were not only elaborately decorated beer halls with spaces designed for concerts and dramatic performances, but German and English language theaters: the Germania or the People's Theatre, and Phillip's Summer Theatre where affordably priced tickets could be had for vaudeville shows. By 1894, Brooklyn boasted thirty German singing societies: men's, women's and mixed choral groups, some with hundreds of members.[7] *Sängerfests*, or song festivals, were held outdoors during the warmer months. These all-embracing community events, to which families were encouraged to bring picnics and beer, were frequently organized by the Turn Vereine: a nationwide society for the promotion of German culture, physical activity and liberal politics. The Mersingers would have participated in these, and the early voice training which Concordia was said to have received may very well have come from these societies, as well as through her schooling.[8]

Concordia, or Konney as she was sometimes known, began to mature into a young woman, with dark eyes and hair and a long but full face. Her family and friends thought her warm, bubbly, bright and clever. According to her sister Katie, Concordia completed her compulsory grammar school education, which would have ended around the age of fourteen, "and then took a course in a high school."[9] By the end of the nineteenth century, high schools had been devised to offer students separate courses of study which might prepare them to enter industrial or commercial trades or to attend a university. What precisely Concordia studied at one of the few high schools in Brooklyn in the late 1880s is unknown, but she appears to have acquired what her family described as "a very good education." Whether or not her sister Louise's claim that Concordia knew seven languages was true, she was a fluent speaker of German and proficient in French.[10] According to Katie, her sister completed her schooling at around the age of sixteen or seventeen, and then "became a governess for a wealthy family."[11] It was at this time too that Frederick revealed to his stepdaughter her true parentage, that she

was in fact a Mackamotzki not a Mersinger. Concordia's feelings about this are not recorded, but it seems significant that, shortly afterward, she began to call herself Cora Turner. Cora, a popular first name at the time, must have felt like an appropriate abbreviation for Concordia. Turner, while not an immediately obvious choice, was a surname used frequently by immigrants affiliated with the Turn Vereine, societies that held an important position at the center of German communities. Members were referred to as "Turners." It is possible that Cora, feeling unmoored from her familial identity, reached for another cultural one to replace it.

<p style="text-align:center">★★★</p>

Along the streets of Bedford Stuyvesant, the neighborhood to the south of Williamsburg, there was greenery to be found. There were trees whose leaves sprouted, colored and fell. There were plants with buds that swelled and opened into flowers. Even the sound of birds could be heard. The houses there, most of which had only recently been built by German and Irish laborers, were much larger. Some had even been designed as free-standing villas with stained-glass windows and ornamental turrets, surrounded by gardens.[12] These were comfortable homes for lawyers and architects, doctors and business owners—men who defined themselves as leaders of their communities, who went to church or to synagogue, who liked to believe that their fortunes came from the active use of their minds. They kept servants and had wives and daughters who joined the local lawn tennis clubs and played croquet.

At 814 Lafayette Avenue lived Charles Cushing Lincoln, his wife Estelle, his older brother, James, and Harry and Frederick, the couple's two children. Sometime around 1891, perhaps earlier, Cora came to work here as a servant, the sole maid in a mid-sized household. At a time when domestic service was a role largely filled by young female Irish immigrants, the Lincolns seem to have preferred girls of German descent. Whatever the circumstances of her employment, Cora appears to have arrived in the Lincolns' lives during

a period of upheaval. In July of that year, Charles had his wife declared insane and committed indefinitely to an asylum in Connecticut. His brother James was then granted legal guardianship over her, and a move was made to assume the interest she possessed in the family property, a substantial farm in Cohasset, Massachusetts, worth at least $40,000.[13] What prompted such a decision, whether it came from legitimate concern or a more sinister motive, is never revealed. The Lincoln brothers were entrepreneurs whose business was in stoves and hot-air heating, but their interests had recently begun to expand into the acquisition of land.

By February of 1892, Charles Lincoln's family life was unrecognizable from what it once had been. With his wife no longer at home, his sons were sent elsewhere to be raised. Only his brother and Cora, the hired help, remained in the house. It was at this time that her situation, too, underwent a change. On the New York census of that year, she is no longer listed as their servant, and had adopted the prefix of "Mrs" before the name Turner, as was customary for women who lived out of wedlock with a man.[14] Interestingly, the Mersingers did not appear to know about their daughter's altered circumstances, nor does it seem they were aware that by the summer of that year, Charles Lincoln had got her pregnant. Among her neighbors in Williamsburg, unmarried pregnancy would not have been looked upon with kindness. As Betty Smith described in her semi-autobiographical memoir *A Tree Grows in Brooklyn*, such perceived lapses of morality by young women were considered sinful and deeply shameful. Cora would have been at the mercy of her community and exposed to public and private ostracism, ignored or persecuted by neighbors and harassed on the street. Unmarried mothers and their children might even be subjected to violence by a society that would have sought to make a lesson of her and her offspring.[15] Cora could not have returned home in such a condition, and as Charles Lincoln did not demonstrate an inclination to marry her, a remedy was sought for her predicament. Lincoln called upon the discreet services of a neighboring homeopathic physician with a specialism in gynecology and obstetrics, Dr. George Clinton Jeffrey,

and his new assistant, recently arrived from Salt Lake City, Dr. Hawley Harvey Crippen.

Someone among Crippen's professional circle, whether his old mentor, Dr. Phil Porter, or another specialist in obstetrics and gynecology, must have made the introduction that saw him placed with Dr. Jeffrey. Since Crippen had recently suffered a bereavement, his colleagues would have been naturally sympathetic to his wish for a change of scene. Brooklyn, and the affluent middle-class clientele of Bedford Stuyvesant, would have given him a chance to reinvigorate his prospects. Jeffrey offered Crippen a room in his home at 343 Jefferson Street, where his practice was also based.

Despite working in a state with some of the strictest anti-abortion laws in the country, Dr. Jeffrey and numerous physicians like him quietly continued to perform terminations as part of their services. By 1872 abortion had been made a felony in New York, punishable by up to twenty years' imprisonment for a doctor who even attempted to perform one, whether or not the woman was actually pregnant. The woman, too, could be charged with a felony, as could any other party peripherally implicated.[16] Notwithstanding this, as long as desperate women were willing to take the risks necessary to end pregnancies which threatened their livelihoods, their reputations or their well-being, doctors would make themselves available to perform these illicit procedures. As the anonymous "Alice Smith," a turn-of-the-century sex worker in San Francisco found: "Almost any doctor'll fix you up—for money."[17] Nearly every one that she approached for a surgical abortion acquiesced, though the more reputable, "safer" ones charged exorbitant fees, anywhere from $150 to $200, which included drugs for the pain.[18] Physicians who engaged in these practices fastidiously covered their steps, but things did not always go to plan. Newspapers regularly featured stories of women who had died under the hands of abortionists, either as a result of blood poisoning or a botched operation. Dr. Jeffrey was involved in at least two cases where a woman in his care had undergone a "delicate operation." Remarkably, he managed to evade prison, though a colleague, Dr. Hanford, was not as fortunate.[19]

Crippen seems to have suggested that the "delicate operation" or "miscarriage" that Cora underwent had required some further care from Dr. Jeffrey and, as Jeffrey's assistant, also from himself. How the relationship between a doctor and a vulnerable patient who had just endured a harrowing, illegal procedure then grew into a romantic affair begs many questions. According to Crippen, at this time, Charles Lincoln's financial situation was in a state of flux. He had let out his house and was "living in a room."[20] Cora, although still supported by Lincoln, appears to have been left pregnant and alone in her own rented room. The pretty young "fallen woman," hiding her shame from her family and grateful for the doctor's expertise and care, must have proved tempting for the widower. According to the beliefs of the era, a woman prepared to have sex out of wedlock was morally compromised and therefore would have no compunction about sharing her sexual favors with others too. As for Cora, the attentions of a thirty-year-old junior doctor must have been welcomed. Lincoln, with his complicated life and financial troubles, would not have seemed a favorable long-term prospect for a young woman, not quite nineteen years old. Crippen's courtship must have been an enjoyable distraction during the warmest part of the summer. He claims to have taken "her to several places for some weeks," engaging in the traditional seasonal pastimes: promenades in the parks, visits to the seaside, and an inevitable trip to Coney Island with its sea bathing, fireworks, roller coasters, aquariums and racecourses.[21] Cora, a poor girl from Williamsburg, who might have expected to marry a factory worker, or perhaps a policeman or a shopkeeper, was instead sashaying down the boardwalks on the linen-suited arm of an educated professional who had been to Europe and traveled across the United States. Undoubtedly, her admirer, with his famous charm, set something alight in her heart too. He was tender toward her and, as a doctor, his concern for her well-being was constant. Few things could have felt more flattering or reassuring, especially when she considered the financial stability his medical career was likely to bring.

Whatever would be said about the couple in later years, the love

that existed at the inception of their relationship must have felt thrillingly real. Crippen had only taken up his position with Dr. Jeffrey around June of that year. His first wife had been in her grave for hardly more than six months when he met Cora. There was no obligation for a man so recently widowed to marry again, but perhaps this young woman, with her youthful air, who loved to sing, reminded him that he could escape from the unpleasant reminders of his past, whatever those may have been. There were other more immediate pressures to consider too. By the end of the summer, Charles Lincoln had begun suggesting to Cora that she "go away with him." Upon learning this, Crippen insisted that he "would marry her right away."[22]

While Crippen's bold decision might have seemed impulsively romantic, there was also a practical reason for marrying before the autumn. According to the *Southern Journal of Homeopathy*, Dr. Hawley Harvey Crippen had accepted a prestigious position in Louisville, Kentucky, at the newly created Southwestern Homeopathic Medical College, as the Chair of Ophthalmology and Otology.[23] Although the college and hospital were still in their fundraising stage, it was intended that Crippen would become a founding member of the school, while working as one of the region's sole homeopathic practitioners in that field. With his medical colleagues touting him as "one of the most accomplished writers in homeopathy," this appointment was guaranteed to raise and finally secure his standing among his profession.[24] Certainly, this was the sort of prominent post that Crippen had been seeking as he had wandered from San Diego to New York and out to Salt Lake City. As he was due to assume the role in October, he did not have much time to waste in Brooklyn. The obvious solution was to board a ferry or a train and elope to Jersey City.

New Jersey, the state that lies just across New York Harbor, was a haven for runaway couples wishing to wed quickly. Over the years its many border towns—Newark, Camden and Jersey City—had acquired the reputation of being "Gretna Greens," named after the Scottish town to which couples eloped from neighboring England.

In 1892, New Jersey had notoriously lax rules governing matrimonial unions. Unlike New York and Pennsylvania, an application for a marriage license was not required. Remarriage following a divorce was also not prohibited, and the state adhered to "no particular form of celebrating the marriage ceremony." As a result, an entire industry of "Marriage Mills," or churches willing to marry anyone quickly, flourished. A journalist reporting for the *Chicago Tribune* visiting the town of Camden remarked that passengers at the ferry port were confronted by "a line of hacks" each in the employ of different ministers who were paid to spirit couples off to one of the many churches. People arrived daily from "all parts of the country."[25] When they had located a celebrant to wed them, couples were generally asked to pay what they could for the marriage service, which might range anywhere from 2 cents to $40.

On September 1, two days before her nineteenth birthday, Cora Turner and Hawley Crippen were married without the knowledge of her family, and, it seems, without much knowledge of one another either. She had given her name as Corinne Konney Turner, the daughter of Joseph Turner and Mary Wolf, on her marriage certificate. It would not be until after their wedding that, somewhat abashedly, she admitted her true name—Kunegunde Mackamotzki. Why the couple insisted on keeping their union a secret is unknown; so too are the details of the early months of their marriage. It appears that Cora, after disentangling herself from Charles Lincoln, had moved to 296 Grand Street, back to her old neighborhood in Williamsburg. Conveniently, her family had since relocated to Newtown, in Queens. From the accounts given by her sisters, Teresa, Kate and Louise, as well as by her stepfather, it appears that Cora remained in Brooklyn while her husband went to establish their life in Louisville. Cora also seems to have embarked on some form of professional singing career. Louise later claimed that "her voice was trained before she met Crippen," while Kate recalled that her first performance was at the Star Theater in Manhattan and that she later joined a traveling company which went "west."[26] Curiously, Frederick also echoes this story, affirming that she left home when

she was in her teens "and went on the stage" before meeting Crippen "in the West."[27] At some point after the autumn, Cora did "go west," but unbeknown to her family, this was to finally settle with her husband, rather than to make a tour of the vaudeville theaters.

In the 1890s, Louisville, Kentucky, was one of many rapidly growing and modernizing cities, throwing up its first "skyscrapers," spreading green landscaped parkways through its urban center and ushering in its first passenger trains through the arches of its own new union station. Like San Diego and Salt Lake City, Louisville was a place for those with ambition. The Southwestern Homeopathic College was one of many such bold projects. It was to be the first medical establishment of its kind in the Southern states.

During that autumn and the early months of the winter, Crippen enthusiastically threw himself into his work. He produced a series of scientific articles for the *Medical Argus*, the *Journal of Ophthalmology, Otology and Laryngology* and the *Homeopathic Journal of Obstetrics, Gynaecology and Paedology* on subjects as diverse as heart disease and congenital ptosis (drooping eyelids) in children, on each occasion proudly describing himself a Louisville practitioner. Eager for homeopaths to swell their ranks and expand the discipline in Kentucky, the founders of the college and his fellow physicians seemed to welcome him warmly into their fold. What then occurred to suddenly change the tenor of the situation is a mystery.

Much like his appointment two years earlier at the New York Ophthalmic Hospital, Crippen spent no more than a few months in situ before handing in his resignation. There is no indication of gross misconduct, no record of any illegal practices. Was it impatience, unrealistic expectations, or a desire for money and prestige that did not manifest to his timetable? Hardly four months had elapsed since his arrival in Louisville before a statement appeared in the February 1893 edition of *Medical Century*, one of the foremost homeopathic medical journals. "Dr. H. H. Crippen, recently located at Salt Lake City, but who was announced to locate permanently at Louisville, has determined upon another field of labor and will not remain in Louisville."[28] His colleagues did not mask their frustra-

tion at his decision, writing several months later that they "were very sorry to see Dr. Crippen leave. There is a crying demand here for an ear and eye man . . ." and reiterating that Louisville was "certainly a splendid location for anyone who is willing to bide his time."[29] It was an impulsive decision, which would cost him dearly. The College was no flight of fancy. It laid its foundation stones and then successfully opened its doors to students in October 1894. If Crippen had been incredulous or impatient, an investment of two years would have seen his name recorded among the list of founding faculty, heralded as one of the incorporators of a great homeopathic medical institution. Instead, he left under a cloud.

In turning his back on Louisville, Crippen effectively closed the door on his last opportunity to make a reputable name for himself in his profession, to show his mentors and all the men who had invested their time and money in his promising genius that he had risen to the level they expected of him. In the early months of 1893, he took another path. Once more, he packed his bags, boarded a train and went elsewhere. For the rest of his life, when listing his prestigious appointments, when boasting about his professional accolades and titles, neither he nor his wife ever mentioned his position at the Southwestern Homeopathic College or breathed the merest hint that he had even lived in Louisville.

In the spring of 1893, Crippen found himself in St. Louis, Missouri, working for Professor H. Hirschberg, "the well-known expert of 629 Olive St.," and the owner of a veritable optical empire. His "non-changeable spectacles," or bifocals, were advertised nationally and sold by sub-agents throughout the country. [30] Hirschberg, whose name Crippen recalled incorrectly as Hirsch, enticed prospective customers with his free eye tests, which were administered by eye specialists at his shops. It was a significant if not mortifying demotion for a man as proud as Crippen, who had once been a surgeon and an instructor at one of the country's top homeopathic teaching hospitals. After walking out on his previous position, Crippen might have finally rendered himself unemployable as a practic-

ing physician. He must have desperately needed the work when he appealed to Hirschberg.

Once he was settled and earning a reliable income, Cora finally joined him in St. Louis. When she did so, she was still maintaining to her family that she was unmarried. She wrote to Teresa with an invented story about how she had obtained a position as a housemaid in St. Louis. While working for her employers her "good looks and happy disposition caused her to receive an offer of a position on the stage." She asked her sister to address her correspondence to Corinne Turner, which she claimed she was using as a stage name.[31]

For the first time since their hasty wedding in September, the couple properly embarked upon their married life. Far from the familiar faces of Brooklyn, they seemed to enjoy telling their acquaintances in this city that they were newlyweds. They rented a small painted clapboard house at 1106 North Leonard Avenue in midtown, surrounded by open land, a distance from the city's industrial heart and the busy river traffic of the Mississippi. According to the neighbors, Cora seemed content, living openly as Mrs. Crippen, tending to her garden, proudly doing her own housework, and occasionally making cheerful exchanges with those who lived nearby. The Crippens seemed "very fond of each other, even for honeymooners." He was gone for most of the day, and "the neighbors often heard her singing, both to her husband and in his absence." It was remarked that "she had a lovely voice, a high soprano."[32] But like everything in Hawley Crippen's life, this small haven of happiness was but a temporary stop. Before the end of the year, the Crippens were packing their belongings and returning to New York.

With nowhere permanent to live, and no job arranged for the doctor's arrival, Cora and Hawley moved into her familial home in Newtown, a more rural part of Brooklyn. According to the census taken the year before, the house was bursting with Cora's six half-siblings: Katie (15), Annie (12), Frederick Junior (11), Louise (8), Julius (6) and Antoin (3), in addition to her parents, her uncle, Antoin Smith, and her paternal aunt, Theresa Mersinger. Somehow,

room was found for Cora and her husband, who "seemed to be in need of money."[33] Although Frederick and Mary welcomed the couple into their home, their eldest's marriage came as somewhat of a surprise. Everyone had been told something different. In a letter, Cora had fibbed to Teresa that they had been married in St. Louis, but eventually showed her "the marriage card," which documented the actual date and place of the wedding. Several iterations of this story made the rounds in the family. Some of the Mersingers believed she had been on the stage in St. Louis and met Crippen there, while others seemed to think Crippen had treated her as a patient several years earlier before making her acquaintance again in Missouri. No one cared to scrutinize the details or compare versions of the tale. Frederick Mersinger confessed he had his doubts about Crippen, as might any patriarch whose daughter suddenly appeared legally bound to a man without any means of supporting her. "Business had been against him," Mersinger admitted, and suggested that it was due to Cora's dedication and encouragement that her husband was finally able to pull himself out of a rut.[34]

The couple remained in the Mersinger home for several months, during which time the family attempted to get to know Hawley Crippen. The house would have been filled with noise: scampering young children, harried women in the kitchen, tired men—a cacophony of conversation in English and German. It would not have been an ideal setting for a doctor whose only paid work was writing and editing scientific articles for medical journals. Despite the lack of privacy or quiet, Crippen remained at his most polished and contained. In that time, he would have learned more about his new spouse than he had previously known. Mealtimes for the Mersingers were important. It was as they sat around the table, cutting into their helpings of fried meat and potatoes, that they held what was referred to as their "family councils."

The clan's newcomer was subjected to many probing inquiries. Frederick shared a story with his son-in-law about how Cora's grandparents "in the old country" wished her to be returned to them after her father's death. A relative had come from Poland with

the intention of fetching the girl. She had been six years old at the time and Mersinger protested that he was quite attached to the child. He told her relations that he regarded Cora as his daughter and refused to part with her. Upon hearing this story, Crippen, sparkling with charm, thanked his father-in-law "a thousand times for having kept her in this country and thus saved her to be his wife."[35] But Crippen would not get away lightly from these family councils. In exchange for these fables, the Mersingers demanded stories from Crippen's past too. They learned he had a first wife, but the doctor ducked and dodged their questions. He told them almost nothing about Charlotte, not even "where his first wife died nor who she was before her marriage." He "never talked about himself." "Sometimes," said Teresa, "we chided him about being a man of mystery."[36]

Around this time, a group photograph was taken of the extended Mersinger household—a large gathering of them congregated outdoors, perhaps in front of their home. They stood where the photographer arranged them, a handful of adults and a gaggle of children, whose number had not yet finished growing; there would be two more by 1895, Bertha and John. There were twelve family members posed for the camera that day. Standing slightly to the side of them, somewhat apart, was the newly sprung branch of the family: Mr. and Mrs. Crippen. They looked nothing like the others. Compared to the Mersingers, who were unaccustomed to posing, who squinted at the camera and tilted their heads, Cora and Hawley appear fashionable and worldly. Cora, in a white mutton-sleeved blouse and tie, sits beside her mother, striking an erect, almost defiant attitude with her hand on her hip. The doctor, smartly attired in a suit, with a short, kempt beard and mustache, stands directly behind his wife, as a slightly detached, but looming presence.

Crippen was indeed a man of mystery, intent on keeping his secrets. Cora came to assist him in this, and he conspired in keeping hers too. One which never seemed to reach the Mersingers' ears was that he had a child by his first marriage, living with his parents in another state. Cora learned about Otto and met him briefly. A St. Louis business directory suggests that Myron had settled in the city

in 1893, at the same time as his son and his new wife. Then, repeating a long-established pattern, he departed when Hawley decided to move on. Shortly afterward, a visit was made to New York with Otto in tow.[37]

As Crippen had remarried, it would have been natural for Otto to be handed back to his father and placed under the nurturing wing of his stepmother. Cora, who had known the care and devotion of a step-parent, would have expected this too. However, her husband was adamantly opposed to this arrangement. Myron would later explain that Hawley believed Cora would be an unsuitable mother: "He thought his second wife . . . being an actress couldn't take care of him as well as we could."[38] It was a convenient excuse for a man who, like his father, was not comfortable with commitments to jobs or to family members. Although Crippen had made a career of studying children and their ailments, how they grew in the womb and were delivered into the world, he had little fondness for them, or for the burden of time and money they represented. By contrast, Cora, as a woman and a devout Catholic, would have been instructed that mothering was her destiny. Family was of prime importance to her, and throughout the years, she expressed that she was "passionately fond of children."[39]

In the 1890s, there was no question of married life not including offspring. The very concept of marriage was inextricably linked to procreation, and the begetting of children commenced on the wedding night. While Crippen's training in obstetrics and gynecology would have given him the knowledge and ability to delay conception, he would have recognized that the arrival of children could not be prevented indefinitely. Hawley Crippen found himself in a predicament. Unless he was prepared to resort to drastic measures, the situation he wished most to avoid would become inevitable.

5

Grand Opera

D URING THE WINTER OF 1894–95, Cora was scheduled for an operation. The night before would have been spent in her private room at the new airy and well-lit homeopathic Hahnemann Hospital in Philadelphia. There, a nurse would have given her a bath and washed her abdomen, the place across which the surgeon would draw his knife on the following day. In the morning, before she was taken to the operating theater, she would be given an enema and dressed in clean stockings and a flannel nightdress, which would be rolled above her waist during the procedure. It was important to maintain the patient's body temperature, and so the room would be heated to 80 degrees Fahrenheit, creating what was believed to be the optimum environment for an ovariotomy, or the removal of a woman's ovaries.

A pillow might be placed at her lower back, to raise her abdomen. The surgeon and his four assistants, after scrubbing their hands, faces and hair with carbolized water and soap, would have fixed the light so as best to illuminate the area. Their instruments, trays, sponges and antiseptic gauzes were laid out for their work. A cone-shaped inhaler, attached to a receptacle filled with ether-dipped sponges, was placed over Cora's nose and mouth. She would have been reassured that she would feel nothing. She inhaled and drifted into a stupor; then the surgeons began their work.

The abdominal incision was made in the median line below the navel. Dr. Phil Porter, one of the acknowledged experts in ovariotomy, recommended it extend to the pubis. The tissues would then

be divided: the skin, fat, linea alba, the transversalis fascia, the extra-peritoneal fat and finally the peritoneum.[1] The peritoneal cavity was opened, the blood flow was staunched, and both of Cora's ovaries were removed from their pedicles. These were then cauterized, and the incision closed with silkworm gut sutures. Only a rubber drainage tube was left in place. Her abdomen was then dressed with carbolized gauze and bandaged. The patient was returned to her antiseptically clean hospital room to recover, though in line with the directives of homeopathy, any pain relief would be administered not as a matter of course but according to how much the patient appeared to need.

As Cora lay in her hospital bed, her excruciating pain dulled by opiates, her mother sat beside her. Mary had come up by train from Brooklyn to be with her for the surgery, and would remain with her during her recuperation period. The recovery would be a gradual one, requiring as much as a month in bed. This would be followed by a lengthy period of rest and reduced activity, in which she would be strapped into a post-operative support belt.[2] The procedure was what her husband's former mentor Dr. Porter described as "a grand operation": not only did it require great technical skill of the surgeon performing it, but the removal of a patient's ovaries would carry enormous consequences for the woman herself.[3]

The purpose of an ovariectomy or an oophorectomy (as they were interchangeably known) was varied and at times vague. The American Civil War surgeon Robert Battey was credited with performing the first successful removal of a woman's ovaries in 1872, which led the medical world to proclaim that a pathway had now been opened to the treatment of many disorders which plagued women. Among these illnesses were life-threatening cases of ovarian cancer, as well as polycystic ovary syndrome, and "oophoritis," or what today might be diagnosed as pelvic inflammatory disease (often caused by chlamydia). The *American Homeopathic Journal for Obstetrics and Gynaecology* also recommended "oophorectomies" for "intractable dysmenorrhoea" (extreme menstrual pain) and "oophoranaemia" (heavy and persistent menstrual bleeding), as well as

for prolapsed ovaries, uterine fibroids and epileptic seizures. In addition to actual physical ailments, it was regularly performed to cure psychological illness, or any irregular female behavior caused by "ovarian irritation." This category included everything from personality disorders and "nymphomania" to "menstrual madness," or what a modern physician might diagnose as premenstrual dysphoric disorder (PMDD).

As medical science demonstrated that ovariectomies could be performed safely and with a relatively low mortality rate for patients, the procedure's popularity increased among doctors in the United States. However, by the late 1880s, this "fashion" for ovarian surgery also came to be viewed with some skepticism by a growing number of critics who believed the operation was being sought as a permanent means of contraception.[4] The "castration of women," as it was called by Britain's most renowned ovariotomist, Thomas Spencer Wells, fundamentally and immorally robbed women of their primary function in life, which was to bear children. He, and an American counterpart, Dr. William H. Baker, condemned the widespread practice of removing otherwise healthy ovaries in "cases where no such serious treatment was necessitated" and advised that "the wiser and more cautious gynecologist will reserve this method of treatment for extreme cases." Even Dr. Phil Porter admitted he "was not in love with the operation because it smacks of makeshift" and, as a homeopath, he would always recommend other remedies prior to resorting to surgery.[5]

Ovariotomies were certainly something about which Hawley Crippen knew a great deal. Having assisted Dr. Porter with at least one, and observed many more, his own interest in the subject would have influenced his assessment of his wife's situation.[6] In a note written in 1910, Crippen would claim that Cora had suffered from a prolapsed uterus and dysmenorrhea, or painful menstrual periods, and this had led to the decision to perform what he described as "a simple ovariotomy."[7] He admitted that once the ovaries had been removed, they were found to be healthy and "were only congested."[8] Medical textbooks and journals from the 1890s did not recommend

ovariotomies for "congestive dysmenorrhea" unless in extreme circumstances, and such a procedure was not suggested as a remedy for a prolapsed uterus, an unrelated condition. There is no indication of how Cora was treated for this second disorder, or if it was ever resolved.

How Crippen's young and fertile wife was persuaded that she required this form of intervention is unknown. Neither Teresa, Louise nor Mary Mersinger were ever convinced that she needed an ovariectomy. In reference to her menstrual cycle, Teresa, who had a close relationship with her sister before and after her marriage, maintained that "Cora never complained of being ill, or sick" during her time of the month.[9] Cora herself never claimed to have suffered from any "female disorder." The Mersingers, with good reason, were firmly of the belief that Crippen had ordered his wife to be sterilized, "because he did not want a family," and had invented some plausible reason to have the operation performed.[10] Whatever the case, Crippen, as her husband and as a trained gynecological expert, was the driving force behind the decision for her to go under the knife. The Hahnemann Hospital in Philadelphia was one of the best in the country and, given his experience in the field and the authority with which he wrote about the procedure, it is likely that he was present in the operating theater, if not a participant in the surgery.

While Crippen's concerns about any further paternal liability would have been assuaged by this radical solution, it was to have a traumatic and devastating effect on Cora's life. The scars of her ordeal would be both physical and emotional. "She talked constantly of what she went through," said an anonymous friend who had visited her in hospital. "The wound did not heal readily," she recalled, which contributed to Cora's distress.[11] In later years Cora would regularly confide in her companions about the horrors of her post-operative suffering, and how "for some time after, the wound gave discharge, and she had a pus bag growing on the skin."[12] "The wound" continued to give her pain long after the operation and Teresa remembered her sister keeping "a cloth laid over it" under her

clothing.[13] In the coming years, family members, intimate associates and new acquaintances alike were regaled with the harrowing details of her procedure. The mere mention of the word "surgery" would prompt her to recount her "very bad operation" in graphic detail.[14] It was not uncommon for Cora to display her scar to her sisters and female friends, to grab their reluctant hands and place them atop the mark on her abdomen.[15]

What suffering Cora endured in the wake of her operation would be compounded by the physiological impact of "surgical menopause." Rather than experiencing a natural and slow decline of estrogen and progesterone in her forties and fifties, this state would have been induced suddenly at the age of twenty-one. Without the benefit of hormone replacement therapy, Cora would have experienced the first indications of menopause within twenty-four to seventy-two hours of her ovariectomy. This was likely to include a range of mild to severe symptoms which might persist for years: hot flushes, night sweats, vaginal dryness, loss of libido, anxiety, depression, insomnia, as well as headaches, fatigue, thinning hair, brittle nails, vertigo, heart palpitations, memory loss, incontinence, changes in vision and loss of bone density. Although doctors were aware of the major physiological changes to a woman's body induced by removing her ovaries, little was understood about the "ovarian secretions" that governed a woman's biology. Ultimately, the "change of life," whether brought on naturally or prematurely through surgery, was judged to render women "superfluous, cast adrift on a sea of mental and physical ruin," for which little could be done.[16]

In the period that followed the removal of her ovaries, Cora's body began to undergo what appears to have been a metabolic change, likely to have been prompted by her surgery. Within a few years, her shape transformed from that of a robust young woman, as seen in her family photo, into what an acquaintance described as a "large, full . . . opulent figure."[17] Cora's physique, altered by her husband, would later become a source of cruel derision. In accordance with the era's prejudices, her size would lead to suggestions that she

was selfish, greedy and unable to control her passions, a woman whose excessive desires rendered her unfeminine.

In addition to the many painful, disorienting and even humiliating physical changes Cora endured would be the alterations to her sense of identity as a woman. Throughout the nineteenth century, the belief that "the dominant function of a woman's life" was reproduction and that "other living actions" merely contributed to this, remained central to society's definition of womanhood.[18] In having had her ovaries removed, many thought that women like Cora had been "unsexed," transformed into "a thing" rather than a woman.[19] A woman without children, who was not able to "mother" either her own biological offspring or those in her care, was seen to have failed in her singular purpose. The acknowledgment of this would sit heavily on Cora, who would continue to lament her circumstances and acknowledge her loneliness to her family. "You know how I love babies . . ." she wrote to her sister Kate in late 1909. ". . . There is only one way to have a complete home, and that is to have a little child in it."[20]

While Cora had been recovering from her surgery, first in Brooklyn and then in sunny Florida, her husband was preoccupied with furthering his career. By early 1894, at the end of a fallow period living under his in-laws' roof, Crippen had found his feet again and secured a job working for the Munyon Homeopathic Home Remedies Company under the directorship of the charismatic Professor James Monroe Munyon. "Professor Munyon is to medicine what Professor Edison is to electricity," it was proclaimed in *Men of the Century*, where his profile appears alongside those of Ulysses S. Grant and Washington Irving.[21] Munyon was a completely self-made man, a living manifestation of the American dream. At the start of his career he was known for boasting that he had "virtually no capital except ambition and a belief in the value of letting folks know about it."[22] Born in Connecticut in 1848, he had worked as a schoolteacher, a lawyer, a social worker, an editor, a songwriter and eventually as a manufacturer of patent medicine. Although he called himself "Professor" and claimed to be a doctor, he was nei-

ther, but with his wild hair and evangelizing energy, James Munyon possessed an electrifying presence which allowed him to become one of the era's wealthiest purveyors of home remedies. With a background in publishing, Munyon had learned that strategic advertising was key to the promotion of his name and his products. From his headquarters at 1505 Arch Street in Philadelphia, he peppered newspapers across the United States with real and invented testimonials from doctors and cured patients, reputedly spending $35,000 per month on advertising. Crippen came to work for him in 1894 when the company had been on its feet for only two years. By then, Munyon was already netting annual profits of $267,000. His empire would soon be worth millions.

Munyon built his enterprise during "the golden age of patent medicine," when trolley cars, the sides of buildings and newspapers bore artistic images and bright slogans for a wide array of curative concoctions. These affordable over-the-counter medications, with their bold claims to heal any imaginable condition or ailment, were extremely popular at a time when doctors were expensive and home remedies were the only other option. Many of these "treatments," which contained toxic substances such as turpentine, arsenic, ammonia, lead and mercury, proved more dangerous than the illnesses they claimed to cure. Others, laced with alcohol, opium, morphine and cocaine, could become addictive and lead to overdosing. In this potentially lethal market, many sought the gentler alternative of homeopathic remedies. Munyon offered what he called "absolutely harmless" cures based on homeopathic dilutions. A sufferer would only be taking a sugar-based pill or liquid, but one infused with the power to heal.

Munyon did not formulate his assorted homeopathic nostrums, pills and potions himself, but employed a large corps of "expert chemists and physicians" to do this for him. According to his slogans, within his cabinet of medicines, there was "A cure for every disease." Quarter- and half-page advertisements recited a lengthy catalog of ailments and illnesses, everything from the common cold to jaundice, insomnia, cholera, headaches, piles, kidney disease, loss

of "male vitality," constipation, malaria and syphilis, for which Munyon provided remedies. For a mere 25 cents to $2 per bottle, customers were assured they would be relieved of their suffering. These pre-packaged remedies were never difficult to obtain and could be purchased at any drugstore or procured by mail order. Munyon even provided a free booklet, his *Guide to Health*, which showed customers how to select their own medicines and cure themselves.

Astonishingly, Professor Munyon never had a single dissatisfied customer. This was not due to the overwhelming success of Munyon's Remedies, but rather because James Munyon had, in the manner of the most influential "patent medicine men," muzzled the newspapers by threatening to withdraw his lucrative advertising should a word be printed against him.[23]

Perhaps unsurprisingly, Munyon's magnetism, his national visibility and his enormous, undisguised wealth appealed to Hawley Crippen. Much like Drs. Breyfogle and Porter, Munyon was a towering figure of great importance in his field and Crippen now looked to him to give his career direction. Having abandoned his position in Louisville and drifted into the more mercenary end of medicine, Crippen had already crossed the Rubicon where his professional respectability was concerned. Patent medicine, and especially men like Munyon who profited by it, were, in the eyes of true practitioners of homeopathy, regarded with contempt. The mere concept of homeopathic patent medicine was considered a bastardization of Hahnemann's principles—the very ideals that Crippen had once pledged to uphold. These one-size-fits-all cures, even if prepared according to Hahnemann's methods, were not individualized to a patient's "totality of symptoms." Worse still, patients were encouraged to self-diagnose or were prescribed mail-order medication by a doctor who had never examined them.

By leaping into Munyon's arms, Crippen finally shed what little remained of his professional credibility. He gave up his associations with the medical journals he edited, and after 1894 his name no longer appeared on scientific articles. Instead, he took up a position in

the New York branch of Munyon's Remedies. According to Professor Munyon's son, Duke, Crippen began working for the company first as a "medical correspondent," presumably assessing mail-order patients' symptoms by letter, before being promoted to assistant manager of the premises at 7 East 14th Street near Union Square. Here, he and Cora set up home above the shop. As he always managed to do, Crippen appears to have made a favorable impression on those around him. Within a matter of months, he had attracted the attention of the great professor himself. Munyon recognized that his employee was very "proficient in medicine"[24] and, impressed by Crippen's ambition, he decided to move him to the head office in Philadelphia. It all seemed to happen quickly. "One day, Cora came to us and told us she was moving to Philadelphia," Teresa said.[25] It would be another new start in a marriage that had already had several.

Munyon had immediately seen the benefit of having a highly qualified doctor on his staff who had been associated with a number of prestigious homeopathic institutions. The patent medicine king was in fact so impressed with Crippen that a drawing of Hawley's face, with his unmistakable glasses, his side-parted greased hair, full beard and mustache, began to appear in Philadelphia's newspapers. "Munyon: A Distinguished Physician Investigates His Cures—Astonishing Results," the accompanying testimonial proclaimed. It described him as "late Assistant Surgeon and Pathologist to the N. Y. Ophthalmic Hospital," an "Honorary Member of the Société Française d'Ophtalmologie of Paris" and the editor of the nonexistent "New York Journal of Ophthalmology."[26] "More than one year ago, I began to investigate Munyon's New System of Treatment. I began with prejudice I must confess, but some of the cures affected by Munyon's Remedies were so remarkable I was quickly convinced that they deserve the attention of scientific physicians . . ." Crippen proclaimed, before declaring that he had tested "Munyon's New Methods" and found the remedies so effective that they cured every distemper, apart from "those diseases claimed by the medical profession as uncurable." The testimonial concluded that "Such a positive

statement, coming from so distinguished a physician as Dr. Crippen, should set at rest all doubts as to the efficacy of this new method of treating disease."[27] A similar advertisement ran in the *Brooklyn Daily Eagle*, a newspaper which will have been read by any number of his former medical colleagues.

Crippen also acted as one of the six advertised "Eminent specialists" on hand to give "free advice" and "a thorough diagnosis" at 1505 Arch Street. Munyon's headquarters, based in a five-story mansion "in the oldest and most respectable part of town," had the appearance of a small hospital rather than a commercial enterprise selling sugar pills. On site there was a laboratory, a packing and dispatch center and consulting rooms. Its waiting room was furnished with "many easy chairs," classical busts, fine carpets and electric lights.[28] Dr. H. H. Crippen would have exercised his famous expertise on the numerous patients who waited to be seen—looking inside ears, down throats and into eyes, examining rashes and swollen lymph nodes before recommending which of the remedies to purchase. It was suggested that Crippen may have received $20,000 a year for waving Munyon's banner. However much he earned, it was enough to bring a level of comfort to his and Cora's lives.

In the months that followed her surgery, Cora had ample time to consider her future and how she might fill it with something other than motherhood. While many women in her situation would have devoted themselves entirely to their husband's wishes and ambitions, Cora turned her attention elsewhere. If she was not to bear children, then she could dedicate herself to another passion, singing. Where some might have sunk under the weight of their thwarted dreams, Mrs. Crippen instead embraced her new path with gusto.

Cora returned to New York, where it was decided she would continue her voice training. In the period since she last pursued a musical career, her aspirations had grown. This time she set her intentions on singing "Grand Opera." In the 1890s, there was no better place to experience and train for opera in the United States than New York

City. In 1883, the Metropolitan Opera House, on Broadway and 39th Street, not far from Hell's Kitchen, threw wide its doors to the top-hatted and bejeweled denizens of Manhattan. With its cavernous gold-leaf interiors and tiers of boxes reaching nearly to its painted ceiling, it instantly became the city's premier venue for operatic works. While the Gilded Age elite would preside over the Met, the seats below them were filled with what were described as "democratic audiences," including many Italian and German immigrants who could partake of high culture in their native languages. In the 1890s, New York had fallen in love with the operas of the German composer Richard Wagner and his romantic sagas of knights and Valkyries. At some point, whether on Crippen's arm or with someone else, Cora was likely to have taken her flip-seat among the audience. What her eyes and ears beheld must have dazzled her: recreations of castles and idyllic landscapes with Gothic, twisted trees, Viking ships in full sail and breastplated, spear-bearing sopranos whose reverberating voices thrashed the back of the house.

New York had no shortage of colleges and music schools offering voice tuition, but it is more likely Mrs. Crippen chose to train with private instructors, a more common route into the profession. Many such teachers, like the famous Oscar Saenger, who tutored Marie Rappold, a Brooklyn-born contemporary of Cora who rose to stardom, had been opera singers themselves. Training for Grand Opera necessitated years of preparation and dogged determination. Lillian Nordica, one of the first successful late-nineteenth-century American opera singers, wrote that it required not only vocal endurance, but discipline, an athlete's dedication to the development of the body, "a disposition that will take criticism," and "a complete mastery" of foreign languages in order to excel at the art form.[29] Ultimately, a budding operatic diva's final polish would be achieved on a stage in Europe and only then would she become a desirable commodity in the United States.

Crippen genuinely believed that Cora had a good voice and saw fit to provide her with the resources to pursue her great ambition.

But his interest in her, the wife he had just rendered infertile, seemed already to be on the wane. He remained in Philadelphia, while she resided primarily in New York, and visits were arranged regularly between them.[30] She, it seems, also traveled south to see her husband. Those who knew the Crippens noted the growing fissures in their relationship. Duke Munyon, the son of Crippen's employer, once spotted them arguing at Philadelphia's Broad Street Station. Cora seemed quite distressed, "and wore a heavy veil over her face" so "no one could see her features." Duke Munyon ascribed their problems to "jealousy."[31]

Things were not to improve. Crippen did not take his wife with him when, at the end of 1895, Munyon sent his star employee to Toronto for six months to establish a Canadian branch of his company. Hawley Crippen had, like his father before him, resumed his habit of periodically abandoning his wife to seek more promising opportunities elsewhere. With the fabulously wealthy Munyon as a champion, these occasions to further his career were no longer empty ones. By the end of 1896, the emperor of homeopathic patent remedies was looking to make a conquest in Europe. He asked Crippen to be his emissary. He had set his sights on London and Hawley Harvey Crippen was tasked with opening an office there. For a man with chronically itchy feet, it was an opportunity too good to pass up.

6

Lady Typewriter

O N MOST MORNINGS, THE streets of Central London were awash with a tidal surge of workers. It rose from the outlying suburbs and flowed into the city aboard trams, trains and underground carriages. Men in round bowler hats and starched white collars, top hats and fedoras jostled for seats aboard the omnibuses. Some took their place on the benches in the low-ceilinged cabins; others climbed the narrow stairs to the open top deck.[1] Passengers sat tightly packed, carrying cloth-wrapped lunches in brown bags or baskets, their wet umbrellas dribbling against their legs. A handful would light their cigarettes and blow clouds of smoke, while their neighbors opened wide their newspapers.

Among those who made this regular journey, who pulled the bell cord to disembark at Holborn and Bloomsbury in the West End, was an ever-increasing number of unmarried women. The presence of workers in skirts, in the previously all-male domain of white-collar business, was a relatively new phenomenon in the 1890s. Twenty years earlier, some larger employers, such as Prudential Assurance, the Post Office and several banks, alighted on the notion that pen-pushing and paper-sorting might be appropriate roles for respectable "daughters of professional men, clergymen, doctors, officers in the army and navy, and merchants of similar social grade."[2] However, these female employees were by no means considered equal to their male counterparts. They were not to be promoted and were paid deliberately less than men, so that their true calling,

marriage, would always appear a better option than working for a living.

But earning an independent income in an office, although it may have been for as little as £1 a week, did greatly appeal to women. Between 1891 and 1901, the number of female clerks employed in England and Wales leaped from 18,947 to 57,736.[3] Maintaining ledgers and processing documents, as well as managing correspondence and taking shorthand dictation, soon became the preserve of the "girl clerk." In her "plain and neat" skirt and white blouse, she was expected to segregate herself from male staff in a single-sex workroom where she often sat in front of a typewriter. Employers were all too pleased to capitalize on women's enthusiasm for clerical positions and hired lower-paid "lady typewriters" to replace the male clerks who now came to see these roles as "feminized."

In order to meet the growing demand for trained female staff, Pitman's Metropolitan School, "the largest commercial school in the world," which claimed to instruct 1,600 students a day in shorthand, typing and "business methods," began to admit "girl pupils."[4] Among the young ladies whose fathers had scraped together the 4 guineas to send their daughters to the prestigious institution were Ethel Neave and her younger sister, Adine. Primly attired, the two teenagers would board the tram from Hampstead, one of London's more salubrious suburbs, and make the daily journey into Bloomsbury for their evening lessons. The Neave girls were the first women of their family to be given such an opportunity, to make the extraordinary leap from the rural fens of Norfolk into the mechanized, electrified world of urban white-collar commerce.

The Neaves had never been a wealthy family. For generations, they had been agricultural laborers in and around the East Anglian market town of Diss, living a basic, impoverished existence. They eked out a threadbare living by cultivating and harvesting the fields of the surrounding landowners, and occasionally selling their own vegetables at local markets. At some point prior to 1871, a subtle but significant change in circumstances occurred. One of the Neaves,

William, became a gardener on the estate of Reverend Charles Robertson Manning, the Rector of Diss, a philanthropist, antiquarian and a celebrated local hero. Neave's improved position enabled him to provide a better education for his son, Walter, whose literacy and numeracy, and his disciplined copperplate handwriting, permitted him to step on to the first rung of the middle classes. Walter became a railway clerk at Diss Station, a tedious job of managing correspondence, receipts, handling cash and tickets, but one which nevertheless proved that his education had not been in vain; after centuries of toiling, the Neaves were no longer laborers on someone else's land.

In the early years of his life Walter Neave was a proud, devout man, possessed of great ambition. Determined to make something of his abilities, he rose to become chief goods clerk at the station, and sang in a choir which, he later boasted, used to perform in Norwich Cathedral.[5] In 1881, he married a local girl, Charlotte Jones, the daughter of a "colt breaker," or a trainer of horses. The couple would live alongside Charlotte's parents and six of her siblings in a small cottage until shortly before the arrival of their first child in 1883.

Ethel Clara Neave was born on January 22 in that year, a time when the soggy fens of East Anglia are draped in fog and sunk in a penetrating wet-cold. Ethel was welcomed into the family in one of the two dank rooms of Walter and Charlotte's rented cottage. The chilled walls, outdoor earthen toilets and ice-fringed water pump would not have made the Neaves' lives and that of their crying infant daughter pleasant or easy. According to her parents, Ethel "was a dear little delicate child," who was "Timid and nervous . . . and constantly catching cold." She had not been born hearty and suffered "a peculiar deformity in the feet," which was corrected by a medical specialist while she was still very young.[6]

Scarcely two months after Charlotte had given birth, she was pregnant again. Adine True Neave arrived just before the end of 1883, on December 15. The sisters were near enough in age to feel almost as if they had been born twins. According to their father,

"They were inseparable." So began an intense, lifelong intimacy based on shared confidences, closely guarded secrets and aggressive sororal rivalries. Nina, as Adine came to be known, was considered the more robust of the two, and was thought cleverer and more "self-reliant." While Nina was quick to grow and learn, Walter observed that his eldest daughter "began to show remarkable peculiarities of temperament." Although she was generally quite "retiring and shy in disposition, there were times when she would break into a passion, and then . . . everyone . . . would receive the full benefit of her little tongue."[7] Nina was the rational and composed daughter. Ethel was the unpredictable one.

Ethel's rough edges as a young girl were suited to a country upbringing. Norfolk's overgrown hedgerows and fields, teeming with little creatures, provided a perfect playground for the girls and their young brother Claude, who was born almost exactly three years after Ethel. In later life, she would recall an early childhood spent climbing trees, throwing stones into brooks and fleeing from bulls. Ethel claimed that she preferred spending time with the canaries, bantams and pigeons kept by her father, and watching the passing trains, to playing with "dolls or other girlish toys." Her mother used to "shake her head" over her torn frocks, and "look ruefully" at the catapults and marbles which she removed from her tomboy daughter's pockets.[8] Memoirist Nancy Jackman, who shared a similar rural Norfolk upbringing to the Neave children, recalled her own experiences, but also that these carefree moments of lying beside rivers and "listening to the breeze" played out against "a constant fear of destitution" which plagued the lives of her parents.[9]

When precisely in 1890 the Neaves abandoned East Anglia for the brick and plaster suburbs of London is not known. Shortly before the family left their cottage on Rose Lane, Walter had been employed as a licensed victualler, the manager of a public house which served food as well as drink. Perhaps it was this job which enabled him to secure a position as "dairyman's manager," handling the paperwork at a dairy shop in the North London district of Hampstead.

For more than a century, the hilltop settlement of Hampstead Town had offered the city's bourgeoisie a respite from the coal smoke and filth of the urban streets. The bucolic beauty of Hampstead Heath had also attracted many painters and writers: Keats and Shelley, John Constable and Ford Madox Brown had all lent the area a progressive and artistic reputation. By the late nineteenth century, as London's neighborhoods continued to stretch into open fields, grabbing at the villages and hamlets within their reach, Hampstead became one of the capital's wealthiest and most desirable areas in which to live. Spacious new terraced housing and villas with fashionable Dutch gables and large "Queen Anne-style" windows attracted recently moneyed merchants, stockbrokers and barristers.

Unfortunately, transitioning from a modest rural existence to a life led in one of the capital's most affluent suburbs would not prove as easy as Walter may have hoped. In Hampstead, clean, well-built and accessibly priced housing was scarce for lower-middle-class families like the Neaves. Unable to afford the rent on an appropriate property for a family of six, which now included another baby boy, Walter found himself in the embarrassing position of having to apply to the Wells and Campden Charity for assistance.[10]

The Hampstead-based philanthropic organization ran two developments of "artisans' dwellings," or housing specifically designed for "artisans, clerks and laborers," members of the so-called "deserving poor" who would have otherwise struggled to afford clean and respectable housing. In 1888, the Campden Buildings, at the crest of the hill on Heath Street, began to welcome carefully screened tenants. The buildings offered one-, two- and three-roomed accommodation. The Neaves, who lived first at number 46 and then at number 20, would have enjoyed the comforts of "a sitting and two bedrooms, a scullery fitted with sink, [a] water-closet, and fittings" as well as "a coal bunker, shelves, cupboards . . . closets, sinks, and a water supply . . . on the outside landing."[11] There was a well-lit and ventilated laundry and a specially constructed bathhouse shared

with the residents of the neighboring Wells Buildings. By comparison to their overcrowded cottage in Diss, the Campden Buildings, with its conveniences and indoor toilet, would have felt modern and novel to the young family. However, Ethel, who had been uprooted from her childhood home at the age of seven, in later years claimed that she "did not like the change" and "yearned for the country."[12]

Ethel was to find this new urban environment alien and at times difficult. In Diss, she and her sister had been privately educated at a little school, but their move to London meant attending the larger, less personal state-operated national school with its raucous city-bred pupils. Ethel found this daunting and upsetting. "The teachers seemed more stern," she complained, and "the other children a good deal rougher."[13] The Neaves, living in the Campden Buildings, were considered poor. Ethel was bullied and teased, often returning home from school with a tear-stained face. Walter, too, recalled how his daughter was heckled in the streets by more finely dressed children, assailed with cries of "old yellow stockings!"[14]

Tenement-living, wedged between the slum dwellings of Old Hampstead village at the top of the hill and the mansions of the wealthy at the bottom of it, was not what the proud Walter Neave had had in mind for his family. Whatever his expectations of a London dairy manager's salary had been, the proceeds of it were thinly spread between the expenses of rent, cheap cuts of meat and coal. The birth of a third son, Wilfred, in 1891 would only have exacerbated matters. Ethel recalled that her father did his best to keep them "well-fed and neatly clothed," but ultimately, Walter would never escape the shame of knowing that he and his dependants were a "charity case," at a time when "receiving handouts," whether from the workhouse or in the form of private philanthropy, was seen as a mark of failure.[15]

It would not be until 1896 that Walter's resolution to better his family's prospects eventually bore fruit when the Neaves were finally able to leave behind the Campden Buildings for their own house at 61 Gayton Road, down the hill. At the time of their move,

the eight-room property with hot and cold running water, a bathroom, a sitting room and a dining room belonged to Brumbridge's Dairy. Presumably, the dairy shop on the ground floor and the yard adjacent to it were overseen by Ethel's father. He, along with his wife,would have welcomed the additional space, when Sidney, the eighth and final member of the family, arrived that October.

Lower-middle-class life was, characterized by the sorts of swells and troughs of fortune experienced by the Neaves. The larders were rarely ever full, a family might have bread and butter, or bread and jam for breakfast, but never both. Cups of tea stopped rumbling bellies. In the evenings and on rainy days, there were parlor games and amateur theatricals written and presented by Ethel, Nina and their brothers. The Neaves had just enough money for occasional trips to the seaside and to feed their pets: a cat, birds and rabbits. For families of the lower middle class in the 1890s, the local theater and the recently "cleaned-up" music hall played important roles. Here, "respectable" entertainment featuring a range of artists from singers to comedians, jugglers, illusionists and equestrian acts could be enjoyed for upward of 3d. Children and their parents might return home on the tram, singing the tunes they had heard performed by the stars of the stage. Equally important, and at times seemingly at odds with these indulgences, was the outward display of Christian piety. For Walter and Charlotte, church attendance, good manners and the cultivation of a strong moral character were essential, as was education.

Other than a home with a parlor or sitting room, there were few indicators of late-Victorian middle-class status which were more compelling than the ability to afford private tuition for one's daughters. While wealthy middle-class households might have sent their girls to prestigious boarding schools, families at the lower end of the scale, like the Neaves, scrabbled together the shillings to provide their daughters with additional lessons in subjects that were often not part of the standard state school curriculum. This frequently included music, art and foreign languages. These "accomplishments" not only denoted that the head of the household was

earning a sufficient amount to keep his daughters out of the labor market, but that they also had leisure time to study and work on "improving" themselves. Music and musical education played an important role in the Neave household. Charlotte in particular saw to it that her girls were "well trained . . . under a special master," though this appears to have sparked a rivalry between the two siblings which resulted in Ethel refusing to use the same piano as Nina.[16] Indulging her whim incurred an additional expense, but it was one about which her father was pleased to boast.

Walter and Ethel bonded over music. At some point around 1900, the dairyman's manager began to advertise himself for evening concerts. For many working- and middle-class men, performing a repertoire of songs in small local venues was viewed as a potential stepping stone to a career on the music hall stage. Walter appears to have been serious about this new direction, and by the following year he was performing as part of a male voice quartet calling themselves the Leidersingers.[17] On occasion, Ethel would accompany him on piano when he rehearsed "some of the most difficult pieces from the oratorios," and even joined him on stage for duets of popular folk melodies such as "Caller Herrin." According to her father, the pair were always well received, as too were Ethel's appearances at local concerts in Hampstead, both as a solo performer and as part of a vocal trio. As a professional singer, Walter wanted a moniker more fitting of his middle-class persona. In an article he wrote for *Answers* magazine, he admitted to inserting the prefix "Le" before Neave. This seemingly minor adjustment to their surname had not been an arbitrary one. The East Anglian Le Neves had been an ancient—though obscure—landowning family who had held property in Norfolk since at least the thirteenth century. Walter's "Le" had the effect of gentrifying him, or suggesting as much to those who might recognize the name. This was not intended simply as a stage name either. On the 1901 census, the Neaves of 61 Gayton Road had all been rechristened Le Neave by their head of household. Interestingly, of her entire family, it was only Ethel who continued to

use the surname, and to take the bolder step still of dropping the "a" from Neave, so there would no mistaking the ancestral association.

Walter's ambition had rubbed off on his eldest child, who yearned as ardently as her father for comfort and status. Charlotte, as the practical parent, kept a wry if not censorious eye on her daughter's developing tastes and proclivities. Given the family's precarious financial position, she had concerns about Ethel's "fondness for pretty things." According to her mother, while Ethel was still a young child, she had acquired "a liking for silk garments." Charlotte recalled how her daughter used to enthuse about the qualities of the fabric, how she found it "so soft and clinging." Ethel had her "little vanities," her mother claimed. Affecting to appear wealthy, she refused to be seen "carrying the smallest parcel in the street." Even as a schoolgirl, "she insisted on her sister carrying her books."[18] She loved eau de cologne and studied the latest Parisian fashions. After trips to the West End, she would return home to trim her hats in the latest styles. Ethel affected a "prim and proper" manner, and, according to her father, was not above scolding her sister for indiscretions like staring at strangers.[19] While her mother occasionally despaired of her eldest daughter's pretensions, her father quietly approved of what he came to regard as Ethel's discernment, viewing her observations and attitudes as proof of intelligence and wisdom "beyond her years." As a teenaged girl, she wrinkled her nose at boys her own age, and confessed to her parents that young men seemed to lack substance and sophistication. "All the young men I see seem to be so foppish, and to have nothing in their heads but thoughts of dress and amusement," she complained.[20]

Charlotte's concerns for her daughter were not entirely misplaced. Girls such as Ethel and Nina, sandwiched between the working and the middle classes, found themselves in a potentially awkward situation. As historian Deborah Gorham suggests, lower-middle-class girls received two contradictory sets of messages about their expectations in life. On the one hand, such young women were told

that their "gentility was an asset to the family and that [they] enhanced not only their own, but [their] family's status by engaging in ornamental activities."[21] However, while a family's social status remained "aspirational," they were also expected to fulfill traditional working-class roles within the household, to prepare meals, change the baby's nappies, or to get down on their hands and knees and scrub the stairs, regardless of their penchant for silk and French millinery. Walter may have taken pride in Ethel's accomplishments and her polite comportment, but there was also no question about what part she was meant to perform around the house. In his series of articles for *Answers*, he was as boastful about Ethel's fluency at the piano as he was about her abilities as a housekeeper. He claimed that she "was exceedingly domesticated, and an excellent cook." More importantly, Walter implied that for all his daughter's refinement and snobbery, he had taught her to "divest herself of the outdoor garments in which she looked so well, put on a pinafore apron, roll up her sleeves to the elbows, and polish a stove or black a lead grate with all the zeal of a general servant out on her first situation."[22]

For young women such as Ethel, a future which included office work provided a perfect corridor between these two identities. An office job spoke of status. Walter Neave had learned first-hand how acquiring an education and taking up clerical work could alter a young man's prospects. Now, in the 1890s, when the labor market was expanding and such positions were available to young women, he wished his daughters to reap these benefits too. According to the pioneering female economist Clara Collett, in her studies of the lives of educated working women, it was through becoming a clerk within a prestigious body, such as the civil service, that a lower-middle-class girl could join the ranks of the upper middle or professional class.[23] From the perspective of lower-middle-class parents like the Neaves, there were other advantages to placing a daughter in clerical work. The office was largely a masculine space, filled with professional men, all of whom were on better salaries, and

many of them eligible candidates for marriage. While a significant number of clerical women protested that they did "not enter into business-offices or any other public place with a view of . . . 'getting married,'" there were others who viewed the workplace differently.[24] Romantic unions were so common between employers and their female staff that even the word "typewriter," used to refer to both the machine and its operator, became intertwined with innuendo.

With so much to recommend an office job, Walter Neave took matters into his own hands. When Ethel was fourteen, the age when her formal schooling was about to come to an end, he introduced her to an acquaintance.[25] "One night my father brought a friend home with him to supper, and in the course of the evening he asked me what I was to do with myself when I left school," Ethel recalled.

I did not know what to say. I had not given the thing a thought.

"How would you like to learn shorthand?" he asked. "A typist life is quite good—better than dressmaking or standing behind a counter."

"I would like to learn shorthand," I replied, "but it's dreadfully difficult, isn't it?"

"Not a bit! It's as easy as anything to anybody who wants to learn. Would you like me to teach you?"

I nodded my head. It would be just grand. "Show me now how to write my name."

. . . My father's friend got pencil and paper at once and showed me how to write my name.[26]

According to Ethel's account, both she and Nina were introduced to stenography and typewriting. The Neaves later sent their girls to evening classes at Pitman's, where in addition to studying typing and shorthand, they also took lessons in French, German and Latin. "Ethel, in particular," said her father, "showed remarkable quickness

at learning typewriting [and] shorthand," though didn't fare so well with the languages.[27]

In the late afternoons, the sisters made their way to the imposing brick building in Bloomsbury, which overlooked the gardens of Russell Square. For the better part of a year, Ethel mounted the stairs with numerous other teenaged girls in straw boater hats and white blouses to sit in classrooms where they learned how to manage ledgers, answer telephones and to compose appropriate letters. Shortly before her sixteenth birthday, she received her certificate of completion, which recorded her typing speed of eighty words per minute. Charlotte Neave, who had acquired little more than the most basic of education, would preserve this confirmation of her eldest daughter's achievement with great maternal pride.

Ethel was thrilled at the thought of experiencing a taste of independence. She claimed that, as a teenager, she was always "impetuous": "There was never any waiting to consider about me. Everything had to start right at once if I was to be happy."[28] But Charlotte and Walter were a bit more apprehensive about this precarious time in their daughter's life, when she was about to step out on her own into the amoral metropolis. However, in the 1880s and 90s London 's West End was undergoing a change which made its public spaces feel less intimidating to unchaperoned middle-class women. In response to women's increasing financial and social independence, tearooms such as the A.B.C. (or Aerated Bread Company) and Lyons built a reputation for catering to female clerical workers seeking affordable tea and pastries. Department stores such as Whiteleys and Debenham & Freebody also followed suit by opening lunchrooms and providing "private female resting places" (which included much-needed toilets). The floor plans of their shops, too, were arranged to invite a feminine clientele to spend their money on themselves at the cosmetics, hat and glove counters.

To a teenaged girl like Ethel, the prospect of being launched solo into this London of female possibilities was exhilarating. She had the freedom to enjoy tea and a bun on her own or with new female

friends from the office. She could join a West End working girls' club, or in her after-hours browse the department stores. With this independence, she would gain confidence and the courage to forge a life for herself beyond her parents' gaze. Much against her father's express orders, Ethel had already begun sneaking out at night to dances. An elaborate scheme had been orchestrated with her brother Claude, who waited up late, listening for her. Ethel would creep back in, wearing her dancing pumps, which she then would hide away "under lock and key."[29]

Certainly part of the problem for concerned late-Victorian parents like the Neaves was the influence of the "New Woman" on their daughters' expectations. This alluring figure appeared everywhere in the 1890s, discussed with revulsion and fascination in the newspapers, in novels and on the stage. She could be seen charging through the streets on her bicycle, scandalously attired in bloomers or "rational dress." She demanded to be educated. She demanded to play sport like her brothers. She demanded to earn a living by having a job. She smoked and wore makeup. She wanted to be independent and make her own decisions. She didn't think she needed to get married. She believed in free love. She lived in her own lodgings, apart from her family. She even had the audacity to want to vote. The rebellious New Woman was having a cultural moment, just as Ethel was becoming a woman herself.

Despite her mother's concerns that Ethel was too young to fend for herself in a city office, in the spirit of the New Woman, she determinedly set about applying for jobs. One morning, fifteen-year-old Ethel Le Neve (as she had been styling herself) put herself on the train to Moorgate Street. She picked her way through the streets near the Bank of England, searching for a particular firm's address. The pavements were filled with identically dressed men in somber dark suits, waistcoats and hats, most with mustaches like her father's. Upon arriving she knocked "timidly at the door," and "asked to see the manager."

"One of the clerks, a kindly old soul with gray hair, asked if I had

come in answer to the advertisement; And, learning I had, asked me in and plied me with all sorts of questions."

Despite her outward show of determination, Ethel was "dreadfully nervous." She was given a dictation test and shown to a typewriter to transcribe what she had noted. Although there were "one or two mistakes" she was told she could start at 12 shillings a week and took up the position the following day.

The job, and the new exciting life she had imagined for herself, turned out to be a resounding disappointment. The environment she described as "stiff and business like." The head of the firm was no polished sophisticate in search of a wife, but "a gentleman who very rarely spoke to me except when he wanted his letters taken down." As for the other clerks, they were neither lively young women like herself, nor attractive potential suitors, but rather "elderly." Worse still, they looked upon her "as a little typist girl and nothing more."[30]

The adult world was not such a thrilling place. She "left home early in the morning and returned shortly after six o'clock." She had no companions in the office, and during her "luncheon hour" would sit by herself in the grand surroundings of the Royal Exchange building, munching her sandwiches and crocheting. Disappointingly, gentlemen did not show her much interest. The one exception was a compliment she received on her "industry" with her needles.[31]

While Ethel was toiling away in a dreary workplace, Nina was having slightly better luck. Her father had noticed that a company calling itself the Drouet Institute for the Deaf was advertising for a shorthand clerk and typist. The "Institute" was conveniently located on Regent's Park Road, within walking distance of the Neaves' home, and so Walter inquired about the job on behalf of both of his daughters. He later claimed that Nina, being the "more self-reliant" (or determined) of the two, "begged so hard to be allowed to apply" that he consented, and she secured the position with little difficulty.[32]

Nina had a good manager, who she said was "awfully nice." Although he was an American, you would never know it from his ac-

cent, she told Ethel as they sat together beside the fire after work. In fact, Nina thought he was one of the kindest men she'd ever met. All of his requests were made with a gentle smile. Ethel said she used to think how pleasant it would be to work in an office like that. She inquired after his name. He was called Dr. Crippen.[33]

7

Belle Elmore

A MERICANS RAVED ABOUT LONDON. There was so much to see, not just the palaces, monuments and royal parks, but the museums and galleries. Travelers to the capital enthused about the shops and the theaters, and the general "gaiety of life." The pageantry, the antiquity, the quaintness, even the blinding, smoke-filled fogs did not fail to delight. The city was a place of contrasts to those freshly arrived from the ships that docked at Southampton and Liverpool. It was surprisingly fast-paced, some remarked, and cheaper than New York. They found the food terrible—the bread was "hard and stale," the butter was the consistency of ointment, the coffee was undrinkable. They commented on the "brusqueness" and the "cold reserve" of the people and found hotel and restaurant staff "sad-faced" and "dejected."[1] Whether they had come to enjoy "the season," or to make a brief stop before visiting the rest of Europe, they usually preferred to stay in so-called "American" hotels, which complied with US standards of comfort and were filled with familiar faces from New York, Boston and Chicago. The Metropole, the Grand Hotel near Trafalgar Square and the Langham in Marylebone were some of the most favored by well-heeled travelers, while many others found rooms in less expensive accommodation and boarding houses near the British Museum in Bloomsbury.

The Crippens were not among those who traveled first class on a steamer with trunks of gowns for debutante balls and tweeds for touring the Scottish Highlands. Their arrival in London was not announced in the *London American* newspaper, like the families of

86

the wealthy "dollar brides" who had come to find titled husbands. They were among the assortment of others: the businessmen, the artists and writers, the students, the seekers of work or adventure, who slipped quietly into the country. Hawley Crippen arrived in April or May of 1897 with a party from Munyon's Homeopathic Company, which included Munyon himself with the most current of his three wives on his arm, as well as another sales associate, a Colonel L. A. Mackintosh. While the wizard of patent medicine took up residence at the lavish Savoy Hotel, Crippen and Mackintosh occupied themselves with establishing a British outpost of the business at 121–3 Shaftesbury Avenue. Whether by agreement or decree, Cora had been left behind in New York until August. It was only then that, unaccompanied, she made the transatlantic journey to England. According to her husband, in the time it had taken for them to relocate to London, Cora had reconsidered her operatic ambitions and instead had decided that she was "going in for music hall sketches."[2] She was to become a vaudeville performer. While this was a significant alteration in course, it was not an impractical one. It was considerably more difficult to make a debut in opera than it was to make one in Britain's music halls, especially as American entertainers were particularly in demand.

Crippen claimed that he objected to her intentions. Grand Opera, patronized by the elite, was diametrically opposed to the bawdy, low-brow entertainment of the music halls, whose tunes were performed in front of a largely working-class audience. Although, by the late 1890s, the British music hall, or (as it had been renamed) "variety" theater, had witnessed a significant shift away from the ribald songs and suggestive acts of the past, it was difficult to entirely dispel the shadow of its former reputation. "The art of the music hall is the art of elaborate ugliness," wrote William Archer in 1896. He dismissed out of hand its "blatant vulgarity," its "alcoholic humor and rancid sentiment."[3] But despite the disgust of its critics, the music hall held an overwhelmingly popular appeal on both sides of the Atlantic. When Cora arrived in London there were approximately thirty music halls in Central London and roughly the

same amount in the surrounding suburbs. The theaters themselves were often vast, in some cases accommodating audiences of up to 3,000. In order to give them a more inviting and family-friendly air, many had been entirely redesigned with electric lighting, elegant marble foyers and plush red tip-up seating. Every major city and most mid-sized towns in the country had at least one such theater, if not several.

An evening of variety performance offered just that—variety: a range of entertainments from ballad singers and comedians to ballet dancers, ventriloquists, acrobats, magicians and performing troops of animals. By the turn of the century, their programs also included the screening of short motion pictures. On a given night, Polly Newbury "Comedienne and dancer" might share the stage with Permane's Performing Bears. Vesta Tilley, the famous male impersonator, or the superstar comedian and singer Dan Leno would sit on the same bill as a mesmerist or a juggler. The talents of the most successful variety performers, those like Tilley, Leno and the celebrity singer Marie Lloyd, were so in demand that their names would appear on the programs of several music halls in a single evening. Performing multiple "turns" or acts at successive venues was only possible with a carriage or a motorcar waiting with a rumbling engine at the stage door, ready to spirit away performers in full costume to their next appearance. For singing her famous repertoire of songs, Marie Lloyd earned between £250 and £300 per week, and as much as £700 at the height of her career, but the majority of music hall artists commanded nowhere near such sums. Lesser-known entertainers might also do a handful of turns at various venues and earn less in a single night than an actor for one performance of a play. In 1891, the *National Review* estimated that the gross earnings of "rank and file music hall artistes" were roughly between £4 and £5 per week, and that there were performers who earned much less, if not under a pound.[4]

While the most successful of their profession were rewarded with dizzying wealth and a life of glamour—houses, motorcars, racehorses, jewelry, furs and foreign tours—they remained ap-

proachable figures, willing to have a drink with their fans, eager to sign photographs of themselves, and were magnanimous in their acts of charity. Perhaps it was this, as much as the attractive possibility of financial gain, that appealed to Cora Crippen's energetic and warm personality.

Cora came to the capital brimming with enthusiasm for her new endeavor. Everything thrilled her; "she looked so joyous, so contented with life," wrote Adeline Harrison, the journalist and librettist who befriended her shortly after the Crippens had moved to London.[5] Cora had an idea for a music hall sketch which she wanted to perform and Harrison had been introduced to her as someone who could help her write it. Their first meeting had taken place in the waiting rooms of Munyon's, where Mrs. Crippen made a suitably theatrical entrance: ". . . the green draperies parted and there entered a woman, who suggested to me a brilliant chattering bird of gorgeous plumage. She seemed to overflow the room with her personality."[6] Munyon's had been paying Crippen handsomely, and Cora was dressed in the proof of her husband's success. She was a "plump little person," Mrs. Harrison observed, and was tightly laced into the bodice of her fashionable black and emerald-green silk gauze gown. She wore a "smart black hat with a panache of magnificent plumes together with very high heels." The dress's "sweeping train" and "voluminous underskirts . . . swished and rustled as she moved." Adeline found her a captivating, effervescent character, whose bright, dark eyes twinkled with the joy of life. She had a vivacious, rounded face "radiant with smiles," which every now and then would reveal a glint of gold in her teeth. "You know," Cora stated to her, "I'm going to make my debut at the Empire, Leicester Square." The English Adeline was somewhat taken aback by Cora's bold American self-assurance.[7]

"Ah, yes," she responded, though she knew better than to "question a startling, impracticable assertion." Cora then showed her "a few feeble lines of dialogue" she had written for an operetta and asked if Adeline might add something to lengthen it. "I suggested that a little plot might improve matters."[8]

Despite claiming that she found Cora Crippen to be "very sympathetic and pleasant," Mrs. Harrison's public comments about her "friend" were more often vicious and mean-spirited, if not defamatory. She described her as "a fascinating little woman, with whims and fancies," one of which was her "absorbing passion for stage life" and her "visions of fame." Harrison suggested that Cora's ambition was driven by her desire for "appreciation, admiration" and "flattery." She was "possessed of the soul-hunger of the modern woman for notoriety," a phenomenon which Adeline described as "selfitis."[9] She was "truly stage-struck," suggested another friend, Lottie Albert, but unlike Adeline Harrison, Albert, a fellow performer, admired Cora's determination to make a success of her career. Cora, she said "had her little eccentricities. But who hasn't?"[10]

Commissioning Adeline Harrison to write her a short operetta was just part of Cora's larger campaign to put herself behind the footlights of London's music halls. In an era when performers were expected to attire themselves for the stage, Cora had to invest in a range of suitable costumes. According to Mrs. Harrison, her friend purchased "a large stock of expensive stage gowns" which she imagined she would require when appearing "at the Palace, Empire, Oxford [and] Tivoli."[11] As artistes were also expected to advertise themselves with pictures, posed as their characters, performing their acts, Mrs. Crippen went to the celebrated West End studio of George Henry Hana, and "had her photograph taken in every conceivable position."[12] The handful of portraits which remain from that appointment are a testament to her lively personality. In each tableau she assumes a different character: in one she stands in a decorated corset, cape and tights as if performing a song; in another she is a soulful gypsy with wistful eyes and a mandolin. Attired in an expensive striped dress, she lifts her gaze dramatically heavenwards; then, switching into a military cadet's uniform, complete with trousers, cap and stick, she tilts her chin to the camera with a mischievous grin.

Among this group, there is a single photograph which showcases Cora Crippen the woman. She appears without a hat, her dark hair

set in tight, short curls, the waist of her wide-sleeved silk dress cinched into an unforgivingly narrow "V." She leans against a spindly gold chair, her head turned in three-quarter profile, smiling patiently as if listening to someone speak. Between her neck and the low line of her bodice, a great expanse of unadorned white flesh is displayed, and just beneath that, a glittering collection of brooches. Adeline Harrison had remarked on her friend's passion for jewelry and observed that at the time she met Cora, her husband had bought her "several new diamond rings" as well as "a new jewel—'the rising sun brooch,'" a round-shaped piece set with diamonds: twelve radiating out on zigzags of gold from a thirteenth boldly twinkling in the middle.[13] Mrs. Crippen would wear this proudly at the center of her décolletage, often alongside her other assorted treasures: her sparkling rings and bracelets.

With her "attractive photographs" on "expensive professional paper" and her unbreakable spirit, Mrs. Harrison said Cora "would trip around to see the agents." Eventually, she was "successful in procuring some engagements through her own endeavors." "She imagined she was the image of Marie Lloyd," Adeline sniffed.[14]

Contrary to Crippen's claims that he disapproved of his wife's new career choice, he seems to have spotted the potential for profit almost immediately. It was he who had invented a stage name for her: Macka Motzki. Not surprisingly, Cora had other ideas. For this fresh chapter of her life she had chosen the name Belle Elmore. According to her husband, she had "had it in her mind when she came over," but he had "persuaded her to use the other name."[15]

In addition to working for Munyon, Crippen also began moonlighting as his wife's theatrical manager. The doctor, now an expert patent medicine salesman, had learned how to hustle, to promote and to sell through charm and promises. The theatrical world, in which even his mentor Professor Munyon had dabbled, seemed a natural fit for him. For a short time, he and Cora were part of Vio & Motzki's American Bright Lights Company, an endeavor managed by Sandro Vio, a "comic conjuror" and ventriloquist. They were able to secure several engagements, including one at the Balham

Theatre of Varieties in February 1899, where Cora performed *An Unknown Quantity*, the operetta that Adeline Harrison had written.[16] Unfortunately, by the summer of that year, the bright lights of Vio & Motzki's enterprise had faded and Cora took this opportunity to reinvent herself finally as Belle Elmore. After years of shedding names and growing new ones, Belle Elmore was one which would stick. It was an identity she would wear with pride.

Like many American visitors and expatriates, the couple had taken lodgings in Bloomsbury. The Crippens at first settled on South Crescent Street off Tottenham Court Road, and later at 62 Guilford Street, near Russell Square, in a set of rooms at a respectable boarding house. Their situation meant that the doctor could walk to his shop on Shaftesbury Avenue, conveniently across from the Palace Theatre, and next door to the famous costumier Morris Angel. Here, too, Belle was on the doorstep of any number of West End venues, booking agents and the offices of theatrical newspapers. According to Adeline Harrison, her "absorbing passion for stage life" and her "fascination for the society of everyone connected with the profession" meant that "night after night she would visit the various halls in town."[17]

When not gazing up at the performers from the audience, Belle was hustling: meeting stage managers and forging relationships with other entertainers, a strategy that eventually worked to ingratiate the Crippens among some of the industry's best-known performers. Throughout, her husband was beside her. They were "like a couple of children in their love for excitement," Mrs. Harrison declared. The pair spent their evenings bouncing between gatherings and dinners and the theater; "every form of novelty and excitement appealed to them."[18] When the Vaudeville Club opened its doors in 1901 "to gentlemen connected directly or indirectly with the vaudeville profession," Hawley Harvey Crippen was granted membership along with Dan Leno, Eugene Stratton, "Little Tich," Fred Ginnett and Harry Freeman, some of the most powerful men in music hall. Belle Elmore's husband would also become a recognized figure behind the scenes when she was touring. One per-

former recalled that Crippen "was looked upon as what they call in the business, a music carrier." He occupied himself with "taking the band parts to and from the hall" and managing Belle's concerns.[19]

Delightful as it was for Crippen, such a lifestyle could prove distracting. He had been hired to run Munyon's business, not to lounge about in music halls. In August 1898, while Crippen's eyes were elsewhere, a consulting physician under his charge was found to have been pocketing income from Munyon's stock. There was a trial and Crippen was called to testify in the case against James Edward Deane. Hawley made a terrible witness. He and Munyon's Remedies were openly ridiculed in court. It was discovered that Crippen's medical credentials were not recognized in Britain and therefore he could not call himself a doctor. In cross-examination he found himself referring to Munyon's products as "swindles" and failed to convince the jury of the efficacy of homeopathy. He was simply selling "sugar and water." The courtroom erupted into laughter at his expense, again and again.[20] After the ordeal, Munyon summoned his star employee to Philadelphia for a reckoning. Crippen returned to London with his position intact, for the time being.

According to Adelaide Harrison, roughly a year later, a playbill for one of Belle's performances found its way into James Munyon's hands. He was furious to find the name Hawley Harvey Crippen cited on it as her manager. Crippen was ordered to pack his bags and return permanently to the business's headquarters in Philadelphia. In the first week of January 1900, he did so, but his wife did not accompany him.

The Crippens had been very adept at disguising the growing cracks within their marriage. Friends would only ever see the polite face of their relationship. Belle was guarded about her husband's failings, and he made a public performance of catering to her every whim. While an exciting move to London might have provided them with an opportunity for a new beginning, their past problems had followed them overseas; Crippen's secretive nature and Belle's sad discontent about the childlessness he had thrust upon her would never be conducive to fostering matrimonial harmony. Whatever

the catalyst, it appears that the Crippens agreed to separate by the end of that year. Unlike previous occasions, this was to be permanent. Munyon was made to understand that Crippen had left his wife in London, and the doctor's assistant, William Long, observed that the pair would cease to correspond.[21] Like many Victorian couples, the Crippens' separation was implemented without any legal formalities. Hawley had left his wife in their Bloomsbury boarding house and, in accordance with expectations, sent her money to ensure her needs were met. This was the bare minimum expected of all husbands, whether married or otherwise.

In some respects, their arrangement would not have felt like a new routine. The Crippens had already spent significant periods of their short marriage living apart in different cities, pursuing their disparate ambitions. However, while in New York, Belle had her family; in London, she was alone. In the wake of scandal which saw her husband recalled by Munyon to Philadelphia, Belle also appears to have paused her stage career. Her name no longer appears in advertisements from the autumn of 1899. If this was Crippen's doing, she could not have been happy about it. Instead of performing, she returned to taking voice lessons.

It was while visiting her singing instructor in nearby Torrington Square that she was introduced to a fellow expat performer, Bruce Miller. A native of Chicago, Miller was something of a sensation. He had come to London in the autumn of 1899 accompanied by an eleven-woman papier-mâché clockwork orchestra, which had taken him ten years to design. He had perfected the life-size musical ensemble with the help of a female watchmaker, Mamie Frey. Together they had created the dummies and wired them with pneumatic tubing to a pipe organ, which allowed "Professor Miller" to manipulate them with pumped air from behind his music stand. There was a clarinetist, a flutist, violin and viola players, as well as entire brass and percussion sections. Dressed in neat white satin evening gowns and jewelry, each mechanical lady rose to her feet, blinked her eyes and began to play her instrument in time with the conductress. All the while, their creator looked on, his head and

shoulders appearing over the disguised control box. The "Musical Curiosity," or "Automaton Orchestra" as it was billed, was "ruled by one man and one brain," wrote the *Strand Magazine* in its five-page photographic spread, "where the pretty, dead-eyed puppets are posed with their somber master in his black frock coat."[22] Audiences were mesmerized by Bruce Miller's fascinating if cold and disquieting robotic invention. It had also captured the interest of the organizers of the 1900 Paris Exposition, who had invited him to display his miraculous automation that coming spring. In the interim, London presented itself as a distracting and potentially profitable base.

It was toward the end of the Christmas season when the clean-shaven, dark-haired, 34-year-old Miller met "Miss. Belle Elmore" as she dined with her instructor in the home that the two men shared. Miller had stopped back to collect something he'd forgotten but this chance encounter, which began with a handshake, became the spark that ignited a relationship. Believing that Belle was unmarried, he began to call on her and the two would sit together in the drawing room of her boarding house. "She frequently spoke of Dr. Crippen and finally roused my curiosity," Miller recalled. "I asked her who was Dr. Crippen?"

"That is my husband," she said. "Didn't your friend tell you I was married?" Much explaining then ensued. As it happened, the night they first met, January 6, or Twelfth Night, was the date her husband departed for the US.[23]

It transpired that Miller too was estranged from his spouse, Edith, who was living in Chicago with his son. The two American performers turned to each other for entertainment. Miller took Belle to the theater or to dinner two or three times a week. Whether it was an intense flirtation or truly a love relationship, for the next several years the two would continue to commemorate January 6.

At the beginning of April, after a period of romantic indulgence, Bruce Miller departed for the Paris Exposition, where he was scheduled to remain for the next eight weeks. It is unlikely that he or Belle had anticipated the reappearance of Hawley Crippen at the end of that month.

Whatever had occurred in Philadelphia, he and Munyon had agreed to part. He left the company's headquarters and walked two blocks down the road to the offices of their competitor, the Sovereign Remedy Company. Within a short period, he had talked the business into letting him open and manage a London office. He would do for them what he had done for Munyon's, though on a much smaller salary. Crippen had obviously seen enough of London to believe that there was a fortune to be had there in the sale of patent remedies, if only he could hone his craft enough to procure it.

By Crippen's admission, Belle was rather lukewarm about their reunion. He claimed there had been a "change in her manner." Belle, he said, "was always finding fault with me and every night took some opportunity of quarreling..."[24] Crippen complained that at times she was "hasty in her manner." He said that when she was angry, she taunted him by alluding to the "fine men" that she had met when she sailed to England in 1897.[25] But Belle's husband had hardly treated her fairly. The Crippens had been married for almost seven years and, in that time, Hawley had been nothing but inconstant. He had lost positions, he had abandoned her, he had led her from city to city in the pursuit of opportunities which seemed to melt away. Crippen, an older man and a medical doctor, was meant to have provided for his young wife, given her stability and children, but he had explicitly failed in his nineteenth-century duties. The couple were unhappy together, but were unwilling or unable to terminate their marriage.

Upon Hawley's return, some agreement must have been struck between them about how they might continue their lives. It was unlikely to have been spoken outright, but rather implicitly observed. They would carry on as they had, as did so many married couples in their position, refusing outwardly to express their discontent to friends and family. Such an arrangement allowed Belle to resume her relationship with Bruce Miller when he arrived back in London that summer.

Belle's paramour had written to her throughout his absence.

There was never any attempt to hide her correspondence from Crippen. According to Miller, everything about their relationship was made completely transparent to the obliging husband. The doctor knew "perfectly well" that Miller "was seeing her frequently, and dining with her."[26] Crippen's presence changed nothing about their association. He would continue to visit Belle in the front room of their Guildford Street lodgings, and in 1901, after they moved into a flat on Store Street, he would call on her there and sometimes stay for dinner.[27] If there had been a physical element to their affair (and Miller would only ever admit to kissing Belle), it was pursued with the utmost discretion. Eventually, their feelings would cool into something platonic.

Miller denied there was ever any sneaking around. He always felt perfectly comfortable visiting Belle at home, and attested that Crippen was frequently present when he called, though the doctor never seemed interested in meeting him. Belle had wished to introduce Miller to her husband and one night had arranged a supper for the three of them in their flat. As the hours passed, Crippen failed to appear. "I am often disappointed in that way," she sighed, alluding to her absent husband.[28]

Although Crippen and Miller never met in person, the doctor went out of his way to maintain a cordial relationship with his wife's "friend." In 1903, Miller contracted bronchitis while on tour and Belle wrote to him with a prescription from her husband. Crippen never interfered with their correspondence and diligently forwarded the performer's letters to his wife when she was away from home. Belle kept photos of him on her living-room wall, on her piano and on her dressing table. Miller sent her boxes of chocolates, Christmas and Easter cards, and greetings on her birthday, which frequently included a dollar bill to buy herself flowers. As far as Miller was aware, Crippen never uttered an objection to any of this.

Until 1901, Bruce Miller always lived no more than a few minutes from the Crippens' door, but the soaring success of the "Pneumultiphone Orchestra" would change this.[29] Several lengthy tours of Brit-

ain's music halls and a move to South London meant that he and Belle would begin to see less of each other. Between 1902 and 1904, in the final two years of their relationship, the pair would only meet a half-dozen times. On each occasion, they shared a bottle of champagne. Belle would save all six of the corks and record the dates of each of them. When later questioned about their significance, Miller was completely unabashed. He would reiterate that they represented nothing but an affectionate, albeit flirtatious friendship. However, whatever form their relationship had taken, it was not without its share of guilt. The pleading letters Miller had received from Edith, begging him to return home, were shared with Belle. According to Miller, it was she who persuaded him that he "ought to go back to his wife." Belle, too, experienced a certain amount of remorse. Miller recalled that she would write to him about "how good she was, regarding her Church" and that "she was a Catholic" and "very regular in her attendance . . ."[30]

Once Miller had returned to Chicago and to his wife, all that would remain of his connection with Belle was an occasional correspondence. Any souvenirs of his romantic interlude in Europe were discreetly lost. Belle, on the other hand, carefully preserved Miller's notes, postcards and letters. Unless she had weeded out anything especially incriminating, the sentiments expressed in their correspondence seem to have been remarkably tame. The most lurid of these was the manner in which he signed his missives to her, "Love and kisses to Brown Eyes."[31] Even by the standards of the day, this was playful, endearing, roguish, but hardly the impassioned confessions of an adulterous lover. Miller would later swear blindly that there had never been any "improper relations" with Belle, for the very specific reason that he "could not be more than a friend." He repeated this phrase more than once—*I could not be more than a friend.*"[32] It has always been assumed that this was a strategic lie uttered by a man desperate to disguise the nature of his relationship with another man's wife. Instead, it was more likely to have been a carefully chosen phrase which reflected the truth of Belle's physical circumstances.

Belle's surgery would not only have dampened her libido, but was likely to have resulted in vaginal atrophy. This, in addition to her prolapsed uterus, was likely to have made intercourse awkward, if not painful. It is well documented that Belle's surgery and the experience of being "un-sexed" scarred her physically and emotionally. It significantly altered how she perceived her body and its function, and it is questionable if she ever again engaged in sex with her husband, let alone with other men.

Miller's confidence in his innocence, and Belle's candidness about her relationship with him, seems to have stemmed from their absolute conviction that they had nothing to hide. In Edwardian Britain, if a husband wished to divorce his wife, he was required to prove that an act of adultery had taken place. Legally, adultery involved sexual intercourse with someone who was married, but if there had been no penetrative sex, then technically no wrong had been committed. If there were physical impediments to Belle's ability to lead a full sexual life, Crippen certainly would have known about it, and no matter how unpleasant their marriage would become, he would never be allowed to divorce her in the United Kingdom.

Whatever was occupying Crippen's thoughts in 1900, it was unlikely to have been Bruce Miller's attentions to his wife. Not long after his return from Philadelphia, the doctor found himself in serious financial difficulty. According to Adeline Harrison, Crippen had invested some of his own capital in establishing the London branch of the Sovereign Remedy Company, a project which had withered and died by December of that year.[33] The doctor quickly thrust his fingers into other pies, one of which was a creation of his own, Amorette, a "nerve tonic." This was packaged from the couple's home on Store Street with the help of Crippen's trusted assistant from Munyon's, William Long. Long also mentioned that his employer was running another business from his address. A sign was affixed to their front door which read, "Belle Elmore, Miniature Artist."[34] Crippen had recruited the services of an amateur painter at his workplace to turn images from photographs into pocket-sized portraits. Belle used her theatrical talents to pose as

the lady artist. Between the two of them, the Crippens managed to survive the dry spell, which ended in the early months of 1902, when Hawley landed a position at the Drouet Institute for the Deaf.

While her husband scavenged for opportunities in London's crooked patent medicine trade, Belle continued to pursue her music hall ambitions. Having shaken free from Crippen's oversight as her manager and the clunky name he had chosen for her, Belle Elmore began to receive bookings. By the autumn of 1900, an experienced theatrical manager, Harry Goodson, had taken her on and sent her on a tour which included appearances around the country, in Bath, Manchester, Oxford, Sheffield, and as part of a "sister-act" with Nellie Belmore in Grimsby.

Like most performers at the outset of their music hall careers, Belle was paid very little and was expected to gain experience and exposure before her salary improved. Performing at "smoking concerts," especially fashionable in the 1890s, was a way in which both female and male artistes could raise their profiles. Small, privately held "smokers" were designed for male-only audiences who would congregate to listen to a program of music while sucking appreciatively on their pipes, cigarettes and cigars. It was Goodson who put her forward for such work in the trade press, and Crippen would later claim that he objected to Belle taking it on. He asserted that she worked "smokers" without his approval while he was away in Philadelphia, but there is no evidence to suggest Belle was performing in the first half of 1900: her name does not appear in advertisements until December of that year, when Crippen was back in London. If his objections were genuine, he did not seem to have voiced them very loudly at the time.

Under Goodson, Belle had also made her first music hall appearance that year at the Bijou Theatre in Teddington, one of London's suburbs. Her "turn" consisted of three or four songs in her repertoire. "She went fairly well, the audience being quite pleased with her," commented the theater's manager, "but she was not what would be called a hit."[35] In later years, the situation improved. Although a friend in the business thought she "probably" received between £3

and £4 per week, another fellow music hall artist believed that "She drew a salary in the region of the 'twenties,' " and her earnings enabled her to be well dressed and to wear fine jewelry.[36]

Accounts of Belle's abilities and how she was received by her audiences differ according to the date when her performances were being discussed. After the events of 1910, authors and journalists enjoyed exploiting the comedy to be derived from lampooning her. A comment made by Crippen that his wife had done "a sketch at the Old Marylebone Music Hall, but it was a failure and she gave it up," would become the inspiration for wild assertions about Belle's lack of ability.[37] Yet, according to the reviews of her performances in contemporary newspapers, Belle was no better or worse an entertainer than the majority of others who came and went from the music hall scene. Most never achieved even moderate fame, and certainly fewer still reached the superstar heights of Marie Lloyd, Vesta Victoria and Vesta Tilley. Adeline Harrison thought that Belle experienced "varied success," and that generally, her performances were described favorably.[38] In Bath in 1900 she was called "a comely comedienne" who "meets with applause," and she "was thoroughly appreciated" in Bristol in 1902.[39] At various times, she is recorded as having "quickly become a favorite," been "very well received" and given "a splendid reception," as well as having won "unstinted applause," and even been graced with "a double encore."[40] These descriptions contrast markedly with the account given by her "bosom friend" Lottie Albert in 1920. Albert recounts the occasion on which she first met Belle, when they appeared together at a theater in Oxford on October 18, 1900. Belle was backstage in tears after her act had fallen flat. Albert (or the journalist writing on her behalf) describes the scene in hyperbolic terms, her turn was "an utter failure" and she displayed the grief of "one who is utterly incompetent and suddenly realizes it."[41] At the time of this purported event, Belle Elmore had scarcely been back on the variety circuit for a month; she was at the very start of a career which would continue on and off for the next seven years. Had she truly been so terrible and talentless, it is unlikely she would have enjoyed as long a period behind

the footlights as she did. In fact, in later years, another performer who appeared with her at the Palace Theatre in Glasgow attested "she was . . . a genuine artist, she went on fourth turn and made a hit, the audience, in the professional phrase, 'simply eating her.' "[42]

Crippen was frequently present to witness these trials and triumphs. However much he would later pretend that his wife's career on the stage was distasteful to him, that he detested the peripatetic bohemian lifestyle, he certainly seemed to enjoy the income and opportunities it brought the two of them. So long as Belle was preoccupied with tours, rehearsals and her theatrical relationships, he was free to pursue his own ambitions and desires, in whatever form those were destined to take.

8

"The business with Dr. Crippen"

I N F E B R U A R Y 1904, T H E deaf journalist Evan Yellon was sitting on an omnibus "finger-talking" to a friend when something distracted him—signs for the Drouet Institute were plastered everywhere he looked. "A cure for the curse of deafness" shouted the billboards and advertisements above the window and behind him, over his head. Yellon, a campaigner for the interests of Britain's deaf community through his magazine *Albion*, was outraged. He had become increasingly angered by the exploitative claims of peddlers of patent medicines who wrenched money from the hands of men and women like himself. The Drouet Institute was by far the worst offender of all "the petty rat swindlers," pouring £10,000 to £12,000 per year into false advertising. Yellon had had enough and was determined to take them on.

The Drouet Institute's business was conducted primarily by correspondence. After Yellon responded to one of their many adverts, he received a prompt reply from one of the Institute's secretaries, who sent him a questionnaire on which he was asked to provide details of his hearing disorder. This was the Drouet Institute's "free consultation." All Yellon needed to do was fill in the form and, for a "reasonable price," the doctor at the Institute would send him all the medication he required to cure his deafness. Yellon would have none of this. As both he and reputable physicians of the time knew, it was impossible to provide an accurate diagnosis of a medical condition without an actual examination. Instead, he demanded an

in-person assessment at their London office by their resident specialist.

Yellon traveled into town especially for his appointment. He was eventually shown up the stairs to a splendid waiting room, decorated with "china knick-knacks" and "good specimens of modern Chippendale furniture." After a brief period, the tapestry curtains at the opposite end of the room were thrown wide to reveal a consultation space. "A shortish man" whose name he believed to be "Dr. Cuppen" beckoned him forward.

Yellon instantly scented a quack. This so-called medical man "was got up in a very fantastic fashion for a member of a learned and sober profession, and an aural specialist":

> His frock-coat was orthodox enough; but he wore it with a shirt of a startling hue, adorning the front of which was a "diamond" as big as a marble; and the jaunty butterfly tie vied in hue with the shirt. His patent leather shoes were a trifle cracked, and his face a warning to all observant beholders. The flabby gills, the shifty eyes, and the man's appearance generally would have effectually prevented me from being taken in, even had all else failed to do so.[1]

Dr. Cuppen's examination techniques were highly suspect. An array of instruments sat on the doctor's desk, which Yellon decried as some of the filthiest he had ever seen. "Cuppen" stuck a grubby speculum into his ear and prodded about. The entire assessment took hardly five minutes. Yellon had once been examined by a "famous aurist" who took twenty-five minutes to assess his condition, while making additional checks of his nose and throat. When Dr. Cuppen had finished, he simply dumped his equipment back on to his desk, without even disinfecting it.

Yellon was given a prescription, identical to that presented to every other patient. The miraculous remedies consisted of "Dr. Drouet's Genuine Papier Anti-Catarrhal," or plasters that were to be stuck behind the ears each night; "Ear Antiseptic," which was to be

injected into the ears; and hepar sulphuris calcareum "Powders" to be taken "dry on the tongue" three times a day.[2] It would later be disclosed that all of these cures, including the trademark plasters, were made in France to a specific formula, a one-size-fits-all remedy guaranteed to fix a range of problems from post-nasal drip to profound deafness. Yellon's collection of medicines cost £1, or what might amount to the better part of a laborer's weekly wage. His charade of a consultation with "Dr. Cuppen" was an extra 5 shillings.

Evan Yellon had not been the first journalist who attempted to tear down the Drouet Institute with the power of his pen. An effort to denounce the "gang of quacks" who ran the company had begun in 1900, spearheaded by the campaigning editor of *Truth* magazine, Henry Labouchère. It was a stubborn enterprise to sink, kept afloat by a large, ill-gotten profit margin. It had been the brainchild of two swindlers, a mysterious "Mr. Marie A. Derry" who had attended the École des Beaux-Arts in Paris, and a J. H. Nicholson, the American inventor of the so-called magnetic eardrum, who referred to himself as an "aural surgeon."[3] The eponymous Drouet had been an obscure French doctor dying of tuberculosis and alcoholism who had agreed to lend his name to a patent medicine enterprise aimed at "curing deafness."

Like Munyon's potions and similar scams, its success relied on a heavy investment in advertisements. Former customers were endlessly pestered to provide testimonials. One patient claimed she had agreed to give one "only to get rid of the Drouet people."[4] Like the employees of Munyon's, those engaged in the fraudulent exercise knew exactly what they were doing. Its manager, Monsieur J. Carré, only hired doctors with foreign medical qualifications, and British doctors who had been struck off the register. Drouet's remedies were useless, and those who suffered from hearing loss, or who cared for afflicted loved ones, were easy targets for unscrupulous men like Nicholson, Derry, Carré and Hawley Harvey Crippen.

By the time Nina Neave had secured her job with them in 1901, the Drouet Institute had already acquired a reputation for charlatanism,

a situation of which her father must have been ignorant when he recommended the secretarial position to his daughters. At the time, the Institute was a significantly sized concern. It had "a large class of employees" which included a manager, Carré; a senior and a junior consulting physician (Crippen's position was as the latter); a male secretary for each of the physicians; and "six or seven letter-writing clerks," of which at least three were women.[5] The volume of correspondence which poured through the company's letterbox was enormous. An employee estimated "that they had about 17 letters a day each to write" and "sometimes . . . had to work overtime and take letters home . . ."[6] The female typists, like Nina, were instructed as to which version of the covering letter was to be dispatched. Her job was then to "register the case and send off the communication."[7]

Nina had not been at the Institute for very long before she was made head of the "female typists department." This role also involved acting as a private secretary to the junior consultant, the "kind and considerate" American doctor, of whom "everyone was so fond."[8] When the lady typists had lost one of their number, Nina was given the task of replacing her. She did not hesitate to recommend her sister Ethel for the job. Shortly afterward, Ethel gave notice to her "dull" employers in the city and entered the infamous halls of the Drouet Institute.

According to Ethel's memoirs, she became aware of Crippen's interest in her and her sister almost as soon as she arrived at the office. "For some reason the doctor took kindly to us," she writes.[9] He found frequent excuses to chat with the girls, to find himself in the typists' room, to ask if they were "happy and comfortable" and on cold days, if they "were warm enough in the office."[10] When Nina went to "take down letters" for him, he would make a point of asking about Ethel and if she enjoyed her work. While Ethel ascribes these considerate gestures to her employer's good nature, there was clearly an ulterior motive to his solicitousness. Within a short time Dr. Crippen, a married man, was soon taking the opportunity to visit his two teenaged typists at home.

The pretty, dark-haired Neave sisters were unlikely to have been

the first to receive his attention while at work. Crippen had form for pursuing other women while married to Belle. One of the Drouet Institute's former lady typists described the doctor as being "fast," or sexually and morally free in his manner.[11] This sentiment was echoed by an associate who had met Crippen shortly after his arrival in London. He claimed that the doctor was quite boastful and "liked to talk of his successes among women" and that "he had them all running after him."[12] Even Belle's sister Louise recalled her brother-in-law's wandering hands. "Crippen always bothered me as soon as his wife was out of sight," she said. "He also molested my sisters when he visited us in Brooklyn."[13] Whatever his designs on Walter Neave's daughters, they were almost certainly not honorable.

Neither were his visits to the Neaves' home spontaneous or occasional. The Crippens and the Neaves were not near neighbors. The Neaves had relocated to a slightly larger house at 85 Belsize Road, on the edge of St. John's Wood, and the Crippens were at the time living on Store Street in the opposite direction. The Drouet Institute's offices sat between them. According to Ethel, the doctor would frequently "drop in" on the Neave family after work and on Sundays. "He never made any excuse for coming but seemed to look upon our fireside as his own," she recalled. "My father and he became great friends, and for my mother he seemed to have a genuine regard."[14]

The doctor's intimacy with the family would later become the cause of great embarrassment, but in the years when he was making himself comfortable in Walter Neave's armchair it was also likely to have occasioned a good deal of awkwardness. In all of their accounts, neither Ethel, nor Nina, nor Walter are able to provide a clear, corroborated picture of what exactly they knew about Crippen's marital status. Curiously, not only did Crippen never think of introducing Belle to the family, but apparently, in all the time he passed with the Neaves, he never once even mentioned her. Walter claimed he thought the doctor "was a single man" until 1907 and Nina denied knowing anything about a "Mrs. Crippen" until 1909.[15] However, Ethel paints a different picture.

One day in early 1903, a friend of Crippen's paid him a visit at the office, and Ethel and Nina were asked to prepare tea.

"'I wish I had someone to make tea for me,' said the friend. Whereupon the doctor, with his customary geniality, pressed him to stay, and during the chat over the teacups, mention was made of the doctor's wife."

According to Ethel's tale, a surprised Nina then questioned Crippen as to whether it was true that he was married.

"It would take the lawyers all their time to find out," replied their flirtatious employer.[16]

Like so much of Ethel's, Nina's, Walter's and Charlotte's recollections of events, how much is true is to be questioned. What of their stories was concocted, omitted or hidden to save face, and how much was embellished by the journalists who serialized their interviews, is uncertain. At different times, each family member offers a different set of narratives at variance with what others said. The parents frequently contradict each other and their daughters, while Nina contradicts Ethel and Ethel regularly contradicts herself.

It may have been the case that Walter and Charlotte were never introduced to Belle Elmore, but that did not mean they were ignorant of her existence. It's unlikely that Edwardian parents would have allowed their young, eligible daughters to be visited by their wealthier male employer without a clear understanding of his marital status. It is more probable that the Neaves were aware of Hawley Harvey Crippen's domestic position but chose not to broach the matter. The truth would have been too uncomfortable—that Walter and Charlotte were tacitly permitting their daughters to be courted by a married man.

Such situations, though considered shameful and potentially damning if exposed, were not uncommon among the working and lower middle classes, particularly if a family's financial stability was at stake. As Walter remarked, the sisters were paid handsomely for assisting in the swindles of the Drouet Institute. Ethel received a starting salary of £2 5s. per week, which he thought was "extraordinarily good remuneration for a beginner."[17] It would not have been

in the Neaves' best interests to shut their door to the man who lightened their burden, regardless of his intentions. The memoirist Nancy Jackman, writing about such attitudes in the first decades of the twentieth century, suggests that if there was sufficient reward to be had, parents often turned a blind eye to arrangements with employers which may have proved dangerous or sexually compromising for their children. If Crippen had also implied that his marriage was uncertain or impermanent, Walter and Charlotte may have cautiously allowed his relationship with their daughters to continue, in the hope that it might one day lead to marriage. It was a perilous gamble, especially as the Neaves did not appreciate they were dealing with a manipulative fraudster.

Fortunately for Nina, in 1903, a genuine candidate for marriage did present himself. Horace Brock was the son of a solicitor and held a position in the city as a clerk to a fruit brokerage company. Although Nina was nineteen and her fiancé was fourteen years her senior, his respectable middle-class background made him a suitable match for the daughter of a newly appointed "commercial coal agent," who now managed orders for Wallace Spiers & Co. As Nina's July wedding approached, Ethel's emotions would have been mixed. The sisters' lives, their decisions and experiences, had always been intimately entwined. As the elder of the two, Ethel might also have expected to marry before Nina. While Nina would go on to fulfill her intended role as a wife and mother, Ethel would be left behind. Charlotte remarked that her eldest daughter "seemed like one dazed when Nina left to get married," and this, apparently, was when "the business with Dr. Crippen" first began.[18]

Shortly before Nina's wedding, Crippen made arrangements one day after work to take the sisters for a lavish, celebratory meal. He ordered a taxi to convey them to the top of Oxford Street to Frascati's, an elegant restaurant next to the famous Oxford Music Hall. This was a grand gesture. Frascati's was palatial in its scale and decor, an assembly of polished marble, gilt rails and pillars topped with silver angels. "What is not gold or shining glass is either light buff or delicate gray, and electric globes in profusion, palms, bronze

statuettes, and a great dome of green glass and gilding," wrote a late-Victorian restaurant critic.[19] A string band serenaded diners as French and Italian waiters in black coats ferried platters of oysters, bottles of Burgundy, filet mignon Victoria and truffle-scented *ris de veau* to linen-dressed tables. Frascati's was a restaurant where wealthy gentlemen of business brought women they wished to impress. On his visit there in 1899, Nathaniel Newnham-Davis noted that the dining room was filled predominantly with couples. The ladies he assumed to be the wives of these men or "handsome young representatives of British womanhood" who would eventually "honor them by becoming so." Ethel, who had grown up in charitable housing and dreamed of silk dresses, must have been dazzled.

Over the years, the doctor had been gently but persistently laying the groundwork, hoping to snare one of the Neave girls as a mistress. With Nina gone, he turned his focus exclusively to Ethel. In the wake of Nina's wedding, Charlotte Neave believed that Crippen noted Ethel's loneliness and vulnerability and set about exploiting it. His first move was to promote her to Nina's position as his private secretary, thereby drawing her more closely into his confidence. The timing of Nina's departure was also quite fortuitous; the day after her wedding, on July 12, Belle sailed for New York to pay a month-long visit to her ailing mother. In his wife's temporary absence, Ethel's employer was now free to spend as much time as he wished in the company of his secretary.

Whatever her mother's view of her daughter's relationship with Dr. Crippen, Ethel appears to have thrived in her new position of responsibility. Equally, the doctor came to rely upon her organizational and letter-writing skills, as well as on her discretion working in a trade that peddled fraudulent cures. However, what ultimately drew the odd couple together—he, a married man, twenty-one years her senior, and she, a quiet young woman with a traditional upbringing—was the strangely harmonious fit of their respective characters. Hawley Harvey Crippen asserted his dominant position in the world by "fixing" women. Although he was drawn to independent and self-reliant female figures, it was also these women's physical vulner-

abilities (perceived or otherwise) that attracted him. It was "female weakness" that allowed Crippen to take ownership of the women he loved, to control them and their bodies. Ethel assisted him in this: she wore her frailties openly, as part of her identity.

Since infancy, Ethel had been viewed as the sick, meek child of the family, the one who required surgery before she could walk. She was never strong or sturdy, always pale and thin. She had difficult menstrual periods and, according to her father, as a young woman she suffered from neuralgia, or nerve pain, a disorder which was believed by some doctors of the era to occur in the "excitable," the "anxious," the anemic or "poorly fed."[20] It was a disorder frequently associated with "hysterical women." Ethel was described by a work colleague as "delicate" and "always ailing." Her standard response to any inquiry about her well-being was "not very well, thank you."[21] In later years, her children suggested that Ethel used illness to her advantage and wouldn't suffer physicians who didn't pander to her.[22] Ethel needed Dr. Crippen. She would relish the detailed attention he paid to her welfare, and the free medical advice he offered to her and to her mother, who was also in fragile health. This surely must have been interpreted as a type of romantic devotion. For his part, Hawley Crippen must have enjoyed Ethel's surrender to his greater knowledge of her body and its failings. She would be his work-in-progress, a willing model with which he could tinker.

The situation between Ethel and her employer began to shift from their first dinner at Frascati's. "Ah! How even in those early days we began to realize how near and dear we were to become to each other," Crippen reminisced in a letter. Their after-work meals at the restaurant were to become a regular occurrence and the pair soon had "their favorite corner by the stairway," discreetly out of view.[23] This platonic courtship continued for a year, until the summer of 1904 when the couple could no longer deny their feelings for one another. Crippen had planned a full-day's outing for them. "One Sunday, how early I came for you," he wrote, "and we had the whole day together, which meant so much to us then. A rainy day indeed,

but how happy we were together, with all sunshine in our hearts."[24] Ethel, who was then still living in the family home, appears to have kept these early trysts with Crippen a secret, though Walter, who often seemed absurdly ignorant of the obvious, recalled that his daughter used to receive love letters while she worked at the Drouet Institute. Her mysterious admirer was a regular correspondent, but she refused to reveal his name. "We chased her about it when the letters appeared on the breakfast table; but she would simply flush angrily, and then hurry away to her bedroom to read the communication in peace," he wrote.[25] Curiously, no suitor ever made himself known to the family.

For a young woman raised by a devout father, Ethel does not appear to have been too troubled by Crippen's marital status. If initially she had harbored reservations, they were gradually eroded by her pursuer's skillful persuasion and staged stunts. The more information Crippen offered Ethel about the details of his unhappy marriage, the more intimate their relationship became. Naturally, her devotee's disclosures were entirely self-serving. He confessed that his wife was a financial drain on him. Belle's desire to be a music hall sensation had led them into the hands of charlatan managers who bled them of money, he complained. He was too good-natured to tell his wife she was a failure on the stage, so "when she came to him for money to buy expensive dresses, he paid it over without a single word of rebuke."[26] He insinuated that Mrs. Crippen was determined to ruin them. She had an unruly temper. She was selfish. She loved parties and entertaining when he, a simple soul, preferred a quiet life. His wife even had the audacity to be unfaithful to him. Belle had formed an attachment to an American performer, whom she preferred to her doting husband. "By sheer accident," Ethel confessed in 1910, "I happened to see some of the letters which he had sent her." What she read in them (conveniently) "relieved me somewhat of any misgivings I had with regard to her husband."[27] The poor doctor led a terribly tragic existence, concluded Ethel, yet despite his sufferings she "never heard him say a really bad word about Belle Elmore."[28]

Crippen had so perfectly primed the canvas that when Ethel finally did encounter her love rival, she had already drawn a ghastly portrait of her. When a strange woman appeared at the office one day in 1904, without even ascertaining her identity, Ethel claimed to have taken "an instinctive dislike" to her. "What an awful woman," Ethel is said to have declared, before learning that the visitor was indeed Mrs. Crippen; "I don't like her a bit."[29] Crippen had convinced Ethel that Belle only came to see him when she had run through her shopping money. The brash, self-obsessed music hall actress "with her obviously bleached hair" would "flounce" in and begin a noisy row with her husband. She "did not care a brass farthing how much she showed him up in his own office." When she was finished, "out she came . . . in a fury and . . . banged the door behind her in a temper."[30]

Hawley Crippen was anything but the hen-pecked, defenseless husband. When it suited his purposes, he was as much of a performer as his wife. Following another angry visit from Belle, Ethel saw the doctor suddenly fall off his chair. "I ran up to him," she recalled. "He was very ill, and I believe that he had taken poison. He told me that he could bear the ill treatment of his wife no longer." In a noble feat of heroism, Ethel managed to assist him off the floor and revive him with the aid of brandy. His pantomime was a success. "I think it was this, more than anything else, which served to draw us together," Ethel confided.[31]

9

The Garden of Eden

Store Street was a colorful place to live at the turn of the century. It was neither insalubrious, nor fashionable. Its inhabitants all seemed cut from the same cloth as the Crippens: bohemian, metropolitan types. French, German, Italian and Russian were spoken in the neighboring flats. Like everywhere in Bloomsbury, American accents could be heard too. The surrounding accommodation tended to house "theatrical folk" and "commercial travelers," commented the social reformer George Duckworth, who also noted that many of the middle-class boarding houses were run by "Jewesses." There was no overt poverty here. Occasionally, on an adjacent street, a discreet red light might be placed in a window, while on a neighboring road, newly built mansion flats were being rented for between £130 and £250 per year.[1]

The Crippens had resided at 37 Store Street at least since 1902, according to Dr. John Burroughs and his wife Maud, who lived in the flat above them. Belle and "Peter," as Mrs. Crippen liked to call her husband (and by which name he came to be known), were an affable pair. "They appeared to live comfortably together," Dr. Burroughs said. He "never heard any quarrels" and "there never seemed to be any lack of anything in their home."[2] The Burroughses and the Crippens visited one another regularly, dining together and popping in for chats. John Burroughs, a trained medical practitioner and later a surgeon, remembered Dr. Crippen as "a very reticent man" and quite vague about what he did for a living. However, his wife was charming, if not a bit eccentric. He thought she may have been of

114

Russian extraction. Maud recalled an incident where Belle produced an article from an American newspaper and announced rather excitedly, "You would not believe I had a title." The story pertained to someone by the name of Mackamotzki "being a baroness or a countess and entitled to some property in Russia."[3] Belle was convinced that she was that person, though nothing ever seemed to come of it.

The Crippens might have carried on living happily in their Central London lodgings had it not been for Adeline Harrison, who tempted her friends north, out to the suburb of Holloway. At the time, she and the composer Denham Harrison, who had been posing as her husband, were living a quiet idyll on Hilldrop Road along with their illegitimate child. One day around the late summer of 1905, the Crippens came to visit and Belle fell in love with Adeline's "old world garden and bower of roses," bursting with scented blossom and buzzing with insects.[4] Such a lush and romantic retreat from the noise and smells of the metropolis would have been impossible to recreate in the streets off Tottenham Court Road. Belle was so seduced by what she had seen that the couple returned the following day to search for a house. The one which they found at 39 Hilldrop Crescent, a spacious ten-room, three-story terraced house, was just around the corner from the Harrisons. Adeline, entirely in keeping with her usual vicious character, proclaimed their home inferior to hers; however, she was impressed by the Crippens' efforts to "transform the ugly back garden into a flowery bower."[5]

While the area provided the Crippens with space to breathe, it was certainly not a glamorous address. Like numerous pockets of the Edwardian city, Holloway's boundary sat at a junction where all that was refined and decent about London converged with all that was horrible. A few streets to the south of Hilldrop Crescent was the reeking, bloody filth of the Metropolitan Cattle Market, where its lowing, snorting beasts were sold or slaughtered at the on-site abattoirs. This facility joined with a corridor of heavy industry: smoke-stained potteries, coal depots, gasworks, laundries, railway sidings and miles of track leading to King's Cross and St. Pancras

stations. Yet the roads that reached northward were a polite mix of the commercial and the residential: greengrocers, neighborhood pubs and terraced housing where pots of flowers and caged canaries sat in the windows. Hilldrop Crescent was nestled among this. A local newspaper described the road as "green and salubrious" and "a strange contrast of peacefulness and quietude with the hurrying stretch of main thoroughfares that abound it."[6] However, since the late 1890s, the neighborhood had begun to shift gradually and subtly downward. By the time Hawley Crippen paid the £52 10s. necessary to secure the lease on number 39, the location was no longer so desirable. The houses were judged "too large for the set of people who now care to live in a neighborhood like this." The "city men" who tended "to go abroad in the winter" had been replaced by civil servants, commercial clerks and shopkeepers.[7]

The reputation of the area and its residents had also been dented by the publication of George and Weedon Grossmith's satirical novel *The Diary of a Nobody*. Its protagonist was the pretentious Charles Pooter, a lower-middle-class Holloway clerk whose terraced house backed on to a noisy railway line and who fretted incessantly about his social status, his sherry glasses and the style of his Christmas cards. The Pooters came to personify the petty-minded bourgeois character of the area's inhabitants: the sort of person who would have been scandalized to learn that the Harrisons were living in sin and that Dr. Crippen was unfaithful to his wife, while studiously masking their own indiscretions.

For someone like Belle Elmore, who had grown up in a tenement and become pregnant out of wedlock as a teenager, marrying a man who could afford a rambling house like that of 39 Hilldrop Crescent would have felt like a triumph. Although they would fail to fill it with children, the Crippens could use the abundance of space, both inside and out, to their advantage. With a large sitting room and an adjoining dining room on the first floor, Belle would finally be able to host parties and suppers. Hawley had bought her an ebony-colored upright "cottage" piano, around which she and her guests could gather with their glasses of champagne. Her husband might

play his violin, or she might place a record on her new gramophone so the assembled could dance to its scratchy songs. Adeline Harrison remarked that the Crippens rarely switched on the electric lighting upstairs unless they were entertaining. She thought it odd that they preferred to spend most of their time on the ground-floor level in the breakfast room, beside the kitchen. Usually, this was the servants' domain, but Americans like the Crippens, who had not been raised in wealthy households and who viewed the parlor as a room strictly for entertaining guests, did not adhere to the social customs observed by the British middle class.[8] Both the kitchen and the breakfast room were substantially sized and suited the couple's more informal transatlantic lifestyle.

Mrs. Harrison was scornful of the Crippens' arrangements upstairs as well. On the second floor were the principal bedrooms, furnished with neat rugs, heavy mahogany furniture, chests of drawers and overstuffed chairs. Belle had taken two of the three rooms on this floor: one as her own bedroom, as it was not uncommon for married couples to sleep separately if they could afford the additional space, and a second one which she used as her dressing room and filled with her extensive wardrobe. On the third floor there were a further three empty bedrooms, as well as a bathroom. At a later date, perhaps to be nearer to the convenience of the lavatory, the Crippens would move their bedrooms up a flight.

The author Filson Young suggested that Crippen let his wife have a free hand in furnishing and decorating their new home. As a result, Belle splashed her "florid taste" across the rooms.[9] Young liked to think she painted the interiors pink, which Mrs. Crippen was said to believe was a lucky color. If she had, none of their many visitors ever thought it outlandish enough to pass comment.[10] Quite the contrary, those who actually saw the Crippens' choice of furniture and decor judged it to be unremarkable, somewhat old and lacking in "fancy pieces."[11] Belle lined her mantels and shelves with china knick-knacks and the couple possessed eighty-nine pictures and prints: many watercolors and a few oil paintings. She kept a crucifix on her wall (presumably in her bedroom) and she served tea from a

service on which the letter "C" was incorporated into the design. Crippen possessed a brass anniversary clock that ticked away in the parlor, and in an effort to add an air of formality to the room, they purchased an eighteenth-century fauteuil chair, which in American homes was a hallmark of gentility.[12] Ethel, when finally given the opportunity to inspect the Crippens' home, sniffed that "the house was . . . furnished in a higgledy-piggledy way" and that "There was scarcely anything that matched."[13]

The Crippens' move to Hilldrop Crescent was their first genuine attempt to put down roots and settle into married life. It helped to wash their situation with a veneer of stability. Although the couple held a joint savings account at the Charing Cross Bank into which they made regular deposits, and Belle (unbeknown to her husband) had cleverly stashed some money of her own in a Post Office account, the Crippens' financial circumstances were never solid. There would always be an anticipation of rainy days to come. The simple solution to this was to invest in jewelry, whose value was unlikely to diminish and could be turned into ready, portable cash in an instant.

Both Crippens owned and wore diamonds, though a wealthy man intent on displaying his success would traditionally make a show of lavishing them on his wife. Like the fictional Pooters, the Crippens were also obsessively status conscious, but in a manner that was regarded as distinctly American and brazenly materialistic. It made Adeline Harrison bristle with envy and disgust. To her it seemed that the doctor was awarding his wife "some handsome jewel" every week. She watched agog as Belle trotted about town, her purse "always stuffed full of banknotes." Harrison called her friend's "craze for accumulating quantities of jewels" both "strange" and "abnormal." It "knew no limit," she said, and her husband did nothing to curtail it.[14] Belle valued her collection immensely and "would babble to her diamonds and kiss them." She also guarded them fiercely, refusing to keep them in the house and instead committing them to the vaults of the Chancery Lane Safe Deposit, a high-security facility. According to her sister Louise, Belle did not

trust her scheming husband to be left alone with her treasure. Before special occasions she visited the safe and removed only the pieces she intended to wear, transporting them home in a leather washbag which she secreted inside her bodice.[15] To a woman married to an unreliable man, her jewelry was her security and offered her the prospect of financial self-sufficiency. At a time when women could not hold a current account in their own name or a mortgage in their own right, this sort of hoarding and worship of one's jewels was not as unusual as Adeline seemed to pretend.

Belle had many passions with which she attempted to fill her life. The accumulation of jewelry was one, and fashion was another. Ironically, Adeline Harrison, who wrote a fashion column for the *Music Hall and Theatre Review*, was deeply scornful of her friend's devotion to attire. According to her descriptions, 39 Hilldrop Crescent seemed to burst with Belle's "gigantic wardrobe." Her "gowns, mantles, hats, furs, laces, rolls of silks and satins, unmade robes in dozens" overflowed the two rooms she allocated to her collection. She claimed that "every room of the house," including the kitchen, contained "boxes and piles of gowns." Adeline recalled indignantly that on one occasion she had even found "a twenty-guinea dress thrown carelessly across the dresser, side by side with edibles and crockery." From what she could see, Belle's husband said and did nothing to chasten her. If anything, he encouraged her continued indulgence. Mrs. Harrison quietly steamed with jealousy as she followed her friend around "the well-known West End shops" and Belle "purchased endless yards of silks, laces, satins, [and] embroideries." Crippen spoiled her, she remarked tartly. Shortly before Adeline fell out with Belle, she proudly showed her "a new ermine and guipure coat, for which the doctor had paid £85." The husband, she remarked, merely looked on and "smiled blandly" at his wife's childish delight.[16]

There were few things about Belle and her manner of living which did not make Adeline smolder with envy and disapproval. After convincing her so-called friend to make her home in her neighborhood, Mrs. Harrison took every opportunity to judge and

condemn her. Nothing Belle did was clean, polite or in any way acceptable. It horrified Adeline that, for one who occupied such a large house, Belle refused to hire any servants.[17] The 1901 census for Hilldrop Crescent shows that most homes on the road had at least one, if not two live-in staff—generally a housemaid and cook. Instead, Mrs. Crippen insisted on running her home with the assistance of a "daily," or a charwoman, who would come in to do the unpleasant, grimy, heavy work: the scrubbing and washing. Belle's "char," Rhoda Ray, would arrive at 8:30 a.m. and often stay as late as eleven at night but went home at the end of her shift.[18] Belle was too parsimonious and selfish to offer a full servant's wage. She would rather spend money on fripperies than a tidy home, Adeline concluded. She was equally outraged by her friend's penny-pinching when it came to provisions. After spending a day traipsing about the West End with Belle, buying expensive dressmaking fabrics, she would follow her down to the local high street, to the greengrocer and to "the cheapest shops for meat."[19] Belle brought her own cloth bag for grocery shopping, which she swung between her bejeweled fingers. It was unseemly, uncouth, embarrassing. Any respectable middle-class housewife would have sent her servant to do her shopping or ordered her deliveries to her door. That which Mrs. Harrison failed to see was that Belle's habits accorded more with those of American vaudevillians than with the British middle class. In New York, such "economy and simplicity" were considered "the accepted lifestyle" for performers, regardless of an artiste's wealth or fame. Commentators remarked that "even the most spangled women, who look on the stage as if they never lifted a finger for housekeeping" did their own "sewing of socks and mending of buttonholes . . ." "Vaudeville folk" were known for their "thrift" and were more interested in growing their own vegetables than in luxurious living.[20]

At times Adeline Harrison claimed to find Belle's character so tarnished and the inside of 39 Hilldrop Crescent so untidy and disgusting that it is a wonder their friendship endured for as long as it did. She publicly denounced Belle for being slovenly, lazy and dirty,

some of the worst insults an Edwardian woman could sling at a sister. The house was always stuffy because she claimed Belle "disliked fresh air and open windows" and Adeline seemed to delight in relating a scene of squalor which she once discovered in the Crippens' kitchen. Across a dresser was strewn . . .

. . . a heterogenous mass, consisting of dirty crockery, edibles, collars of the Doctor's, false curls of her own, hair-pins, brushes, letters, a gold-jeweled purse and other articles. The kitchener and gas stove were brown with rust and cooking stains. The table was littered with packages, saucepans, dirty knives, plates, flat-irons, a washing basin and a coffee pot.[21]

Of course, no one but Adeline was ever privy to such a wretched spectacle because Mrs. Crippen was certain to clear it all away when she received friends. "The whole scene changed" and Belle laid her table with a lace-bordered cloth, "dainty serviettes, gleaming silver and expensive flowers."[22]

When Crippen took the lease on 39 Hilldrop Crescent, a deal seems to have been struck between him and his spouse. If Belle wanted a respectable Edwardian home life, she must play the respectable Edwardian wife. This would mean giving up her music hall career. It was not an unusual request. Many female variety artistes, including Belle's friend Lottie Albert, who became Lottie Osborn, retired after marriage. Without the stage to fulfill her, the dynamic Belle would have to channel her energy into domesticity and homemaking. Contrary to Mrs. Harrison's assessment of her, Belle was anything but lazy. The lengths of fabric Belle regularly purchased were for her own dressmaking endeavors. Not only was she an accomplished seamstress, but her sister Louise insisted that she made practically all her clothing.[23] When not shopping for or sewing garments, Belle, along with her husband, was engaged in the transformation of the exterior of their home. Neighbors commented that they frequently saw the couple in the garden, toiling in harmony. The scented green haven Belle had sown in her imagina-

tion was slowly brought to life, admired by all who came to the house. Their efforts included a glasshouse filled with delicate plants as well as a freshwater aquarium which Belle tended.[24] Her contented husband dubbed it "the Garden of Eden."[25]

While these projects afforded her a degree of distraction, Belle's deep discontent could never entirely be smoothed over. Without the call of music hall life, her failure to become a mother gnawed at her. Lottie Albert remarked that her sadness about "the absence of children" was perennial; she was never able to overcome it. The three empty bedrooms on the third floor, which had been designed to house a brood of children, must have taunted her, but Belle seemed determined to muffle these reminders and, notwithstanding, to bring life to their home.

The Crippens became devoted pet owners. They had two cats, one black and the other a fluffy white Persian, which, despite being deaf, Crippen "trained to jump like a dog." They had to "knock on the floor" to call him, which is perhaps the reason a cage was built in the garden for when the cats wished to take the air.[26] In another cage indoors, Belle kept seven canaries, and by early 1910, the Crippens had acquired a bull terrier puppy. Mrs. Crippen also had her fish in an outdoor aquarium and, according to a neighbor, a collection of fowl. When fostering animals failed to fill the void and the ache of childlessness returned, Belle turned to her friends with families. They had lots of room, and she regularly entreated them "to let one of their youngsters stay with her for long periods."[27]

To have gone from a life encircled by close and extended family to a half-empty house, an ocean away from her relations, must have been a cause of great loneliness. In London, she had no one beyond Hawley Crippen, and without the music hall, she had no regular community. Eventually, her solution was to create surrogate kin by taking in German lodgers and filling her home with those who reminded her of family.

Among the first of these to arrive in the autumn of 1905 was a German student named Karl Reinisch. As a young man "who wished to enjoy himself in the big city," Reinisch confessed he was

initially skeptical about the conditions that accompanied the offer of board at 39 Hilldrop Crescent. He had been asked not to go out every evening, but rather to "stay in the house for the sake of the company." Belle was upfront with Reinisch about her intention; as the marriage was childless, he was to be a "substitution for off-spring." She wanted someone in the house "who was trustworthy and sociable." The young student later admitted he enjoyed the arrangement. Not only was his landlady "a good housewife" and an excellent cook, but he felt the society of "two cultured people" had a positive influence over him and that their "frequent conversations beside the fire were varied, stimulating and interesting." Although the couple were quite temperamentally different—she "very high-spirited" and he quite "placid"—they were affectionate; her husband let her win at cards and bought her expensive Christmas gifts.[28] Reinisch also sensed that Mrs. Crippen missed her theatrical career, of which she often spoke a great deal.

Another German lodger, Richard Ehrlich, who came to live at the house in December 1906, made similar remarks about Belle's longing for the music hall, though in stronger terms. He claimed she was "inconsolable." She showed him her collection of professional photos in different costumes, acting various roles. She declared "her greatest wish was to return to the stage." She believed in her abilities and spoke candidly "of the disappointment and profound regret she had in her enforced idleness." Like Reinisch, Ehrlich came to understand that Mrs. Crippen didn't take lodgers because the couple needed the money, but "merely for the sake of having people around her." To him, Belle seemed "lonely and worried."[29] Of everyone who had any sort of encounter with the Crippens, it was only Richard Ehrlich who claimed to witness the couple argue:

> She frequently gave way to fits of ill-humor, which caused painful disputes. He, on the contrary, rarely lost his equable temper, even when he was unjustly taken to task. He tried to smooth things over, speaking gently, and let the storm blow over. He must have

had great self-control, for at certain times his lips were white with anger and he shook. He clenched his fist, but he did not raise it. I never heard him use a word of abuse, or saw him make a threat.[30]

The reliability of his somewhat sensationalized account, given as an interview in 1910 to the French publication *Le Petit Parisien*, has sometimes been questioned for its uncertain dates and details. This aside, it is not inconceivable to imagine that there would have been angry eruptions between husband and wife when he had robbed her of the family she so desired as well as the ambitions she had used to staunch those longings.

In the summer of 1906, Belle's 21-year-old half-sister, Louise, sailed to London. If Mrs. Crippen was truly as anguished as Ehrlich described, then it is possible that Louise's visit was intended to mollify her. Belle was overjoyed and wasted no time clearing the house of her substitute family to make room for her real one. She wrote Reinisch a polite note in June that they would be wanting the house to themselves. She had plans "to do a great deal of entertaining," though she also hoped to have him at any weekly receptions while Louise was staying.[31]

Louise's visit proved to be a revealing one for both women. Belle's younger sister had only recently been wed to Robert Mills, an Irish Presbyterian, which would not have been a welcome event in a devout Catholic family. Their married life could not have been going well, as after a short time, Belle asked Louise to move in with her. As two sisters, each in complicated marriages, the women appear to have confided in one another. Belle made it clear to her sister that she didn't trust her husband and claimed that the doctor "often threatened her." There were times when "she was afraid to stay at Hilldrop Crescent alone" with him.[32] Louise also came to the conclusion (perhaps with hindsight) that her brother-in-law was an addict and thought that most of the drugs he purchased were "consumed by himself."[33] Although she would later attest that the couple seemed to get on perfectly well together, her stay was not a

comfortable one. On the occasions when Belle was not present, she found herself subjected to his unwanted attention.[34] Mrs. Mills returned to New York on September 7, in spite of Belle's entreaties that she remain.

Louise was not impressed by Dr. Crippen, or at least she came to dislike him more with closer acquaintance and the passage of time. She objected to the notion that Crippen was in any way put upon by her sister. Mrs. Harrison would later suggest that Belle bullied her husband into managing many of the domestic chores: "he had to rise at six o'clock in the morning to clean the boarders' boots, shovel up the coal, lay the breakfast, and help generally."[35] This was utter nonsense, stated Louise, who had witnessed the household management for herself. "Crippen . . . never cleaned anyone's boots, neither did he work in the kitchen, his wife always cooked our breakfast, and his dinner was served regular." Crippen may have been eager to please his wife and to comply with her wishes on some matters; he converted to Catholicism after their move to Hilldrop Crescent, but this was a performance enacted to keep the peace. When not at home, nothing hindered Hawley Crippen from doing precisely what he wanted. Louise stated that by 1906 Belle already knew "he was intimate with his typist." He was never "the little abused husband."[36]

Petty Rat Swindlers

W HILE HAWLEY CRIPPEN WAS preoccupied with the se-
duction of his typist, the Drouet Institute, which paid for
their oysters and champagne at Frascati's, was under assault.

Over the years, the crusading *Truth* magazine, known for its ex-
posure of fraudulent companies, had been doggedly pursuing the
business. Journalist and MP Henry Labouchère was determined to
take them down and had been publishing weekly updates about the
progress of his endeavors. In one of these articles, he denounced
Drouet's senior consulting physician, Dr. Hanna Nasif Dakhyl, as "a
quack of the rankest species."[1] This sparked a lengthy libel suit in
1904 which rumbled on for three years. Crippen was cited in one of
the trials, along with Carré, for using the Institute's literature to
make false promises of guaranteed cures. In the course of the pro-
ceedings the business was denounced as "a disgraceful institution
carried on for unworthy objects by discreditable means," and Da-
khyl was indeed judged to be a "quack." If this alone hadn't spelled
the end for the Drouet Institute, the news that a mail-order patient
had died after self-administering one of their guaranteed cures cer-
tainly helped to seal their letterbox for good.[2]

Sensing their impending demise, Messrs Derry, Carré and Crip-
pen pre-emptively created the Dean Drug Company in 1903, which
allowed the Drouet Institute to spring to life again under a new
name. By the following year, this enterprise was being run exclu-
sively by H. H. Crippen, with assistance from Ethel Le Neve, Wil-
liam Long and a new partner-in-crime, Mr. Edward Marr, aka

Professor G. Keith-Harvey; Erasmus Colman; Scott Hamilton; Max Dana; and Elmer Shirley. Eddie Marr, under his numerous aliases, was considered one of the most prolific and slippery fraudsters of his age. Under an assortment of names and addresses Marr ran a veritable pharmacy of sham products which included Sanalak, a vitality-restoring tonic; Professor Tissandier's remedy for rheumatism and gout; a catarrh cure; as well as an "aural battery"; an "aural pencil"; a nasal douche; and a lotion for hearing loss. For a time, Marr also dabbled in serious financial fraud, fronting a phony stock- and share-dealing company called Arnold and Butler, which deceived hundreds of small investors, including a group of miners whose entire life savings were lost.[3]

Crippen was introduced to Edward Marr by another equally shady character, a fellow American, William E. Scott, a self-professed "advertising man," who, like Marr, made money from a variety of rackets, including the sale of patent medicines. When the Drouet Institute went under, Scott negotiated the purchase of the 400,000-name mailing list of potential dupes from Crippen and sold it on to Arnold and Butler. As with the Drouet Institute, their targets were always the desperate, the ill-educated, the barely financially solvent, the sick and the hopeful. Scott's moral compass was as fractured as Marr's. For a number of years, he ran the Symonds' London Stores contest, in which readers of his adverts were encouraged to fill in the missing words to famous proverbs (such as "H----y is the best policy") in order to win a prize. Scott proclaimed he had 1,000 bicycles worth £10 10s. each to give away to those who got correct answers. All they had to do was send Symonds' London Stores 2s. 6d. as their entry fee. As might be expected, no one ever received their bicycles. The judge who heard the case estimated that as many as 18,000 people had been defrauded. He had received letters from 300 individuals—mostly those of the working class—farm workers, grooms, apprentice carpenters, a sixteen-year-old typist—all of whom had lost their earnings. A widow with eight children wrote to say she had planned to sell the bicycle to feed her family. Instead, in 1905, William Scott stole their money and fled to France.

He later moved on to Germany, where he set up a similar scam while also hawking Edward Marr's nostrums, before he was arrested in Berlin.

If Crippen had learned the secrets of peddling patent medicines from Munyon, then Edward Marr and William Scott schooled him in criminal agility, how to dodge and duck liability, how to rebrand, and how to operate several simultaneous fiddles from different addresses. These men had become his role models. They were his associates, his counselors, the company he kept.

When the Drouet Institute collapsed, it was to Edward Marr that he turned. Marr's network of schemes, his numerous offices dotted around London—Holborn, Clerkenwell, Marylebone—as well as his villainous wisdom and ability to just about tiptoe along the right side of the law, must have inspired the doctor. After the Drouet Institute refashioned itself into the Dean Drug Company, it was dissolved and reinvented again as the Aural Clinic Ltd. This new concern, too, only lasted six months, but by then, Crippen had already begun to sow the seeds of what he must have envisioned as his own Marr-like empire. The trick, it seemed, was never to tie oneself to any single business exclusively, but to always have multiple irons heating over various fires.

One of these irons was familiar: Munyon's. Now that they were operating as a more streamlined outfit, Crippen returned to managing their office and their advertising at 272 Oxford Circus. At the same time, in 1905, he created a new business and an alias of his own; he became the German doctor M. Franckel, manufacturer of a wondrous cure for deafness: Ohrsorb.

In concept, Ohrsorb ointment bore an uncanny resemblance to a Drouet Institute ear plaster. According to its newspaper promotion, the "Barron Mackamotzki" had discovered its restorative properties, and advised for it to be rubbed behind the ears. When the British Medical Association analyzed the compound, they found it to be "70% Vaseline, about 4% of beeswax, a little soap . . . a little saponifiable fat, and about 8% of a cheap drug containing sulfur."[4] These

were sold at 4s. 6d. per tube. For that same price, one could also buy a "specially prepared Catarrh tonic," and "Nazaseptic" for the nose and throat.

The person who almost certainly taught Crippen how to tend his sapling swindles was another associate, who in 1905 went by the name of F. Sinclair Kennedy. Of all Crippen's questionable partners, Kennedy appears to have been the most menacing. Just out of Edinburgh Medical School in 1896, he went to prison for defrauding a series of unmarried women in an attempt to raise capital for his bogus American and Parisian Massage Company.[5] His technique for extracting the funds involved not only lying, but coercion and threatening behavior—suddenly appearing at his victims' homes, raising his voice and making a scene, then intimidating his captives to sign over their assets. He was on several occasions reported in the newspaper for aggressive drunken behavior, for harassing his estranged wife and for kicking down her door.[6] In 1902, after disappearing to New Zealand for a spell, he re-emerged in London, where he attempted to establish a fraudulent dental practice providing low-cost dentures and dental treatment for "the industrial poor," who were forced to agree to ruinously high-interest finance agreements. In 1904, the whistle was blown on his ruse and Kennedy and his partner were fined.[7]

F. Sinclair Kennedy, with his smashed right cheekbone and scarred forehead, cut a sinister figure. He also proved to be a relentless, one-man fraud factory, compulsively cooking up exploitative scams which he ran from addresses throughout London. His other game was running what would later be known as Ponzi schemes, where investors were guaranteed tremendous returns that never materialized, while he and a small handful of financiers pocketed their money. In 1906 he took over the Harvard Institute, also known as "Harvard's Teeth," at 272 Oxford Circus, just above (or below) the offices of Munyon's, on the busy interchange between Oxford Street and Regent Street. It is here where he was likely to have met Crippen, a kindred spirit.

By peculiar coincidence, Forrester Kennedy, as he had been christened, was born and grew up in Diss. Although he was older than Ethel, the Neaves and the Kennedys attended the same church, and it is likely that the Neaves had at least a passing knowledge of the family. It may even have been Ethel who, one day while climbing the stairs to Munyon's, recognized Kennedy and made the introduction to Crippen. However it occurred, Crippen and Kennedy were able to acknowledge in one another a partiality for fraud which contributed to the formation of yet another dishonest endeavor: the Chemical Blood Manufacturing Company.[8]

Kennedy, with the help of Crippen, who had been signed up as a co-director of the limited company, ran this like his other swindles. Prospectus literature was drafted, quite probably by Crippen, who had practice in such operations, and the usual extravagant claims were made. Their adverts declared that an Edinburgh-based chemist had discovered a permanent cure for blood disorders, which also included gout, rheumatism and acne. It was heralded as the "Greatest discovery of the twentieth-century!" Interested parties were encouraged to make their investments early, while it was still possible to purchase shares for £1.[9] There is no evidence that a single bottle of this miracle remedy was ever produced, or that the Chemical Blood Manufacturing Company intended to manufacture anything beyond an illicit fortune for themselves. With the assistance of newspaper advertising and a crooked firm of stockbrokers who helped to sell the shares, Kennedy, Crippen and their associates began to channel investors' money into their own bank accounts.

Along with the names of Hawley Harvey Crippen and F. Sinclair Kennedy, the Chemical Blood Manufacturing Company's list of nine initial shareholders reads like a roll-call of Edwardian criminality. Among those who chose to back the scheme were Arthur Sale, who went to prison for fraud in 1908, and Granville Hawley Egerton Cooke, who did several stints behind bars for theft and fraud before killing his business partner and himself in 1925.[10] Also making an appearance among this catalog of conmen and killers is Marion Louisa Curnow, the bookkeeper who helped to manage the

Munyon accounts for Crippen. Alongside Ethel and William Long, she was to become one of Crippen's most loyal and trusted employees.

Hawley Crippen was a canny and sharp observer. Many commented on his quiet demeanor, that he said little, that he was more of a listener than a conversationalist. He was calculating. He followed the maneuvers of the men around him and learned from them, imitating their shrewd moves, while carefully side-stepping their mistakes. Although his name appeared several times in *Truth* and *Albion* magazines, and he was cited publicly in at least two trials, unlike Kennedy, Scott and many others within his circle, he managed to escape prosecution for fraud. From his Munyon's office, Crippen will have watched Kennedy cream money from his dubious Harvard's Teeth business. He would have listened to Kennedy talk about the enormous market for dentistry and the sums to be had from it. He would have ruminated over this, before embarking in 1908 on his own dentistry venture.

In December of that year, Crippen entered into a business arrangement with a New Zealand trained dentist, Gilbert Rylance. Rylance recalled they had met during the Kaiser's visit to London in November 1907 while they both watched the royal procession from their office windows. Crippen wasted no time in pursuing Rylance, offering to become his "business agent."[11] The arrangement would be that he performed the dentistry, while Crippen stumped up the initial £200 investment and assumed the role of financier.[12] It is unclear if the "financing" Rylance referred to was of the sort pushed by Kennedy, who employed the dentists while managing the grubby loan deals and debt collecting separately. However, as Crippen chose to name his business the Yale Tooth Specialists, the homage he was paying to Kennedy's model seems obvious.

Crippen also found a new base for his operations: Albion House, at 59–61 New Oxford Street, a turret-topped, red-brick commercial block, with broad-windowed showrooms on street level selling pianos and automobiles. As one ascended through its six floors, its businesses became more varied in character. In addition to a dealer in

blankets and a maker of gentlemen's suits, Albion House was also the address of Maud West, a "lady detective," and Professor Horspool's Vocal Academy. In between these nested betting agents and fly-by-night stock and share dealers, as well as numerous quack companies. Albion House was an ideal location for Crippen to consolidate all his interests under one roof. While the Yale Tooth Specialists occupied one office, Munyon's was moved into number 61, an adjacent room down the corridor. From yet another office on the premises (number 57), he operated his M. Franckel enterprise. By now, he had also set himself up as the Imperial Press Agency, which enabled him to strike deals with various newspapers for the promotion of fraudulent products, while skimming a profit with the artificially inflated fees he would charge Munyon's, Edward Marr and the other companies he represented.

According to William Long, Marion Curnow and Gilbert Rylance, the doctor divided his time between "compounding medicines," very occasionally seeing patients, pursuing advertising opportunities, running about and meeting with people, visiting banks and collecting money. No one ever completely ascertained from where he derived the majority of his income, or what exactly it was that he did. He earned £3 a week from Munyon's.[13] A year later, when Crippen and Marr relaunched the Drouet Institute scam as the Aural Remedies Company, Marr paid him a weekly salary of £2, and guessed that, in total, the doctor was earning roughly £10 a week from all of his ventures.[14] Five hundred and twenty pounds a year was a modest middle-class income, and as Edward Marr hinted, not nearly enough to subsidize the bohemian party-going lifestyle Crippen and Belle were enjoying, in addition to funding Ethel's entertainment on the side. However, Marr was unlikely to have known the complete details of the doctor's finances, or indeed how many other interests and money-generating schemes he was quietly cultivating in the shadows.

Crippen thrived on risk. He was a speculator, a gamester, and did not care how he raised an income, so long as it lined his pockets. William Scott described him as "something of a gambler," who in

spite of losing significant sums at the "English races," was "always able to make money."[15] Similarly, the entertainment journalist William Buchanan-Taylor's introduction to H. H. Crippen was at the gaming tables of the Vaudeville Club, where it was the doctor's custom to go "in the afternoons and evenings to play cards, chiefly poker."[16] When not studying his hand in a gentleman's club, or placing wagers on horses, Crippen was a "habitual customer" at his local public houses, the Lord Stanley and the Brecknock Arms, where he could be found in the billiards room between 8 and 9 p.m.[17] Money came and went, but Crippen seemed to possess a sharply honed talent for materializing it when it was needed. "From what I know of the man and his connections," Scott once said of his business companion, "he will be kept well supplied with money, wherever he is."[18]

As Hawley Harvey Crippen descended deeper into the shadowy world of white-collar criminality, so Ethel willingly followed him. What had begun as a well-paid job opportunity at the Drouet Institute would become a gradual indoctrination in the customs and practices of corrupt commerce. She would not have been ignorant of the verdict of *Dakhyl v Labouchère*, which condemned the Drouet Institute and those involved in its endeavors as quacks. She would have known that the use of Drouet's products had resulted in a death. She would also have understood that Munyon's Remedies was similarly crooked. From the offices at Regent's Park Road, to 272 Oxford Circus and then to his hive of scams at Albion House, Ethel's role in operations remained constant: to assist her employer in the execution of his schemes. Not only was she privy to his machinations and read his daily correspondence, but Crippen had imparted the formulae for his assorted potions to her, which she on occasion manufactured. His letters to her reveal that over the years he had schooled her in the fundamentals of running a successful patent medicine scam. So confident was he of her ability to manage their "method" that he believed she might even prosper in his absence.[19] According to her father, Ethel became Crippen's "right hand." She managed his accounts and the banking for his assorted

interests, and it was down to her particularly persuasive manner and "diplomatic hints" that they were able to put "scores of pounds into the coffers."[20]

Such intimate involvement of a wife or mistress (many of whom had begun as a secretary) in the schemes of a conman was not unusual. Unlawful or barely legal operations strung together with carefully stitched strategies could bind parties in secrecy and deviance. Among Crippen's own circle, Forrester Kennedy's wife assisted her husband in his swindles by helping to reel in female victims, while William Scott's wife served as his secretary, managing his fraudulent US concerns.[21] In the early days of his association with Munyon, even Belle was believed to have lent a hand by "acting as cashier" to her husband. But Ethel was far more emotionally invested in her employer's enterprises than Belle, with her independent career on the stage, would ever be.

In 1904, Ethel, now in her early twenties, was still living at home, assisting her ailing mother and tending to her younger siblings when she returned from work. Crippen would describe it as a terrible life, where she was endlessly burdened and money was tight.[22] Ethel had watched Nina become a bride with her own home and then, in that year, a mother to a son, Ronald. While Ethel had always maintained secrets, sneaking out to dances and hiding billets-doux from her prying family, her relationship with her employer encouraged her to withdraw further behind a veil of secrecy and invented stories.

It is uncertain how much her family truly understood about her working life and the hours she spent with Crippen. Her father claimed that the doctor was "concerned in so many enterprises," many of which involved socializing, that the nature of his work and Ethel's involvement with it began to elude him. At times, what precisely Ethel was telling her parents seems fanciful. Walter was under the impression that Crippen acted as a dentist at the Yale Tooth Specialists. His daughter told him that her job was to hold the hands of nervous patients while he undertook extractions. Ethel herself had had twenty of her own teeth extracted. The reason for this is

unclear, but Crippen seems to have had some influence in the decision. According to Walter Neave, the doctor had presented her with "a beautiful set of false teeth" which her father believed was to advertise the business.[23] Knowing what she did about the nature of Crippen's scams and the misleading claims they both made about the products they sold, Ethel seemed to possess an unwavering devotion to him.

It is not surprising that their relationship eventually became a sexual one. In his correspondence to her, Crippen suggests that the decision to consummate their affair had been mutual, that "hub," as he came to call himself, and "wifie," as he referred to her, "earnestly felt it was impossible to live on and not be able to be all in all to each other."[24] Certainly, on Ethel's part, this would not have been entered into lightly. While many of the era's writers, artists and thinkers, from Tolstoy to H. G. Wells and Havelock Ellis, discussed and openly promoted notions of "free love," the majority of society, and the middle and working classes in particular, found the notion of the sexually liberated woman abhorrent and sinful. As it took Crippen roughly two and a half years from the time of their first clandestine date to persuade "wifie" into bed with him, Ethel obviously had her reservations.

In an era before the invention of reliable or widely available contraception, the stakes of entering into an illicit sexual relationship with a man who was not free to marry were perilously high for a single woman. Although the cervical cap became more popular in the late nineteenth century, gaining access to birth control unless a woman was educated about the subject was difficult, and doubly challenging if she was not married. Even then, it is estimated that only 16 percent of couples in England before 1910 used any "mechanical means of contraception."[25] Ethel would have required a good deal of persuasion and reassurance from Crippen that he would not allow her to suffer the consequences of an illegitimate pregnancy and the shame, dishonor and loss of income this would have brought to her and the aspirational Neaves. According to Nina, Crippen had promised Ethel that he would marry her. He was only waiting for

Belle to run off with Bruce Miller, whose letters to his wife he had shown Ethel. They were unhappily married and it was only a matter of time before she absconded and they could get a divorce.[26] It was certain to happen soon, he assured her, since Belle was always threatening to leave him. Although there is no proof that Belle had any intention of the sort, and Bruce Miller had not seen her for more than two years, this persistent imploring, along with other sweetly worded guarantees, succeeded in procuring the desired outcome. On December 6, 1906, Crippen booked a hotel room and the couple designated this as their "wedding day."

Ethel would have had a complicated time disguising her clandestine courtship from her family, even before it had become a full-blown affair, but now her nocturnal activities would have required the weaving of even more elaborate stories. The only way to avoid the close scrutiny of her parents was to remove herself entirely from the family home. In 1906, she went to live with Nina and Horace, which would have afforded her a degree of privacy. As the sisters had remained devotedly close, even after Nina's marriage, it is likely Mrs. Brock understood more about Ethel's situation than she would later be willing to confess. As the inveterate keeper of secrets, Nina would always be sympathetic to Ethel's troubles and what she would call "her unfortunate love affair."[27]

Later Nina would suggest that she "didn't know that any improper relations existed" between Crippen and her sister, in spite of her very late hours and absences from home.[28] While the doctor maintained that he and Ethel were very discreet in their lovemaking, only meeting at hotels and never spending entire nights together, this was not strictly true; they also had a love nest. For a time, Crippen rented an address at the old Hyams & Co. draper's building, at 80–83 Wells Street, from which to run his Franckel business. Located just off the shopping thoroughfare of Oxford Street, the area was known for its transient population of European garment and restaurant workers. The neighborhood's old buildings, which were divided and sublet, were mostly occupied by tenants

who spoke little English, and this provided a certain anonymity for those seeking a base for dubious activities. Crippen had initially used 82 Wells Street just for correspondence, but soon saw the advantages of such an inconspicuous premises and rented a two-room office next door which came with a bed. The landlord claimed that it was not unusual for him to hear stirring in Crippen's room as late as 1 a.m., and on occasion he would meet with a young woman coming down the stairs from the bedroom.[29]

Although Ethel's overnight stays may have failed to raise questions with Nina, it is difficult to understand how, in the early summer of 1907, Ethel managed to conceal a holiday with Crippen to Boulogne. According to William Scott, who had come to France to discuss "advertising" with the doctor, the couple were ensconced at a quiet country inn, three miles outside of town.[30] Scott believed that Crippen had come abroad to lie low after there had been "some trouble in London." It was here that he was introduced to Ethel Le Neve, "a Cockney girl" with "heavy brown hair" and "dark, snapping eyes," whom he described as "unusually pretty." From what he could tell, Hawley Crippen was "head over heels in love with her" and Ethel appeared to reciprocate. But Scott was taken by something else too. The young woman, he said, was "fascinating." "She knew how to talk," commented the professional charmer. Either Crippen or Ethel boasted that she "often passed as a French girl." "She spoke French perfectly," Scott marveled, though Crippen would later state that Ethel spoke hardly any French. More audacious still, Ethel would claim that "she had been educated by the nuns of a convent in Dijon."[31] Was she playing a game with William Scott? Were she and Crippen teasing him, testing how far their outlandish stories could stretch? Was Ethel a fantasist? Or, like her lover, was she just an extremely adept liar?

Ethel and Crippen had woven themselves together as a pair of fraudsters. Invariably, those who perpetually play with the truth, who trim it, conceal it, restitch it to suit their immediate purposes, lose sight of its threads. All the lies soon become knotted around

one another. Hawley Crippen had been lying to Ethel. Ethel had been lying to her family. She had also been lying to herself, in the mistaken conviction that Belle would one day leave, that her lover would one day marry her, and that it was likely to happen at any time, soon. They only needed to be patient, he told her. But in the late spring of 1908, Ethel could no longer afford to be patient. She was pregnant.

80 Constantine Road

S OME TIME AT THE end of the summer in 1908, Mrs. Emily Jackson placed an advert in the local newspaper. She was hoping to find a lodger to fill one of her upstairs rooms. Her modest-sized home in Hampstead lay on Constantine Road, a lower-middle-class street that snaked along the southern edge of the Heath. At the top of the road, in South End Green, was the tram terminus which, during the week, ferried the area's residents: the clerks, restaurant managers and bookkeepers into town, and on weekends transported the day trippers with their kites, parasols and picnics to the Heath. It was a perfect location for a single professional: a medical student or a typist.

In September, a young woman in her mid-twenties came to inquire about the advertisement. As it happened, she was a local girl who had grown up in Hampstead and whose family lived nearby. She worked at an office in Holborn, employed by a doctor who provided a glowing character reference. Mrs. Jackson found her to be "gentle, retiring and sympathetic." She liked the young lady very much and agreed to let the room to her for 7 shillings per week, which included breakfast and supper.

Each morning, Emily Jackson's new lodger would take her breakfast in the kitchen. Sharply dressed, with her hair piled high under her hat, she would then depart for New Oxford Street at 10 a.m. She returned each evening, sometime between 6 and 7 p.m., and together with Mrs. Jackson and her husband Robert, who was a traveling mineral-water salesman, sat down to a hot meal. Emily grew

so fond of her lodger, Ethel, that in the evenings, after she had put her two small boys to bed, she would join Ethel upstairs in her bedroom for cozy chats. A genuine bond formed between the two women, and Ethel was soon referring to Emily as "Ma" or "Mum." Given Mrs. Jackson's favorable impression of her lodger, she was taken aback by what occurred scarcely two weeks after Ethel moved in.

One day, the young woman began to experience severe abdominal pain. She had been back and forth to the lavatory before retiring to her bed in distress. When Mrs. Jackson asked her lodger what might be done for her, Ethel gave her the details of a specialist in women's medicine. It was the phone number of Dr. Ethel Vernon, one of the most highly regarded female physicians in Britain, whom Hawley Crippen had instructed Miss. Le Neve to contact. Dr. Vernon was not local and would have come at considerable expense from her office in Westminster, but Crippen had undoubtedly foreseen this. It did not take long for Dr. Vernon to apprehend the situation—Miss. Le Neve was having a miscarriage. She had been pregnant for four months.

Emily Jackson, stunned, stood by as Dr. Vernon questioned her lodger closely. Such a situation was scandalous—the young single woman would certainly have known of her "condition" when she rented the room, but equally concerning would have been the position in which Ethel had placed the Jacksons. A "miscarriage" under these circumstances was likely to have been suspected as an induced one, and as abortion remained unlawful in Britain, both Mrs. Jackson and Dr. Vernon might find themselves implicated if Ethel were to die. Although her patient was distressed, the doctor pressed her for answers, asking her repeatedly about the whereabouts of the baby. At first Ethel claimed she did not know, but eventually she admitted that she "had been to the lavatory and while there felt something come from her." Both the physician and the landlady then inquired after the father's name, but despite numerous attempts to coax it out of her, Ethel remained determinedly tight-lipped.[1] After the initial drama subsided, Mrs. Jackson's unfortunate

lodger would remain confined to her bed for the next two weeks. In the days that followed the event, a short man with a gingery mustache came to the door, inquiring after Ethel. He handed Emily Jackson his business card and explained that he was Dr. Crippen, the young woman's employer. Mrs. Jackson showed him upstairs to Ethel's room, where he "only stayed a few minutes" before departing.[2] The following week, he appeared again, and once more stayed only briefly. Although Ethel shared many confidences with her landlady, she never made mention of these mysterious visits. It was only later that Emily arranged the pieces in her mind.

Not a word was spoken of Ethel's "miscarriage." Ethel had been fortunate to find a compassionate landlady in Mrs. Jackson. Many less understanding Edwardians would not have suffered a "fallen woman" to have lived alongside their young children. However, while Emily was willing to overlook Ethel's transgressions, her husband Robert would not be as forgiving.

Although the Jacksons were privy to Ethel's secret, it appears she managed to keep her pregnancy successfully hidden from her parents. At the time of the conception, she was back in the family home, at 34 Willow Road, part of a row of workers' cottages, overlooked by the red-brick Hampstead houses of the wealthy. It is difficult to fathom Ethel's thoughts upon the discovery of her pregnancy while living in a cramped home under the gaze of her mother and father. However, if she had convinced herself that this would be the definitive incident which prompted her lover to leave his wife, she was to be gravely disappointed.

The use of contraception had most likely avoided this situation from arising earlier in Crippen and Ethel's eighteen-month-long sexual relationship. As Belle had learned at the beginning of her marriage, Hawley Crippen was no lover of children. Not only had he taken pains to ensure that his second wife never bore them any, but he abjured any responsibility for the upbringing of his only child from his first marriage. By 1908, it had been ten years since he had last seen Otto,[3] and Crippen was certainly in no mind to welcome an illegitimate child into his life, with all of the extra expense

and hassle, and the additional lies and cover-ups that would have been required. With his expertise in gynecology and obstetrics, prevention of such a misfortune would have seemed simple enough. The pair might have made use of any number of methods available in the early twentieth century, from a cervical cap and douches concocted from quinine and boric acid to condoms made from animal intestines, as well as the practice preferred by many married couples, coitus interruptus. But, as Ethel was to discover, none of these was failsafe.

Whatever Ethel had been led to believe, or had convinced herself, as summer faded into autumn, she and Crippen were confronted with an urgent situation. The doctor was not in a position to leave Belle or procure a divorce, and certainly not on the grounds of his wife's alleged adultery. Any claim would be quashed in the face of Crippen's own misdemeanors, of which there would now be ample proof in the shape of his pregnant mistress. Neither could Crippen have afforded to support Ethel and a child. To complicate matters further, her "maternal condition" would soon make it impossible to employ her. Pregnant women, especially those without husbands, would never have been tolerated in the Edwardian office workplace. Quite simply, the child Ethel carried could not be born.

When faced with such a situation, many women opted to take matters into their own hands. In 1908 it was widely held that a pregnancy was not viable before the end of the first trimester or until a woman felt the "quickening" of the fetus moving within her. Inside that window of time, it was acceptable to "bring down the menses" by taking "remedies" and "cures." Some of these concoctions involved ingesting herbs such as pennyroyal, or boiling coins and nails and then drinking the water. If a woman had the financial means, she could purchase any number of patent medicines advertised in the newspapers such as "Widow Welch's Female Pills" and "Towle's Pills for Ladies," which promised to cure "anemia, bloodlessness and all ailments of the female system," and to "restore regularity." Most of these "cures" contained toxic substances such as aloes, iron, quinine, borax and lead, which were not unknown to

cause death among those who took them. If these tablets proved ineffective in bringing on a miscarriage, a surgical abortion could be attempted with what newspapers often called "an implement": a knitting needle, a skewer or occasionally a piece of slippery elm bark which contained properties that helped to gradually open the cervix after insertion. For those of the middle classes and above, certain "medicines" might quietly be prescribed by doctors. Apiol (extract of parsley) and quinine were considered the most effective abortifacients by the medical profession, and "Apioline" was even advertised in *The Lancet*.[4]

While these methods of abortion were by no means safe, the majority of women who opted to "induce a miscarriage" were able to do so discreetly and without ever encountering the law. It was only when circumstances took a turn for the worse, when a woman died or became seriously ill and required a doctor, as did Ethel, that a crime might be exposed. Physicians like Dr. Vernon would have been accustomed to attending women in Ethel's position, writhing in pain or hemorrhaging blood, and understood what information it was necessary to seek in order to treat them or to make someone accountable in the event of their death.[5] Ethel's reticence in naming the father of her child might have had as much to do with protecting Crippen from the law as it did with safeguarding their relationship.

It had been more than four years since Ethel had become entangled with Crippen, a man who repeatedly promised her marriage, and yet whose assurances had never manifested. Ethel was approaching her twenty-sixth birthday, a time by which most women would have been married and raising children. Instead she had ended her pregnancy and was still waiting: waiting for Belle to run off with her lover; waiting for a divorce; waiting to have a home and family of her own. Ethel had been quiet and patient, but this did not mean she was content to be so.

As early as 1906, around the time she and Crippen had begun their sexual relationship, Ethel started to make cautious incursions into her lover's home life. She had never been to 39 Hilldrop Cres-

cent, and one evening she decided to change that. Her employer had "received an important message" after leaving work, she claimed. The Crippens owned a telephone, so she could have rung, but instead she appeared on his front step with it. Crippen, always calm and collected, answered the door and invited her in. Belle was at home and called out to ask who had arrived, before inviting "Miss. Le Never" downstairs to greet her. It was a "courteous" and friendly meeting, but from beneath her downcast gaze, Ethel took the opportunity to survey the Crippens' home.[6]

Here was the middle-class family house appropriate for a successful medical man, his wife and their many children. Its polite drawing room was furnished with a piano, there was a dining room and bedrooms reaching up to the attic. The windows would have provided her with glimpses of a thoughtfully cultivated garden just beyond. It was a world away from her own unsatisfactory and incomplete existence. The ungrateful Belle had everything Ethel believed she rightly deserved.

This would be only the first of many such visits to 39 Hilldrop Crescent. After Ethel's "miscarriage" something would change between her and Crippen. A balance was tipped. Ethel, strung along on promises, had made one too many sacrifices for Crippen. Her famous fortitude and tight-lipped patience was now running thin.

Ladies of the Guild

O N JANUARY 21, 1907 music halls around the country went dark. A dispute over demeaning low pay for evening "turns" and even worse remuneration for matinee performances had been brewing for some time. When the artistes, musicians and stage-hands finally walked out and took up placards, they had reached the end of their tether with theatrical management. They formed picket lines on the streets outside the venues and, much to the delight of passersby, often broke into song, performing their famous reper-toires for the gathered crowds. Among their number were super-stars Marie Lloyd and Joe Elvin, who helped to fund the strike. By the start of February, the protest had ended, but not before manag-ers had contacted every ambitious new artiste or retired performer to coax them into strike-breaking. While a number did accept offers and cross the picket lines, others refused, but did deals with well-connected friends to ensure their solidarity was compensated with appearances after the dispute was settled. Belle Elmore was among those who seem to have negotiated such an arrangement. At the beginning of March, more than a month after the strike had been settled, Belle returned to the stage for a short run at the New Bedford Palace of Varieties, a theater in Camden Town, not far from her home.[1] Whether or not her husband had permitted it, Belle was determined to have one last engagement in the footlights.

In years to come, when everyone professed to have a story about Belle Elmore, it would be said that she had been a blackleg, a strike-breaker. An anecdote was ascribed to Marie Lloyd who it was

claimed had watched Belle, dressed in her finery, barge through the pickets into a theater. When the strikers had tried to stop her, Marie was alleged to have called out, "Don't be daft! Let her in and she'll empty the theater." Had Belle actually broken the strike, it is unlikely she would have maintained the many friendships she had formed with those in the profession, or been accepted into the Music Hall Ladies' Guild, of which Marie Lloyd was president, later that year.

It was through an association with the famous American "blackface" performer George Washington "Pony" Moore that Belle first learned of the MHLG.[2] Moore kept an open house for his fellow countrymen and -women in the entertaining world, and it was at one of his gatherings that Belle struck up a friendship with his daughter, Annie Stratton. Annie too had a career in the family business, "blacking up" and performing as a singer and a sketch player as part of her father's company, Moore & Burgess Minstrels. Her marriage to Eugene Stratton, whose international celebrity status rivaled that of Pony Moore, brought an end to her years on the stage. Instead, Annie turned to charitable work. When, in 1906, a charity was founded by music hall women for the benefit of female music hall performers and their families, Annie joined their ranks.

The Music Hall Ladies' Guild was designed as an organization similar to that of the Theatrical Ladies' Guild. At a time before the creation of the welfare state, charities were the only safety nets available to catch those who had fallen on difficult times. Women who found themselves out of work and destitute, or abandoned by their breadwinning husbands, or unable to afford to feed and clothe their children, were eligible for charitable relief from the Guild. The MHLG sponsored fundraising events: performances, luncheons, bazaars, teas and grand dinners, and they solicited donations of money and unwanted clothing. They assisted new mothers who could not afford to purchase linens and clothing for their infants; they found employment for widows, poor children and orphans. They visited sick boys and girls and offered them toys and books. They would donate stage costumes to struggling performers

and help them to buy coal and food. They brought Christmas to those who would not otherwise have been able to celebrate it. They raised funds to pay for legal advice and doctors' bills and assisted older applicants in the acquisition of pensions.

Much like their male equivalents, the philanthropic Grand Order of Water Rats and the Beneficent Order of Terriers, the Music Hall Ladies' Guild was about more than just charitable giving; their intention was to bring together women of the variety world. Their ideal was to foster a strong sense of community within the profession at a time when women were recognizing the need for a unified voice and organizing themselves into unions and federations, agitating for social change, labor rights and the vote. The Guild's membership requirements were relatively broad: any woman who had even a tenuous connection with the music hall was welcomed into their fold—whether they were the wife of a male performer, had retired, were little known, or enjoyed top billing.

If Belle had been seeking a purpose, an outlet for her passion, then the Music Hall Ladies' Guild gave her this. Within two months of becoming a member in 1907, Belle was elected to the executive committee as the organization's treasurer. She threw herself into her role with zeal, diligently attending each Wednesday afternoon board meeting. She also found them a new base for their operations: Albion House, in a room down the hall from her husband's offices.

Belle quickly became one of the MHLG's most vocal advocates, eagerly selling tickets to events, canvassing for donations and minding stalls at fundraising bazaars. She and her sister members also participated in fundraising for associated charities; special sports days organized by the Variety Artistes' Benevolent Fund, and the Music Hall Artistes' Railway Association dinner and ball, which featured as the most anticipated event on the calendar. In 1908, Belle's dedication to the cause helped to raise £413 6s. 5d., which covered the MHLG's administrative costs and succeeded in bringing aid to over 300 distressed performers and their dependants.[3] Each of the cases was investigated personally by the committee, who also participated in distributing the aid.[4]

The Guild allowed Belle to find her métier—a single point to which she could draw all the assorted strings of her interests and desires: her love of the stage, her need to belong, her desire for a family, her sense of Catholic devotion, her longing to nurture, and her wish to be recognized and adored. Within two years as treasurer, she had risen to become one of the stars of the organization. By positioning herself in the wings of the variety world, she had achieved the distinction she once sought on center stage. The membership was eager to celebrate the sincerity of her endeavors and chose to honor her at the annual dinner on September 25 1909. Attired in their satin and velvet, the queens of the music hall and their retinues convened at the Boulogne Restaurant where Belle Elmore was presented with a basket of pink roses and a written expression of gratitude in a silver frame. She was also awarded a box of gloves and a gold bangle, on to which the words "To the Hustler" were engraved. Belle, in a pale salmon silk gown and adorned with her diamonds, rose to her feet with a blush. "I really do not think I deserve it," she said.

"Yes you do!" the audience shouted back.

"I never expected anything like this," she continued. "The work I have done for the Guild I did because I loved it: any reward was that we were always pretty successful. Knowing that this lovely compliment is paid me in appreciation of my work for the Guild, I can only say that so long as I am permitted to, I endeavor to work in the future, as I have in the past."[5]

On that night, George Hana, the theatrical photographer who had taken Belle's professional portraits twelve years earlier when she had only just arrived in London, was on hand to commemorate her award. He posed her triumphantly, lifting her bounty of flowers aloft, a picture which would appear in the trade newspapers, alongside an acknowledgment of her hard work.

While the Crippens had been known in music hall circles since the late 1890s, it was only after Belle had joined the Guild that they truly became part of the variety theater establishment. To Belle, the relationships she forged appear to have meant as much as the char-

ity work she undertook. Her sparkling personality and boundless enthusiasm earned her the devoted friendship of many, including the Guild president, Isabel Ginnett. Mrs. Ginnett, who assumed the role after Marie Lloyd stepped aside, hailed from a family of performers no less celebrated than the Queen of the Music Hall. The Ginnetts and their troupe of equestrian daredevils, led by her husband, Frederick, were considered circus aristocracy. In addition to raising their children and helping to manage their company of performers, Isabel, in her pink satin riding habit, regularly performed beside her husband, dazzling crowds with her mounted acrobatics.

Belle's involvement with the Guild also helped to foster a close friendship with Clara Martinetti. Like Isabel, Clara, a "pantomime comedian," had made a fortunate marriage: hers was to Paul Martinetti, a renowned mime artist from the United States. Until her retirement, she had performed with Paul and his siblings as part of the American Pantomime Company, who were known on stage for their harlequin "knock-about antics." Belle had met Clara at one of Pony Moore's parties and immediately recruited her to the MHLG. She was to sit beside her on the executive committee along with her numerous other friends: the famous comedian and singer Lillian Nash (known on the stage as Lil Hawthorne); the Guild's secretary and retired burlesque performer Melinda May; the MHLG's vice president and former dancer Louise Smythson; and Louise "Louie" Davis, a singer-dancer.

When not rattling the coffers for the MHLG or distributing their charitable takings, the business of socializing topped the agenda. The Crippens are listed among the guests at many of the balls and gatherings thrown by the era's most distinguished performers. The daughter of popular composer Leslie Stuart recalled many of her father's parties and the assortment of "stage folk and musical celebrities" who crowded into the aspidistra-and-lace-curtain-ornamented rooms of their Edwardian home. Eugene Stratton, along with "all the great men of the music halls," the gamblers and horse-racing set, would behave "like crazy kids." The servants would be sent to bed and the children locked away in the nursery.

Waiters from the Vaudeville Club would turn up and the games and schoolboy antics would begin. Late into the night, it was not unknown to hear gunfire.[6]

The gatherings the Crippens began hosting at 39 Hilldrop Crescent were notably more subdued, but no less glamorous. They and their immediate circle held what Lottie Albert referred to as "Bohemian little affairs."[7] In February 1909, they hosted Pony Moore's ninetieth birthday party. Much to the dazzlement of their neighbors, all evening, motorcars puttered along the road, depositing and collecting the guests in their trailing gowns and top-hatted evening attire. The lights in the drawing room blazed into the early hours as the Ginnetts, the Strattons and the Martinettis drank, feasted and sang.[8] At last, Belle was able to fill the empty rooms of her home, not only with people, but with purpose and a sense of belonging. Lottie Albert was present at many of the parties where Belle rushed about, greeting her guests in one of her carefully selected outfits, her diamonds pinned to her bodice or swinging from her ears. The girl from Brooklyn was always "childishly excited, overflowing with good spirits, delighted at the gathering." At her elbow and "solicitous for the comfort of her guests" was Crippen—"suave and polite," speaking very seldomly unless he was drawn out of his shell.[9]

According to Belle's charwoman, Rhoda Ray, her employer led a busy social existence during her reign as MHLG treasurer. She was out most afternoons for luncheons and there were Guild teas every Wednesday at 4 p.m. During the week, there were usually smaller drinks parties, card parties and suppers organized by the ladies for birthdays or to mark the occasion of one of their Guild sisters embarking on a foreign tour. They visited at one another's homes and at restaurants, with and without their husbands. They bought each other gifts and communicated in daily volleys of notes and telegrams. They dispatched floral bouquets and sent postcards when they were traveling abroad.

Although Crippen participated in the rounds of socializing and appeared to enjoy the company he kept, he had little interest in understanding his wife's friendships, nor could he comprehend their

significance to her. Belle needed intimacy: female companions with whom she could discuss her private thoughts, to whom she could disclose her feelings and express her concerns. Some of these concerns involved her husband's secretary.

"I don't like the girl typist Peter has in his office," she announced one day to Maud Burroughs.

"Why don't you ask Peter to get rid of her, then?" Maud replied. Belle said she'd raised it, but her husband had protested that "the girl was indispensable to the business."[10]

Belle voiced her worries to Lottie Albert too. The actress recalled an incident when a general conversation about the men of their acquaintance took an unexpectedly uncomfortable turn. Lottie had mentioned that she thought all of them to be trustworthy. Belle's expression fell. Her face assumed a "half sorrowful, half dubious" look. "Not all of them, Lottie, not all," she said.[11]

Whatever the underlying situation, when together, the Crippens would never reveal anything but a respectable and amiable front to their collection of new friends. According to Melinda May, one of Belle's cherished companions, the Crippens seemed in a festive and bright mood on New Year's Eve in 1909. She was among a handful of guests invited to 39 Hilldrop Crescent to help usher in 1910. At first, Miss. May was uncertain that she would be able to attend, but Belle insisted. She telephoned Lillian Nash and her husband to collect Melinda in their automobile and spirit her away to Holloway. It was about eleven o'clock when they reached the curve of Hilldrop Crescent. Upon their arrival, Belle immediately went downstairs to mix some American cocktails in the kitchen. The ember-like moments of the old year were dying away as their hostess handed round the drinks. At midnight, they threw wide the door to the street, opening their warm home to winter's bite. Belle called out to the Nashes' chauffeur and to a passing constable, and "invited them to take some refreshment, which they did, joining in the good wishes for the year 1910."

She and Melinda stood at the top of the steps, embraced by the cold, listening "to the hooting of sirens, the ringing of church bells,

the hammering of trays, and the rest of the strangely moving noises that are made by the watchers who hail the New Year." Belle turned to Melinda, her face half lit by the candescence of her home.

"I'm so glad you're here, Miss. May," she said. "I'm so glad that we're together now, and I do hope that we shall all be together again this time next year."[12]

13

Promises

B Y 1908, ETHEL HAD gone from a situation where she rarely encountered Mrs. Crippen, to one where Belle's presence was felt at least once a week. Every Wednesday, the Music Hall Ladies' Guild met down the hall from her office in Albion House. Ethel must have heard them: Belle and her glittering companions in their furs and their enormous feather- and veil-trimmed hats. The voices that echoed through the corridors were those she would have recognized from the music halls. Ethel would see them together and overhear their conversations about the galas, the glamorous fundraising events and the parties that the Crippens had hosted and attended.

In March 1909, photographs of one of these extravaganzas, the wedding of John Frederick Ginnett and Maude Sanger, the children of the two great circus dynasties, filled the papers. Joining the revelers at the Sangers' winter quarters at Burstow Lodge were elephants, lions, tigers and camels, who were treated to "a special wedding feast" while the guests were given tours of the grounds and regaled with acrobatic entertainment.[1] Like so many of the balls and dinners at which the Crippens were present, Ethel could read all the details. To her, Belle and Hawley's life must have seemed an endless round of celebrations, a whirl of singing and dancing in diamond jewelry. She would listen to these tales and then board the crowded tram back home to 80 Constantine Road. She would sit with Emily Jackson and her screaming toddlers and eat her supper

in the kitchen. As she would one day weep to her landlady: "when I see them go away together, it makes me realize my position, what she is and what I am."[2]

How much Ethel's parents and sister knew of her difficult situation, and when precisely they were given the scant handful of details, is uncertain. It could not have been easy avoiding the prying questions of well-meaning relations and friends who inquired about young men and courtships. They must have pitied the solitary office girl with the timid demeanor, taking dictation and eating her beef paste sandwiches in silence. Ethel felt sorry for herself, but she had also learned to evade unwelcome questions by knitting beautiful lies.

Many of these prettily embellished veils were created to screen her from the inquiries of her aunt and uncle, Alice and Richard Benstead. The Bensteads, who lived in Brighton and ran a boarding house, were favorite relations of Ethel. Alice Benstead had recently retired from her position as lady's maid to Frances Anne Spencer-Churchill, the Dowager Duchess of Marlborough, grandmother to Winston Churchill. A connection with one of the most preeminent aristocratic families in the country conferred a certain degree of prestige on Mrs. Benstead, which in turn must have appealed to Ethel's vanity and ambitions. Her aunt would have had intriguing stories to tell about the fashionable Marlborough House set, the scandalous duke and his American duchess, Consuelo Vanderbilt, and the grandeur of Blenheim Palace. Unlike her provincial parents, Alice Benstead was worldly and understood the complexities of modern life. She also took an interest in Ethel's romantic affairs. However, her niece was careful never to reveal too much. During 1909, she told stories about two separate suitors and an engagement, which was eventually broken off—a narrative which skillfully managed truth in balance with obfuscation.[3]

In January of that year, John William Stonehouse entered Ethel's life through the front door of 80 Constantine Road. Stonehouse, a pharmaceutical clerk employed at the British Drug Houses Ltd, had taken the second spare room at the Jacksons'. He and Ethel struck

up a friendship and, after a few months, the two began "walking out" together. Usually, this entailed a visit to one of the local pubs. The couple would sit for a half-hour or so amid the dark wood interiors where Ethel would enjoy a bottle of stout or a glass of port wine. Sometimes they would ramble further afield, across the Heath to the Coach and Horses, and on occasion Stonehouse would meet Ethel after work amid the petrol fumes of New Oxford Street. The two would talk about their respective jobs in the medical field. Ethel frequently mentioned "the doctor" and once pointed out Albion House as her workplace. Stonehouse looked through a directory and concluded she must have worked for Munyon's. Ethel never mentioned the name Crippen.

After her "miscarriage" in September the previous year, Ethel may have genuinely been attempting to move on with her life, but it is more likely that she wished to provoke Crippen's jealousy and the attentive John Stonehouse provided just the opportunity to do so. It seems that Robert Jackson, Emily's husband, had got a sense of this, and one evening, shortly after Stonehouse and Ethel had begun "stepping out," Mr. Jackson took him down to the Stag public house and had a word with him, man to man.

"Miss. Le Neve had a child by someone unknown," Stonehouse was warned, and "She was implicated with someone else."[4] She was *that* sort of woman. John Stonehouse, whose own private life was far from circumspect, would not be deterred by a "rumor." He had a wife and children in Leeds, though presented himself as an eligible single man to the Jacksons.[5] At any rate, he would later deny that any "undue familiarity" existed between him and Ethel. They "treated each other as friends and nothing more," though Ethel's childhood acquaintances and local publicans recognized them as "sweethearts."[6] If Stonehouse was truly interested in Ethel, then she did not reciprocate his feelings. He found her behavior at times to be mysterious and erratic. In March 1909, she told him she was going away, but did not say to where. She cleared out her room at Mrs. Jackson's and didn't return. It was not until sometime later that Stonehouse received a letter from Portslade, near Brighton. Ethel

explained she had gone to assist her aunt, Mrs. Benstead, while her uncle was unwell.

It has been speculated that Ethel's sudden disappearance to Brighton might have been on account of another unanticipated pregnancy.[7] What seems to lend credence to this theory is the appearance of an infant niece, Ivy Ethel Brock, in September of that year. Nina had given birth to her son in 1904 and this second baby, born in 1909, was to be her only other. It is equally peculiar that Ivy's father, Horace Brock, appears to have had problems remembering her birthdate, citing it as August 30 on his army conscription papers, when her birth certificate lists it as September 20.[8] But it is difficult to imagine how such a magnificent deception could have been successfully managed. It would have required the complicity and absolute silence of the entire Neave family, the Brocks, the Bensteads, the Jacksons, Crippen, as well as those Ethel worked with: Gilbert Rylance and William Long. Under the exacting police and press scrutiny to come, not one of them made the slightest mention of any irregularity in this regard; not a lengthy, unaccounted-for absence or even the merest whisper of an illegitimate child or a pregnancy. Ethel, it seems, was also back at Albion House by August. There was no sign of a rounded belly or a baby.

By the end of the summer of 1909, Ethel must have been making her feelings patently clear. Months were passing; the seasons were changing. It was now nearly a year since her "miscarriage." Another year of waiting and Belle was still his wife. Ethel was still only his mistress, and now living alone in an unsatisfactory room on Store Street. She decided it was time to rekindle her relationship with John Stonehouse. On this occasion, she wrote to him from Albion House, right underneath Crippen's nose. Ethel said she wished to see him, and the two arranged to meet on a Saturday in Hampstead. At the end of their date, her suitor insisted on walking her back to Store Street. Ethel made certain that Stonehouse knew how much she disliked her living arrangements. She complained that she found it "uncomfortable." Wishing to help, Stonehouse sug-

gested that she might have her former room back at Mrs. Jackson's.[9] This seemed an agreeable plan, and within a week or so, he returned from work to find Ethel there.

Crippen could not have been happy with Ethel's dissatisfied mood and her attempts once more to arouse his jealousy. Perhaps in an effort to placate her, on August 14 he walked down the road from Albion House to Messrs Harvey & Thompson Ltd, a jeweler at 21 New Oxford Street.[10] He said he was interested in buying a diamond solitaire ring for a lady. The assistant showed him several, from which he selected two. Crippen put down a £1 deposit and the jeweler followed him back to his office where both rings were presented to Ethel. She chose the one which cost £50. It was fitted to her finger and Crippen paid the balance two days later. Ethel had an engagement ring. It was a promise that a marriage would be forthcoming, on the understanding that, for the present, it would have to be kept a secret—or at least, a partial one.

Almost as soon as Crippen had given her the ring, Ethel felt compelled to share her good news with her confidante, Emily Jackson. By then, Mrs. Jackson had learned something of her friend's romantic entanglement with the man who employed her. "Of course I knew that Dr. Crippen had a wife living and I asked how she in those circumstances could be engaged to him," Emily recalled. Ethel responded by telling her that "Mrs. Crippen had been threatening to go away to America with another man. Then the Doctor will divorce her—divorce is easy in America—and he is going to marry me." Unfortunately, whatever soothing balm Crippen's gesture had applied to Ethel's emotions was not to last long. Shortly after she had showed Mrs. Jackson the ring, her mood grew gloomy again. It did not take much for Emily to intuit the cause of this. "I told her that she was unwise to be engaged to a man whose wife was alive." At that, Ethel "burst into tears and exclaimed, 'Please don't talk to me about it. It makes me so unhappy.' "[11] Ethel appears to have found some distraction from her misery by permitting John Stonehouse to court her again. The two resumed their walks and

visits to pubs until Ethel broke it off in October. By then Stonehouse had moved away to a new and less convenient address at the top of Hampstead Heath, and Ethel no longer found him useful.

There must have been something about the promise Crippen had made to her in August, insured with a diamond solitaire, that made this guarantee more binding than any of his others. Or possibly this time she had enforced it with an ultimatum, after demonstrating to her married lover that there were other men who could easily replace him. By the end of the year Ethel seemed to be growing more confident that Belle Elmore would soon be gone. She brought out her engagement ring again and showed it to a confused Mrs. Benstead, who now could not remember to whom she was engaged. She had mentioned a number of names, but never Hawley Crippen's.[12]

It would seem more than coincidence that as Ethel was about to turn twenty-seven, a decision was finally taken to give her the gift she had been awaiting for six years. Around January 15, 1910, roughly one week before her birthday, Dr. Crippen went to Lewis & Burrows, the chemist's across the road from Albion House.[13] He was a regular, customer there and, in the past, had ordered mercury, morphia and cocaine, all of which were used in his dentistry business.

"I want five grains of hyoscine hydrobromide," he said to Charles Hetherington, the chemist who took his order. As was the usual practice when dealing with poisons, Hetherington asked him the reason for his order. Crippen answered that it was for "Homeopathic purposes" for his work with Munyon's. The chemist had no reason to suspect him, Crippen was a good customer and always signed the poisons register, but he later recalled thinking that the amount Crippen requested was "very unusual." In all the time he had worked there, never had he "known near that quantity of 5 grains in stock."[14] Hetherington had to telephone a wholesaler, the British Drug Houses Ltd (coincidentally, John Stonehouse's employer), to source Crippen's order. The chemist knew that hyoscine hydrobromide was often used as a sedative, but only in infinitesimally small doses. Large measures, or anything above a quarter of

a grain, could incite delirium and excitement, followed by unconsciousness, paralysis and, eventually, slow death. Lewis & Burroughs normally kept only one-fifth of a grain in stock.[15] Chemist shops rarely held more than a single grain at a time, and such a significant amount as five grains would usually only be requested by a hospital. Such a large order meant that there would be a wait for it to be filled.

Several days later, on the 19th, Crippen called in at the shop and collected his tightly wrapped packet of five grains of hyoscine hydrobromide, which he brought home to Hilldrop Crescent.

Ethel was excitedly, though discreetly, mentioning to her friends that she was soon to be married. On January 22, Mrs. Jackson decided to hold an intimate birthday celebration at her home for her lodger. Ethel's childhood friend from the Campden Buildings, Lydia Rose, and her mother came to visit on that Saturday to have some tea and cake. Ethel had told Lydia her happy news a few weeks earlier but took the opportunity to announce it to Mrs. Rose. As Ethel was not forthcoming about her fiancé's identity, neither of the Roses pressed her on the matter. "I trusted her and thought that she would have told me if she had wished me to know," said her friend.[16] Ethel waved her left hand about so the Roses, who still lived in charitable housing and remembered the eldest Neave sister in her threadbare clothing, could now admire her diamonds.[17] Although she would not dare spell it out, Ethel's contentment sprang from the knowledge that she was about to marry her employer, a glamorous American doctor, a man who attended the parties of some of the most celebrated performers in the land. Her fiancé entertained her in expensive West End restaurants, made love to her in hotels, bought her jewelry and took her to France. The girl who had been born in a two-room cottage in rural Norfolk was about to make an unparalleled success of her life.

14

Potluck

THE THIRTY-FIRST OF JANUARY was an unsettled day, with little light. What thin, pale sunshine peered between the rolling clouds was only visible for a fleeting spell, before the rain began again. It brought with it a fresh wintry wind, which whipped around the buildings of Bloomsbury, roared down its streets and shook the empty branches of the plane trees. By mid-afternoon, office workers had switched on the electric and gas lighting to dispel the lengthening shadows of early nightfall.

From the windows of Albion House, Hawley Crippen could see King Edward's Mansions looking back at him. The two turreted red-brick blocks, quite similar in design, nearly faced each other across the junction of New Oxford Street and Shaftesbury Avenue. It was there, over the road, on the second floor, that the Crippens' good friends Paul and Clara Martinetti lived. Both had retired from stage life, an existence of endless train journeys, swaying transatlantic crossings and nights passed in anonymous hotels and boarding houses. Paul, once a legend of "harlequining," had come to rest in a luxurious five-room mansion flat in the West End. He was sixty-three, and a life of intense physicality, of tumbling and dance, had begun to take a toll on his health. Clara, his wife, was almost twenty years his junior, and lived a contented and quiet life alongside her husband. In recent years, they had purchased a bungalow (or a cottage) outside London at Penton Hook Island, a place around which the Thames gently coursed. They christened their little lodge "Clariscio" and passed their days there when the weather was fine.

The previous summer, in August, they had invited the Crippens to come for a week. Belle and Hawley had arrived by train on a Sunday to idle away the warm days at the edge of the river; however, the doctor had returned to London that evening citing "business" (or Ethel). Belle remained, and heartily enjoyed the hospitality and kind company of her friends. Unlike those less fortunate players at the end of their careers, the Martinettis were in the enviable position of possessing both wealth and leisure time and, happily for Belle, they frequently chose to spend it with the Crippens.

Of Belle's many friends, it was the dark-haired, full-faced Clara with whom she was closest. Aside from their shared lives as performers, both women were married to slightly older men, and both had grown up speaking German—Clara Engler, as she had once been called, was born in Berlin. This in itself might have been enough to seed the relationship, but the Martinettis' immediate proximity to Albion House certainly helped to nourish it. When Belle had asked Clara to join the Music Hall Ladies' Guild she could not have refused when the meetings were held but a minute from her front door. From this, a deeper friendship grew, not only between the women, but between the couples, of whom three of the four were American. According to Crippen, for the first eighteen months of their acquaintance, they would see each other most weeks. "Either we were at their house or they were at our house," he recalled. Often following the Wednesday afternoon meetings at Albion House, the Martinettis and the Crippens had dinner together, and then they might meet again later in the week to eat, drink and play cards.[1]

In the course of any given day it would not have been unusual for Hawley Crippen to slip across Shaftesbury Avenue and knock on the Martinettis' door. As the street lamps came to life, sometime between 4 and 5 p.m. that Monday, this was precisely what he did.

He rapped at 212A and Clara answered. Belle would like you to come to our house this evening and take potluck dinner with us, he told her. Potluck did not imply its modern meaning, that the Martinettis were to bring a dish, but rather that this was a casual night, that Belle would serve whatever she had at hand. There would be

no fuss. The idea would just be for the Martinettis to come as they were. Clara, in theory, was not opposed to going to Holloway for the evening, but the problem was Paul. As age had crept up on her husband, so had illness. Clara had discreetly told Belle and Crippen (as he was a doctor) the nature of his condition. Whatever it was, Paul went regularly for treatment on a Monday, and would always return feeling "very queer and weak." Clara guessed that "he would not care to go" on account of this.[2]

"Oh make him, we'll cheer him up," Crippen insisted, "and after dinner we'll have a game of whist."

"We'll see what Paul says and if he cares to go, we go"—but she told Hawley Crippen (whom she affectionately called "Peter") that she didn't expect him back before six o'clock. Crippen explained that it wasn't an inconvenience and that he had "a little more work to do at the office" and would call again around 6 p.m.

Paul returned home at that hour and his wife put the dinner proposal to him. Hardly had she done more than raise it before "Peter" was back at the door. The three discussed whether it was wise to venture out. Paul admitted that he was indeed feeling "queer," but that he would like to go. A lifetime spent performing through the worst indispositions, aches and ailments would have hardened the artiste to the more minor bouts of distemper. It was nothing that a little stiffener of strong spirits couldn't abolish. Clara suggested that they make their way to Hilldrop Crescent together, but Crippen thought it best to go on ahead and offer Belle some warning that they would be receiving guests. As soon as he departed, Paul went into his study, shuffled some papers, put some letters away in his desk, and asked his wife to pour him some whisky and water.

It was one of those nights in London when it seemed impossible to get a taxi. It was cold, and the Martinettis found themselves walking from Shaftesbury Avenue to Tottenham Court Road, about five minutes away. Here they boarded one of the new motorbuses to Hampstead Road, and then changed on to an electric tram which brought them directly to the corner of Hilldrop Crescent.

They rounded the curve of the street. The bare lime trees that

fringed the edges of it held their knobbly fist-like branches up to the night sky. The lights were on at number 39. Crippen had been watching for them and opened the door. Belle joined him and with a teasing smile began shaking her finger at their friends. "You call that seven o'clock?" She laughed. It was nearer to 8 p.m. when the Martinettis mounted the front steps. They had forgotten that "Peter" had mentioned seven. Belle gathered them in from the January night and gave them a warm greeting. She sent Clara upstairs to the front bedroom to remove her coat and hat. Crippen helped Paul with his in the hall.

"I hope you don't make any fuss with the cooking," Clara called out to Belle. "Peter said it was potluck dinner."

Belle shooed away her concerns, it was "only a little soup," she said before disappearing below stairs to the kitchen. Mrs. Martinetti then went to join the gentlemen, who were sitting in the parlor. After a short spell, her hostess returned with some glasses and asked what they'd like to drink "for an appetizer." Paul fortified himself with a whisky, and Clara was poured a gin soda before Mrs. Crippen disappeared again to tend to her cooking. Paul was obviously feeling "queer," and by the time dinner was called, had medicated himself with a second whisky.

Belle beckoned her guests into the Crippens' multi-purpose breakfast-dining room near the kitchen. As she did so, she stopped her guests to show them her "funny little bull terrier" whom they kept below stairs. He was still just a gamboling puppy, impolite and not yet house-trained, she explained, but with his tiny eyes and peaked ears, he was sweet and she made a fuss of him. She then turned her attention to the table: if there was anything missing on it, could Clara see to it? Both she and Crippen adjusted the cutlery, serving ware and glasses and then took their seats.

Their hostess bustled in with the soup, which was dished out and graciously consumed. The empty plates were gathered, and she and Clara took them into the kitchen. "You must not trouble," she said to her friend as Mrs. Martinetti followed her. Belle then returned with a joint of beef, which she placed before her husband to carve,

and filled the table with "salads" (or side dishes). Crippen skillfully slid his knife into the meat, shaving off slices which he offered to his guests, while Clara and his wife passed around the accompaniments. Drinks were offered and Mrs. Martinetti had a glass of stout, while their host drank ale. Paul mentioned he would have another whisky at the end of the meal.

Following the main course, both Crippens rose to clear the plates, and Belle reappeared carrying two or three different kinds of sweets.

"You give yourself a lot of trouble," exclaimed Clara. "We did not want all that!"

Belle just laughed, ignoring Clara's entirely predictable protests. Which one would you like? she asked through her gold-tinted smile.

Once they had all filled themselves with cream and sugar and whatever else had been whipped or baked and then dolloped into dishes, coffee was brought out on a tray, followed by liqueurs. The latter was offered, and Crippen complained that they did not agree with him. Belle turned to Clara and insisted that she should have one, but her friend declined, stating that she preferred coffee that evening.

What about the cigarettes? said Belle as she reached for the box they kept in the breakfast room. There was a special brand she thought preferable, and she asked her husband to find them, but other than Paul, no one was particularly interested in smoking. He was content to have an ordinary one. He lit up and took a drag. The room gradually filled with an ashy haze and languorous after-dinner conversation. Eventually, the men decided to go upstairs to the parlor. Clara insisted on helping Belle to clear the table, but again polite protests were exchanged, and she sent her guest to join the two husbands. She would be there in a minute. Would you have Peter get the cards ready? she asked Mrs. Martinetti.

When Belle came into the parlor, the table had been prepared for a game of whist. It was decided that Paul and Belle should play as a team, in opposition to Clara and Crippen. The hands were dealt, and eventually the hours were shuffled away with the cards. Clara

soon lost track of just how many games they had played, but she was aware of the room beginning to feel rather overheated. She asked Crippen to turn down the gas stove, which he did. After another round, they paused for refreshment. During that interlude, Clara noticed that Paul had gone rather quiet. She regarded her husband closely. Paul was not one to readily admit to experiencing discomfort, but his wife suspected that he was not feeling well. After a moment, he got up from his chair, excused himself and headed to the lavatory on the third floor. "There is a light upstairs, Paul," Belle called after him.

"Yes, I see," came the response from the hall, where Paul was creeping up the stairs.

Clara began to fret, muttering something about it having been better if they had stayed at home that evening.

When Paul returned, he did not look himself. He commented that he had suddenly grown cold. He walked around to his seat and, as he did so, his wife noticed that he appeared "very white" and that "his hands were very cold." He began to tremble. His entire demeanor had shifted. "How will we get a taxi?" Paul asked.

"Well, Paul, you always get away from here all right," Crippen remarked.

Belle poured Paul a glass of pure brandy. "Drink that, Paul," she said, passing it to him.

Clara was growing more concerned. "Oh no, Belle, that is too much, I don't think he ought to have brandy after the whisky he had."

"Let him have it," her hostess insisted.

"No, Belle, I'd rather not, you know I have to take Paul home."

"You let him drink it, I take responsibility," said Belle.

Paul sat with the glass in front of him as the women argued.

"Give him some pure whisky. I really don't care for him to mix his drinks," Clara announced.

With that, Belle poured him a glass of whisky and then turned to Crippen. "Well, will you get a taxi, dear?"

Crippen slipped on his coat and hat, and sometime between mid-

night and 1 a.m., stepped out into the enveloping gloom of an early February morning.

The three continued to sit in the parlor. They waited for Hawley Crippen to reappear. At various intervals, Belle got up and went into the hall, thinking she could hear him coming up the steps. She pulled back the drapery and peered out on to the still, black street. "It seemed as if he would never return," Clara recalled uncomfortably. Then, at last, he did return, chilled and red-faced, apologizing that he had walked a long way but still failed to find a cab.

The four exchanged worried looks. The Martinettis seemed especially concerned. Paul had not improved. The chill had settled in; he appeared drained. Belle suggested that perhaps they should stay the night, but Clara was quite insistent that they return home. If Paul's condition worsened, she would prefer him to be in his own bed.

The hour was growing later.

"Can't you see anything else?" Belle implored her husband. "A cab or a four-wheeler?" She looked at her pallid guest. "Would that do, Paul?"

Paul was now no longer hiding his desire to get away, even though the thought of venturing out into the freezing air and then enduring a rattling ride in an unheated horse-drawn cab into the West End could not have appealed. A quick escape home in a motorized taxi would have been far preferable, but the Martinettis would be grateful for any sort of vehicle. "Anything. Anything," Paul said.

"Perhaps there will be something now. Go and see," Belle directed her husband, and so out Crippen went again.

Belle and the Martinettis eagerly waited at the window.

Within moments he returned with a four-wheeler (or a growler, as they were called, for the rumbling noise the carriage wheels made against the cobbled road). Clara dashed upstairs to collect her coat and hat as the doctor and his wife bundled up their ailing friend in the hall. Crippen took hold of Paul and assisted him down the steps, while Belle stood in the door with Clara. "Don't come down, Belle," she said, preventing her hostess from straying beyond the threshold, "it's too cold and you only have a thin blouse on." She

leaned into her friend's warm cheek and kissed her. She would be seeing her at the Guild meeting on Wednesday. It had been a lovely evening, notwithstanding Paul's indisposition. Clara, with her fur wrapped around her, set off down the front steps, pushed through the gate and, with Crippen's assistance, stepped into the cab. Before the door was shut, the doctor asked if Paul would like a rug to keep him warm. Clara said not to worry, as she would give him her sable. It was very late—nearly 1:30 a.m.—already Tuesday February 1, but they would be home soon enough.

As the horse started down the road, it is difficult not to imagine Clara looking back, just for an instant, at Belle, her silhouette in the doorway, the light of 39 Hilldrop Crescent glowing behind her.

ACT III

"Somebody has gone to America"

15

Rising Sun

IT WAS NOT QUITE lunchtime on Tuesday, February 1 when there came a knock at the Martinettis' door. The night before had been a late one, with a cold ride home to follow it. Paul was still in bed when Clara went to see who was calling. It was Peter Crippen. He removed his hat and stepped inside. He wanted to ensure that Paul's condition had not deteriorated since their early-morning departure from Hilldrop Crescent.

"He is not worse," Clara told him. She had rubbed his chest and given him a hot drink when they got home. "If you don't mind, Peter," she continued, "Paul is fast asleep just now, and I don't care to wake him up."

Crippen waved his hand. "No, don't wake him up. I am glad he is not worse," and with that, he turned to leave. Clara walked him to the entrance of their flat.

"How is Belle?" she asked as he was departing.

"Oh, she is all right."

"Give her my love, will you?"

"Yes, I will," he replied as she shut the door behind him.[1]

By the end of the week, Clara would be searching her memory, attempting to recall every word of that brief conversation, every expression that crossed Crippen's face, every twitch or nod of his head.

She had been unable to make the usual Wednesday afternoon meeting of the Music Hall Ladies' Guild on the 2nd and so was particularly perplexed to hear the news of the upheaval that day.

As Isabel Ginnett, the Guild's president, had been away on tour in the United States since October 1909, the charity's secretary, Melinda May, had assumed the duties of running the organization. Of its entire membership, no woman had worked more tirelessly to further the Guild's aims than the indefatigable Miss. May.

Melinda, whose real name was Harriet, had begun to wind down her career when she entered her forties and could no longer bound across the stage dressed in boys' breeches. Tall, fair-haired and "handsome," she had toured as part of an acrobatic troupe in the 1880s performing a "skipping rope dance," and rose to fame playing male roles in pantomimes a decade later.[2] She had now packed away the remnants of those glorious days. As of 1910, she was unmarried, and there is no evidence that she had any children. For Melinda, as for many women, the music hall had been more than a means of earning an independent living, it had become her community and her identity. Melinda was frequently at the offices at Albion House, three doors down the corridor from Crippen's dental business. It was through her hands that the requests for charity passed. Melinda read each of the letters they received, filtering out those which might be sent elsewhere—to the Variety Artistes' Benevolent Fund—and deciding on which to present to the committee. She headed the investigation into the worthiness of each case and organized the distribution of the relief. While the presidents, Isabel Ginnett or Marie Lloyd, acted as the figureheads of the MHLG, Melinda was the real power behind it.

It was Melinda's responsibility to convene the Wednesday committee meetings, which brought the executive members together to discuss business, but also (of no less importance) to socialize.

The meetings always began at one o'clock in their office.

As the top of the hour approached, the members began to arrive. Among them, removing their hats and their furs, were Louise Smythson, Louie Davis and Lottie Albert. Belle Elmore had been expected too.

At 12:50 p.m., the young woman often referred to by the Guild members as "Mademoiselle" appeared quietly in the doorway. Crip-

pen's typist, Miss. Le Neve, lingered until noticed. In her hand she held a packet which contained a bank passbook, a checkbook and a paying-in book. There were also two letters, one addressed to Miss. May, and the other to the committee. "I think these are yours," she said to Melinda.

The secretary opened the letter with her name on the front. She pulled a piece of Belle's light green stationery from the envelope. It was headed "39 Hilldrop Crescent." "Dear Miss. May," it began:

Illness of a near relative has called me to America on only a few hours'
notice so I must ask you to bring my resignation as Treasurer before the
meeting today so that a new Treasurer can be elected at once. You will
appreciate my haste when I tell you that I have not been to bed all night
packing and getting ready to go. I shall hope to see you again a few
months later but can not spare a moment to call on you before I go, I
wish you everything nice till I return to London again. Now good-bye
with love hastily.

The letter was signed "Yours, Belle Elmore, pp. HHC," indicating that Crippen had taken his wife's dictation.[3]

Uncertain what to make of this, Melinda then opened the next envelope, this one addressed "to the Committee of the Music Hall Ladies' Guild." Again, it had been written on Belle's paper and headed from Hilldrop Crescent.

Dear Friends,

Please forgive me a hasty letter and any inconvenience I may cause you,
but I have just had news of the illness of a near relative and at only a
few hours' notice, I am obliged to go to America. Under the
circumstances I cannot return for several months and therefore beg you
to accept this as a formal letter resigning from this date my Hon.
Treasurership for the M.H.L.G. I am enclosing the checkbook and the
deposit book for the immediate use of my successor and to save any
delay I beg to suggest that you vote to suspend the usual rates of election

and elect today a new honorary treasurer. I hope some months later to
be with you again and in the meantime wish the Guild every success
and ask my good friends and pals to accept my sincere and loving
wishes for their own personal welfare.

Believe me, yours faithfully,
Belle Ellmore[4]

Like the first letter, this one too was not in her handwriting.

The situation was so startling and so entirely out of character that Melinda was not sure what to make of it. She passed the letters among the committee members. They each puzzled over them. Bemused, they did what the letter instructed them to do, and elected a new treasurer, Lottie Albert. The meeting was adjourned but the matter was far from concluded.

Melinda went back to her desk and began writing letters to the absent Guild members, notifying them of the surprising event. One of the first women she contacted was Lil Hawthorne.

Like Melinda May, Lillian held a deep affection for Belle. The two had met at an MHLG Christmas charity event for "poor children" in 1907. Belle, whom she described as "a bonny, handsome woman, very bright and vivacious," left an impression on her. "From that time, we became close friends, and we corresponded regularly, exchanged visits and dined at one another's houses."[5]

Of all of Belle's female companions, none was more famous in her own right than Lil Hawthorne. Her husband, John Nash, was content to take a supporting role in his wife's life by acting as her manager. The two had met in the United States; Lillian had been born in Illinois and John, a Londoner, became a naturalized American citizen while working in touring productions of Gilbert and Sullivan operas. By the late 1880s, John had fashioned himself into a theatrical director and it was in this role that he made the acquaintance of twelve-year-old Lillian. It would not be until 1900, eleven years later, that they would marry.[6] By then, "Lil" Hawthorne had become a sensation as part of a singing trio, the Sisters Hawthorne,

with her siblings Eleanor "Nellie" and Adelaide "Lola." The hit that shot them to stardom, "The Willow Pattern Plate," was an ingenious piece of staging which featured a blue and white background designed as a china plate. The sisters, camouflaged by their blue and white dresses, emerged from the tableau to sing in harmony. It delighted and amazed audiences on both sides of the Atlantic.

Much like Paul Martinetti and Eugene Stratton, Lil Hawthorne and her husband eventually found it more convenient to base themselves in London, and from here Lil's solo career branched into everything from pantomime to early motion pictures. Lil shared West End billing with Marie Lloyd, Little Tich and George Formby. She shot around the city performing one turn after the next with the assistance of her chauffeur-driven car. When not on the British circuit, she was boarding a ship to America or Europe for months of touring, all the while maintaining a close correspondence with her friends and dispatching her responsibilities as an executive committee member of the Music Hall Ladies' Guild.

Lillian thought it "strange Mrs. Crippen should resign the Treasurership so suddenly."[7] In fact, both she and John found this behavior so surprising and irregular that they felt the need to confirm it was actually true. John immediately sent a telegram to Hilldrop Crescent. It was a brief but pleading message that Belle withdraw her resignation. They wanted to see her in person and hoped to talk her down from her position. They proposed coming on Saturday night. Lil was playing at the Tottenham Palace in North London and they would stop by the house that evening, on their way back into town. They had hoped she had not yet sailed for America. The Nashes drove up to number 39 that night, but the windows were dark. "I knocked and knocked," said John "but could get no answer."[8]

Clara too had received word from Melinda about Belle's resignation. The entire narrative of events did not add up to her. It was baffling and so unlike her friend to suddenly depart the country without sending her a telegram or at the very least a note. To relinquish a position which she cherished did not sound at all like Belle Elmore. "During the time I was with her on the Monday she never

said one single thing about leaving for America, and there was no sign of her going on a journey," Clara would later insist. "She was just her usual self."[9]

By the following Monday, when Crippen came over to King Edward's Mansions to pay his usual friendly call, Clara was quite put out.

"Well, you are a nice one; Belle gone to America and you don't let us know anything about it! Why did you not send us a wire?" she demanded. Had she known Belle was departing on a journey, Clara would have seen her off at the train station with a bouquet of flowers. This was a tradition for the ladies of the Guild. Certainly, Crippen knew that.

The doctor made his excuses. There had not been time to tell the Martinettis. It had all come about so quickly. He had received a cable late on Tuesday night, after he had already seen Clara. The news had come "to say one of them had to go to America . . . she wanted to go, so I let her go." Crippen then claimed he had been too busy to tell them. There was some important paperwork pertinent to the journey which he needed to find.

Paul had been listening to this odd exchange, trying to make sense of it. "But what has she gone over for in such a hurry?"

"On very important business for me—legal business. In fact, to it is attached a title but I shall not use it."[10] Crippen added that she "might be away for six months," and that he was considering selling the furniture.[11]

This must have seemed rather far-fetched to the Martinettis, but there was still some room for doubt. For years, Belle had talked fancifully about being a baroness or a countess, after reading a story in a newspaper about an unclaimed Mackamotzki title in Russia or Poland.

"The rest of the night was spent packing," Crippen said.

"Packing and crying, I suppose?" asked Clara, referring to the bereavement overseas.

"Oh no, we have got past that."

Clara must have imagined the scene: Belle's dressing room turned

over, the enormous task of choosing which items of her immense wardrobe to bring on a transatlantic winter crossing—which bulky furs and coats, the heavy dresses, jackets, skirts, blouses, woolen undergarments, hats, gloves, muffs, jewelry, boots, shoes.

"Did she take all her clothes with her?"

"No, only one basket."

Clara was surprised at his answer. It made no sense at all. What woman, especially Belle Elmore, would embark on such a journey with a single wicker suitcase-sized basket, barely large enough to hold a few basic changes of clothing? "That would not be enough, one basket to go all that way?" she pressed him. "She will want a lot more things."

"If she wants any things, she can buy them."

He left Clara to digest this. It did not settle easily. "I suppose we shall hear from her," she said. "Oh, she is sure to send me a postcard from the ship."

Mrs. Martinetti recalled him just nodding his head when he left them.

Another week passed before he returned. Surely, as he made his way over the road from Albion House, he must have anticipated the response.

"Look here, how is it she has never sent us a line from the boat?" Clara questioned him. A transatlantic crossing took roughly between a week to ten days, and more than that time had passed since Crippen claimed she had departed.

"I don't know."

"I thought she was going to New York and would be seeing Mrs. Ginnett."

"Oh no, she does not touch New York."

"Why didn't she write to me from the steamer?"[12]

He seemed perplexed and muttered something about "not being able to make it out."

The awkwardness lingered. Clara changed the subject.

"Are you going to the Benevolent Fund Dinner and Ball?"

This grand event, the highlight of the variety world calendar, was

scheduled for February 20. It was to be held at the glamorous Criterion restaurant and ballroom in Piccadilly Circus in honor of the Variety Artistes' Benevolent Fund. It promised to bring together all the industry's charitable concerns under one roof to raise funds for the creation of a retirement home for performers—Brinsworth House, in Twickenham. Two of the biggest names in Music Hall, Joe Elvin and Joe O'Gorman, were behind the scheme, while the event itself was to be hosted by the Crippens' good friend Eugene Stratton. The Martinettis were also sponsoring seats at a table.

The doctor was hesitant. He said he did not think he would go.

"Well," said Clara, "if you want to go, Paul could get you tickets from the Club [the Vaudeville Club, to which Crippen also belonged]. They are half a guinea each."

"All right then, I will take two."[13]

It was perhaps not the answer Mrs. Martinetti was anticipating. With his wife away on a sobering errand in the United States, Clara would not have wished to make "Peter" feel excluded, but certainly she must have paused to wonder who else he intended to bring.

<p style="text-align:center">★★★</p>

The 20th was a Sunday, a day when theaters were officially shut and the pink and gold West Room at the Criterion had been prepared for a banquet. An extensive E-shaped table had been laid and decorated with vases tumbling with flowers, fruit and foliage. A band of musicians serenaded the guests as they passed through the entry hall. As the dinner hour approached, the room, like the night sky, soon filled with stars. The comedian-singer George "the white-eyed Kaffir" Chirgwin and his wife appeared; so too did male-impersonator Ella Shields, the comic Harry Weldon, and Percy Honri, whose act was to play a concertina against a backdrop of a motion picture. This was a loud crowd; high-pitched laughter, raised voices and exuberance competed with the music.

It is difficult to know who among the band of Guild friends was the first to notice Hawley Crippen enter the room. Their attention

alighted on the short bespectacled man only fleetingly before it skipped to the slender dark-haired woman on his arm. At first glance some were uncertain of her identity, but others recognized her immediately as Miss. Le Neve, Crippen's typist.

Louise Smythson was surprised, to say the least. Belle had scarcely been gone three weeks. Louise wasted no time in descending upon her friend's husband.

"Have you heard from your wife lately?"

He paused; not a hint of surprise crossed his expression. "Oh yes," he replied.

She then pressed him for Belle's address.

"She was right up in the wilds of the mountains in California," he said.

Louise awaited a better answer. None was forthcoming. "When you get to hear of her, will you let us know?"

"Yes," answered the doctor cordially, "when she has a settled address, I will let you know."[14]

He escorted Ethel away from the ambush and toward the tables. They had been placed opposite Lil Hawthorne and John Nash, and next to the Martinettis. Polite greetings passed between them, and pleasant smiles.

"We were all very much shocked to see Dr. Crippen come to the table with his typist," John Nash would later state.[15]

That Crippen had dared to appear at a public event in the company of another woman was not in itself a reason for raised eyebrows. The variety world was not easily scandalized by marital infidelity; nor was illegitimacy, divorce or posing as a married couple unusual in this circle. Such arrangements, which otherwise would have outraged the churchgoing, law-abiding Edwardian middle classes, were commonplace. Within this climate, Ethel's presence at the table was certainly considered audacious, but that which rendered it truly scandalous was something altogether different.

Annie Stratton could not take her eyes off Dr. Crippen's typist. A brooch Ethel was wearing had attracted her attention. It was a round, star-shaped gold piece set with thirteen diamonds, in a design

known as a "rising sun." The typist had pinned it at the center of her bodice, for everyone to admire. Annie recognized it immediately—that was Belle's diamond brooch. She prized it and wore it frequently. Why would she have left it behind, and why would she permit the typist to wear it? At some point during the dinner, she cornered Clara Martinetti. "Miss. Le Neve is wearing Belle Elmore's brooch."[16]

Clara was surprised, but also uncertain if Annie was correct. She took an opportunity to study Ethel's bodice more closely, then turned to Annie. It certainly looked just like the brooch Belle owned.

Annie caught the attention of Lil Hawthorne. Lil mentioned it to John. The Nashs discreetly eyed the piece of jewelry. They exchanged looks. They were positive it was Belle's rising sun, and the realization of this "painfully affected all of us," John recalled.[17]

The news spread down the tables, catching the ear of Melinda May and Louise Smythson, as well as other Guild members. Astonishingly, Belle's husband and his typist seemed neither to notice nor to care. "Crippen and the girl were drinking very freely of wine," remarked John Nash. He was watching him closely: ". . .there was no shadow on his gaiety."[18]

After the meal wound to an end, Crippen and Ethel must have begun to sense a certain *froideur* in the air. The Martinettis and Nashes inched away from them. "We were all so disgusted that we gave them the cold shoulder," John recalled.[19]

It had been a shocking spectacle, aggressively unambiguous in its message: Belle was gone and Ethel had stepped into her place, her beloved diamonds winking at them from her breast. *What were they going to do about it?* Crippen seemed to dare them, while behaving as if it were all entirely normal, as if his wife would not have given it a second thought. If they had reserved judgment until that time, withheld the worst of their suspicions, they could no longer. The rising sun had made that perfectly obvious.

16

"Brazen the whole thing out"

WHEN THE DOORS OF the Criterion were opened to her, Ethel stepped off the polluted streets of Piccadilly and entered the splendorous realm of an entertainment palace. Long corridors and antechambers, a bar, a banqueting hall, restaurants within restaurants and a theater unfolded before her. The ceiling glistered with gold mosaic tile. Fires blazed invitingly in antechamber hearths. Cigar smoke and expensive eau de cologne wafted like incense. Miss. Le Neve, the typist, moved among a stream of wealthy and famous ladies in head feathers, tiaras, pearls and twinkling jewels. Hanging from Dr. Crippen's arm, she joined the river of guests as it coursed into the dining room. This was her debut.

When a gentleman's typist accompanied him to a formal event in place of his wife, observers would be in no doubt as to the status of their relationship.

Ethel would have spent years imagining this moment, but when recounting her experience, she feigned indifference about the evening. Neither she nor Crippen were ever truly interested in attending. The doctor hated dancing, but as "he wanted to keep on friendly terms with the theatrical people," he felt it worth the effort. He also "thought it would make a nice change" for Ethel, who did not get out very often.[1] For her part, Ethel claimed that the mere possibility of appearing at the event made her anxious. "I knew that people would talk about me going with the doctor while his wife was away," and she worried that it had been "such a long time since [she]

had done any dancing" that "the ordeal would be too much." In the end, Ethel said she simply "went to please him."[2]

The matter of finding something appropriate to wear also troubled her, as a girl could not "go to such a ball in an ordinary frock."[3] The possibility of wearing one of Mrs. Crippen's gowns had occurred to her. She had been aware that Belle had left behind much of her clothing when she went away, as well as a good deal of "dress lengths" which might be used to make up a frock. But Ethel claimed she would never actually do such a thing, and even if she'd wanted to, "Mrs. Crippen's big figure and my own small size would have made it absurd for me to put on one of her gowns." Instead, she claimed she had one made for her from fabric she had purchased with her own money at Swan & Edgar, a department store.[4] "All I wore of Belle Elmore's was 'the rising sun brooch,' which Crippen persuaded me to accept," Ethel professed.[5]

Despite her many objections and protests, Ethel would declare that she had enjoyed herself immensely, and she and Crippen made themselves "quite at home in the ballroom."[6] The orchestra played sixteen dances that night and the doctor set out conspicuously to revel in the entertainment with Ethel as well as with other partners. She was convinced that "he had made a good impression on everybody."[7] Paul Martinetti certainly remembered Crippen looking "very jolly" that evening, while the entertainment journalist William Buchanan-Taylor commented that Belle Elmore's husband appeared "excited" and "livelier" than ever as he waltzed, cotillioned and quadrilled away the hours.[8]

If anyone was excited and lively, it would have been Ethel, filled with drink, triumphantly sporting Mrs. Crippen's diamonds while spinning in the arms of Mrs. Crippen's husband in a ballroom crowded with Mrs. Crippen's friends. The years of biding her time as the other woman had come to a glorious close. Until that night, many of them did not even know her name, while many others assumed she was Dr. Crippen's wife. A fortunate oversight meant that she was recorded as "Mrs. Crippen" on both the seating plan and the place cards. She even appeared listed as such in *The Era*.[9]

As far as Ethel was concerned, the occasion had been a resounding success. She was thrilled to have been "quite accepted by the friends of Belle Elmore." If they had found her presence awkward, then they certainly did not betray themselves, Ethel claimed. After all, "they were theatrical ladies, and they played their part naturally, and played it well. There was nothing for me to complain about. Nobody stared at me, and not a single cattish word did I hear . . ." The looks and whispers that had passed between the Guild members and their husbands had obviously gone undetected. "I did not even know that each and every one of them had noticed the rising sun brooch and recognized it as the property of Belle Elmore."[10] Ethel caught not the faintest whiff of their outrage, or if she did, she simply didn't care. Later she would declare that most women believed that she had gone to the ball "to brazen the whole thing out," and although she denied that that had been her intention, she could not "blame them for that natural inference."[11]

Of all the accounts that helped to form the picture of the events surrounding Belle's disappearance, Ethel's contributions would be the most peculiar and suspiciously inconsistent. Few of her recollections tally with those of others. She was to give four separate narratives of what had transpired in the first few days of February. She gave two accounts in 1910, another in 1920 and a final version in 1928.[12] On each occasion, incidents are altered, sometimes omitted, and other times embellished (usually by the hand of the journalist interpreting them). For one who had spent six years anxiously awaiting the day when Belle Elmore would exit Hawley Crippen's life, she seems to have no clear memory of what actually occurred when that moment finally arrived.

In her 1910 memoirs, Ethel stated that on the morning of February 1, she went into the office at Albion House as she always did on a Tuesday. She claimed that she "saw the doctor all that day as usual, and worked with him, until he left his office in the evening, when he wished me good night quite cheerfully, and went back to Hilldrop Crescent, leaving me to return to my lodgings in Hampstead." But, by 1920, Ethel had changed her story significantly. In this version

she stated that "Hawley Crippen had not arrived at the office" when she came in that morning. "This was unusual," she remarked. "No matter what was happening the night before at his house, he was always punctual, always there before the other members of the staff." Ethel then remembered finding a note which "either he had left . . . or he had sent it by some messenger." She could not "remember the exact wording of the letter. But it was to the effect that he had some business to attend to and would not be in the office until later in the day . . ." She would recall that Crippen had gone to see the Martinettis to check on Paul's health, and when her employer returned to the office later that afternoon "he came over to my desk and with a quiet smile, spoke" to her.

"'Well, she's gone at last.' He did not say who had gone, but I knew instinctively.

"'Has she gone across the water?' I asked.

"'Yes,' was the reply . . ."

Crippen then suggested that he and Ethel "go out tonight and have a little dinner by way of celebration." She claimed that they then "left the office together and went to the West End" where they had a "modest but nice" meal, before he walked her home to Mrs. Jackson's.[13]

Those were the events of February 1, she affirmed in 1920. But they could not have been—for Crippen would claim he had only discovered that Belle had carried out her threat to leave him when he returned home that night.

In her 1910 memoirs she then describes the following day, February 2. When she "reached the office at nine o'clock in the morning I found on my table a note from the doctor, enclosing two letters. One was addressed personally to Miss. Melinda May, the secretary of the Music Hall Ladies' Guild . . . and the other to her in her official capacity." There was also a third note, addressed to Ethel, which read: "B. E. has gone to America. Will you kindly favor me by handing the enclosed packet and letters to Miss. May as soon as she arrives at her office, with my compliments? Shall be in later, when we can arrange for a pleasant little evening . . ."

Ethel supposed that Dr. Crippen "was at this time . . . at Craven House, Kingsway," tending to his Aural Remedies business which he ran from an office at the site. She "imagined that he had come to Albion House the first thing in the morning, left the note for me, and then gone on to Kingsway." In this account, Ethel claimed that it was on the 2nd when she learned Belle had left and became "immensely excited at the disappearance of Dr. Crippen's mysterious wife."

Around twelve o'clock she dutifully "stepped round the passage and handed the packet and letters to Miss. May." Ethel "naturally supposed that the letters had some connection with the departure of Belle Elmore," but she paid little more thought to it than that. Crippen then finally appeared at the office around four o'clock.

"I have had your note," I said when he arrived. "Has Belle Elmore really gone away?"

"Yes," said the Doctor. "She has left me."

"Did you see her go?" I asked.

"No. I found her gone when I got home last night."

"Do you think she will come back?"

"No, I don't," he said, shaking his head.

"Did she take any luggage with her?"

The Doctor's answer was: "I don't know what luggage she had, because I did not see her go. I dare say she took what she wanted . . ."

According to this 1910 version, something quite "remarkable" then took place.

The Doctor thrust his hand into his pocket and drew out a handful of jewels . . .

"Look here," he said, "you had better have those. At all events, I wish you would please me by taking one or two. These are good, and I should like to know you had some good jewelry. They will be useful when we are dining out, and you will please me if you will accept them."

I said, "Well, if you really wish it, I will have one or two. Pick out which you like. You know my tastes."

After selecting a few pieces, Ethel then suggested to Crippen, a man who had spent his married life investing in jewelry and educating himself in the worth of diamonds, that it might be a sensible idea to pawn or sell the remaining jewels.

"'That is a good idea,' he said. 'I will take your advice.'"

And with that, Hawley Crippen walked out on to the London streets and went to the nearest pawn shop, his pockets bulging with thousands of pounds' worth of diamond and gold jewelry.[14]

While Ethel's recollection of events appears confused and unreliable, others were able to recount her movements, behavior and conversations more clearly. Emily Jackson remembered that as early as the beginning of January, something seemed to be troubling her lodger. It all began about five or so days into the New Year, she said.

She recalled noting a change in Ethel in the evenings. The young woman would leave work, take the tram to the terminus at South End Green, and walk through the winter darkness to 80 Constantine Road. Emily would greet her, usually between 7 and 8 p.m., slightly later than she had in the past. This in itself was not odd; rather, it was Ethel's demeanor. She did not seem like her usual self, but appeared "very miserable and unhappy about something." Whatever it was, "it made her look very ill." This seemed to worsen as the weeks progressed. "Throughout the whole of January she was depressed" in a way which made her eyes look "very strange and very haggard." On at least a dozen occasions, Mrs. Jackson begged Ethel to confide in her, but her lodger-friend dismissed her concern. She claimed it was only "the accounts in the office" that were worrying her, but Emily was never convinced this was the entire truth. She had seen Ethel unwell before. The young woman suffered from a range of complaints: anemia, colds and unusually painful periods, but Mrs. Jackson sensed that whatever bothered Ethel was something different. It seemed to be more of a psycholog-

ical affliction, some sort of internal agony, as Emily described it. It gnawed at her progressively, until one night, Ethel snapped.[15]

It occurred at the very beginning of February, Mrs. Jackson recalled. Ethel had come home as usual that evening, but something was wrong—much more so than it had been of late. Ethel was greatly distressed. She was "pale and agitated" and excused herself from supper. She could eat nothing, she told Mrs. Jackson, and then said that she wished to go straight to bed. Emily had come to know Ethel intimately, and found this so out of character for her that she followed her lodger up to her room.

"I am sure you have got something on your mind, do tell me what it is," she begged, but Ethel assured her that it was nothing. "Between you and me," Mrs. Jackson continued, "it must be something awful or you would not be in this state, you will go mad if you don't relieve your mind . . ."

Ethel did not respond.

Emily lingered in the room, waiting for Ethel to speak. As Mrs. Jackson stood there, Ethel silently got into her bed and began putting curlers in the front of her hair. Emily continued to observe the young woman, waiting for some explanation. She noticed that Ethel's "whole body was trembling with suppressed agitation." Her fingers quivered so much that she became frustrated and, in a frenzy, began to pull and claw at her hair. Then, quite suddenly, she stopped, "looked straight into a recess in the corner of the room and shuddered violently."

Her friend pleaded with her and asked Ethel several times to tell her what the matter was.

"Oh, go to bed," Ethel said in exasperation. "I shall be all right in the morning."

She lay down and refused to say any more. Emily was too unnerved to leave her and took a seat beside the bed. She remained there until 2 a.m. when she believed that Ethel had finally drifted off to sleep.

The following morning, Ethel came down to the kitchen. She

was fully dressed for work, but she appeared as distressed as she had been the night before. She was still unable to eat, so Mrs. Jackson sent her back to bed, and brought her up a cup of tea. She noticed that Ethel's hands were so tremulous that it was impossible for her to hold the cup and saucer. Emily could not allow Ethel to leave the house in such a state. She offered to telephone the doctor and tell him that his employee was "not fit to go to business." Ethel agreed, and after her landlady returned from telephoning her employer, the two sat down together. Mrs. Jackson was determined to know the source of her friend's distress.[16]

"For the love of God, tell me what is the matter, are you in the family way again?" she asked. Ethel assured her that she was not. It was another matter. She would be willing to tell her the whole story, but not immediately. Ethel had to work up the courage.

Two hours passed.

Later that morning, Ethel returned to Mrs. Jackson. "Would you be surprised if I told you it was the doctor?" she said.

"No," replied Mrs. Jackson, who thought Ethel was referring to her "miscarriage." "Do you mean he was the cause of your trouble when I first knew you?"

"Yes," Ethel replied.

"Why worry about that now it is all past and gone?"

Ethel's eyes suddenly flooded with tears. "Oh!" she cried. "It is Miss. Elmore!"

Emily Jackson regarded the young woman. She wondered what she meant. She had never heard Ethel mention a Miss. Elmore before.

"She is his wife, you know," she sobbed. Ethel then explained that she had been reminded all too often of her secondary role. Mrs. Jackson listened with as much sympathy as she could muster, but then attempted to counsel her friend.

"My dear girl, what is the use of worrying about another woman's husband?"

But Ethel would not hear it. "She has been threatening to go away

188

with another man, and that is all we are waiting for." Ethel reiterated, as she had on other occasions, that as soon as this happened, the doctor had pledged to divorce his wife and marry her.[17]

Emily Jackson remained as skeptical as she always had of this grand romantic scheme. The entire scenario was deeply sordid and dishonorable. As she listened to the revelations, she must also have grasped the full disappointment of her friend's life, indeed how many months and years this game had been in play and for how long Ethel had been waiting. On that day, all the pieces must have come together in Emily's mind: the story behind Ethel's "miscarriage"; the reason for her ambivalence toward John Stonehouse; as well as the realization that Ethel had not been telling her the full truth. Emily assembled these facts, but they never entirely accounted for everything—especially the reason why Ethel had crumbled at that particular moment. What had been the inciting incident that finally pushed her over the edge? Why had her mood increasingly darkened in January, at the same time she had been telling her friends she was engaged? Emily Jackson could not answer these questions. "She never gave me any other explanation of the cause of her agitation and worry."

Even more peculiar still was what happened the following week. After this dreadful and mysterious incident, Ethel's mood lifted. No longer in the grip of anxiety, she returned one evening, elated. She seemed to float on relief and happiness. Mrs. Jackson was startled by it. "Has someone died and left you money?" she joked.

"*Somebody* has gone to America," Ethel chimed, with a smile.[18]

Mrs. Crippen

I T WAS AT THIS point that everything changed.
From the middle of February, Mrs. Jackson remembered Ethel
staying away from home "four or five times a week."[1] Emily did not
usually pry into Ethel's life. The two chatted openly about most
things, or so Emily had always thought. However, on one occasion,
Emily asked her where she had been. Ethel told her she had been at
Hilldrop Crescent with Crippen. She boasted that he had been
teaching her how to use "a little nickel plated" revolver. In addition
to this "they had been staying up till 12 o'clock at night searching
the house" for anything of value that Belle Elmore had hidden from
her husband. Ethel was given free rein to take possession of her love
rival's life: to rummage through her locked drawers, to read her
private correspondence, to relish the experience of learning her se-
crets and knowing her weaknesses, to judge her keepsakes, to
thumb through her photographs, to touch her hairpins, her tooth-
brush, her undergarments. She admitted that they had found "a di-
amond tiara and some beautiful rings which the doctor had since
raised £175 on in the West End." She claimed he had invested the
money in the business "to put it on a firmer footing."[2] After this
conversation, Ethel began coming home with diamond rings. One
was a solitaire. "This is my proper engagement ring," she said, hold-
ing her hand out to her landlady. A few nights later, she came back
to the house with a similar one. "Do you know what this cost?" she
teased Emily. Mrs. Jackson said she had no idea. "Twenty pounds,"
Ethel announced with delight. Following this incident there was

another ring, which she claimed "the Doctor had made for her." She lied that the others had all once belonged to his mother.[3]

Other pieces of jewelry magically appeared. Mrs. Jackson remembered three bracelets in particular: "one was chased" and "one was set with amethyst stones, which I remember was too large for her," and there was another whose description Emily had difficulty recalling. Of all of Belle's jewelry, the gold bracelet she was given by the MHLG a few months earlier engraved "To the Hustler" seems to have vanished—or perhaps this was the third bangle to adorn Ethel's wrists. Emily also noticed that her lodger had started wearing "a star shaped brooch set (with) diamonds or brilliants." Ethel revealed to her friend that "she had previously seen this brooch at the house in Hilldrop Crescent" and "by a little persuasion" managed to get it out of the doctor. This acquisition was accompanied by "two gold watches," one of which "the Doctor had made her a present of," but how the other came into Ethel's possession, Emily did not know.[4]

Into whose hands the many other pieces of Belle's sizable and expensive collection of diamonds were placed is largely a mystery. As early as February 2, Crippen visited Jay Richard Attenborough & Co., an Oxford Street pawnbroker, and secured £80 for a diamond ring and a pair of diamond earrings. He would return a week later, on the 9th, with a diamond brooch and six diamond rings, for which he was given £115.[5] Crippen evidently had gained access to the bulk of his wife's jewelry, which, prior to Belle's death, had been moved from the Chancery Lane Safe Deposit into a safe in their home. Ethel and Crippen negotiated between themselves which items she might appropriate and what he felt was necessary to keep for financial reasons. The remainder would have been dispersed throughout London, among a variety of jewelers and pawnbrokers, both respectable and otherwise. Crippen, a gambling man with criminal connections, would have known precisely at whose shops he could exchange a hoard of diamonds for banknotes with no questions asked. Many jewelers walked a thin line with their dealings. If the rings, necklaces and watches being offered to them were not listed

in the published gazettes of stolen goods, agents were not troubled by the objects' provenances.[6]

Ethel's newly acquired jewelry was accompanied by a substantial gift of clothing and expensive fabrics. The low-paid typist in her modest white work blouses and plain skirts now had more luxury at her disposal than she could have ever dreamed. She assumed ownership of many of Belle's most lavish furs: a long sealskin coat, a light fur coat, a fox-fur cape, two fur boas which dangled with animal heads and tails, as well as two fur muffs and fur-lined gloves. On one occasion, Mrs. Jackson recalled Ethel and Crippen arriving at the house on Constantine Road with "a large dress basket, containing all kinds of dress material—all new."[7] Ethel opened the basket in order to dazzle her friend with her bounty of silks, satins and wools. Afterward, she took her fabrics and articles of clothing to Caroline Elsmore, a local dressmaker, to be altered or made into new gowns.

According to Mrs. Elsmore, Ethel appeared in her shop in early February "with a large box and said, 'Oh, I want you to do a lot of work for me because in six weeks' time I am going to be married.' "[8] Ethel explained how her fiancé's aunt had a house on Hilldrop Crescent which had been left to him. The aunt had asked Ethel's fiancé to dispose of everything when she returned to America but wished "all of these things" to go to the future bride. Between February and June of 1910, the dressmaker created five different outfits for her: a dress and matching jacket of blue serge, another of light gray, a white princess-style dress trimmed with gold sequins, a mole-color "costume" with a black silk collar and a similar one in dark "vieux rose." These all were made from lengths of new fabric, except for a light heliotrope- (or violet-) colored dress which was too large for Ethel and had to be "cut down" to fit her. Ethel had also given Mrs. Elsmore a roll of amber silk from which to make another dress, as well as a brown coat to alter.[9] Whatever Ethel chose to wear to the Benevolent Fund Ball, it was more likely to have come from Belle's collection of fabrics and Caroline Elsmore's sewing machine than from Swan & Edgar department store.

Ethel was drowning in clothing, shoes and fashionable accesso-
ries, much of which she resolved to give away as gifts to her friends
and family. Mrs. Jackson was rewarded with a short brown fur coat,
as a mark of gratitude for her loyalty. "Doctor thought you would
like to have this," Ethel told her as she handed over the extravagant
present.[10] This was just the start of it. A steady stream of assorted
apparel was showered upon Mrs. Jackson between February and
March: matching skirt and jacket sets in stripes, moleskin and black
voile, blouses, a yellow skirt, winter coats, three hats, nightdresses,
stockings, slippers, articles of costume jewelry and a length of helio-
trope fabric. Ethel sought to bless each of her friends with some-
thing from Belle's wardrobe. Lydia Rose and her mother were sent
a fur muff, a linen dress, beads and some blouses. Even former lodg-
ers of Mrs. Jackson, Caroline Rumbold and her daughters, were
given some costume jewelry, stockings and shoes. Naturally, the
best was reserved for Ethel's sister Nina, on whom was bestowed a
black silk dress and petticoat, a maroon velvet skirt and jacket, a
golden shantung silk dress, a black coat with heavy braiding, a
cream-colored stole cape, hats, ostrich feathers, pieces of embroi-
dery and a pair of ladies' boots.[11] Ethel was obviously cautious about
stirring her parents' curiosity and suspicion, but did not wish to
omit her mother from her acts of generosity. She gave Charlotte
Neave some bed sheets which were immediately pawned.

Ethel must have been resolutely confident that the owner of these
items would never again need them or return to Hilldrop Crescent.
It was "the most natural thing in the world" that a woman should
walk "straight out of the house, abandoning her old home life, and
relinquishing everything it contained," she would later explain.[12]
Ironically, the Music Hall Ladies' Guild, who placed weekly appeals
in the newspapers for unwanted articles of women's clothing, would
have gratefully received the contents of Belle's discarded wardrobe.
Melinda May and the other members would have found it highly
out of character for Mrs. Crippen not to have contributed her be-
longings to the charitable endeavor.

After six years of tireless waiting, Ethel was finding it difficult to

subdue her impatience. She was eager to move her life forward. A timeline which might have progressed more gradually was only to be hurried by yet another imperative. Emily Jackson's husband had accepted a new job and the family would be giving up their rented home and moving to South London on March 19. This was a hard deadline which would require Ethel to find alternative accommodation, though she had no intention of living anywhere other than 39 Hilldrop Crescent. In order to do that, without scandalizing her friends and family, Ethel needed to be married.

Ethel had wasted no time in writing to Nina and informing her that Belle had finally left Crippen. She claimed he was seeking a divorce in America. The problem was that this was a lie—there would be no divorce, and so there could be no marriage. Thus would begin the process of weaving an extensive and intricate tapestry of falsehoods designed to distract everyone from the truth.

In late February, while Ethel and Crippen were visiting the Brocks, Ethel took Nina upstairs and announced to her that she would be getting married in three weeks' time. Nina admitted that she was relieved "the road was clear" for the two of them.

"Yes, dear," responded Ethel, "I think I shall be very happy and I shall try and make the Doctor very happy."[13]

Having told her sister this first lie, it became necessary to pull the entire piece of yarn through and make a convincing picture with it. Right on schedule, in early March, Ethel dashed off a brief note to Nina: "We have been and gone and done it."[14] She then wrote to her friend Lydia Rose that she had been "quietly married last Saturday" and that she and her new husband intended to go away over the Easter holidays.[15] They would be going to the fashionable port town of Dieppe on the north coast of France, which Ethel claimed would be "their honeymoon." Now that she had broken the news to her sister and to her friend, the difficult and delicate chore of informing her parents loomed. If Ethel planned to go away with Crippen over the holiday weekend of March 25–27, she had to tell them soon.

Ethel had instructed Nina to say nothing to their parents about her marriage. She would broach the subject herself, as it required a

light and calculated touch. Walter and Charlotte were certain to disapprove of a secret wedding to a man with a complicated past. She went alone to see her mother, on an evening in mid-March when Walter was not at home. Ethel was anxious but managed to slide the news casually into her conversation. Charlotte, who had neither been invited to her daughter's wedding, nor even informed of an engagement, was shocked. At first she thought Ethel was making "one of her usual jokes." "I had never dreamed of such a thing!" she exclaimed. Ethel, apparently, just laughed and stated that being her employer's wife "was much nicer than just being his typist." She informed her mother that they had been married at the St. Pancras register office and that the ceremony had been witnessed by two of the doctor's "intimate friends," neither of whose names she provided.[16]

Later that night Charlotte informed her husband. Walter was furious. He was "disgusted" at his daughter "for marrying the Doctor" and failing to consult her parents about her choice. "When I heard of Ethel's wedding, I asked about the former Mrs. Crippen," her father admitted.[17] There would have been a genuine fear that Ethel had wrecked a marriage, that she was at the center of an adulterous scandal and had married a disreputable cad of a man—a divorcee. Walter was so angry that Ethel felt it necessary to assuage her father's concerns further: she revealed to him that Belle Elmore was dead. To add further credence to her story she explained that "a friend of Crippen's had come from America specifically to report her death."[18]

Ethel would not have the honeymoon for which she had waited six years spoiled by her father's opprobrium. The new, unofficial Dr. and Mrs. Crippen went to Dieppe, notwithstanding. Finally, Ethel was able to embrace her dream and wear openly her status as the doctor's wife.

Dieppe, a stylish resort town, was an appropriate backdrop against which to enact her fantasy. Situated halfway between Paris and London, artists of the avant-garde joined members of the aristocracy on the breezy terraces to paint, flirt and sip brandy sodas while staring out at the green sea over rows of bathing machines.[19]

Although "Dr. and Mrs. Crippen" made the most of the town's glamorous surroundings, they did not stay at one of the grander establishments, the Hotel Royal or the Metropole, but a discreet one owned by a Madame Vacher, on the corner of the rue de la Morinière and the rue Aguado, facing on to the sea. Crippen obviously wished to remain mindful of whom they might encounter during that holiday weekend.

Ethel sent Nina a postcard raving with the enthusiasm of a newlywed about "what a lovely place Dieppe was" with "beautiful valleys" and "beautiful weather, so different from chilly England." After which she added that she had just learned Belle Elmore had died. In spite of having told her father weeks earlier, she disclosed to her sister that "Hubby had heard that morning that she was dead" and apparently "she had caught cold going across, result[ing] in pneumonia . . . was it not sad that one in the prime of life should be cut off?"[20]

The timing of this is significant. Just before she and Crippen had slipped away to France, he had gone down to the offices of *The Era* and placed an obituary in the paper, formally announcing Belle's death. It appeared on Saturday the 26th, while they were abroad. Later Ethel would claim in her official statement that she had no knowledge of Belle's death until the night of their return to Hilldrop Crescent—or perhaps it was the night after that? She could never quite remember. She would say that after Crippen delivered the news to her, she and her "husband" never spoke of it again.

With the public announcement of Belle's death must have come a sense that everything had been simplified. Although Crippen and Ethel's marriage would be considered indecently hasty, at least there would be no more questions about the former Mrs. Crippen's whereabouts. While Ethel warmed herself in Belle's furs against the fresh sea breezes, she must have felt quiet relief that the long noses of Albion House would soon be put in their place, and that she could assume her rightful position as the chatelaine of 39 Hilldrop Crescent.

18

Observations and Inquiries

I N THE IMMEDIATE AFTERMATH of the Benevolent Fund Ball, few of the Crippens' friends wanted much to do with Belle's husband. The doctor and the typist, who was obviously his mistress, had behaved abominably, flaunting their relationship in front of his wife's friends while she was overseas tending to a family crisis. The situation was at best awkward and at worst increasingly suspicious, especially as no one had heard from Belle since her departure. Her companions and professional associates were bemused by such uncharacteristic silence, and as the weeks passed, few were convinced that her husband was telling the entire truth. Nevertheless, they continued to await some communication from her—a letter, a postcard, anything which would add clarity to the confusion.

The Martinettis too had kept their distance, except for when Hawley Crippen paid what had started to feel like obligatory visits to them, casually dropping by in the middle of the afternoon, as if nothing unusual had happened. When he appeared at their door in the middle of March, Clara had begun to lose her patience. "Well, did you not hear from Belle yet?" she asked upon greeting him. Much to her surprise, this time he answered "Yes."

"I cannot make it out," he continued. "I have a letter from my relations to say she is very ill and had something the matter with one of her lungs." Clara said that Crippen seemed genuinely perplexed. He must have noticed her concerned expression, for he added, "I also got a letter from Belle to say that [you] must not worry, she is not as bad as they say."[1]

This, like all the details Crippen had previously provided, struck Mrs. Martinetti as strange. "I never knew she had anything wrong with her lungs," she commented.[2]

This unsettling news was to be followed a week later by a letter written from Hilldrop Crescent, which the Martinettis received on Monday, March 21:

Dear Clara and Paul,

Please forgive me for not running in during the week, but I have really been so upset by the very bad news from Belle that I did not feel equal to talking about anything, and now I have had a cable saying she is so dangerously ill with double pleuro-pneumonia that I am considering if I had better not go over at once. I don't want to worry you with my troubles, but I felt that I must explain why I had not been to see you. I will try and run in during the week and have a chat. Hope both of you are well, with love and good wishes.

Yours very sincerely,
Peter[3]

Paul was so concerned by the letter's contents that on Tuesday he went directly to Albion House. He climbed the stairs and found Crippen in his workshop with William Long, compounding and packaging medicines. "Look here, Peter," said his friend, "if I were you, I should take the first ship I could get hold of and go to America."

The doctor had been taken off guard by this unexpected visit. He looked at Paul, "made no answer but simply shrugged his shoulders."[4]

Later that day, Crippen went over the road to King Edward's Mansions to clarify matters. Clara was extremely anxious to see him and to learn what she could about her friend's condition. How was Belle? she inquired.

She noted Crippen's downcast expression.

She was very bad, he responded.

"But double pneumonia," Mrs. Martinetti exclaimed, "I cannot understand how she got it."

It was Belle's own fault, her husband stated. She "was always a girl who was so self-willed and would go out after having a cold."

The following day, the Wednesday before Easter, the MHLG met as usual. Clara shared the unsettling news of Belle's ill health among the ladies, who had until then been starved of information about their friend. They turned over their many concerns and questions among themselves. When the meeting concluded, and Clara and Annie Stratton were departing, they spotted Hawley Crippen at the entrance to Albion House. "How is Belle?" Clara hailed him with the all-too-familiar question.

The doctor was glum. "I have got a cable and I expect another any minute to say that Belle is gone." He opened the heavy front door, hoping to escape from them, but Clara and Annie followed him out. He crossed the road, avoiding the rumbling motorcars, but the ladies kept pace with him, interrogating him as he strode on.

"If anything happens to Belle I shall go to France for a week," he announced.

Clara found his response strange. "Whatever for?"

"I could not stay in the house and want a change," he said before darting off.

The Martinettis spent the rest of the day on tenterhooks, awaiting word from Crippen. The next day, a telegram arrived. It had been sent from Victoria Station to their flat: "Belle died yesterday at 6 o'clock. Please phone Annie. Shall be away about a week, Peter."[5]

Crippen was on his way to France.

Clara was stunned, but this emotion soon burned away, leaving behind a smoldering sense of incredulity. Something about this did not seem right.

With the telegram in her hand, she marched over to Albion House and knocked on the door of Gilbert Rylance's office. She held out the message and asked him "if he knew anything about Mrs. Crippen's death."

The dentist examined the telegram. "I know nothing at all about it," Rylance confessed, equally perplexed.

Clara was not convinced. "What? Does he not confide in you?"

she asked, barely disguising her annoyance. "Didn't you know Mrs. Crippen was ill?"

"Mrs. Martinetti," he responded, "I don't know anything. The Doctor does not confide in me about his private affairs."[6]

Clara then informed Rylance that his business partner was going to France for a week, was he not aware of this? Again, the dentist claimed he knew nothing about it, nor had any idea as to where his partner had gone.

Clara strongly suspected that they were being had. She looked over at where Ethel normally sat. "Where is Dr. Crippen's typist?" she inquired.

"Oh, she has gone on her holidays," Rylance remarked.[7]

That was all Mrs. Martinetti required. She went home and immediately telephoned Annie Stratton. Then she went directly to her friend's house and brought Crippen's telegram with her. The two women spent the afternoon poring over it. "We both thought it was very strange," she said.[8]

Over that Easter weekend the spurious news of Belle's demise fanned out across the Guild. Letters were written to the absent president, Isabel Ginnett, who was headquartered for the winter at their touring company's horse farm in Roselle, New Jersey. If this was true, it was a devastating turn of events. The members found themselves even more confused when that Saturday a death announcement appeared in *The Era*: "Elmore—March 23 in California, USA, Miss. Belle Elmore (Mrs. H. H. Crippen)."

Unfortunately, John and Lillian Nash, who were among some of Mrs. Crippen's dearest friends, would be the only party to remain ignorant of what had come to pass. On the day of Mrs. Crippen's reported death, they had embarked on a visit to the United States, which, conveniently for Hawley Crippen, would keep them at a safe distance for several months.

If Crippen had hoped that the Guild members and their husbands would grieve quietly, leaning on one another for solace before moving forward with their lives, he was to find himself quite mistaken.

On Wednesday, March 30, he was back at Albion House, and so too was the Music Hall Ladies' Guild Executive Committee.

Louise Smythson, one of the MHLG's five vice presidents, was not about to let the matter lie. Constance Louisa Hodgson Cole, as she had once been known, had learned much about the behavior of men in her forty-seven years. She had begun her career as a teenaged performer in Glasgow, as one half of the double act Jim & Louisa Cole. Within a handful of years of performing and touring together, she had borne Jim Cole a daughter and then been abandoned by him. She had also appeared on the football pitches as a member of one of the first Scottish women's squads, a novel idea alighted upon by a theatrical manager who wished to find employment for his out-of-work actresses and dancers.[9] However, after violent crowds of men attacked the bare-shouldered players in their frilly knickerbockers, Louise and her teammates returned to the stage.[10] Following several years of performing and raising her daughter alone, she married Clarence Smythson, with whom she appeared as a comedy duo. Louise did not suffer fools and, like Clara Martinetti, suspected that Hawley Crippen was not being truthful. After the meeting, she and Clara decided to question Belle's husband and to press him for the finer details of their friend's death.

The two went to his office and began by offering the bereaved doctor their condolences; they conveyed to him how sorry they were to hear of his trouble. The awkward Crippen "simply shrugged his shoulders." The ladies persisted. Louise asked him how long Belle had been ill. He answered that "she was taken ill on the boat" and then had failed to "look after herself sufficiently."[11]

"The ladies wish to send an everlasting wreath for her grave," Louise explained, but they also were curious to know the details of Belle's death—where she was when she died and where she was likely to be buried.

Crippen didn't answer her questions. Instead, he made it clear that he did not want a fuss. A wreath "was quite unnecessary."

"Oh yes, we have to do that," Clara implored. "We would like to do it. We have to do it."[12]

The Guild "were very anxious to send some little token," Louise explained, if he would just let them know where she was to be buried.

Crippen continued to object. Belle was "now dead and no one of their friends in America knew of the Ladies Guild . . ." No, he insisted. It was "quite unnecessary" to give out the address.

Louise held firm and pushed him again for the name of the place where Belle died.

Crippen quickly pivoted. "She is not going to be buried, she is going to be cremated," he stated. In fact, "he was going to have the ashes sent to him" and then they could have a ceremony in London.

Clara then asked if any of Crippen's relations had been present at Belle's bedside.

"I will give you my son's address," he announced.

"Did she die with him, and did he see her die?" Louise asked.

For a moment, Crippen seemed confused. "Yes, my son was with her when she died in Los Angeles," he finally replied.[13]

He took a pencil and then scribbled down: 1427 N. Hoover Street, Rural Delivery, Los Angeles, California, the address of his son, Otto, who he had not seen in at least twelve years.[14]

Both women seemed satisfied enough to depart with this scrap of information. They took the address to Melinda May, who made a note of it, as did Clara and Annie Stratton. Louise immediately wrote a postcard "asking for particulars of the death of Miss. Elmore."[15] This, Mrs. Smythson decided, was to be but the first strike against Crippen's facade of stories.

The second assault would begin on the following day, when Louise paid a visit to the headquarters of the Metropolitan Police at Scotland Yard. She went down to the Gothic building at Victoria Embankment and asked to see an inspector. She was offered a seat and proceeded to recite her concerns to the police, repeating each of Crippen's tales and his strange explanations. She told them about the events of the ball, and about Ethel and the brooch she wore. Whichever member of the constabulary had listened to these stories was not moved. No one appears to have taken this theatrical

lady's concerns seriously, at least not enough to have documented it in their records.

"I was under the impression that Scotland Yard kept their eye on all suspicious persons," Mrs. Smythson would later complain in *The Performer*, "but the inspector told me that unless I made a definite charge he could not give me any aid."[16] Frustrated, she left, but not before asking the inspector to write down the names and addresses of several shipping offices and the American Embassy, which he had instructed her to try. Louise wasted no time. From Scotland Yard she went directly to the embassy and attempted to learn where Belle's death might have been registered in the United States. She fared little better there than she had with the police. All she was given was an address of a county clerk in the United States to whom she could forward her queries.[17]

Back at Albion House, the walls had grown eyes and ears. Marion Curnow, who had taken over as the official manager of Munyon's since February 1, had long suspected that Crippen had been romantically involved with his typist. He "had appeared to be on familiar terms with her" for years, she would comment. Shortly before Easter, the doctor had mentioned to her that "he was going to Dieppe for a holiday." She thought it interesting that his typist had also planned to take her holiday at the same time. Marion "had a shrewd suspicion that he went with Miss. Le Neve" and, after his return, quickly put it all together—the disappearance, the illness and death of Mrs. Crippen.[18] Soon, she, Clara Martinetti and Melinda May were quietly discussing the situation, comparing notes.

Having witnessed Crippen and Ethel's behavior and listened to his prevarications and inconsistent claims, the Guild ladies were now even more of the conviction that something was amiss. Without the assistance of Scotland Yard, it had become incumbent upon them to pursue the mystery of Belle's disappearance themselves. Because the police could not charge Crippen with any particular crime, Melinda May determined that the MHLG Committee had to go on "observing and making inquiries."[19]

Mrs. Smythson was eager to continue in her role as detective. In

the coming days, she sent committee member Violet Bartram, a tightrope walker known as "La Belle Atalanta," to follow up with the shipping companies who ran services to the United States. Violet went to the offices of White Star Line, Cunard Line and American Line and, with the assistance of the clerks, examined the passenger lists.

In the meantime, Louise enlisted the assistance of Louie Davis and together they paid a visit to Hilldrop Crescent. They knocked persistently on the door of number 39 and after meeting with no reply, began canvassing the neighbors. The two nicely dressed ladies politely inquired if anyone had seen Belle Elmore recently. It appeared that no one had, at least not since Monday, January 31. They asked the residents if they had noticed any luggage being removed from the Crippens' home. No one had observed this, either.[20] Louise reported the disappointing news to her friends; but Clara and Annie remained determined to confront Crippen and extract some useful information from him. A few days later, on April 3, they too mounted an excursion to Hilldrop Crescent. This time they turned up at number 39 with a man: Annie Stratton's 22-year-old nephew, the son of prizefighter Charley Mitchell. The ladies sat in a motor taxi and sent young Mr. Mitchell to knock on the door. He banged at it repeatedly and waited. Just before he gave up, Hawley Crippen appeared. He came down to the kerbside to speak to them, but did not invite the ladies in. Crippen was guarded and sparing with his conversation. Annie made a point of asking which ship Belle had taken to the US "Wait, let me think," he said, before mentioning a name like *La Touvee* or *La Tourenne* or *La Lorraine*—Clara could not recall the name exactly—but "he said it sailed from Havre," a French port.[21]

With their case progressing only in small increments, Lottie Albert, the Guild's temporary treasurer, took the decision to hire a private investigator, Michael Bernstein. In fact, Bernstein would later confess that he was merely "an amateur detective."[22] His day job was as a "translator and interpreter," but "the task of solving a mystery [had] always appealed . . . irresistibly." He had known Belle

and a number of the Guild members socially, perhaps through his wife Christina, who was a musician.[23] Bernstein claimed that his suspicions had been aroused after spotting Belle's death announcement in *The Era*. When Lottie Albert approached him, she explained that the friends of Mrs. Crippen "were merely anxious for full reliable information as to her disappearance." No one had imagined "that anything was seriously wrong."[24]

As a translator, he was given the assignment of searching the passenger lists of the Compagnie Générale Transatlantique who operated a steam liner called *La Touraine*, which sailed from Marseilles, a considerable distance from Le Havre in the north. Not only could Bernstein find no trace of a Belle Elmore or a Mrs. Crippen, or any variation of her name, in their records, but he also discovered that *La Touraine* had been unable to sail in early February on account of engine failure.[25]

While Bernstein rooted through documentation and met with Lottie Albert and the Martinettis, Mrs. May kept a shrewd watch on Hawley Crippen, who continued to conduct his life as might any bereaved widower. Melinda was never convinced by his role-playing. Every day until the weather grew warmer, he appeared at work wearing "a black hat band and a black armlet," as he "feigned grief."[26] He appeared "studious" and "calm," acting his usual contained self. Like her colleagues, the secretary's curiosity and her implacable suspicion led her to make repeated, unsolicited calls at 39 Hilldrop Crescent. On her first visit, she was not surprised to find Miss. Le Neve answering the door. In every instance, Ethel would show her in and chat with her, but Crippen "always remained downstairs" until Melinda had departed.[27] His artifice was immaculately crafted, she concluded, but if they were to learn anything, it would become essential to dismantle it, or at the very least to sneak a glimpse behind it. Michael Bernstein did what he could in this regard. On several occasions, he appears to have tailed Crippen, and on another, he was able to gain an invitation to a dinner party attended by the doctor and his typist.[28] Disappointingly, even these efforts revealed nothing.

It was not until the end of May that the Guild ladies were to receive their next perplexing piece of information. It had been nearly two months since Louise and the other committee members had written to Otto Crippen in Los Angeles, hoping to corroborate the events of their friend's death. On May 24, his eagerly awaited response arrived at the Guild office, addressed to Melinda May.

May 9ᵗʰ 1910

Dear Madam,

Received your letter forwarded to me from the County Clerk, April 23ʳᵈ 1910, but owing to many misfortunes, sickness and death of our son, I overlooked your letter until this date. The death of my step mother was a great surprise to me as to anyone. She died at San Francisco and the first I heard of it was through my father who wrote to me immediately afterward. He asked me to forward all letters to him and he would make all the necessary explanation. He said he had through a mistake given out my name and address as my step mother's death place. I would be glad if you find out any particulars of her death if you would let me know of them, as I know as a fact that she died in San Francisco.

Yours, etc.

H. Otto Crippen[29]

If ever there had been any doubt that Hawley Harvey Crippen had been lying to the committee, then this confirmed it. However, if the contents of the letter were partially true, and Belle *had* died, and died in San Francisco, why would he not tell them this? What was he hiding? Only the week before, Louise and Clara had spied Crippen "and the typist" in a shop on Tottenham Court Road and cornered him. On that occasion, Louise had pressed him for further information about his wife's funeral in California. Had there been one? "Yes," responded Crippen, "it is all over, and I have her ashes at home."[30] This news too came as a surprise. To Louise and Clara, and to Belle's other friends, nothing seemed to be making any sense.

What was clear to them was that they were not getting the an-

swers they demanded. In a change of tack, Lottie Albert arranged to see Bernstein again. She handed over Otto's response to their letters, as well as Belle's notes dated February 2 to the MHLG, resigning her position. Lottie provided the detective with the necessary background, explaining that (apparently) both letters had been dictated to Crippen by his preoccupied wife as she packed and prepared for her journey. Belle put her signature to one of the letters, Lottie pointed out. The amateur sleuth examined the correspondence closely and took special note of the manner in which Belle had written her name. When comparing it to another signed letter, known to be from her, he noticed immediately that the signature was a forgery. Not only that, but it seemed that whoever had copied it had made the mistake of spelling Elmore with two "l"s. What made this even more suspicious was that no one among the committee recognized the handwriting as either Belle's or Crippen's.[31]

The Guild had been circling, drawing nearer and nearer to Crippen, but he was proving artful. The doctor always seemed to be at least one chess move ahead. Belle's friends were now adamantly convinced he was hiding something, but what exactly that was, they had yet to discover.

19

The Bad Girl of the Family

IN THE SECOND HALF of February, Ethel threw herself into the task of cleaning 39 Hilldrop Crescent. While engaged in "putting the house straight," she allowed her closest confidante, Mrs. Jackson, to have a look inside the home that would soon be hers. Ethel, who had been gloating over her inheritance of clothing and jewelry, savoring the promise of her future life, obviously wished to share a glimpse of her good fortune with her landlady. Although Mrs. Jackson was shown around the many spacious and well-furnished rooms, her lasting impression of 39 Hilldrop Crescent was of "a very strange smell all over the house, particularly downstairs." It was so overpowering that she mentioned it to Ethel. She described it as "a fusty, musty smell."

"Yes," Ethel commented, taking it in her stride. "The place is very damp, and in a filthy condition. This is how Belle Elmore left it before she went away to America."[1]

After that, Emily was not invited back for some time.

Her next visit was in mid-June, and Ethel assured her before she came that the smell was now gone. "I have been so busy with the wretched house and think you would hardly recognize same . . . It's real hard work to keep it anywhere near clean and spend the afternoon in bliss."[2] Ethel seemed to complain incessantly about the tidying to be done. In her memoirs, she claimed she would spend each morning tending to it and then doing the shopping before she was able to go into the office and perform her secretarial duties. Considering the size of the place, Mrs. Jackson expressed wonder at how she managed to clean it all herself. Nina, too, when she first came to

view the house in March, quizzed her sister about the obvious absence of a servant. "I don't think Belle Elmore could keep a servant," Ethel sneered, "as she always kept them short [of money]."[3]

With all the work to be done around the house and all the complaining that Ethel did about Belle's slovenliness, it would be a further three months from the time Ethel moved in before the couple chose to hire any domestic help.

Whatever cleaning and clearing the newly-weds were undertaking was certainly more than the usual. Through-out February and March, they were disposing of a significant amount of un-wanted items from within the house. For several weeks, piles of belongings, paper and clothing were burned in the garden. There was so much smoke and waste that the neighbors told the rubbish collectors that they believed the occupants of 39 Hilldrop Crescent were in the process of moving out. Elizabeth Burtwell, who occupied the top back room of the house that overlooked the Crippens' garden, remembered seeing the doctor bring out four enamel pails' worth of detritus that he was burning in the metal rubbish bin. It was an unusual spectacle, she remarked, as she had never seen them burn anything before and "there was a lot of smoke."[4] The dustman, William Curtis, who had been collecting the rubbish from 39 Hilldrop Crescent for the past nine years, was struck by the unusual amount of waste that was produced in the middle of February. There were "4½ baskets of burned refuse." In addition to what had been thrown into the metal bin, there were piles lying beside it. Curtis remarked on the collection of women's clothing he found in the heap: "petticoats, old skirts and blouses," which looked as if they had been "wetted" beforehand and therefore failed to fully burn. The volume of waste was profuse for the next three weeks, though on the second and third weeks it was all ash: "it was very light stuff, white ash, it was not paper ashes. There was no ordinary ashes from the fire grate among it, just plain ash," he recalled. On the third occasion, as he and his assistant were ferrying this away, Ethel leaned out of the window. "Here you are, dustmen," she said, "get yourself a drink; and handed him 3d. for their extra effort."[5]

In the midst of this great change in Ethel and Crippen's life came another one with much broader implications. On May 6, King Edward VII, who had struggled through the day suffering from a tight chest and dizzy spells, finally took to his bed at 11:30 p.m. He would not rise again. With his death, the Edwardian era, a chapter of history marked by decadence, optimism (for some), social disquiet (for others) and remarkable technological advances, officially came to a close. The 68-year-old monarch's death heralded a period of mourning; the duties of Parliament were suspended and a state funeral was planned for May 20, when banks and businesses would be shut. This day of mourning allowed roughly 5 million of the late King's subjects to line the parade route to Westminster Abbey and pay their respects to Queen Victoria's son. For others, this solemn occasion presented an opportunity to take a holiday.

With the weather turning mild, Crippen and Ethel set out on a second trip to France. This time, they visited Boulogne, to the north of Dieppe, popular with British tourists. Unlike Dieppe, Boulogne was judged by the more discerning class of traveler for its "vulgar friendliness" and its ubiquitous "English chophouses."[6] The Hotel Folkestone, where Crippen and Ethel stayed, advertised widely in the anglophone press: "First class house. Near Casino and Beach. Excellent cuisine."[7]

However Dr. and Mrs. Crippen passed their time in the seaside town, their visit succeeded in determining them on one matter: Hilldrop Crescent needed a French maid. Crippen inquired with his hotel proprietress if she knew of a girl eager to go into service in London. After several weeks of correspondence, one such candidate was found: seventeen-year-old Valentine LeCocq, a young woman from Boulogne who had previously worked for a French family in London, but who spoke no English. She was ideal, Crippen decided.

On June 11, Valentine, with her small box of belongings, crossed the Channel on a steamer and, after a long day of travel, was met by her new mistress at Charing Cross Station. According to Ethel, the girl was less experienced than she had hoped and, although eager to learn, had arrived with "hardly a rag to her back." She complained to Mrs. Jackson that Valentine had evidently expected her employer

to provide her with a uniform for she had "not a black blouse or anything" and now it fell to Ethel to "rig her out nice and tidy."[8]

A French maid in her black dress and sharp white apron, traditionally employed by sophisticated society ladies, would have been preposterously out of place in a rented house in lower-middle-class Holloway. Whether the choice to recruit such a servant was one which accorded with Ethel's perception of her new status, or whether it was Crippen's intention to ensure that conversations and correspondence could never be understood, hiring Valentine suited both purposes. Whatever had been tidied and cleared away in the months before her arrival, the residents of 39 Hilldrop Crescent would continue to harbor their secrets.

In the week of the new maid's arrival, Ethel was preparing discreetly to conclude a project which had begun several months earlier. Of the many discoveries that were made following Belle's departure, few had Ethel so excited as the bank book for a previously unknown Post Office savings account held by the former Mrs. Crippen. While still a lodger with Mrs. Jackson she had come home that evening and boasted to her landlady about it. Apparently, the account had been deliberately hidden from Hawley Crippen and contained nearly £200.

On April 5, action was taken to retrieve these sequestered funds. Dr. Crippen's "wife" walked into the Western Central District branch of the Post Office, on New Oxford Street, near Albion House. She had brought Belle's bank book with her to be countersigned and then returned to her by post in a self-addressed envelope. Under the watchful eye of the bank clerk, she took up a pen and signed the name Belle Elmore. She had been practicing and perfecting Belle's signature so that, to the untrained eye, her version, at least superficially, matched those of the originals.[9] Between that date and June 16, Ethel repeated this audacious act of fraud a further seven times until the total balance of £196 11s. 4d. was drained from the account. On each occasion she committed this crime with a Post Office clerk inspecting her, writing with a hand as steady as her nerve.

This was unlikely to have been the first or only occasion in which

Ethel had forged Belle's signature. The resignation letter delivered to Melinda May on February 2 bore a signature that no one—not those who worked with Crippen, nor members of the Guild's executive board—was able to identify. The writing belonged to neither Belle Elmore nor her husband, though the resemblance to Ethel's hand is clear. Further to this, on March 1, the doctor's other loyal secretary and bookkeeper, Marion Curnow, was asked by Crippen to put an envelope in her safe. It was marked with his name and the word "Personal." Its contents included nine Charing Cross Bank deposit notes for Crippen and Belle's accounts worth £600, as well as "some fire insurance receipts." Slipped in among these important documents was also "a piece of blotting paper with Belle Elmore's signature." Marion had been instructed by her employer to give the envelope to Miss. Le Neve if anything happened to him.[10] Later, a similar piece of paper bearing Belle's signature, written repeatedly as if someone had been practicing it, would also be discovered at Hilldrop Crescent.[11]

Both Ethel and Crippen would have known that the crime of "forgery with intent to defraud" was a serious offense, especially as Ethel had committed eight counts of it against the Post Office, a government agency. Punishment for those found guilty included periods of imprisonment and hard labor. In 1905, Gwendoline Howell had taken her neighbor Hortense Lavener's Post Office savings bank book. She attempted to withdraw money by falsifying Hortense's signature but the alarm was raised by a Post Office employee. Howell was found guilty at the Old Bailey of "Feloniously forging and uttering a receipt for £4 with intent to defraud" and received a year of hard labor in prison. In 1912, Annie Warner attempted a similar scheme for the amount of £10. She also received a sentence of imprisonment with hard labor, but for eighteen months.[12] Ethel had taken more than £196 over a period of three months. It is difficult to discount the possibility that similar crimes of forgery and fraud were committed by the couple in the period from February. If Ethel was prepared to do this, if she and Crippen had signed Belle's name on correspondence and financial documents, what other opportunities might they have taken? Long after Belle's disappearance, Crip-

pen continued to use a checkbook for the account he shared with her. The account required her co-signature on each of the checks and without it he would not have had access to their funds. He claimed that prior to abandoning him, his wife had (conveniently) co-signed each of the checks in their joint account. While it was not uncommon for women to pre-sign checks for their husbands' use, it would later become impossible to prove or disprove whether her signatures were genuine.[13]

Where the money from Belle's Post Office savings account went is undocumented, but Hawley Crippen had decades of experience shifting and hiding ill-gotten gains. Some may have been invested in his business along with the money he received for disposing of Belle's jewelry, while undoubtedly other portions of the plunder were spent to maintain the new Mrs. Crippen in her desired lifestyle.

Throughout the spring and early summer, "Ethel Crippen" settled in comfortably at Hilldrop Crescent. She made herself feel more at home; she wore the previous inhabitant's clothing and jewelry; she ate at her table, used her plates, played her piano, slept in her bed and assumed her name. As Belle's rosy bower, her lovingly tended "Garden of Eden," came into full bloom, Ethel opened up her home and assumed the role of hostess. Emily Jackson and her boys were invited to dine with her in the summer house. Lydia Rose came for tea "and an enjoyable musical evening."[14] Nina came with baby Ivy Ethel, whom she rocked in the garden. At the end of June, Mrs. Benstead took the train from Brighton and dined at Hilldrop Crescent with Gilbert Rylance and his wife. Alice Benstead recalled certain oddities about the day. Crippen would not allow her a private moment with Ethel. He followed them around the house and into the garden, and even traveled with Ethel and her aunt in the cab back to Victoria Station. It seemed as if something weighed upon his mind. When Gilbert Rylance mentioned that his wife was a vocalist and was thinking of embarking upon a singing career, Crippen became suddenly defensive and bitter. He said he was surprised that Rylance would permit such a thing as "he did not think there could be a chaste woman in the profession."[15]

Apart from her sister, Ethel's immediate family were not regular visitors at Hilldrop Crescent. She had only ever invited her father to the house once, and never her mother. The Neaves were still not convinced that their daughter had been legitimately married to Dr. Crippen. On several occasions, Walter and Charlotte had asked to see Ethel's marriage certificate, but their daughter always invented some excuse not to produce it. It appears that Walter threatened to verify that his daughter had been married at St. Pancras register office, but Nina covered for her sister and claimed they had actually been married at Dieppe.[16] Around June, Walter came to Hilldrop Crescent with Ethel's youngest brother, Sidney. Walter claimed it was his "first and only invitation" to visit. Although he had been invited to dine, his true intention was to ascertain once and for all whether the couple were living honorably together.[17]

Walter was "greeted warmly" by Crippen, who had been anticipating this confrontation. Knowing that Ethel's father liked music, "he got out his gramophone and put on some of the finest records" Walter had ever heard. As the hours passed, Walter began to feel the awkwardness of his position. Neave did not wish to spoil the mood or "cause an estrangement," especially as his daughter appeared so content as she waited upon them. "She addressed Crippen as 'dear' and he constantly referred to her as 'Ethel darling.' She was happy as a lark; she did not seem to have a care in the world." Walter eventually buckled and decided it was "a woman's task" to ask to see a marriage certificate, not a father's. When he departed, Crippen gave him a box of cigars and waved him off at the gate.[18]

Ethel and Crippen knew precisely what they were doing. The two had practiced subterfuge and deception, had mastered all the moves of lying and bamboozling as if it were a choreographed dance. They lulled family and friends into their orchestrated falsehoods, always remaining one turn ahead.

The new "Mr. and Mrs. Crippen" enjoyed keeping many secrets, and even inside jokes. During the first part of March, they decided to attend the theater. At the time, a melodrama by Frederick Melville was being staged at the Aldwych. It was called, ironically, *The*

Bad Girl of the Family. Whose idea it was to purchase tickets can only be guessed, but certainly it must have been the source of some private mirth between the couple.

Seemingly by chance, as they were leaving the theater that night, they spotted Clara and Paul Martinetti, who had also been among the audience. The Martinettis were on their way over the road to have a drink at the Gaiety Theatre restaurant. Politeness compelled them to extend the invitation to Crippen "and the typist."[19] Given the circumstances of the Benevolent Fund Dinner and Ball, Belle's friends would have found this encounter awkward. However, the star-struck Ethel appears to have thoroughly enjoyed herself. So much was this the case that several weeks later Crippen called on Paul and invited the Martinettis to dinner and the theater. "Of course we guessed it was also with the lady typist and we refused," said Paul.[20]

After hearing so many stories about Belle and Hawley's close relationship with the Martinettis, Ethel appeared to have developed a jealous fascination with them. She coveted every aspect of Belle's life, even her friendships. On the day of the ball, Ethel had told Emily Jackson that she would be going to Mrs. Martinetti's flat beforehand, where Clara would be doing her hair. As the revelries were to conclude late, she would also be spending the night at the Martinettis.[21] Later, she would tell Mrs. Jackson, as well as her family, that she and Crippen were planning to move from Hilldrop Crescent nearer to the office. The place they had in mind was a top-floor flat in a modern block on Shaftesbury Avenue.[22] One can imagine Ethel gazing across the road from Albion House up at the illuminated windows of King Edward's Mansions, dreaming, planning, plotting.

If it was Ethel's intention to fully possess the identity of "Mrs. Crippen," then by June she had all but accomplished it. She had succeeded in swallowing Belle's existence, devouring her home, her belongings, her name, her money and her husband. She had swept the woman's traces from the house, physically occupying all the corners which had once been Belle Elmore's. However, that which would forever lie beyond her reach were the affections of Belle's friends.

"Some little town in San Francisco"

I N 1909 A GROUP photograph was taken of the attendees at the annual dinner of the Music Hall Artistes' Railway Association. All the big names in variety theater, and everyone from the Crippens' inner circle, were there that evening. The photographer arranged the guests in rows. Hawley Crippen was seated next to the performer Marie Dainton, and just behind him was Belle, beside the MHLG president, Mrs. Ginnett. The two women, with flowers and jewels tucked into their fashionably coiffed hair, sat with their arms linked, their shoulders resting intimately against each other's.

Belle and Isabel were dear and affectionate friends. When the Ginnetts' troupe and their prized horses departed on an American tour in October of that year, the two women pledged to maintain a close correspondence.[1] Postcards, letters and telegrams frequently passed between them until February 1910, when, for some unfathomable reason, Belle's letters stopped. At first, Isabel worried that Belle had taken offense at something. Then she received word from the Guild of Mrs. Crippen's mysterious departure. As the weeks passed, Isabel was drip-fed the details as they unfolded, and eventually was notified that Belle had seemingly expired of double pneumonia while in Los Angeles. Frustrated by her lack of proximity to her MHLG sisters, Mrs. Ginnett decided she would begin to investigate Crippen's claims from within the United States.

At the beginning of April, she wrote to the Los Angeles Chamber of Commerce, seeking to confirm that a woman by the name of Belle Elmore or Cora Crippen had died in that city. She waited a

month for a reply which never arrived. After hearing of the dismissive response Louise Smythson had met with at Scotland Yard, Isabel began to suspect that the authorities would be more likely to take a man's concerns seriously. She applied to an acquaintance in her local town, Judge Van S. Roosa, to follow up on her letter to Los Angeles. Equally determined not to be thwarted by Scotland Yard's indifferent attitude, Mrs. Ginnett solicited the assistance of the producer Wal Pink, who had been visiting the United States and would soon be returning to England. "As the authorities would pay no attention to the woman . . . I thought I would ask a man to place the matter before them," she told the *Boston Globe*. It can only be assumed that Pink followed through on Isabel's request and approached the police in London, but nothing came of this attempt either.[2]

Lillian and John Nash had also received word of Belle's unlikely journey and strange death in California. The news had arrived in a letter from Clara Martinetti, but Isabel claimed to have informed them of the shocking turn of events shortly after the couple had reached New York in early April. Two months later, when the Chamber of Commerce had finally responded to Judge Roosa's letter, and granted Belle's friends in America the confirmation they were all expecting, "that no one by the name of Crippen died during the month of March," both the Nashes and Mrs. Ginnett decided that the matter had now become one of urgency.[3] As Lil and John prepared to depart New York on June 15, Isabel joined them at the ship to bid them farewell. "Mrs. Ginnett's last words to me . . . were to urge me to have Belle's disappearance investigated, and I was determined I would," pledged John Nash.[4] "I promised her that as soon as I reached London I would go and interview Crippen."[5]

The Nashes were home by the following week and quickly sprang into action. They spent the next several days gathering information from among their associates, who "all expressed their disbelief of Crippen's story as to his wife's death."[6] By Tuesday the 28th, they were fully armed for a confrontation with Belle's husband.

The couple ventured to Albion House and appeared at the door

of the doctor's office. John removed his hat and the couple offered condolences to their friend. It was the first time they had seen him since his wife's death. From his recent interactions with the members of the MHLG, he may have suspected that this was not to be an easy interview. Crippen took a seat behind his desk, perhaps wishing to place a barrier between himself and the pair. He appeared "very nervous" from the outset. As John and Lillian chatted with him, he began to riffle anxiously through some papers. "He seemed much cut up," John remarked. Nash was even more surprised that Crippen began to sob when asked to recount the details of Belle's death. In keeping with his original story, the doctor maintained that "his wife had died at Los Angeles," but upon noting the Nashes' incredulity, he changed the location to "some little town in San Francisco."

Hawley Crippen could not have known that he had unwittingly stumbled into a trap. John Nash had worked for an opera company in San Francisco for two years, and in that time, had come to know the area. "He was rather surprised when I questioned him about a number of districts," said Nash. "I tried to refresh his memory and I mentioned Alameda or Allemaio."[7] Was that the name of the place? Nash asked.[8] Crippen hesitated.

"Peter, do you mean to say that you don't know where your wife has died?"

The doctor responded that he could not remember, but he thought it was Allemaio.

"I hear you have received her ashes?" John continued.

"Yes, I have got them in the safe."

Nash wanted specifics. He asked about "the name of the crematorium and . . . the certificate of death."

Crippen must have known he was now cornered. He held a paper in his hand which he twitched distractedly. "You know," he began in a vague tone, "there are about four crematoria there. I think it was one of those."

John regarded him quizzically. "Surely you received a certificate?"

"I think I have got it somewhere."

The theatrical manager scrutinized the weepy, nervous character before him and saw the situation plainly. His answers were not satisfactory. "When a man cannot tell where his wife died or where her ashes are from," the truth was obviously being hidden. "I began to feel there was something wrong."[9]

The Nashes felt they had observed all that was necessary. They excused themselves, hailed a cab and hurried to Scotland Yard.[10]

How it came to be that John Nash, in his carnivalesque world of singers in sequins and feathers, came to befriend Frank Froest, the superintendent of the Criminal Investigation Department (CID) of the Metropolitan Police, is a story unknown. Froest, short and stocky, was said to carry all the gravity of a Prussian field marshal when he appeared in his uniform. Fortunately, he was just the sort of acquaintance that the Music Hall Ladies' Guild now required. John and Lillian appeared at Scotland Yard and asked for their friend, only to be told to return the following Thursday. The tiresome clock which had been counting down the hours since Belle's disappearance added yet more time to the laborious pursuit of answers. On the 30th, the final day of a lengthy June, Froest at last opened the doors of his office to the Nashes.

The two artistes began to unroll their tale. It was by now a story that had been repeated so often, and to so many people, that sitting in Froest's office must have felt like a performance, another date on a tour which had begun months earlier. They laid out all the scenes: the disappearance, the letters, the ball, the brooch fastened to Ethel's bodice, the obituary in *The Era*, Crippen's slippery excuses and nonsensical narratives. The superintendent listened and pondered the details. Then he went and fetched a colleague, Chief Inspector Walter Dew, a man with a heavy, dark mustache at the base of his long, downturned nose. Froest made the introductions before explaining that the couple had come to see him "in connection with the disappearance of a friend of theirs, a Mrs. Cora Crippen, a member of the Music Hall Ladies' Guild and known on the stage as Belle Elmore." It was added that she was "the wife of a Dr. Crippen living out Holloway way." The superintendent then stated that Mr. and

Mrs. Nash were "not satisfied with the story the husband has told." "Perhaps you had better listen to the full story," he said to Walter Dew.[11]

John and Lillian then launched into an encore, careful to provide their new audience with as much color and detail as they had earlier. At the close of their second show of the day, Froest turned to the inspector. "Well, Mr. Dew, that's the story. What do you make of it?"

Dew claimed he did not hesitate for a moment.

"I think it would be just as well if I made a few inquiries into this personally."[12]

Serious Trouble

A T AROUND NINE THIRTY on the morning of July 8, there
came an unexpected knock at the front door of number 39
Hilldrop Crescent. Ethel heard this from upstairs and wondered
who it might be at such an early hour. Usually, tradesmen and ac-
quaintances used the side entrance on the ground floor. She listened
as Valentine LeCocq answered the door. "Is Dr. Crippen in?" asked
a male voice.

Valentine, who was still grappling with her command of English,
mistakenly answered "Yes," and showed the two gentlemen into
the hall. Ethel was annoyed. The doctor had left for the office shortly
after eight o'clock and now she had to come down and manage the
misunderstanding.

"You wish to see Dr. Crippen?" said Ethel.

The tall, well-dressed man, with what Ethel described as nice but
serious eyes, answered, "Yes."[1]

"He is not at home," she said, "and will not return until after six
o'clock this evening."

The man regarded her closely and then continued. "I am sorry to
doubt your word . . . but I am given to understand that Dr. Crippen
does not go to his office until after eleven. I feel quite sure he is in
the house, and I may as well tell you at once I shall not go until I
have seen him." He introduced himself as Detective Chief Inspector
Walter Dew. The man beside him was Detective Sergeant Arthur
Mitchell. "Who are you?" he said to Ethel in a pointed manner that
made her shrink with awkwardness.

"I am his housekeeper," she answered.

"Are you not Miss. Le Neve, Dr. Crippen's typist?"[2]

A flush passed over her cheeks. "Yes."

Dew noticed that she was wearing the round rising sun diamond brooch that had been described to him by Belle Elmore's friends. Other than this, he thought Ethel to be "neatly and quietly dressed." "She was not pretty," he surmised, "but there was something quite attractive about her."[3]

Ethel insisted that Dr. Crippen would not return until between six and seven o'clock and that if they wished to see him, they should call back at that time.

That was unfortunate, said Dew, as he wanted "to see him rather urgently."

Ethel admitted that by this point she was growing angry and defensive. The police refused to tell her what this matter concerned. Dew was suggesting that the doctor might still be in the house, and he and Mitchell took a seat in the sitting room, as they waited for Ethel to answer their questions. Instead, the "shy" and "retiring" Miss. Le Neve, the typist with the "downcast eyes," laughed contemptuously at the two senior police officers.[4] Ethel was stalling. To them, she seemed uncooperative and untrustworthy.[5] In their statements, both Dew and Mitchell claimed that she "hesitated," "demurred" and acceded to their requests "very reluctantly."[6] She offered to telephone Crippen at the office, but the inspector told her not to, as he feared she would warn him that the police were on their way.

"Would it be asking too much for you to take us down to Albion House? I am anxious not to lose any time," Dew eventually suggested.[7]

"All right," said Ethel. "But you must give me time to dress properly." With that, she went upstairs while the men waited for her below. Ethel said that, as she arranged her hair and changed her blouse, she "had no compunction in making them wait a good long time."[8] She heard them creeping around, cat-like, moving from one door to the next, listening for any indication of the doctor's pres-

ence. When she returned to them, Dew noticed that she'd removed the rising sun brooch.[9]

Ethel protested again before they left. "It was a dreadful nuisance," she complained, as she "was leaving all the housework." "I told him frankly I was a person of methodical habits and did not like having all my usual program of the day upset in this fashion."[10] Eventually, Dew and Mitchell got her to consent to accompany them. They took an electric tram to the Euston Road, and then a taxi the remainder of the way to Albion House. Ethel, if not physically squeezed between these two formidable men, certainly felt herself in the unrelenting grip of their gazes. As they approached the office block she began to squirm.

"Look here," she said. "I would not be a bit surprised if we did not find Dr. Crippen there. He may be at the other office in Kingsway at this time."

Dew was having none of this. He gave her a serious look. "We will take Albion House first."[11]

Ethel was getting desperate to keep them away from Crippen. As they came into the entryway of Albion House and began to mount the stairs, she stopped.

"I do not propose to go upstairs with you two gentlemen," she announced. "I shall have to pass through two rooms where everybody knows me, and there will be a lot of talk and questions if I go all about the place with you." Instead, she offered to bring Dr. Crippen down to them.

It was here that the usually vigilant and methodical Inspector Dew made a foolish, almost inexplicable error.

According to Dew's memoirs he heartily protested at her suggestion. He insisted that she allow them to "come upstairs at once," but Ethel ignored his orders, "darted up the stairs" and escaped from him. After skillfully avoiding all of Ethel's evasion tactics, preventing her from using the telephone, and insisting on traveling with her to the workplace, Chief Inspector Dew allowed an obstructive and defiant potential accomplice to slip from his grasp. She scampered

up three flights of stairs to Crippen's office and gave him the warning: Scotland Yard had arrived.[12]

What precisely Ethel said to Hawley Crippen in those "few moments before she reappeared" will never be known. In her embellished narrative of these events, Ethel claimed that she had found the doctor (who was the business's financier, not a dentist) with Gilbert Rylance, "working at some gold plate for dental purposes." She called Crippen aside and told him about the detectives waiting for him in the corridor. Apparently, "He showed no sign of fear or agitation. He was absolutely calm." Dew concurred with this. When the short-sighted, "insignificant little man" presented himself, he seemed completely unruffled.[13]

Dew introduced himself and then Mitchell.

"We have called to have a word with you about the death of your wife," the inspector began. "Some of your wife's friends have been to us concerning the stories you have told them about her death, with which they are not satisfied. I have made exhaustive inquiries and I am not satisfied so I have come to see you to ask if you care to offer any explanation."

Crippen, in a quiet and confident voice, said it would be his pleasure to tell the gentlemen all he knew. He ushered them into his private room. As Dew and Mitchell took their seats opposite, they could see Ethel just outside, "flitting to and fro with documents in her hands."

Walter Dew did not seem in much of a hurry to interview Dr. Crippen. More than a week had passed since he had met John and Lillian Nash and listened to their story. In the first instance, the inspector thought Belle's disappearance to be "somewhat singular" but when he considered "the Bohemian character of the persons concerned," the sordid circumstances, the histrionics, the erratic behavior, it all seemed a rather predictable scenario.[14] Dew did not believe such a case warranted urgent attention, and took his time questioning some of the Crippens' friends: the Martinettis, Melinda May, Annie Stratton, as well as Dr. Burroughs and his wife Maud. By the end of it, he felt somewhat disappointed; his "inquiries had

yielded little." At this point, the only thing left "was to interview Crippen personally."[15]

Mitchell readied himself at a small table, preparing to catch Crippen's testimonial with his pencil and paper.

"I suppose I had better tell the truth," the doctor began.

"Yes," said Dew, "that would be better."

Then Hawley Crippen dropped a bombshell about his wife.

"The stories I have told about her death are untrue. As far as I know she is still alive."[16]

Dew did not record his thoughts when Crippen revealed this. Whatever may have crossed his mind did not rattle him. He persevered with his questions. He began by asking the doctor about his past. Slowly, but freely, the polite, moderate man before him presented his narrative.

He gave his age as forty-eight. He told the inspector about his birth and upbringing in the United States, about Myron and Ardesee, the movement between Michigan and California and then to Ohio, where he qualified as a physician. He discussed his work with Dr. Porter, his short marriage to Charlotte and the birth of Otto. Then he told the story of how he came to meet Belle in New York, making certain to reveal that she had ruined her reputation with C. C. Lincoln long before he came along. He covered the period following their marriage, his involvement with Munyon and his relocation to England, as well as Belle's decision to give up opera for a career in the music hall. He objected to this decision, he claimed. She made no money at it, he said, and she was a failure. When he was called back to Philadelphia to work, he left her alone in London, while sending money to her. In that time not only had he discovered that she had been "singing at smoking concerts for payment" but that a fellow music hall artiste, Bruce Miller, "had been a frequent visitor to her." Apparently, they were fond of each other, and she had no compunction about telling her husband so.[17]

The doctor went on to describe how disagreeable his wife had become after they moved to London. "Her manner toward me was entirely changed, and she had cultivated a most ungovernable temper,

and seemed to think I was not good enough for her . . ." She claimed that other men were willing to make "a fuss of her." While they lived at Store Street and at Hilldrop Crescent it appeared to everyone that they "lived very happily together" but the truth, he claimed, was different. "There were very frequent occasions when she got into the most violent tempers and often threatened she would leave me, saying she has a man she could go to and she would end it all." Crippen suggested that this man was Bruce Miller and that he had seen letters from him to her, "which ended 'with love and kisses to Brown Eyes.'" On account of his wife's unpleasant outbursts, Crippen claimed that, four years earlier, he had "discontinued sleeping with her, and have never cohabitated with her since." He allowed her to go and do "what she liked; it was of no interest to me." Despite the freedom he granted her, Crippen complained that she frequently threatened to leave him, and she warned him (conveniently) that "if she did, she would go right out of my life, and I should never see or hear from her again."[18]

Crippen's history was a long one. Lunchtime was approaching and Dew and Mitchell decided to continue the task of taking his statement at an Italian restaurant, "a few yards from Albion House." They adjourned there together, where the doctor ordered a beefsteak, and while slicing his meat and dabbing the corners of his mouth, he proceeded with his tale.[19]

Eventually Crippen came to the night of January 31, when the Martinettis visited for supper. He claimed that after they had left, Belle "abused" him for not showing Paul Martinetti upstairs to the lavatory. According to the doctor, his wife exploded: "This is the finish of it. I won't stand it any longer. I shall leave you tomorrow and you will never hear of me again." As she had uttered this idle threat so often, he claimed he rarely took notice of it, but this time she was more explicit in her statement; she told him that he "was to arrange to cover up any scandal" with their friends and with the Ladies' Guild. The following day he went to work and when he returned home between 5 and 6 p.m. he "found that she had gone."

Crippen then detailed his cover-up. First, he had to sit down "and

think it over." Somehow, he had to account for her absence without causing a scandal. "On that same night, or the next morning" (he couldn't recall which) he wrote a letter to the Guild and began to tell people. He went on to explain that, afterward, he "realized that this would not be a sufficient explanation for her not coming back" and so he had to invent a tale about Belle falling ill with bronchitis and pneumonia, from which she eventually died. Everything which then flowed from this single lie was a stream of untruths: the location of where she died, the death notice in *The Era*, the telegrams from California, the cremation, the name of the ship on which she sailed to America. He unraveled all of it for them. After unburdening himself, Crippen offered the detectives a confession: he had no idea where she was. She had walked out of 39 Hilldrop Crescent, never to be seen again. It was likely that she went to Bruce Miller in Chicago, but he had no idea how to find or to trace her.[20]

Belle had left almost the entirety of her belongings and clothing behind, her husband explained. Before she departed, she had said she wanted nothing from him. He believed she had taken one "theatrical traveling basket" with her, as well as some of her jewelry. She had so much that he wouldn't know what was gone; though, so far as he could see, she had left four rings and a diamond brooch behind. He flatly denied that he had ever pawned or sold any of her jewelry, either before or after she had left him.[21]

Inspector Dew also prompted Crippen about his relationship with Ethel Le Neve and was surprised to find that the doctor was very candid about it. He provided the full details of their affair, that she had worked for him "for the past 8 years" but was now living with him as his wife. He told Dew that the relationship had become sexual three years earlier and that they had "frequently stayed at hotels," though he "was never away from home at night." Yes, they had gone to Dieppe together at Easter, where they posed as "Mr. and Mrs. Crippen," and yes, Ethel had worn his wife's brooch to the Benevolent Fund Dinner. She had also worn Belle's furs.[22]

Walter Dew had passed five hours in conversation with Hawley Harvey Crippen. It was nearly five o'clock by the time Arthur Mitchell

had written the last word of the statement.[23] The interviewee had spent a significant portion of that time representing his wife in the worst possible light, blackening her character, discrediting her, and thereby defending his indifference to her disappearance. Throughout, Dew had trained his inspector's eye on his subject's every expression. He had watched for signs of emotion when Crippen first mentioned Belle's name, but "his face betrayed nothing. There was not so much as a flicker of an eyelid." The doctor related his entire story in his usual quiet voice. At the end of it, Dew was convinced of one thing: the man with whom he was dealing was "an accomplished liar."[24] He was skillful and slick, his deceptions sinuous and ever shifting. The statement Crippen had given was almost a complete contradiction of the earlier story. In concocting the new one, he had stirred truth into his elaborate falsehoods, attempting to beguile the listener with his candor and his mildness. Dew knew that all of this had been rehearsed; not only the interconnected details of his updated version with their overlapping layers of explanation, but the delivery of it too—the sedate manner, the insouciance. Crippen had been anticipating the arrival of the police. He had thought through his strategy, sewn shut every hole, and was ready.

Before he asked the doctor to sign his statement, Dew made a request of him. The inspector was not satisfied that he could gain a purchase on Crippen's lies without searching the inside of 39 Hilldrop Crescent. He told Crippen that he wished to return to the house, mainly with the objective of finding "letters which may throw any light on the matter." The doctor, in his usual manner, politely acquiesced.[25]

Next, the inspector turned his attention to Miss. Le Neve. It was late, and in her account of events, Ethel recalled that she "was absolutely fainting with hunger."[26] The gentlemen had gone out for their lunch but had prohibited her from leaving the office. As she had waited patiently for Dew and Mitchell to finish with their interview, both Gilbert Rylance and Crippen's technical assistant, William Long, had guessed the identity of the doctor's callers. A tension had

lingered in the air throughout the day. Ethel was anxious when the chief inspector and the sergeant finally sat down with her.

Dew told the typist that he wished to hear "all she knew" about Mrs. Crippen's disappearance. Ethel provided them with the vaguest of details. It happened sometime around "the early part of February." She could not recall exact dates. In her story's fogginess, it appeared to adhere to Crippen's convoluted narrative, simply because she revealed so little. The inspector also asked that she divulge private information about her relations with Dr. Crippen. As she sat alone with the two men, Ethel became embarrassed, blushing and averting her eyes. She confessed that as of late February, she "had been living at 39 Hilldrop Crescent with Mr. Crippen as his wife." In fact, she had "been on intimate terms with Mr. Crippen for between 2 and 3 years." For whatever reason, the couple had evidently agreed between themselves that they would never reveal the actual length of their affair. Perhaps a shorter spell together seemed less shameful. Ethel lied again when she told the police that her parents believed her to be Crippen's housekeeper. There was no mention of a marriage, sham or otherwise.[27]

What became apparent through the haziness of Ethel's statement was that she and Crippen had discussed not only the details of their cover story between them, but how they would perform it should the police come calling. The routine would be similar to that which they had honed for years. When moneylenders, angry "business partners," the disgruntled or the swindled came to the office looking for Dr. Crippen or "M. Franckel," initially it was Ethel who would have to contend with them. In every case, Crippen would feed her a story, an explanation which she would be required to repeat. She had learned diversionary tactics: how to delay, how to lie, how to distract; the same ruses she attempted to deploy against Dew and Mitchell earlier that day. When it came to giving her statement, it was only when the inspector asked her questions that had not been a part of the couple's agreed script that Ethel was seen to falter. She was asked if he publicly mourned his dead wife. Although

others, such as Melinda May, clearly recall him wearing the appropriate black garments for weeks, Ethel, who lived with him, stated that she could not "remember if he went into mourning." More tellingly, Ethel was asked to recall what Crippen had told her about Belle's trip to America. Did the doctor specify whether his wife would be returning, or whether she was gone for ever? "I don't remember if he told me she was coming back or not," Ethel answered, which was a strange response from one who had so eagerly appropriated the missing woman's wardrobe and jewelry.[28]

According to Ethel's version of events, in the course of her interview, Dew revealed to her that Crippen had been lying about everything. "He has just admitted to us that, as far as he knows, his wife [is] still alive, and that the story of her death in America was all an invention." Ethel claimed she was "stunned" at this news.[29] She was "stricken with grief, with anger, with bewilderment."[30] Her feelings, she believed, "must have been plainly evident to the detectives," yet in all of Dew's accounts of their hour-long conversation, he makes no mention of any such response from Ethel. When they had finished, she described herself as feeling "faint and sick," as if she were "living in a nightmare."[31]

The horror was to continue. By six o'clock, Crippen, Ethel, Dew and Mitchell were in a horse-drawn "growler" cab heading north to Hilldrop Crescent. Ethel, her head awash with troubling thoughts and fears, sat in complete silence. The doctor filled it by talking all the way, attempting to keep the detectives amused and hoping to disarm their suspicions.[32] Inspector Dew clearly remembered the lovers sitting beside one another, neither of them making "any attempt to disguise the affectionate relationship which existed between them."[33]

Dew and Mitchell searched the house, with Crippen and Ethel escorting them through each room. This was not just a cursory glance thrown across a space: the detectives looked through "the wardrobes, the dressing-tables, the cupboards, and every other likely place." They inspected Crippen's correspondence and papers. They examined Belle's belongings, the "extraordinary assortment of women's clothing," and noticed that her photographs were still in place around the house. They also noted that in some rooms, belongings

had been packed away in boxes and carpets rolled up, awaiting removal.[34] They poked around in the garden; they went into the attic. They ventured into the kitchen and the breakfast room and asked to see inside the coal cellar. Crippen and Ethel stood in the doorway as Dew and Mitchell descended the stairs into the blackness. Dew struck a match so he could see. For a few moments a burst of illumination was cast against the walls. It was enough for the detectives to see "a small quantity of coal and some wood," before the yellow flame flickered out. He lit another. He sounded the floor with his feet, tapping his heel against the bricks below. Dew turned and regarded the couple, peering through the entrance at the top of the stairs. They waited patiently, saying nothing. Crippen's hands were in his pockets.[35] The inspector decided that there was "nothing unusual" about the cellar and he and Mitchell re-emerged into the light.

The four adjourned to the breakfast room, where Dew asked to see the jewelry his wife had left behind. Crippen produced some of the pieces Ethel had been wearing; "four rings (three single stone diamond and one set [with] four diamonds and one ruby) and the rising sun brooch."[36] When Dew concluded, he addressed the doctor, "Of course I shall have to find Mrs. Crippen to clear this matter up."

"Yes, I will do everything I can," he replied. "Can you suggest anything? Would an advertisement be any good?"

The inspector said he thought that would be an excellent idea and Crippen added that he "would advertise in several American papers." He then produced a sheet of paper and together the men composed several lines:

MACKAMOTZKI

Will Belle Elmore communicate with H.H.C. or authorities
at once. Serious trouble through your absence. 25 dollars reward
to anyone communicating her whereabouts to . . .[37]

Dew left the advertisement with Crippen and said he would return to see him again. This business was not yet over.

Valentine LeCocq had observed this peculiar visit from down the

corridor or behind partially shut doors. She could not make out what was being said, but she understood very clearly that something was terribly wrong. When her employers and the police came through the door that evening, she had been sent out "to buy vegetables." When she came back, she could see that her mistress "appeared nervous." The detectives remained for two hours and left at some time near 8:30 p.m., at which point, Ethel began to cry "and went directly to her room." Crippen went upstairs to join her. The door was shut for the rest of the night and "she talked for a long time with her husband."[38]

There is only Ethel's version of what was discussed, translated into compelling copy by two journalists in 1910 and in 1920. In both of these accounts, Ethel exonerates herself of any wrongdoing. She believed absolutely in whatever Crippen had told her concerning his wife's departure and her subsequent death in California. She never once thought to question him, never believed anything was suspicious. She never spoke of the former Mrs. Crippen at all, or even thought of her, until Dew revealed that her lover had been lying. Ethel felt sick, angry, hurt and deceived. The person who she "believed most in the world" had betrayed her.[39]

"For mercy's sake," Ethel claimed to have begged Crippen, "tell me whether you know where Belle Elmore is. I have a right to know."

"'I tell you, truthfully,' he said, 'that I don't know where she is.' He repeated this several times. He had not the least idea, he said, as to her whereabouts. She had gone off suddenly, as she had often threatened to do, and no word had come from her. He believed that she had disappeared forever from his life.'[40]

That declaration ended the discussion. Ethel went to bed, miserable, though somewhat reassured.

ACT IV

"Murder and Mutilation"

22

"Just a little scandal"

THE FOLLOWING MORNING, CRIPPEN decided that some drastic action needed to be taken. He had lied to many people, and because his wife's whereabouts still could not be accounted for, he believed the scandal would be tremendous. He explained to Ethel that as an unmarried woman living out of wedlock, she was likely to suffer the full force of condemnation. Her reputation would be destroyed, and with the tiresome Music Hall Ladies' Guild "talking and gossiping," the atmosphere at Albion House would become unbearable. More concerning still, the police would return and probably hold him until Belle was found. Ethel claimed he looked directly at her and announced, "My Dear . . . there seems to me only one thing possible to do, and that is to get away."[1]

It was then that Crippen hatched his plan. He told her "a disguise would be necessary": Ethel would have to dress as a boy. The doctor had asked her to leave the matter to him. He would arrange everything and "see after any luggage . . ." Ethel, the inveterate accomplice, only need fall into line. The aim was "to slip away with as few questions as possible."[2]

This was certainly not the first time in Crippen's life that he found himself in trouble or having to contemplate leaving town, nor would the decision to do so have come as a surprise to Ethel. For those within their circle of confederates, running from the law, lying low or changing one's identity was simply a hazard of their work. William Scott had fled to France and then to Germany; F. Sinclair

Kennedy had changed his name and gone to New Zealand; Edward Marr had darted from one address to the next under an assortment of aliases. Indeed, if Scott's comment is true, and in 1907 he had encountered Crippen and his mistress outside Boulogne living "under cover because of some shady transaction or other," then the couple had already performed at least one "get away."[3] However, this time the situation was more serious and greater care needed to be taken.

Contrary to Ethel's story, it is unlikely that such a contrived plan was formed entirely on Saturday morning. Valentine LeCocq described a fraught and anxious start to the day. Ethel had obviously been awake and in distress much of the night. The maid reported that her mistress's "eyes were very red" and that when the milkman knocked, Ethel jumped and "was white with fright." She spent most of the morning yelling at Valentine to hurry with her work.[4]

If their plan was to be carried out successfully, both Ethel and Crippen had a mountain of tasks to conquer and only a matter of hours in which to surmount them. There were clerical loose ends to be tied and groundwork for the escape to be laid, money gathered, bills paid, letters to be written, tickets purchased. Inspector Dew might return unannounced at any time. As Crippen would have reminded Ethel, it was essential that they behave as if this were just another Saturday morning. They would go to Albion House as normal. They would wear clothing appropriate for the office and carry only what they might on an average day.

Around eight thirty, Crippen left Hilldrop Crescent in his gray suit and bowler hat and headed for the tram. As Ethel normally arrived at the office after ten, that morning would be no different. She dressed in her blue jacket and matching skirt and put on her fashionable turban hat. She fastened the rising sun to the front of her blouse and adorned her fingers with the rings that Dew and Mitchell had inspected on the previous night. She carried a small reticule with her, and no other bag.[5]

It had been agreed between Crippen and Ethel that she could bid Nina farewell that morning. A story had been confected for the occasion containing just enough truth, surrounded by a hard shell of

lies. Just before eleven, Ethel arrived at the Brocks' house in a taxi, which waited for her as she knocked at the door. As her sister showed her into the front room, Ethel inquired nervously "if anyone was in the house" and if Nina was alone. It was then that Nina realized something was wrong, that her sister appeared "rather troubled."

"Oh dear," she exclaimed, "what is the matter? What could have happened?"

Ethel's lips began to quiver, and Nina gathered her sister into her arms. Ethel then recounted the events of Dew and Mitchell's visit. "Belle Elmore's friends don't seem to think she is dead," she said, "and who am I? Everybody will think I am a bad woman of the streets!" With that, Ethel began to sob.

Nina watched her sister's tears fall before she "pulled herself together again." Ethel then apologized that she could not stay long, that she wanted to come and say goodbye.

"Where are you going?" asked Nina with surprise.

"I cannot tell you, I don't know, but as soon as I know and get settled I will let you know."

Nina couldn't understand why it was necessary that her sister should follow Crippen on this errand.

Ethel reasoned that there was no purpose in her remaining there without a job and with her character ruined. At any rate, she had lied to the police and told them she "was only Harvey's housekeeper." She then pitched their formulated falsehood to Nina: Crippen's intention was to go away and "find the person who had sent the cable to say she was dead, or to find Mrs. Crippen." "For all I know she may not have gone to America at all," Ethel said, "she may still be in London and have got somebody across the water to send a bogus telegram informing of her death and keep in hiding till we got married and confront us with bigamy."[6] Ethel claimed to have no idea where they were going. She knew only that they had to find this person, or find Belle, even though she might still be in London or possibly somewhere in the United States. Her sister must have found this shocking, if not completely confounding, especially as

Ethel had gone to great lengths in March and April to convince her and the Neaves that she had been married.

Nina urged her again to let her know when she was settled. The sisters held and kissed one another. Then Ethel got back into the taxi and raced off to Albion House.

In the time that Ethel had been with Nina, Crippen had been studiously preparing matters at the office. When he arrived that morning, slightly earlier than usual, William Long was already there. His assistant noticed something was amiss as soon as he greeted his employer. Crippen's face was white. His expression appeared worried or unwell. "Is there any trouble, Doctor?" he ventured.

"No," Crippen replied. "Just a little scandal."

Nothing more was said until around ten when Crippen reappeared in the workroom with a list. He directed Long to go to Charles Baker, a gentlemen's outfitter on Tottenham Court Road, and purchase the items he had written down. His assistant looked over the list and found that it included "a boy's suit of clothes . . . a pair of boots, two collars, a tie, two shirts, a pair of braces" and a matching brown bowler hat. Crippen also instructed him to buy "a gray felt hat." The doctor never indicated for whom these clothes were intended, but, as an employee, it was not Long's place to question him. When he returned with his shopping, Crippen told him to put the items in a store room on the fourth floor with the equipment for the Yale Tooth business.[7]

While Long was out of the office, Crippen went down the corridor to Marion Curnow. Like Ethel, over the years Marion had remained a reliable paragon of discretion, following her employer's directions, covering for him and holding her tongue. Since March, she had been keeping two envelopes filled with jewelry and important banking and insurance documents in the Munyon's safe for him. While Dew and Mitchell had been questioning Ethel that Friday, he had slipped out to ensure his secret stash was still secure. With the police in the other room, he asked if anyone knew she was storing items for him. She had answered no. "Well, if anyone should ask you, you know nothing, and if anything should happen to me,

kindly give anything there is of mine to Miss. Le Neve," he had instructed her.[8]

Not only had Marion's loyalty always been of assistance, but her cooperation was also essential to the implementation of many of his schemes. On that day, he wished to settle his outstanding debts with her. He owed her a small sum for the adverts she had placed for Yale Tooth on his behalf, for which he repaid her with postal orders. Then he asked her if she could cash a check worth £37 for him. She agreed. Crippen took one of Belle's pre-signed checks out of his pocket and gave it to her with explicit orders not to pay it in until Monday. He also asked if she "would be good enough to change a £5 note for him," to which she consented as well.[9] He requested that all of the cash be paid to him in gold coins—guineas (£1 1s.) and pounds—which in 1910 were easier to transport and spend than banknotes.

Ethel arrived at the office sometime between eleven and twelve. For many, Saturday was a half working day and employees began to make their way home around lunchtime. One of Marion Curnow's last tasks, just after noon, was to go to the bank and withdraw cash for the doctor. William Long completed his business and departed at one. By then, Ethel and Crippen were alone. It was then that he took her up to the fourth floor and showed her the suit of boy's clothes.

Ethel balked at this. "If it were necessary for me to disguise myself, why not do so in some feminine way?" She thought the idea was ridiculous. She could not "pass muster for a minute as a boy" and was sure she would betray herself.[10]

Crippen eventually persuaded her. "You will look a perfect boy in that, especially when you have cut your hair."

To dress in male clothing was one thing, but to permanently alter her appearance, to shed her long locks, a hallowed emblem of early-twentieth-century womanhood, would have been a considerable sacrifice. In one version of her story, Ethel claimed she was horrified and protested vehemently at the suggestion. In another, she stated she "was more amused than anything." However, in the aftermath

of the excitement, she would privately admit that Crippen had ordered her "rather roughly" to do it.[11]

Ethel slipped out of her woman's attire; she let her blue skirt, her white starched blouse and her matching jacket, as well as any underskirt or slip she had been wearing, fall into a pile on the floor. However, she kept on her corset, chemise and drawers as she stepped into her new male identity. The suit "was not a very good fit," Ethel said, and she immediately split the trousers down the back. She would have to pin the seam together, she thought, and started to laugh at the absurdity of it.

"Now for the hair," Crippen announced, reaching for the office scissors, and "with one or two snips" her "mop fell to the floor."

She put on her bowler hat and attempted to walk about the room while assuming a male gait. "I shall never be able to face the world in these things," she said, but after some encouragement from the doctor, and assurances that she was unrecognizable, she tentatively found her courage.

The plan was for them both to leave Albion House separately and meet outside Chancery Lane underground station. It would necessitate a fifteen-minute walk down the hectic thoroughfare of High Holborn. Crippen advised her she should "take no notice of anyone," but to try to concentrate "on the fact that she was a boy."

Ethel made her way down the winding staircase and paused at the door of the office block. She lit a cigarette, so as to "play the part more perfectly."[12] She had never smoked before and was anxious that she would be sick. She was also "terribly self-conscious" and "felt awkward" as the absence of a skirt worried her. As she swaggered down the pavement, the crowds surging past, she claimed that she felt "just a little bit ashamed" and worried "that everybody must be noticing my legs," though she confessed that her limbs were feeling "so free and easy." An approaching policeman filled her with a sudden sense of guilt, and she considered diving down an alley. However, by the time she had reached the meeting point she had realized that her disguise had been so successful that not one man had turned his head.[13]

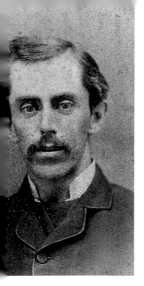 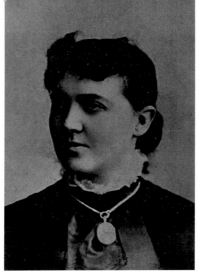

Above left: Hawley Crippen in the early 1880s, photographed by N. L. Merrill of Johnson, Vermont.

Above center: Charlotte Jane Bell, photographed by Marc Gambier at his studio in New York, *c.* 1882–4.

Above right: Crippen, *c.* 1905, with the full moustache and thick-lensed glasses for which he became known.

Below: The Mersinger family with Mr. and Mrs. Crippen, shortly after their marriage, *c.* 1893–4. Belle and Crippen are seen in the far left of the photo. Beside Belle is her mother, Mary, and next to her is her step-father, Frederick Mersinger. The four girls in the back row are likely to be: Teresa (*left*), Katie (*center*), Annie (*right*) and Louise (*standing in front of Katie*). The boys are: Julius (*far right*), Antoin (*front center*) and Frederick Jr. (*bottom left*). Antoin Smith, Belle's uncle, stands at the back (*far right*).

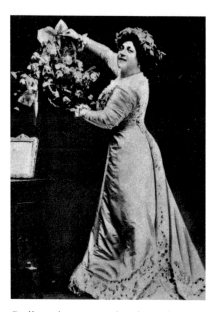

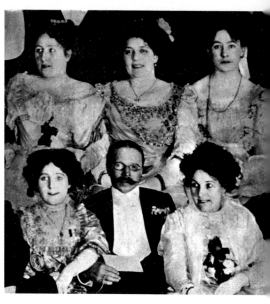

Belle, photographed on the night of September 25, 1909, with the flowers and framed letter of gratitude for her work as Treasurer of the Music Hall Ladies' Guild.

Belle and Crippen at the 1909 Music Hall Railway Artistes' Railway Association dinner and ball. Belle (*center*) sits between Isabel Ginnett (*left*) and Louise Smythson (*right*). Below, Crippen sits with Marie Dainton (*left*).

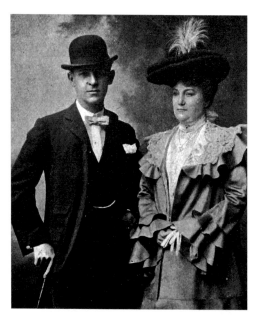

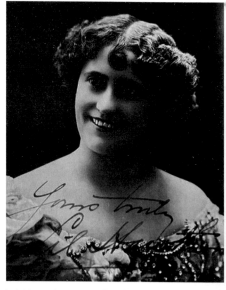

Eugene and Annie Stratton. Annie was the daughter of the famous American expat "blackface" performer George Washington "Pony" Moore.

Lil Hawthorne, also known as Lillian Nash after marrying her manager, John Nash, was a member of the MHLG and an internationally celebrated American singer.

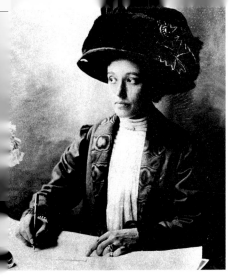

Above left: Photo of Ethel taken to accompany the publication of her *Life Story*, November 1910. She is pictured in her blue suit and wears a wedding ring as a symbol of her enduring fidelity to Crippen. And **right**: 39 Hilldrop Crescent.

Below: The Neave family, Walter (*right*), Charlotte and Sidney (*left*), posing for a photo at their home in the Goldington Buildings in 1910. The Neaves were once again living in social housing. In the interview that accompanied the photo, Charlotte comments that the family had previously been better off.

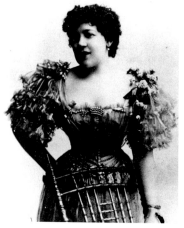

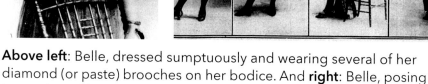

PRINCIPALS IN THE HOLLOWAY MYSTERY.

Above left: Belle, dressed sumptuously and wearing several of her diamond (or paste) brooches on her bodice. And **right**: Belle, posing in a variety of her costumes.

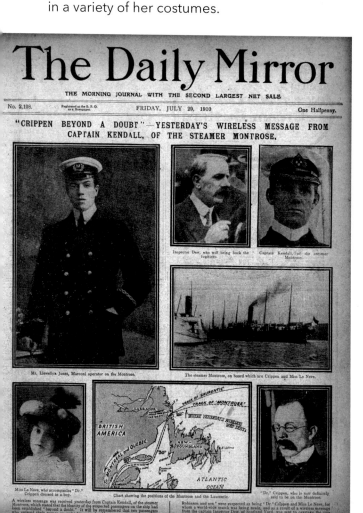

The Daily Mirror

THE MORNING JOURNAL WITH THE SECOND LARGEST NET SALE

No. 2,108. | Registered at the G. P. O. as a Newspaper. | FRIDAY, JULY 29, 1910 | One Halfpenny.

"CRIPPEN BEYOND A DOUBT" — YESTERDAY'S WIRELESS MESSAGE FROM CAPTAIN KENDALL, OF THE STEAMER MONTROSE.

Mr. Llewellyn Jones, Marconi operator on the Montrose.

Inspector Dew, who will bring back the fugitives.

Captain Kendall, of the steamer Montrose.

The steamer Montrose, on board which are Crippen and Miss Le Neve.

Miss Le Neve, who accompanies "Dr." Crippen dressed as a boy.

Chart showing the positions of the Montrose and the Laurentic.

"Dr." Crippen, who is now definitely said to be on the Montrose.

A wireless message was received yesterday from Captain Kendall, of the steamer Montrose, which stated that the identity of the suspected passengers on the ship had been established "beyond a doubt." It will be remembered that two passengers who entered their names on embarking on the Montrose at Antwerp as " Mr. Robinson and son " were suspected as being " Dr." Crippen and Miss Le Neve, for whom a world-wide search was being made, and as a result of a wireless message from the captain Inspector Dew, of Scotland Yard, was sent to overtake the fugitives on the faster steamer Laurentic.

Left: Front page of the *Daily Mirror*, July 29, 1910, featuring pictures of Captain Henry Kendall (*top right*), the *Montrose* and the routes sailed to Quebec by the *Montrose* and the *Laurentic*. The picture purported to be of Ethel (*bottom left*), which was reproduced in the "wanted" bulletins, is in fact of Nina, her sister. Charlotte Neave stated that Ethel had destroyed most photographs of herself because she didn't like how they made her look.

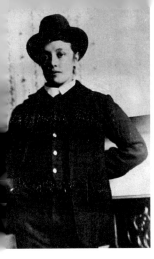

Left: Ethel Le Neve posing in her boy's suit (or another one like it) for her *Lloyd's Newspaper* photographs.

Right: A photo of Ethel and Crippen snapped (supposedly) by Captain Kendall as they posed as father and son on board the *Montrose*.

Left: Sergeant Ernest Walden of the Brooklyn Police, along with Isabel Ginnett (*right*), Betty Hyde (*center*), Louise Mills (*left center*) and Poppet Ginnett (*left*), about to inspect the ships coming into New York's Chelsea Piers.

Above: Crippen, hidden under a hat, scarf and overcoat, being escorted off the *Megantic* by Inspector Dew. Ethel and her wardresses are seen coming through the door behind them.

Above: A large and rowdy crowd awaited the arrival of Crippen and Ethel on the *Megantic* at Liverpool Docks. Ethel claims they were chased to their train as they disembarked.

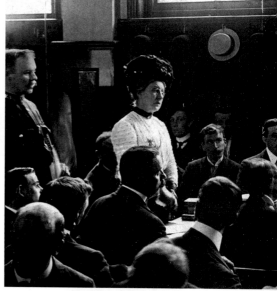

Above left: Louise Smythson (*left*), Melinda May (*left center*) and Clara Martinetti (*far right*) walking to the Coroner's Inquest.

Above right: Melinda May testifying at the Coroner's Inquest.

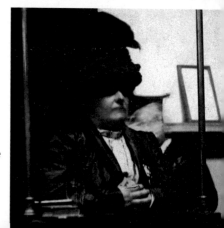

Right: Clara Martinetti giving evidence at the committal at Bow Street.

Right: Crippen and Ethel at their committal at Bow Street Magistrate's Court, September 1910. Ethel is dressed in the blue suit, hat and motoring veil that she would wear for all of her court appearances.

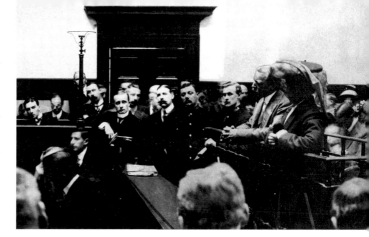

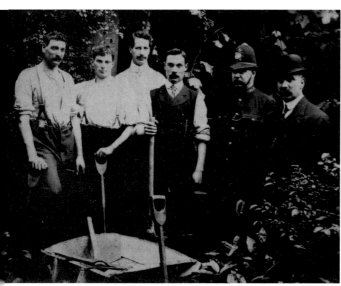

Left: The dig at 39 Hilldrop Crescent. Chief Inspector Walter Dew (*right*) and (probably) Sergeant Arthur Mitchell next to him.

Below: Crippen's trial at the Old Bailey attracted enormous public interest. Journalists and members of the public gathered outside the court every day from October 18-22, 1910, in the hope of hearing news or catching a glimpse of the star witnesses.

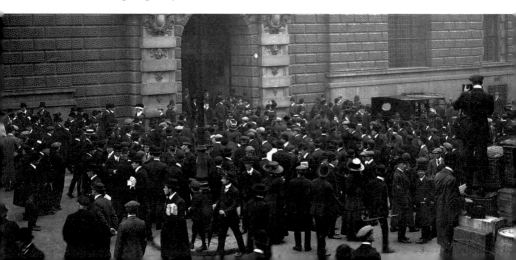

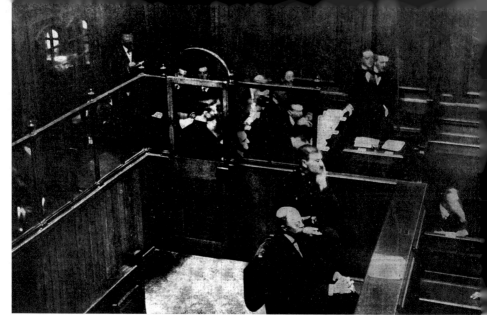

Above: Crippen sitting in the dock during his trial at the Old Bailey.

Below: Ethel as she appeared in 1928 for her series published in *Thomson's Weekly,* "How I Have Been Persecuted."

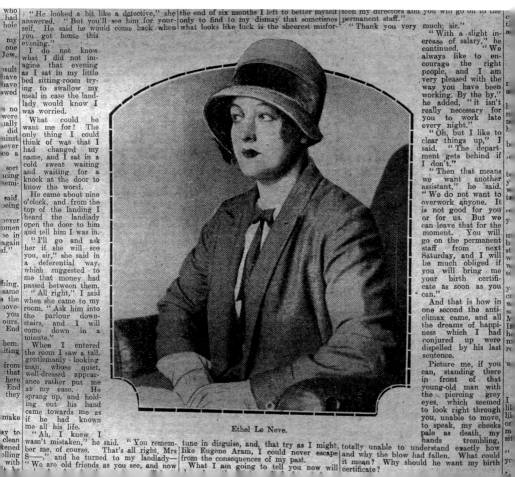

Ethel Le Neve.

"He looked a bit like a detective," she answered. "But you'll see him for yourself. He said he would come back when you got home this evening."

I do not know what I did not imagine that evening as I sat in my little bed sitting-room trying to swallow my meal in case the landlady would know I was worried.

What could he want me for? The only thing I could think of was that I had changed my name, and I sat in a cold sweat waiting and waiting for a knock at the door to know the worst.

He came about nine o'clock, and from the top of the landing I heard the landlady open the door to him and tell him I was in.

"I'll go and ask her if she will see you, sir," she said in a deferential way, which suggested to me that money had passed between them.

"All right," I said when she came to my room. "Ask him into the parlour downstairs, and I will come down in a minute."

When I entered the room I saw a tall, gentlemanly-looking man, whose quiet, well-dressed appearance rather put me at my ease. He sprang up, and holding out his hand came towards me as if he had known me all his life.

"Ah, I knew I wasn't mistaken," he said. "You remember me, of course. That's all right, Mrs S——," and he turned to my landlady. "We are old friends as you see, and now

the end of six months I left to better myself only to find to my dismay that sometimes what looks like luck is the sheerest misfortune in disguise, and, that try as I might, like Eugene Aram, I could never escape from the consequences of my past.

What I am going to tell you now will

seen my directors and you will go on to the permanent staff."

"Thank you very much, sir."

"With a slight increase of salary," he continued. "We always like to encourage the right people, and I am very pleased with the way you have been working. By the by," he added, "it isn't really necessary for you to work late every night."

"Oh, but I like to clear things up," I said. "The department gets behind if I don't."

"Then that means we want another assistant," he said. "We do not want to overwork anyone. It is not good for you or for us. But we can leave that for the moment. You will go on the permanent staff from next Saturday, and I will be much obliged if you will bring me your birth certificate as soon as you can."

And that is how in one second the anti-climax came, and all the dreams of happiness which I had conjured up were dispelled by his last sentence.

Picture me, if you can, standing there in front of that young-old man with the piercing grey eyes, which seemed to look right through you, unable to move, so to speak, my cheeks pale as death, my hands trembling, and why the blow had fallen. What could it mean? Why should he want my birth certificate?

She stood nervously at the entrance to Chancery Lane Station among a congregation of people waiting to meet friends. After a few minutes, the doctor appeared, having changed his suit and shaved off his mustache. Together, they proceeded underground and took the tube to the railway station at Liverpool Street. Unfortunately, they arrived to discover that the train they were hoping to catch to the port of Harwich had already departed. The next one was not until five o'clock. They had several hours to pass, where they could not run the risk of being spotted lounging in the waiting room of a major rail terminus.

Crippen suggested that, instead, they spend the time riding about East London on an omnibus. They climbed to the top floor and sat in the open air, Ethel beneath her heavy bowler hat and Crippen with a gray fedora over his eyes. The bus trundled through Hackney and back again. For the return journey, the couple assumed different seats downstairs. They made very little conversation, for they feared that Ethel's voice would betray her.

Their train departed as scheduled and, much to the doctor and his son's relief, they were alone in their carriage but for one other passenger. They would reach the port of Harwich in an hour and a half's time. According to her *Life Story*, that evening, Ethel was entirely consumed in her thoughts. She curled up in her seat and smiled at her companion.

As she would one day tell journalists, Crippen was so "cheerful" and "free from worry" that it put her at ease. It all seemed "a merry joke" to him, and for her it was "an adventure." Crippen laughed. He laughed at her in boy's clothing, he laughed at her haircut. He laughed so hard that "he had tears running down his cheeks," and amid this contagious mirth she soon "forgot all her troubles."[14]

23

Pieces

ALL WEEKEND, INSPECTOR WALTER Dew felt haunted. His mind refused to rest as it pored over the events of Friday. Crippen was mendacious, he had lied outrageously, and although Dew could not arrest the man for this alone, he also could not fathom Crippen's need to create such a great pageant of deceptions. Dew wondered what secret he had been cunningly trying to hide from Belle Elmore's friends.

Agitated by lack of sleep, he rose and went into Scotland Yard on Saturday morning where he drew up a missing person's description of Belle Elmore to be circulated to every police station in London. The case gnawed at him still. Instead of returning home, he spent the rest of the day pursuing inquiries. On Sunday he sat rereading Mitchell's notes, studying Crippen's statement, analyzing the details, searching for a contradiction or a hesitation which he had missed. It was with mounting expectation that Dew anticipated Monday morning, when he planned to revisit Albion House and put Crippen to another round of questions.

When he and Mitchell arrived, Ethel Le Neve, who would have normally greeted them, was not there. Instead, they were met by a perplexed Gilbert Rylance, who had just received a strange letter from his business partner. The dentist showed Dew the message, which had been written on the company's stationery and posted on Friday afternoon. "I now find that in order to escape trouble I shall be obliged to absent myself for a time," it began.[1] It went on to assure Rylance that the business should be able to continue as usual

and it gave him directions for settling various bills and accounts. Dr. Crippen had fled. There was no indication of his intended destination or if he would return. The typist had gone with him.

Dew was shocked, yet his suspicions had been validated. He believed that "The manner of his going pointed to guilt," as "a completely innocent man with nothing to fear would have seen the thing through."[2] Now, having unexpectedly found himself several steps behind, he and Mitchell had to quicken the tempo of the investigation.

The detectives began to question Crippen's employees, the ever-faithful William Long and Marion Curnow. Miss. Curnow immediately opened her safe and ceded the doctor's two sequestered envelopes to the police. William Long also cooperated with Dew's requests. Like Gilbert Rylance, Long too had received a letter from Crippen, though his had reached his home that Saturday night. As the doctor's factotum, Long had been accustomed to assisting Crippen with a variety of tasks which not only pertained to his patent medicine concern but to his personal business. It was in this capacity that his employer had sent him instructions to settle his household affairs. He was to pay the outstanding rent on 39 Hilldrop Crescent, selling whatever furniture and possessions were necessary to do so. He was then to assist the maid, Valentine LeCocq, on her way back to France. He believed her wages should cover her passage. Finally, Crippen's technician had been asked to return the keys to his landlord, Messrs Lown & Sons.

The news of Crippen's flight had fallen on Long from the sky. He had only just seen his employer that afternoon and beyond Crippen's comment about "a little scandal," he had mentioned and done nothing especially unusual. It was after 7 p.m. when William had been given this message, and with the early summer lending him several more hours of daylight, he and his wife Flora went directly to Hilldrop Crescent to check on the maid. When Valentine opened the door to them, they found Ethel's thirteen-year-old brother, Sidney, keeping her company.

This had been unexpected. The Crippens wanted everyone to believe that they had not plotted their escape. Ethel had to make it

appear as if she had planned to be at home that weekend. As a cover, on Saturday morning she sent a postcard to her family, inviting her brother to visit that evening or to join them for Sunday lunch. At the same time, she wrote another note, which Valentine was to give Sidney when he arrived, apologizing that she and Crippen had been called away. Her brother knocked at the door around midday, and, finding the house empty but for the maid, decided he would instead pass the day following her about and chatting in French.

The Longs arrived after eight o'clock, at which point William struggled to explain the dramatic turn of events to Valentine. He asked if she had received any messages from her master and mistress. "No," she replied. But Sid corrected her. A letter had come about an hour ago, written in both French and in English: "Do not be afraid, we shan't be back tonight; going to the theater."[4] She showed it to the Longs, who were bemused. They offered to escort Sidney home on the tram and to have a word with his parents.

Walter and Charlotte were stunned, and the more Long told them about Crippen's letter, that he intended this as a lengthy absence with no stated date of return, the angrier and more distressed they grew.[5] Long told Ethel's father that Crippen had given him the authority to sell his possessions in order to clear his bills. Walter worried that some paintings he had given his daughter might be claimed by mistake and therefore the two men made arrangements to meet at 39 Hilldrop Crescent the following evening.

Much to Walter's disquiet, he found that the house had been left in a tumbled and disordered state. He went into the upstairs rooms and saw that the bed had been left unmade, the sheets and coverlet thrown off in haste. The maid had evidently not been permitted into the bedroom. Clothing had been strewn about: Crippen's shirts and boots; Ethel's new dresses and "a half dozen pairs of expensive shoes." They had left toothbrushes and hairbrushes behind. Everywhere was evidence of what Neave described as "a panic-stricken flight." Ethel's father concluded that Crippen had been robbing his business and that Ethel feared she too would be implicated. They would have fled together in the hope of avoiding imprisonment, he

had speculated.[6] He pressed Long for any information as to where the couple might have gone, but Crippen had not revealed this to his technician.

William Long conveyed much of this to Dew on that Monday morning, after which Dew and Sergeant Mitchell determined that they should return to 39 Hilldrop Crescent and search the house once more. Long handed over the keys and followed the detectives there.

Flora Long had been at the house with Valentine since the early part of the morning. She learned that the maid did not have the resources to get herself back to Boulogne, so Mrs. Long had gone into a wardrobe and gathered together two bundles of skirts, dresses and underclothing to bring to a second-hand dealer. Dew later explained to her that all of this would have to be reclaimed from the shop: it was potential evidence. He then handed over the management of Valentine's travel to the police. As the couple continued to discuss matters with Dew, William mentioned that his wife had found a piece of paper with handwriting on it under the sofa. He retrieved it and gave it to the inspector. It was the missing person's advertisement he had drafted with Crippen on Friday night. Despite his reassurances that he wished his wife to be found, the doctor had never bothered placing it.

The fire beneath Dew's suspicions positively crackled. As he cast his eye over the rooms of 39 Hilldrop Crescent, he remarked to himself on the great advantage he now possessed. Without Crippen standing at his elbow, obstructing his path, the inspector had "free run of the house." He might search every crevice, every drainpipe, every pocket. He could take whatever time he required. They returned to the bedrooms on the first floor and began digging through the drawers. Dew remarked repeatedly at the profusion of "ladies wearing apparel" including a number of expensive furs.[7] They searched through the desks and found letters and postcards addressed to Ethel as "Mrs. Crippen." They uncovered Crippen's medical diplomas and credentials from American institutions. In the wardrobe of the main bedroom, Dew recovered a five-chambered revolver.

Presumably, this was the little nickel-plated handgun that Crippen had been teaching Ethel to shoot. Downstairs in the breakfast room, Mitchell found a corresponding box of cartridges and several cardboard targets, which had been laid aside in the kitchen.

With the best of the daylight dwindling, Dew and Mitchell locked up the house and returned to Scotland Yard where they asked the police to begin making inquiries of porters and cab drivers who might have removed boxes or packages from 39 Hilldrop Crescent. Dew also issued "a full description of Crippen and Le Neve to all ports, home and abroad," with a request to report any sightings.[8] Unfortunately, as no firm evidence had yet emerged of any crime, the inspector could not call for their arrest.

The next morning, Tuesday the 12th, they began afresh on the house. Starting from the top, they worked their way to the bottom, "combing every room" for the barest hint of foul play. Dew descended into the kitchen and then into the coal cellar, where he stamped about on the floor, and peered at the brickwork under the glow of a flame. He surveyed the garden, examining the small mounds and irregularities of the ground. He and Mitchell located a pair of spades, removed their coats, rolled up their sleeves and began to dig. Although they had been turning up nothing by way of clues, Dew had begun to itch with the sense that Belle Elmore had been murdered.[9] When the daylight had fled and he was unable to continue the search, he lay in bed, running through each room in his head. His mind kept stopping at the coal cellar. That evidence of a murder might lurk beneath an otherwise unassuming floor was certainly not an original notion. As recently as December 1908, George Hume, in South London, had disposed of his wife under the linoleum and floorboards of his shop. Like Hawley Crippen, Hume had also told his wife's friends that she had "gone away," but he was later spotted with some of her jewelry.[10] The horror of the crime and the ensuing trial in 1909 at the Old Bailey had been widely reported in the newspapers.

Wednesday the 13th came. Dew and Mitchell began by making inquiries throughout the neighborhood and visiting the train sta-

tions to see if anything suspicious had been placed in left luggage. They were both exhausted, dog-tired. After they concluded their interviews, Dew suggested they return to 39 Hilldrop Crescent.

They resumed digging the garden, until, finding nothing, Dew turned his sights to the coal cellar. The inspector grabbed a poker from the kitchen, so he might prod the brick flooring. Together, he and Mitchell navigated the dark passage and the stairs. A collection of detritus was scattered across the ground: a small quantity of coal, bits of rubbish, some wood cut from garden trees, and a disused chandelier. With a lantern beside them, Dew and Mitchell got down on their knees and pushed at the chilled, damp brickwork. Mitchell pressed the thin point of the poker against the flooring in several places, testing it, tapping at the hard surface. Suddenly, the resistance gave way. The poker sank into the dirt between two bricks.[11] One brick became loose, and then another. Mitchell and Dew began pulling them up with their hands. Others around them were wiggled free, revealing a smooth surface of flattened clay. Charged with excitement, Dew sent Mitchell to the garden for a spade. The sergeant passed it to the detective. Dew stuck it into the exposed earth, which seemed to fall away loosely. He shoveled it again, and then a third time.

The smell which rose from the shallow hole was unmistakable. It filled their nostrils with a nauseating, putrid foulness. Fearing they would be sick, the men scrambled up the stairs, gasping for breath. Dew and Mitchell knew what they had found, or rather, who they had found. As they stood in the cleansing daylight, filling their lungs, the inspector felt the gravity of the discovery they were about to make.

They descended for a second time into the thick, poisoned atmosphere and, on this occasion, the spade struck "a large mass of flesh."[12] After a short spell, the men found it necessary to come above ground again and fortify themselves with brandy. Once more, they dug, the shovel turning up earth and flesh. That was enough for them. Dew sent for Assistant Commissioner Sir Melville Macnaghten, and for Dr. Thomas Marshall, the divisional police

surgeon for Kentish Town, the local district. He also called for assistance in the further excavation of the cellar. By now it was late afternoon: 5:30 p.m. Constables arrived on the scene to help with the dig and Dew sent one of them out for disinfectant in order to quell the persistent stench. When Macnaghten turned up, along with Frank Froest, he brought with him a box of cigars for a similar purpose. The heavy tobacco smoke would be used by the diggers to mask the scent as they toiled in the cramped confines of the space.

The police constables stripped down to their braces, removed their starched collars and pushed up their white sleeves. The hole was deepened to the length and breadth of a human body. Further remains were found and removed: pieces of flesh, some of them with fat, muscle and viscera still attached, but not a single particle of bone was discovered. In addition to these ghastly finds, the constables had unearthed the remnants of a man's handkerchief with two ends tied in a reef knot, as well as a piece of coarse string and a small bit of brown paper stained with blood. There was also a blood-soaked set of ladies' combinations (or a combined suit of camisole and bloomers traditionally worn as an undergarment beneath a corset) as well as a portion of a woman's undervest with buttons and lace. With these distinctly feminine items was found a Hinde's hair curler (a popular make) twisted around which were a few strands of fair hair with dark roots. Finally, part of a gentleman's striped pajama jacket bearing the label "Jones Bros. of Holloway" was excavated from the site and placed in a tray with the other items. The contents of what Dew would refer to as "the grave" had been covered with quicklime, a substance which was intended to increase the decomposition of the remains, while absorbing the noxious smells emitted by them.

As the day drew to a close, a police photographer was summoned to make a record of the grisly scene. For hours, neighbors had been gathering outside 39 Hilldrop Crescent. The constant activity: the arrival and departure of strange men and uniformed police, the erection of tenting around the garden and the deliberate obscurement of the windows had aroused the excitement and suspicion of

the entire area. Around eleven at night, the loud popping of a photographer's flash could be heard, followed by great bursts of light from behind the canvas-shaded ground-floor windows. Onlookers were now convinced that there had been a murder on this quiet green crescent.

As the sun rose on Thursday the 14th, Dew and Mitchell steeled themselves for a long day ahead. The first task was to remove the remains and examine them thoroughly. Called to the scene was Dr. Augustus Pepper, a pathologist and consultant surgeon at St. Mary's Hospital. He was joined by an undertaker from Leverton and Sons who had brought with him a coffin and a more crudely fashioned coffin-shaped shell, designed for transporting the remains to the mortuary. Before leaving Hilldrop Crescent, Pepper and Dew made another inspection of the house. They were about to make a crucial discovery. Under Crippen's bed, in a box, Walter Dew found "two suits of flannelette pajamas and an odd pair of trousers of another suit."[13] The pattern of this worn pair of bottoms appeared to match the remnants found in the grave site.

The contents of the coffin and the tray were laid out at the Islington Mortuary Chapel of Ease on Holloway Road for Drs. Pepper and Marshall to examine. Dew, Mitchell and the mortuary keeper then joined them for the official post-mortem on what was believed to be "all that remained of the once charming and vivacious Belle Elmore."[14] The pathologists' job was to determine, as far as possible, that these fragments of human being were indeed her, or at the very least, female. Finally, there was the matter of murder, and whether one had been committed, and committed by Hawley Harvey Crippen. Of this, Walter Dew felt fairly certain. Mrs. Crippen had not been seen since February 1 and her husband had fled in the wake of an interview with the police, so "what other explanation could there be of the presence in Dr. Crippen's coal cellar of the parts of a human body?" In Dew's experience, unless there was "something criminal to conceal," "bodies were rarely buried in such a way."[15] Putting the entire story together, all the pieces, both literal and figurative, began here, on the post-mortem table.

Each small element of her person was laid out and scrutinized, sometimes deliberated over for hours. There was so little of her, and the realization of that struck all of them at various times. On the table before them there was "one piece of skin with some subcutaneous fat attached to it which measured 11 inches by 9 inches." This was believed to be from the upper portion of the abdominal wall and the front of the chest. Another section "consisted of the lower part of the back and the buttocks," and a third "large piece" came from the upper part of the back. A further strip "measuring 7 inches by 6 inches" of fat and muscle came from "the lower part of the abdominal wall in front." On this section there was a mark which resembled a scar and indications of what appeared to be pubic hair. There were smaller fragments, including those which came from a limb and a thigh. Remarkably, all the bones were absent. So too was the head. Every part of the sex organs were also missing. However, most of the viscera were present. Because the quicklime had been dampened in places, it had acted as a preservative for the liver, stomach, gullet, part of the windpipe, both lungs, the heart, the diaphragm, the kidneys, the pancreas, the spleen, the small intestine and most of the large, which were all intact.[16]

The medical men were able to draw a number of conclusions. What had caused her death was as yet unknown, though the remains had been buried in the cellar for approximately four to eight months. From the samples that were available to the naked eye, neither Marshall nor Pepper could make an assessment of what act or instrument had ended her life, though Marshall was convinced this was a homicide. A specimen had been sent for a toxicological examination to determine if a poison had been used, but the results would not be available until after Monday the 18th, the date of the coroner's inquest. Both agreed that the dissection and dismemberment had been carried out by someone with considerable anatomical knowledge of the human body and probably professional training as a medic or a surgeon. The intention had been to obliterate all indication of identity and sex; however, Dr. Pepper believed

there was enough to suggest these were fragments of an adult female body.

When the post-mortem had been concluded, Belle's organs, her strands of hair with their hair curler, as well as the assorted pieces of underclothing, pajama top and handkerchief, were placed in five stoppered jars. Arthur Robinson, the mortuary keeper, then sprinkled her parts with carbolic powder and placed a sheet of wallpaper lining over them.

From this date, Belle Elmore ceased to be a person; instead, she became a series of pieces: clues, body parts, other people's memories. On Monday, the coroner's inquest was held to determine to whom the remains belonged, and how, where and when the individual had died. This event would be covered extensively by the press, who would reveal to the public the true horror of what had been inflicted on the woman hidden beneath the cellar bricks. The utter brutality of the killer, the ruthless and inhumane treatment meted out on her lifeless form, was enough to shock even the coroner. Danford Thomas, who had been involved in roughly 40,000 such inquiries over the course of his career, stated he had never seen anything like it.[17] "It must have been an awful business taking the flesh from the bones, then burying it in the cellar," he said. "I do not remember such a case."[18] The nature of the atrocity that had been committed at 39 Hilldrop Crescent stunned the public. That a man could not only extinguish the life of one entrusted to his care, but then desecrate her body, a woman he had once loved and held in his arms, was unthinkable. It was bestial, sub-human, a profanely evil violation of moral and social order. Many wondered at how he could have performed such a barbaric act. How could a civilized, educated, professional man, who lived in a ten-room suburban house with a verdant garden, dismember his spouse's body and then continue with his ordinary existence, catching the tramcar to his office and attending the theater? How could he have sectioned it and detached the joints, as blithely as a high-street butcher? What sort of fiend stripped down the fingers that cooked his meals, sewed

dresses, made music, stroked his face? He silenced her songs; he shuttered her eyes. He removed her breasts, her vagina, and what remained of her reproductive organs. How an intimate family member brought himself to amputate and then destroy the head of the woman whose face he once animated with happiness was inconceivable.[19] How he could have found it in himself to then defile her further, to burn her bones and grind them down or to dispose of them in a body of water (as Dew suspected) was soul-chilling. Crippen's objective was to eradicate any trace of Belle Elmore, to make it seem as if she had vanished into the breeze.

Edwardian newspapers loved a terrifying tale of true crime, and the story of what had been uncovered at 39 Hilldrop Crescent contained all the elements that readers relished. Less than twenty-four hours after Dew and Mitchell had made their discovery, the names of Hawley Harvey Crippen, Belle Elmore and Ethel Le Neve appeared in headlines around the world. Their narrative was both sensational and Gothic. It was not simply the dastardly, spine-tingling act of murder and dismemberment that drew public interest, but its characters and scenarios. There was an air of moral ambiguity surrounding each of the three players—the wife: a glittering American music hall performer; the husband: an untrustworthy Yankee medical man; and the mistress: a typist, a single, vulnerable girl who lived apart from her family at the center of a morally bankrupt capital. That it had all unfolded behind the tree-shaded houses of polite suburbia further heightened the sense of titillation. A middle class that had only recently glimpsed an uncomfortable image of itself reflected in the Pooters now found itself staring hard at the Crippens. Were the aspirant middle classes really so far removed from events of 1888, when Jack the Ripper destroyed the lives and bodies of women living in the slums of Whitechapel? No amount of social climbing, crystal sherry glasses, seaside holidays or gala dinners was enough to spare them from the urban depredations of murder and mayhem. Hilldrop Crescent could be any respectable neighborhood. The Crippens might be *your* neighbors.

It was the intoxicating mixture of horror and romance, in a con-

text which felt so safe and familiar, that held the world's attention. On that Wednesday the 13th, before the remains had been found, William Long had come forward with a confession. He admitted to Inspector Dew he had neglected to mention that he had purchased a suit of boy's clothing for Dr. Crippen on the day he and Ethel absconded. It was possible that Ethel was traveling disguised as a young man. After Dew drew up the warrant for "Murder and Mutilation" which would be circulated internationally, the story acquired yet another lurid and incredible twist: cross-dressing.

For those on the outside, the unfolding of this sordid spectacle provided a thrilling escape, a mystery to be followed and solved in real time. Each edition of the newspapers provided another installment. Yet for a handful of others, those whose lives were personally impacted by events, the discovery at 39 Hilldrop Crescent proved deeply traumatic. For those who loved Belle Elmore, news of her vicious murder came without warning and fell hard.

On the evening of July 14, Melinda May was riding on a tramcar in South London when, over the conductor's shoulder, she happened to glimpse a headline about a body at Hilldrop Crescent. Upon opening her own copy of the newspaper, she had what she called "one of the most severe shocks I have ever known."[20] Melinda claimed she fainted. She and several members of the Ladies' Guild were recalled numerous times to try "to identify some pitiful relic of the murdered woman." "The very sight of those bits of clothing and personal fragments made me positively ill," Melinda wrote. At the end of it, she claimed her "nerves were shattered" and her health never recovered.[21] Both Lillian and John Nash were similarly affected. After they had made their complaint to Frank Froest, they "hardly slept." Worse still, until July 13, Scotland Yard regularly called upon John to examine the bodies of women recovered from the Thames.[22] Like Melinda May, Lillian was summoned to identify Belle's remains and found the experience so upsetting that she had to cancel three weeks of professional engagements on account of "strain" and "anxiety."[23]

Such emotional turmoil and stress also took its toll on the Neaves.

Once it had been revealed what lay in the cellar of Ethel's home, Walter and Charlotte were terrified for the safety of their daughter, whose life was in the hands of a suspected murderer. At this desperate time of worry, the Neaves were besieged by the press. Walter claimed that his "life became unbearable with the constant knocking at the door day and night." For weeks, the family found themselves forced to hide in their flat, as the press installed themselves outside, assembling on the landing or on the street in front of the Goldington Buildings, where they lived. One journalist knocked more than thirty times in one day, while another walked straight into their home through the front door.[24] Charlotte Neave, who had always been of fragile health, found herself "strained almost to breaking point by her trouble."[25] In the coming weeks, she would suffer a nervous collapse.

Word of the heinous crime also made its way to Los Angeles, where representatives of the press found the "Toothless, nearly blind and senile" Myron Crippen, living on a meager income in a block of apartments on Third and Flower Streets.[26] Crippen's father, from whom he had been estranged, was greatly affected by the news, and wept as he spoke with the journalists. Across town, a man called Jacob Herwig sat on his porch with a Winchester rifle across his lap, warning reporters to leave his family in peace. Inside his home, his son-in-law Otto Crippen sheltered from the relentless press frenzy, and nursed his feelings of dismay.[27]

When Hawley Crippen committed his callous deed, he saw only the elimination of a problem. Without this obstacle in his path there would be freedom for him and space for Ethel. The killing and unpleasant disposal would merely be the bridge to this place. He would replace the bricks on the cellar floor, then a spell of time would pass. The seasons would turn; she would dissolve into the ground, her memory eventually drifting away like a whisper. There would come a day when her friends would no longer mourn her, her family would no longer grieve her absence. What he failed to imagine was the opposite outcome. That in removing Belle Elmore he was

destabilizing the lives of many others, who in turn would upend his own. He failed to see how all the pieces aligned, that murder is never a single act of destruction, but experienced as a series of interconnected injuries, a spray of shrapnel scattered throughout the lives of all those in close proximity.

24

Manhunt

THE FRENCH NEWSPAPERS DECLARED that Crippen had been found on July 21. In Vernet-les-Bains, near the border with Spain, a man with a light-colored mustache and glasses had fled from a cafe without paying his bill and headed into the wilds of the Pyrenees. Only days before, in Bourges, south of Paris, a young woman believed to be Ethel Le Neve had shot herself in a hotel room. A railway official in Dieppe was certain he had seen Crippen come off the boat from England on the 19th, but on the same date, a clothier in West London swore the fugitive had come into his shop and asked to buy "a lady's costume and underclothing" for himself. The doctor was also seen in Copenhagen on that day, while former colleagues of Crippen claimed he had been spotted in mid-July in Chicago and Philadelphia. He was all over London as well as in various seaside resorts: Brighton, Bournemouth, Ramsgate. A barber in Liverpool claimed he shaved off Crippen's mustache, while a "wardrobe dealer" near Paddington Station believed Ethel had come into his shop on the 11th looking to swap her outfit. On July 17 Mr. J. Johnson of Victoria Villas in Waltham Abbey marched into his local police station and claimed he had seen Crippen at "half past five on Wednesday." He had never been more sure of anything. In one London neighborhood, a crowd surrounded and harassed an elderly man "wearing spectacles" who happened to be accompanied by a young lady. Another gentleman was mistakenly arrested twice on suspicion of being Crippen, while in an act of jealous spite, a for-

mer lawyer tipped off the police that Crippen was living at the address of his professional rival.

"There has never been hue and cry like that which went up throughout the country for Crippen and Miss. Le Neve," Walter Dew commented. As the newspapers were full of the case, "it was the one big topic of conversation. On the trains and buses one heard members of the public speculating and theorizing as to where they were likely to be." Like modern-day reality-television viewers, the newspaper-consuming public felt they were active players in this real-time, high-stakes drama. "The whole world was flooded with circulars asking for the detention of the runaways on a charge of murder," wrote Dew, and so the invitation was for everyone to become a vigilante. As a result, the sightings continued to gush forth, inundating the police. The inspector claimed he was working sometimes more than sixteen hours "out of every twenty-four."[1] Meanwhile, the newspapers taunted Scotland Yard. "Eleventh day of Crippen's flight" the *Daily Mirror* proclaimed in a headline on the 20th. Every subsequent day that passed was met with another reminder that the fugitives were still at large.

On Monday the 11th, the very day that Dew himself discovered that Crippen and Ethel had fled, Melinda May caught wind of this development from down the corridor in Albion House. The news spread almost instantaneously among the Music Hall Ladies' Guild, who immediately wired Isabel Ginnett in New Jersey. The urgency of the message sent Mrs. Ginnett straight to her local station where she boarded a train to Brooklyn. Her destination was the headquarters of the Brooklyn Police on State Street, an imposing five-story building settled amid a neighborhood of brownstone boarding houses and grit-splattered clapboard facades. She was directed to the 3rd floor where Sergeant Ernest Walden of the Bureau of Lost Relatives listened to her concerns. Isabel knew that Belle had family in Brooklyn but could not recall more than a handful of details. Her sister was a Mrs. Mills with a husband "employed in some way with a soap factory."[2] Sergeant Walden suggested that she place an advertisement in the local papers and together they drew one up:

If the sister of Mrs. Dr. Crippen professionally known as Belle Elmore of London, England, is living in Brooklyn, will she please send her address to Ginnett, Roselle, N.J.[3]

After further discussion, Walden thought he might have enough information with which to begin a search. With that promise, Mrs. Ginnett put away her drafted advertisement, and awaited word from the police sergeant.

Brooklyn was a smaller place than Isabel Ginnett had imagined, and much to her surprise, Walden contacted her the next day to inform her that he had located Mrs. Louise Mills at the home of Belle's stepfather, Frederick Mersinger. The glamorous Mrs. Ginnett in her expensive London attire accompanied the police sergeant to East Williamsburg, and to an old wood-frame house surrounded by a few acres of vegetable garden. They were greeted by Louise and the elderly Frederick, who were to find this visit quite unsettling. Louise said she had been disquieted by a nagging intuitive sense that something was amiss. Although she had intended to set off for Rhode Island, where her husband had started a new job, she felt she needed to stay. "I thought I might receive some news," she later confessed.[4]

The group discussed what they knew, arranging the pieces of this perplexing puzzle. Louise produced the last letter that she and her husband, Robert, had received from Crippen. It was dated April 7, informing them of Belle's death. He rehearsed the usual story, complete with expressions of misery and prodigious grief at his loss. The letter had brought terrible sadness to the Mersingers, but Frederick and Louise both admitted they found many things strange. In the first instance, they thought it highly improbable that Belle would have come to the United States without at least writing to them, and the message itself said nothing about the place of death or what was to become of her body. They found themselves "uneasy about the vagueness of it."[5] They would become more troubled still when informed that Crippen had admitted to lying about everything. Isabel would depart the Mersinger home with the distinct impres-

sion that her friend had been murdered.[6] She would soon be proved correct.

Ernest Walden had been given the task of conveying the distressing news to the Mersinger family. He returned to the house on Grove Street, which was now swarming with journalists. At first Louise was too stunned to believe it, but then Walden placed the newspaper reports in front of her. She became "prostrate with grief" and "leaned her head on her hands and moaned that it could not be so."[7] Her sister Kate was "shocked to the point of hysterics."[8] After Mrs. Mills composed herself, she faced the press and described the visit she had paid to her sister four years earlier, when Belle and Crippen appeared to live quite happily together. As Louise had seen her brother-in-law comparatively recently, Walden asked her to accompany him and Mrs. Ginnett to the passenger ship piers. The New York authorities had reason to suspect that, as an American citizen, Crippen would be heading back to his native land, and with Isabel and Louise's assistance, they hoped to create a dragnet in which to catch him.

The operation began that Friday the 15th at 6:30 a.m. at the Chelsea Piers in Manhattan. The newspapermen and the press photographers were poised for the moment when the four-funneled *Lusitania*, one of the fastest and most luxurious ocean liners afloat, passed quarantine. The dock was lined with police, among them four lieutenants from the NYPD, as well as Sergeant Walden and his two pairs of eagle eyes: Mrs. Ginnett and Mrs. Mills. From their position at the customs enclosure, they inspected "nearly every one of the cabin passengers," but Dr. Crippen and Miss. Le Neve were not among them.[9] They proceeded to steerage, then made a tour through the ship, peering into the polished dark wood cabins, peeking behind velvet drapery and into the closets. The police looked inside the lifeboats. They searched the faces of the crew, the stewards and stokers. After depositing her first- and second-class passengers, the *Lusitania* proceeded to Ellis Island, where those in steerage disembarked to be processed separately. Isabel and Louise walked the snaking lines of those making their arrival in America and performed a

second search for familiar faces. As they had failed to find any, they returned to the pier. Waiting for them there was the German liner *Friedrich der Grosse*, and after that, the *Pennsylvania*. On each occasion, the entire exercise was repeated, but to no avail. "We're going to keep it up . . ." Louise pledged. "We will identify Dr. Crippen the instant we see him, no matter how he may be disguised, and we will call for his arrest at once."[10]

The ladies returned the following day to greet the *St. Paul* arriving from Southampton, and the *La Lorraine* coming from Le Havre, on which Crippen had once claimed that Belle had sailed. However, given the time required to cross the Atlantic, it was believed that the fugitives were more likely to have boarded a ship scheduled to arrive after the 16th. The White Star liner *Cedric*, and the *Minnetonka*, coming directly from London's Tilbury Docks, were thought to be possible vessels used for an escape, as too were the *Kroonland*, the *Chicago*, the *Carmania* and the *Zeeland*. Of the thousands of visages hidden under flat caps, bonnets and veils, there were a handful of false alarms: a German man, flamboyantly dressed and wearing heavy spectacles, was pulled out of a queue. Beyond this, the search was proving fruitless, lengthy and tiring. To assist in their efforts, Isabel invited her sister-in-law, the entertainer Betty Hyde, who had also been a friend of the Crippens, to join them. So too came Poppet, Mrs. Ginnett's eight-year-old daughter. As an experienced performer, Isabel knew precisely how to make the most of their situation. There were few more effective methods of ensuring that Belle's story was championed on the front pages than to provide the newspapers with compelling images of elegant ladies and a sweet little girl. They arrived at the pier each morning in their white summer dresses, wearing hats piled with flowers and feathers, a stark contrast to the legions of uniformed men. Poppet strode beside them like a jolly mascot, carrying a tiny parasol. The press photographers eagerly snapped their cameras, trailing them as they marched shoulder to shoulder along the pier, catching pretty Louise staring wistfully at the ships, and Mrs. Ginnett looking redoubtable and dour.

The revelation that the Crippens were American with ties to New York sent journalists in the city scrambling and digging in every direction. Those who were not congregating at the piers or outside the Mersinger house were, by July 16, making their way to Queens and a small apartment on Forrest Street. The day before, William Bell had received what would have undoubtedly been the most alarming news of his life. Whether it came to him by opening a local paper or was relayed in person, Bell would learn that the man who had married his sister Charlotte in 1887 was now wanted for the murder of his second wife. He was still reeling when the press found him. He was prepared to go down to the ports or the police cells and identify his former brother-in-law, if it came to it. Bell spoke as if his fists were clenched. He hoped Crippen would come to America, he stated, so he could play some role in his capture. He declared that he was never convinced by the reports Crippen gave of the death of his sister. He also made it clear that eighteen years ago, he had contacted "the authorities of several American cities to probe the circumstances of her passing," but nothing conclusive ever came of his efforts. William also disclosed that Charlotte had a sister in Manhattan, and so the press scattered in the direction of Selina Leary's home. They knocked at her door until they were able to gain some confirmation of her brother's statements, and a forlorn photograph of Charlotte, removed from a frame or an album. "It had not been generally known that Dr. Crippen had been married before he wedded the good-looking actress," wrote the *New York American*, but once the story had broken, this rich morsel of information was dropped into the larger narrative. On account of the questionable circumstances of Charlotte's death, the international press began to speculate that Crippen might be facing two charges of murder. Suddenly, the situation could not have looked more perilous for Ethel, "the girl" in Crippen's grip.

25

Titine and Old Quebec

A ROUND THE BACK OF the Gare du Nord in Brussels ran the busy rue de Brabant, a street of low-slung shops' canopies, tobacconists and small working-class cafes. Down the center of the road glided the tram on its electrified wire. At number 65 was an establishment run by Monsieur Vital and Madame Louisa Henry-Delisse, the Hôtel des Ardennes, a small, three-story building with twelve compact bedrooms. It was the sort of hostelry frequented more by locals than by tourists, with "a typical Belgian restaurant and café with wood and leather benches" on the ground floor. The bar was stacked with bottles of liqueur served to clay-pipe-smoking patrons by a "very stout" and "bare armed" Madame Henry-Delisse.[1] For the equivalent of 5 shillings a night, visitors could stay in one of the tiny rooms decorated with dull yellow wallpaper and lace curtains.

Just before 3 p.m. on July 10, a short, middle-aged, clean-shaven man and his pale sixteen-year-old son came through the door and inquired after a room. Madame Henry-Delisse offered them one on the first floor. The gentleman, a merchant from Quebec, signed the register as John Robinson. His son, by the same name, had a medical complaint. They had been traveling on the continent for his health, Robinson Senior explained, and had most recently taken in the sights of Vienna. Their intention was to tour Belgium and Holland, to visit Amsterdam and Rotterdam, Antwerp and the surrounding area, before returning home to Canada. Upon first impressions, they seemed ordinary, simple pleasure-seekers, though the proprietress and her husband did think it somewhat odd that they only

carried one small 12-by-24-inch wood-fiber hamper between them on such a long journey.

In an era before passports, a person could adopt any identity, tell any story about their past, and move with relative ease through borders. On the night of July 9, Hawley Crippen and his "son" were able to board a crossing to the Hook of Holland with no trouble. They had arrived at Harwich and then taken a modest supper near the pier before making their way to their private berth on the ship. Ethel claimed that she slept as soundly as a child that night. Tucked into her bunk, her concerns drifted out to sea. The doctor had been entirely forgiven for deceiving her and she was safe in the knowledge that "Belle . . . was somewhere in America, and we would never see her again."[2]

Crippen woke her at five the next morning to tell her that they had arrived. He suggested that they get a train to Rotterdam, less than an hour away "and have a thoroughly good time." Ethel was thrilled by the idea. They arrived in the city with "no program." The idea was just to roam, to permit the wind to blow them in any direction. They wandered "up and down interesting streets" and "walked alongside the quiet canal," gazing "at the long gables of the quaint houses," which Ethel claimed appealed to her "romantic imagination." She stared wide-eyed at the Dutch men "in their big baggy trousers and wooden sabots." During their perambulation, the doctor bought her a cheroot which she attempted to smoke. She found "it . . . horrible but . . . liked the adventure." They went to the Zoological Gardens and strolled about looking at the monkeys, squawking parrots and wild beasts. There was something so daring about this stunt, about abandoning their lives and their identities, and strutting about undetected in boy's clothing, that Ethel seemed to experience a sort of euphoria. She would declare that she had "never felt so girlish, so full of high spirits in my life."[3]

Crippen spotted a barber shop and proposed that a professional should complete the makeshift male haircut he had given his "son" at Albion House. Ethel said that, at first, she hesitated. Barber shops were distinctly masculine domains, places where decent women never

ventured, where men smoked and bantered about their physicality, their interests and their pleasures: gambling, sex, sport, drinking, politics and their otherwise unmentionable health problems. "Never in my life had I been inside a barber's shop," she said, "but at last with a courage I did not think I possessed, I strolled inside and sat down in a vacant chair."[4] Crippen placed himself in another one nearby and watched her through the mirror. Although the barber critically examined her ragged locks, she did not think he suspected anything, at least not until he took up his clippers and applied them to the nape of her neck. Ethel started, and through the reflection, could see Crippen "laughing in secret amusement." Once the ordeal had concluded and they stepped outside, the two could barely restrain their hilarity, or so she claimed. The real test of her transformation came afterward, while they were sitting in a cafe. Two Dutch girls, perhaps around sixteen, were casting admiring glances in her direction. Ethel was certain that they had fallen in love with her. "Oh the Pretty English boy!" they exclaimed in English, before giggling and conferring in their own language.[5] The word "pretty" was undoubtedly chosen deliberately.

Neither Ethel nor Crippen seemed to realize that her disguise was not particularly convincing. Monsieur and Madame Henry-Delisse suspected something was amiss almost immediately. Ethel arrived that afternoon off the train from Rotterdam wearing ladies' shoes. After seeing her again, they also noted that she had "a girl's figure," which could not be hidden beneath a boy's suit. Two days into the Robinsons' stay at the Hôtel des Ardennes and the proprietors were absolutely certain that Ethel was a young woman. As part of her male charade, she kept her hands concealed deep inside her trouser pockets; however, at mealtimes her "beautiful and white" hands with their "well-kept nails' were visibly on display."[6] Fearing that her female voice would betray her, Crippen would never allow "his son" to speak. After Madame addressed Master Robinson and received only a blank stare, Mr. Robinson explained that his son was "stone deaf" and that he also had a throat condition. However, the Henry-Delisses noticed that Crippen "was stupid

enough to talk to her in whispers," to which she always responded.[7] Their conversations were conducted in corners, but never beyond the proprietors' gaze. Madame and Monsieur soon came to the conclusion that Crippen was a professor who had run off with one of his female students. They referred to them jokingly as "Titine and Old Quebec"; Titine was a diminutive of Christine, then a popular girls' name, while Crippen was given his moniker for his constant chat about his imaginary homeland.

According to Ethel's account of events, they had succeeded in fooling everyone. Their sojourn in Brussels became a joyful celebration of a carefree existence. Ethel claimed that it was she who had chosen Brussels as their destination and Crippen allowed her to follow her whims and "go exactly where I wanted to go." Never did he try to keep her indoors.[8] At the time, Brussels was hosting the Exposition Universelle, a world's fair in which twenty-five countries participated. The extensive grounds, featuring elaborate pavilions for each of the nations and landscaped formal gardens, were situated at the edge of the Bois de la Cambre, the city's large green space. Visitors could view an American "Wild West show," a recreation of an Italian Renaissance villa, and a Senegalese village, as part of the "Palace of the Colonies." The French had loaned some of their finest pieces of modern art, works by Monet, Renoir, Matisse and Rodin, while the Belgians exhibited their scientific achievements in electricity, engineering and agriculture. The Exposition occupied Crippen and Ethel for several days, as they "wandered about the palaces and the side shows and had good fun at the old Flemish fair."[9] They "traveled on the train, visited the picture galleries, the museums and the public gardens." They also spent "charming hours among the trees and on the lawns of the Bois de la Cambre, listening to the bands and the birds." Ethel floated from one scene to the next, "delightfully happy." For the first time in her life, she "was free and without a care in the world."[10]

As they were whiling away the hours amid the delights of Brussels, Crippen kept a wary eye on the newspapers. According to Ethel, he read *L'Étoile Belge* daily and also examined several other

local publications, but never did so with any indication of nervousness. Although Ethel would contend that she never looked at the papers while they were abroad, she would later admit that she "sometimes picked up and glanced at" *L'Étoile Belge*. The doctor made no attempt to keep her from doing so, because he knew her French to be so poor. Apparently, she was incapable of even recognizing the words "Crippen," "Belle Elmore," or her own name. She claimed that she remained ignorant of everything because there were no photographs printed in the newspapers (but there were). At any rate, even if she had been able to decipher the news and learned they "were wanted for the murder of Cora Crippen," she was certain that the doctor would have given her "a plausible explanation, which would have lulled my suspicions."[11]

The picture that Ethel was determined to create of their lighthearted adventure was not reflected in what Madame and Monsieur Henry-Delisse observed of the pair. "They both looked very tired, the son especially," the proprietress remarked about their arrival at the hotel.[12] The boy often appeared "distressed and embarrassed."[13] For the first two days, Mr. Robinson seemed particularly uneasy, but eventually began to relax. He read the papers eagerly, but from what Madame was able to gather, did not share them with "the boy." The Henry-Delisses noticed that they spent most of the time in their room, a space dominated by an overbearing wooden bed. They went out for "a couple of hours" in the morning before returning around 1 p.m. and then going out once more in the early evening. They regularly turned in by 9 p.m. Crippen was constantly on his guard: "he always retired to his room when some customer came in." If he was taken by surprise, he would quickly hide himself, turning toward Ethel and engaging in conversation. Usually when he did this, he would take her into a dark corner or shield her face, so it was in shadow. "He never left the girl alone one minute," the proprietress said. It was not until the 16th that Crippen bought his "son" some proper men's canvas shoes. The "boy-girl" usually wore a straw boater, but on that day, Mr. Robinson also purchased

a gray felt hat which Madame Henry-Delisse noticed "she wore with the rim turned down over her eyes."[14]

Crippen must have sensed from the rigor of Inspector Dew's questioning that the detective was unlikely to give up until he hit the bottom of the coal cellar. No matter how careful he had been in disposing of the remains and expunging all evidence of a crime, he could not be entirely certain that every inch of the house would withstand the sharp point of Dew's scrutiny. The anxiety of this, of knowing that the police were likely to be crawling around his home on their hands and knees, must have been driving him to distraction. Three days after their arrival in Brussels, Crippen was looking to move on. That morning of the 13th, the day before Dew's discovery appeared in the international news, he and Ethel went to the booking office of the Red Star Line shipping company and inquired about a second-class passage from Belgium to Canada. He was looking for a vessel "that sailed at once."[15] The clerk informed him that a ship called the *Montrose* traveled that route, calling at Quebec City and then Montreal, but not until August 3. Crippen returned the following day, perhaps after having had his worst fears confirmed by the morning news. If he had been anxious on the 13th, he would have been desperate on the 14th. He had hoped there had been some alteration to the schedule, but unfortunately, that was not the case. The clerk had nothing further to offer him, but he did suggest instead taking a route to Canada that went via England. Crippen declined.

On the 15th, he and Ethel called in once more at the Red Star Line booking offices. Crippen anxiously approached the desk. Ethel loitered in the background, head down, hands in her pockets. This time they were "informed that the *Montrose* would now sail on the 20th." Crippen must have struggled to hide the relief on his face. The Robinsons booked themselves "two tickets to Montreal and reserved cabin no 5."[16] It was a second-class cabin of four berths, but the doctor purchased the entire room for about £21, which he paid for in English gold coin. The expense of this, and the cost of their

crossing from Harwich, their meals and accommodation and the purchase of John Robinson Junior's shoes and hat had begun to stretch the limits of their resources. Toward the end of their stay at the Hôtel des Ardennes, Monsieur Henry-Delisse had noticed that they seemed reluctant to spend money on anything and "they made their meals of nothing but pastry."[17] In the haste of their departure Crippen had made certain to stitch into his undervest the jewelry Ethel had been wearing. The rising sun brooch, as well as four diamond rings and a paste butterfly brooch (which must have had some sentimental significance), had traveled with them from London. This was their emergency fund, on which £119 might be raised, but only as a last resort.[18] After purchasing their passages to Canada, Crippen made a discreet inquiry of the clerk: could he provide him with the name of a moneylender? The Red Star Line employee apologized, he was unable to assist him.

The situation at the Hôtel des Ardennes must have been growing tense. The Henry-Delisses knew that the Robinsons were not what they pretended and perhaps this had become too obvious. It was time to leave. Crippen announced his intention to do so on the evening of the 17th when he bought drinks for the proprietors and their staff. The next morning, he shook everyone's hand, then he and his "silent, pale 'son'" departed with their small valise.[19] He had mentioned their intention was to go to Vilvoorde, so Master Robinson's health might benefit from the fresh country air, but on the 19th at around noon, Madame Henry-Delisse spotted them walking from Gare du Nord away from the city, and then returning again an hour later.[20]

Ethel offered another completely fanciful narrative of their movements. She maintained that they went directly to Antwerp, and that they only left Brussels because she had grown bored of looking at the shop windows. Crippen had suggested they go to Paris, but she was ambivalent. Then he mentioned Antwerp, and she agreed. It was only once they were there that it was decided to buy tickets to cross the Atlantic.[21] Where they actually spent the nights of the 18th and 19th is unknown. By then, handbills, posters and advertisements featur-

ing photographs and descriptions of the fugitives were in wide circulation. On the 16ᵗʰ, the police in Antwerp had shown Crippen and Ethel's images to all employees working at the port. Fortunately for John Robinson and his son, the Red Star Line clerk who interviewed them and stamped their tickets on the early morning of the 20ᵗʰ had been too distracted to closely examine their faces. It was a small miracle that they made it up the gangway to the *Montrose*.²²

In Ethel's carefully varnished 1920 account of their flight from Antwerp, one single, remarkable statement stands out like a beacon among a haze of lies and invention. It seems to cast a light on the entire terrible chain of events and how she and Crippen came to find themselves disguised as father and son, sneaking on to a ship to Montreal.

The murder of Belle Elmore had never been a foregone conclusion. A couple illicitly in love and with a powerful wish to be together always had options. While a divorce in Great Britain might have been unobtainable, at the turn of the century it was still possible to seek one at several overseas "divorce mills." Paris and Reno, Nevada, had established themselves as destinations where complainants could initiate a suit for the dissolution of a marriage on the basis of everything from an unforgiven act of adultery to public nagging (an *injure grave*); however, these solutions could require a considerable commitment of time and money without the guarantee of a favorable legal outcome. Failing this, Crippen and Ethel might simply have eloped to the United States, leaving Belle behind in London and posing as a married couple in some American city or town where no one was likely to question them. Apparently, Crippen had suggested that they might make a future for themselves in Detroit "and build a nice little business," but the thought of moving permanently abroad horrified Ethel. "To sever all ties . . . to leave behind my father, mother, and the land of my birth; to go thousands of miles across the sea to an unknown land, to an unknown fate . . . was another thing." She regarded it as "a terrible decision" and it was only under extreme duress, when every other option was closed to her, that she eventually consented to it.²³

Despite her enormous reservations, Ethel claimed that she boarded "the big steamer" in her boy's clothes "without the slightest sensation of nervousness." She and Crippen were "buoyant and laughing" over their "secret voyage." He was "calm and untroubled" and she "trotted along" at his side, looking forward to "getting all the fun it was possible to get" out of their adventure.[24] They went to their cabin, their only haven of privacy for the next twelve days. It offered them a porthole for a breath of fresh air, a settee on which to sit and read, a washstand, and a mirror affixed to a chest of drawers. They pushed their small, locked suitcase under the settee and changed their hats before heading out on to the deck. From here they would enjoy the spectacle of the steamer pulling away from port and traveling through the Scheldt estuary to the open North Sea. Ethel would tell the world that she was reveling in the experience, leaning over the rails, free from anxiety. Instead, contrary to this story, she was uneasy.[25] She and Crippen attempted to locate an undisturbed spot where he could comfort her.

It was unfortunate that the lifeboat they chose to shelter behind was directly in view of Captain Henry Kendall's cabin. After steering the ship through a particularly treacherous part of the estuary, the captain had left the bridge for a quiet moment and a smoke. As he lit his cigar and gazed out of a porthole, he "observed the lower portions of two men," their top halves obscured by a lifeboat. As he was watching, one of them squeezed the other's hand. Kendall was taken aback, and for "several minutes" he continued to study them and "form certain conclusions." Eventually, the elder of the two emerged from around the lifeboat's stern and peeped along the deck to see if anyone was looking. Satisfied that they were alone, he returned to his position.[26]

Although homosexuality was not considered unlawful in Belgium (and the *Montrose* was still in Belgian waters), the ship was registered in England, where gross indecency laws had recently sent Oscar Wilde to prison for "the love that dare not speak its name." As the keeper of law and order on the ship, Captain Kendall had a duty to investigate. He walked over to where the couple were standing.

At his approach, the two men stepped away from the boat. Not wishing to alarm them, Kendall engaged them in polite conversation and together they discussed the river scenery and the many windmills visible on both the Dutch and the Belgian sides of the water. As they were chatting, certain characteristics about the man's face struck him. He noticed that "his eyes protruded" and "there was a deep mark on the bridge of his nose, yet there were no spectacles." He was clean-shaven and without a mustache, but he appeared to be growing a "chin beard." As he spoke, the captain detected an American accent. The "boy" on the other hand was "very reserved" and said nothing but coughed rather harshly. The man apologized for his son: "my boy has a weak chest," he said. "I am taking him to California for his health." After "making a few complimentary remarks regarding the youngster," Kendall returned to the bridge.[27] He had a strange suspicion he had seen this pair before.

Once inside, he retrieved the English newspaper he had been reading earlier and turned to the page which featured Crippen's and Ethel's photographs, their physical descriptions and samples of their handwriting. "More than ever I was convinced that Dr. Crippen and Miss. Le Neve were these two passengers."[28]

Over the next forty-eight hours, Captain Kendall would conduct an investigation into these two mysterious travelers worthy of Scotland Yard itself. He began by returning to the deck and inviting the gentleman and his son to sit at his table for their meals. This was a tremendous honor, and the pair could hardly refuse. Kendall then turned his attention to the passenger list and the ship's file of validated tickets. The man had given his name as John Philo Robinson. His son was John George Robinson, aged sixteen. He noted that they had purchased their tickets in Brussels and were among a slim handful of passengers not from continental Europe.

The bell sounded for lunch. Kendall, in his blue uniform, with his hard frown and chiseled jaw, took his position at the top of the stairs. He carefully monitored the passengers filing into the dining saloon. When he was certain the Robinsons had passed through the

doorway, he speedily stole away to cabin 5 and unlocked the door. He scanned the room and noticed there were two hats resting on the settee. He examined each of them. One belonged to the elder Robinson, but the second was for a smaller head. He lifted it up and noticed it had been purchased in Brussels and that the rim had been packed with newspaper to make it fit more tightly, a trick ladies often employed with their fashionable and often cumbersome headgear. He also found their single, modest valise, but was unable to open it. Just as he turned to leave, another object caught his eye: a white bit of fabric had been left to dry and was "hanging from one of the toilet hooks of the washstand." He moved closer to investigate. It had once been the sleeve of a woman's under-bodice but was now being used as a rag. Kendall, in his 1939 memoir, for decency's sake could hardly have called it what it evidently was—a makeshift bit of sanitary dressing used to staunch a menstrual flow. Instead, he suggested that Ethel had been using it as a face flannel. "Another confirmatory clue!" he declared.[29]

Kendall returned to the dining saloon to take his seat. Ethel was placed to his right, with Crippen to her right. She had been strategically situated there, he believed, so no one other than he could converse with her. Now certain that the boy was really a girl, Kendall studied her intently. He spoke with her congenially, though she said very little in response. Throughout the meal he noticed how Master Robinson ate, the "careful handling of knife, fork, and spoon together with the dainty fingering of fruit."[30] There was nothing male or adolescent about "him." In fact, by the end of lunch he was fairly sure she was a woman in her twenties.

The captain contrived other opportunities to inspect the Robinsons at close range, and set them a number of tests. As "father and son" strolled on deck, he called out to Mr. Robinson, but Crippen had forgotten himself and his supposed identity. It was only after Ethel tugged at his sleeve that he recognized his name and responded. Kendall invented excuses to engage them in conversation. He invited them to his cabin for tea. He knew Crippen had lived in San Francisco, Detroit and Toronto and, after mentioning these des-

tinations, soon discovered that John Robinson had been resident at these places too. Like Crippen, Robinson also practiced medicine. Kendall decided he wanted to see an example of Crippen's handwriting to compare with the sample that had appeared in the newspaper. He asked the Robinsons to attend him in his cabin while they completed their passenger manifest forms. Crippen obliged him, and after he left, Kendall promptly pulled out the newspaper and found that he had a perfect match.

He then performed one final test. As the Robinsons were stretched out on deckchairs, not twenty feet from his cabin porthole, the captain pinned the newspaper photograph of Crippen to a drawing board. With a piece of chalk, he "deleted both mustache and spectacles." He regarded the man, and then the photo, and "had no hesitation." He performed the same trick with Ethel's picture. Although her image displayed a woman with a profusion of dark hair and a stylishly large hat, he blotted these details out by cutting a circular hole in a piece of cardboard and fitting it around her face like a frame. He then glanced at young Master Robinson seated outside and knew "there could be no mistake."[31]

Captain Henry Kendall was positive that he had Crippen and Le Neve. He also recognized that it was "his duty as a ship master and as a law-abiding individual to let Scotland Yard know."[32] It was now July 22 and Kendall understood that if he was going to send a wireless message to England, it had to be done imminently.

At the time, wireless telegraphy was a relatively new technology. While telephones and telegraphs relied on cables to enable communication, wireless telegraphy was unhindered by the need for miles of entangled and cumbersome cord. Instead, messages could be relayed through invisible radio waves that sailed through the air and bounced between transmitters and receivers. After being granted a patent by the British government in 1896, the Italian inventor Guglielmo Marconi created the first business to develop what would become known as "Marconi Wireless." Navies and shipping companies immediately saw the advantages Marconi's development could offer in providing a method of sea-to-land communication that had

not previously existed. By the end of 1902, the Marconi Wireless Telegraph and Signal Company had established permanent wireless stations in England, Ireland, Nova Scotia, Newfoundland and along the northeastern coastlines of Canada and the United States. When they were within a range of between 150 and 600 miles of radio antennae, ships could send and receive messages in Morse code. They could also pick up messages being volleyed between other ships. For the first time, commercial liners could remain in contact with their land-based headquarters, and first-class passengers might have the luxury of communicating with friends, family and colleagues. However, in 1910, having a Marconi wireless set on board was still a comparative novelty. Henry Kendall estimated that "barely sixty ships throughout the globe were thus fitted." Fortunately, the *Montrose* was among them.[33]

At that time of day, the captain knew he needed to be within 150 miles of a transmitter to effectively send a message. He decided he would use the wireless to contact Mr. Piers, the managing director of the shipping company in Liverpool, who would then notify Scotland Yard. Kendall sent for his wireless operator, swore him to secrecy and then disclosed the nature of the message he was about to tap out. From that point onward, all communications received by the ship needed to be reported directly to Captain Kendall and kept from the eyes of anyone else. Kendall wrote five sentences on a slip of paper. The operator took his seat in front of his device.

Piers Liverpool—130 miles west Lizard—Have strong suspicions that Crippen London cellar murderer and accomplice are among Saloon passengers. Mustache taken off growing beard. Accomplice dressed as boy. Voice manner and build undoubtedly a girl. Both traveling as Mr. and Master Robinson. Kendall.[34]

26

Crime of the Century

O N THE AFTERNOON OF July 23, a man in a green Ulster coat and a tweed cap, with a "bulldog pipe" clenched in his teeth, got off a train in Liverpool. The station was already heaving with journalists. He had been instructed to push through the crowds and locate a plain-clothes police officer wearing a red rose in his lapel. This gentleman would escort him as quickly and quietly as possible to the docks. There, the White Star liner *Laurentic*, due to sail for Canada that evening, would be waiting for him to board. He was informed that only the captain and a handful of trusted officers would know the man's true identity or the nature of his business aboard the ship. He would be known as "Mr. Dewhurst" during the journey. His disguise, one newspaper wrote, was "almost impenetrable . . . and it was nearly an hour before the passengers succeeded in ascertaining who . . . the mysterious gentleman was."[1] Had the story of the discovery of Crippen and Miss. Le Neve on a vessel bound for Quebec not been leaked that morning, the presence of a Scotland Yard detective on a ship sailing a similar route might never have been noticed.

A seemingly miraculous feat of technology had grabbed Captain Kendall's message from the air and placed it into Inspector Dew's hands by 8 p.m. on the same day it was transmitted. Dew wasted not a minute. He went immediately to the home of Sir Melville Macnaghten, the Assistant Commissioner of the Metropolitan Police, and requested permission to travel to Quebec. His intention was not only to pursue the fugitives, but to arrive in Canada before

them. The *Laurentic* was a faster steamer than the *Montrose* and, if the voyage went as planned, the ship would arrive at Father Point (Pointe-au-Père), at the mouth of the St. Lawrence River, the day before Captain Kendall's vessel. Dew proposed to alight here, board the *Montrose* before it came into its first port, Quebec City, and arrest Crippen and Ethel Le Neve. It was a strategy of high risk. If he failed, if the *Laurentic* was caught in a storm, if there was a delay, if somehow Crippen received word of the pursuit and slipped away, Dew would have squandered a vast amount of police resources. The debacle would be mortifying for Scotland Yard. Nevertheless, both Macnaghten and Dew agreed it was worth a chance.

Walter Dew was absolutely circumspect about his plans. When he packed his bag, he did not even inform his wife where he was headed. However, she, like the rest of the globe, learned of his daring scheme on the front pages of the newspapers. Most of the passengers aboard the *Laurentic* were respectful enough to pretend the man called "Dewhurst," "with a furtive air and a suspicious mien," who deliberately avoided the smoking room and the lounge, but who passed hour upon hour in the wireless cabin, was simply "an Englishman out for a little pleasure jaunt" and not Chief Inspector Dew incognito.[2]

From the moment he boarded, the detective was determined to make contact with the *Montrose*. For the next day or so, they would remain in range of land, pulsing out urgent messages to Captain Kendall, but they received nothing in return. Instead, their line sparked with endless inquiries from the press. The race across the Atlantic had begun, and the *Laurentic* was towing the entire world's fascination behind it.

It was a journalist's message to the *Laurentic* that the *Montrose* first intercepted on the 24th, as they pushed further out to sea, beyond the Irish coast.

> *What is Inspector Dew doing? Is he sending and receiving wireless messages? Is he playing games with passengers? Are passengers excited over the chase? Rush reply.*[3]

To Captain Kendall's delighted eyes, this was a confirmation of one thing: Scotland Yard had received his words and "the right man would be waiting in Canada should everything go according to plan."[4] It was now incumbent upon him to keep the Robinsons close and to maintain the convivial charade. He continued to dine with them, noting, along with a number of the stewards, the odd familiarity that existed between father and son, the way the elder shared his salad and his beer with "his boy," the way he politely cracked nuts for his teenaged "child." They spent a good deal of time sitting on deck reading. Kendall and Crippen discussed books and recommended titles to one another. The elder Robinson told him that Master Robinson was consuming Dickens's *Pickwick Papers*, and mentioned how they both enjoyed Edgar Wallace's *Four Just Men*, about a London murder. Not a hint of unease crossed Crippen's features when he remarked on this. He was a cunning man, the captain noted. The Robinsons also attended the passenger concerts in the saloon. Crippen was especially fond of the comic tune "We All Walked into the Shop" and continued singing the chorus well after the performance had ended.

While Crippen appeared relaxed, optimistic, even jolly at times, Kendall observed that "the boy" did not seem to be faring as well. Pale Master Robinson, who never ran, shouted or played, seemed to "talk very little," even when a young man of his age attempted to befriend him. Ethel did her best to keep up with the discussions about cricket and football. "The girl was playing her part well, even though outwardly in great distress. The strain of make-believe, the suppressed excitement, the secret anxiety, imposed on her a great mental and nervous strain . . ." The captain claimed that one morning, as father and son were sitting near his porthole, Master Robinson swooned. When she revived herself, she looked at Mr. Robinson and admitted, "I'm done for."[5] Kendall had begun to suspect, as did numerous newspapers, that Crippen was exercising a sort of "hypnotic influence" over her. She was "fascinated by him," captivated like a fainting heroine in a melodrama, rendered helpless by an evil, mustache-twirling Svengali.[6] Ethel would later object to Kendall's

assessment, and to those of others who suggested that Crippen had some mesmeric hold on her. She was not "a girl with a very weak will" she protested. She felt "sure of [her]self" while dressed as a boy, and not "in the least embarrassed."[7] Certainly "there was no hypnotic influence between Hawley Crippen and myself . . ."[8] Ethel would explain that what she felt toward Crippen was simply devotion. However, the depth of his devotion seemed at times variable.

As the *Montrose* slowly approached Canada, Ethel had begun to notice a change in Crippen's demeanor. After taking the air on deck he returned to their state room, subdued and serious. On their journey, Crippen had always looked after their money, but he suggested that now she should have the £15 that remained. Ethel was puzzled and asked him for his reasons.

"'Well,' he said hesitatingly, 'I may have to leave you.'"

Ethel was astounded. "It seemed to me incredible that I should come all this way and then be left alone."

Crippen continued. "'Listen, dear,' he said. 'When you get to Quebec you had better go on to Toronto . . . You have not forgotten your typewriting, have you . . . ?'" Ethel realized he was setting forth a plan to "go ahead and prospect the country in order that we might settle down in peace in some out of the way spot."[9]

This proposal did not sit well with her. The thought of being abandoned in a foreign city would have frightened her. She asked about her clothes. She pointed out that while posing as a boy, she could not walk into a shop and buy herself a dress: he would have to do that for her (presumably as a husband purchasing a gift for his wife). Crippen had not considered this, and it made him pause. His answer was that they would go to a hotel as soon as they landed. He would then go out and select some clothing for her. She would quickly change into her new attire and then they would immediately part company. Ethel agreed to this, only because she sensed Crippen had a premonition that the police might be waiting for them when they disembarked.

It was more than intuition. The doctor had been reading the newspapers. He had watched the story explode, its ripples spreading

from one end of the globe to the next. He knew they were expecting him, and he had begun to panic. On the off-chance that they passed beneath the noses of the Canadian authorities unimpeded, it would have been safer to separate and to assume other identities. How precisely Crippen would have found Ethel again in Toronto with a new name, no settled address and no means of contacting one another, begs many questions. On the other hand, it would have made perfect sense to simply leave her behind and to never look back. It certainly would not have been an unprecedented choice for Hawley Crippen.

As the days at sea wore on, he must have suspected that Kendall's attentions, his munificent displays of cordiality, were not simply because the captain had taken a liking to him. Standing on deck, Crippen could hear the electrical crackling as messages to and from the ship sparked off the antennae. "What a wonderful invention!" he had exclaimed to Kendall one day, looking aloft.[10] Surely, he feared, and not incorrectly, that some of what was zipping through the ether concerned him.

Crippen may have been on deck on July 29 as the first hint of land appeared on the horizon. This was Belle Isle, roughly 20 miles north of Newfoundland, and the site of a Marconi transmitter. The *Montrose*'s wireless suddenly juddered awake. A deluge of press inquiries came pouring through in thousands of rapid dots and dashes. Amid these there was also a message from Chief Inspector Walter Dew of Scotland Yard. Despite Dew's assiduous efforts in the *Laurentic*'s wireless room, the *Montrose* had remained uncontactable as she traversed the Atlantic. Throughout the period of silence, Captain Kendall continued to broadcast confirmations that the fugitives were on board, but there had been no response from the *Laurentic*. As he approached the Canadian coast, he had no certainty of Dew's position until the words "Your message to Liverpool 130 miles Lizard Friday last—will board you at Father Point . . ." were handed to him.[11]

Inspector Dew had only just landed at Father Point, the day before the *Montrose* was due to arrive. It was a desolate, fog-bound

outpost, the site of a large lighthouse and a scattering of wooden shacks. Traditionally, this was the location where ships sailing up the St. Lawrence River would be joined by pilots to guide them through the waterway. The mysterious Dew in his overcoat, carrying his holdall, was the sole passenger to disembark and the crowd of journalists and photographers who awaited him cheered when he came down the gangway.

From the time of the inspector's arrival, he and Kendall were in constant contact as they tied the final strings of their dragnet. The *Montrose's* captain agreed to Dew's plan: the ship would arrive at Father Point at around 6 a.m. on the 31st. He advised Dew to disguise himself as one of the pilots and to come on board in a small boat. This would enable him to evade notice by Crippen and spring on the pair unannounced. The inspector consented to this, but also warned Kendall to keep Crippen and Le Neve "under discreet observation."[12] In such cases, when fugitives sensed their options were narrowing, suicide was not uncommon.

As the hour of the planned arrest approached, Dew was growing increasingly anxious. While he was confident Henry Kendall would do his best to deliver the errant passengers, he did not trust the aggressive crowd of journalists swarming Father Point. He found himself hassled incessantly. They banged on the door of his lodgings, and bellowed questions at him, but he refused to speak any word which might jeopardize his operation. When it came to his attention that a group of "American newspapermen" were planning to hire a boat and sail out to the *Montrose* before he could board it, Dew was furious. In order to stop them, he found it necessary to strike a deal which allowed the press to board the *Montrose* after the arrest. The captain would blast the ship's siren three times, signaling that the fugitives were in custody, and only then would they be welcome.

Kendall passed the evening of the 30th on tenterhooks; "every hair of my head (was) on duty," he wrote. He had begun to grow uneasy that their plan would be foiled if Crippen caught sight of the unusually large number of "pilots" expected to board the ship. Inspector

Dew would be accompanied by several Canadian detectives who would be assisting in the arrest, in addition to the actual pilot charged with directing them. Reasoning that it would be useful to have Crippen on deck (and in his sights) that morning, Kendall suggested to him that he should "get up early if he wished to admire the St. Lawrence River." He also casually mentioned that they would be "picking up half a dozen pilots who were bound back to Quebec."[13] He hoped that would mitigate against any rising suspicion.

The sun dipped and darkness spread over the water. The thick layer of fog which had been sitting between the *Montrose* and the coast during the day now blotted out what little visibility remained. The ship cut through the dense gray, guided by the dolorous moan of foghorns and the occasional blurred flash from a lighthouse. Kendall recalled spying Crippen pacing the deck that night before he finally descended into his cabin.

On the final day of July, morning broke around 4 a.m. The full glare of day was still stifled by the mist. Crippen dressed himself and told Ethel that he planned to watch the ship enter the St. Lawrence. He asked her to join him on deck, but as it was early and the weather was cool and dull, Ethel preferred to stay below and read.[14]

The *Montrose* was a few hours behind schedule, but Kendall was not concerned. Crippen appeared on deck and leaned against the rails, just as Kendall hoped he would. The captain kept a close watch on him from the bridge. As if by divine intervention, just as the *Montrose* approached Father Point, the veil of fog suddenly rolled back, revealing the jagged beauty of the Canadian coast. It also exposed the small boat of "pilots" now rapidly approaching the starboard side of the ship. Crippen suddenly turned to the *Montrose*'s surgeon, who was standing beside him. "Isn't it unusual for so many pilots to come aboard?"[15]

His question went unanswered.

Dew and the Canadian police, disguised in their peaked pilots' caps and heavy coats, scaled the ladders dangling from the ship's side and entered her through an internal staircase. They followed this to the captain's cabin, where Kendall had come to meet them.

He and the inspector shook hands. "Where is Crippen?" Dew asked at once.[16]

Kendall pointed through a porthole to the saloon deck.

Dew spotted a small, slight man emerge from behind a funnel. He looked somewhat like the Dr. Crippen he had interviewed at Albion House, but without his heavy mustache or thick spectacles. Two of the Canadian officials in their pilots' uniforms were dispatched to invite him to the captain's cabin. As Dew observed the man approach him, he was overcome with the thrill of what he was about to do.

"Let me introduce Mr. Robinson," said Captain Kendall.

Dew reached out his hand. "Good morning, Dr. Crippen."[17]

It took him a moment. Then, his eyes suddenly widened, and his Adam's apple began to twitch. "Good morning, Mr. Dew."[18]

"You will be arrested for the murder and mutilation of your wife, Cora Crippen, in London, on or about February 1st last," the inspector stated.[19]

Crippen did not respond as Inspector Denis, of the Quebec Police, made the formal arrest and placed the handcuffs around his wrists. He was then taken away to a vacant cabin, while Kendall, Dew and his Canadian counterpart, Inspector McCarthy, proceeded downstairs to apprehend Ethel.

Ethel had been lounging on the narrow settee reading when there came a rap at the door. She had expected to see Crippen when she looked up from her book. Instead, the door opened and three gentlemen stepped over the threshold. "Good morning," said the tall man at the front. He removed his pilot's cap. "Do you know who I am?"

Ethel knew precisely who he was. She recognized him instantly. The shock of seeing him, of hearing him announce his name, made her "heart beat violently." She was "filled with horrible forebodings," with "terrible terror."[20] Ethel began screaming and crying. She screamed and screamed until she nearly passed out. Dew claimed that had he not been there to catch her, she would have collapsed on to the floor.[21] This was before he read out the charge.

"You are arrested with Doctor Crippen and charged with the murder and mutilation of Mrs. Crippen," Inspector Dew informed her.

Ethel claimed she heard this spoken "as in a dream." "His words seemed far off." She had no idea what he meant. She was "too ill to make a reply" and "could only answer in monosyllables."[22] Ethel would later tell the journalists who helped to craft her *Life Story* that she had thought all along that Belle Elmore was still alive; in fact, it had been her intention when they reached Canada "to confront the person who had sent the cablegrams to Dr. Crippen" (assuming for some reason that the telegrams had been sent from that country). It was only at that moment that Ethel had learned that Belle was dead, and not just dead, but murdered. Worse still, she "was charged with being a party to the crime." Ethel described how she was "paralyzed with fear and astonishment." She "could say nothing." She "could think of nothing."[23] She never once protested her innocence. She never expressed any surprise when learning of Belle's true fate. There is no record of her uttering sentiments of disbelief, pity or revulsion. She never asked any questions. She never spoke a word. Instead, for the rest of the day, Ethel "wept hysterically and moaned."[24] It was reported that "her sobs were audible all over the deck."[25]

Dew left her in the hands of one of the *Montrose*'s stewardesses, "a big, pleasant woman" called Freida Heer.[26] It was decided that, for decency's sake, Ethel should be restored to female clothing, and so some articles of ladies' dress were hunted down and given to the despondent young woman. While the stewardess was distracted, Ethel was reported to have seized the moment. According to several newspaper accounts, she sprang from her bunk and took either a package or "a white paper" from her luggage or her pocket and bolted for the cabin window.[27] Mrs. Heer "dropped the clothes she was carrying and grabbed the prisoner by the wrists. For a few seconds there was a silent struggle in which the stewardess had the backs of her hands scratched," but she was unable to prevent the object from being thrown out of the porthole. Afterward, Ethel fell back on to the bed and became "so hysterical that the ship's doctor was sent for."[28] After a sedative was administered, Ethel became

283

"quieter" and eventually allowed the stewardess to help her change.[29]

After securing Ethel's arrest, Dew and his team returned to Crippen. The prisoner was stripped and searched, and it was then that they discovered the hoard of diamond jewelry sewn into his underclothes. Riffling through his pockets, they also found two false business cards. Crippen must have ordered these when they arrived in Brussels. On one side appeared:

E. ROBINSON & CO.
Detroit, Mich.
presented by Mr. John Robinson

On the opposite side of one, he had written in pencil:

I cannot stand the horror I go through every night any longer, and as I see nothing tonight ahead and money has come to an end, I have made up my mind to jump over-board tonight. I know I have spoiled your life but I hope some day you can learn to forgive me. Last words of love.
Yours, H.

On the second piece of card were the words "Shall we wait tonight about 10 or 11? If not, what time?"

The inspector took this as confirmation that the prisoner had intended to take his own life and therefore ordered that Crippen was to remain in handcuffs.[30] As he explained this to the doctor, Crippen's cool containment began to thaw. He stated that he would not jump overboard. "I am more than satisfied, because the anxiety has been too awful."[31]

Crippen's concerns then turned to Ethel. "How is Miss. Le Neve?" he asked.

"Agitated," Dew said, "but I am doing all I can for her."

"It is only fair to say that she knows nothing about it; I never told her anything," Crippen pleaded.[32] He must have been supremely shaken to have said this. For months, he had plotted out his words

as if they were chess moves. There was always an excuse and an explanation prepared in advance. Whatever he had intended by the first part of his statement, a gallant attempt to protect Ethel from incrimination, the second half would work to undo him.

Crippen and Ethel would remain locked and guarded in their separate cabins until the *Montrose* arrived at Quebec City at 10 p.m. While Crippen read and slept soundly, and Ethel remained sedated, the ship was under siege by the press. The moment the captain gave the signal, the boat of photographers and journalists which had been bobbing on the water, just out of sight, raced for the ship. Kendall remarked that most of them did not even wait for the gangway to be erected and scaled the ropes. He commented that the sight was reminiscent of "a ship being raided by pirates."[33]

The *Montrose* would become the forge in which the stories that shaped the case would be furiously hammered out by thousands of typewriter keys. The press scoured the ship for angles and interviews. They peered through windows and the cracks of doors; they chased down the stewards and the wireless operator, and pursued Dew, who adamantly refused to speak. They scavenged for every minute fragment of the narrative and pieced it together, whether supposition, fact, rumor or opinion. In addition to detailed descriptions of the Robinsons' habits and movements, fanciful tales also emerged: Crippen carried a gun and wore false eyebrows, and Ethel had attempted suicide.[34] Others reached beyond the immediate spectacle, reflecting on the wider implications of Crippen's arrest.

On August 2, the *Boston Globe* published a piece entitled "Greatest Crime of Century" in which the journalist A. J. Philpott marveled at the role modern technology had played in the capture of Crippen and Le Neve. Not only did he cite wireless telegraphy as "the real captor of the dentist and the weak young woman" but that "the instant publicity" made possible by telephones and cablegrams allowed newspapers to simultaneously publish the story around the globe. Had Captain Kendall not been able to read about Crippen and Ethel's flight in the Antwerp papers, he would never have known that the fugitives were aboard his vessel. Similarly, a powerful

new propulsion system had allowed the *Laurentic* to outrace the *Montrose*, enabling Dew to make his sensational arrest.[35] Philpott stated that this alone would have been a significant measure of life in this new century, had the murder too not been exceptional. He suggested that it was through the *Studies in the Psychology of Sex*, the groundbreaking work of English sexologist Havelock Ellis, that the motivations of such an unusually heinous crime could be fully understood. The multi-volumed work, first published in 1897 but banned in Britain, offered an exploration of every aspect and dimension of human sexuality, and would influence Ellis's contemporary, Sigmund Freud. The scientific analysis of the mind, of its suppressed longings and sexual impulses, was to many the way of the future and had the potential to unlock the mysteries of abnormal and criminal behavior.

This entire spectacle was what many believed the twentieth century had in store for them. The sky was filling with airplanes and dirigibles; projected beams could X-ray the human body and throw moving images on to screens. Motorcars were becoming faster; electricity brightened the darkness of night. A pair of criminals were captured by a net of radio waves. Such was the marvelous, progressive triumph of human invention. On the other hand, some in Britain worried that civilization had entered a state of moral and physical decline. For the prescient inhabitants of 1910, the Crippen case felt like no other. It gathered up all the strands of their world, their fears and their hopes for the future, and emblazoned it on the front page of every newspaper.

On the 31st, the public and the press would be treated to their first glimpse of the characters at the center of this intercontinental drama. Until their arrest, how the world imagined Hawley Crippen and Ethel Le Neve was down to what could be extrapolated from the photographs and physical descriptions that appeared in the papers: a man with a mustache and heavy spectacles who "threw his feet outward when walking," and a dark-haired, blue-eyed young woman with "a pleasant, lady-like appearance." Henry Kendall estimated that thousands had lined the wharf to catch sight of them

disembarking on that sultry summer's night. The crowd shouted and booed as Crippen, a small, crumpled, weakling of a man in handcuffs, was hurried down the gangway and into a police vehicle. This was not the vision of an angry, wife-dismembering brute, a remorseless, sneering reprobate, but something altogether more prosaic and pathetic. The incongruity of expectation and reality would become an ever-present issue in how Crippen's public image would be shaped. Surely a man so meek and slight could never be capable of the crime of which he was accused?

Reporters and the public were also privileged to their first glimpse of Ethel. Until this time, newspaper coverage of Crippen's companion fell into one of two types. When interviewed, most of her friends, family and colleagues universally expressed their incredulity that quiet, gentle Ethel could have had anything to do with a murder. It was assumed that she had somehow become swept up in events beyond her ken. Nina claimed that her sister "would not stay with the doctor when she learned the truth." She was certain that Crippen was keeping the news from Ethel. Her sister was "a brave girl, but she would completely collapse if she heard that the Doctor was wanted for murder."[36] By the 20th, the *Morning Leader* was speculating that Crippen must have confessed to her, if only to explain the reason for the hue and cry. The newspaper wondered "what means were being employed to keep her mouth closed." It conjectured that he must have been "deluding her into the belief that she was involved" and thought that it was only a matter of time before she would "break down under the strain."

A second depiction of Ethel was also proffered by associates and family. Amid the concerns for her safety and assurances that she was ignorant of the crime were a number of sharp and insinuating comments about her character. Valentine LeCocq remarked on Ethel's enormous wardrobe, that she had "too many [dresses] for one wife" and that she always wore "jewels, diamonds and pearls."[37] Her love of "sham jewelry," which she "always wore a tremendous lot of," came in for criticism by an anonymous colleague at Albion House, and her dressmaker could not help but notice that she decorated

herself with "a lot of brooches."[38] Less than subtle hints were dropped that Ethel and Crippen had been engaged in an affair for some time; it was well known that they frequented Frascati's restaurant, and that Mrs. Crippen had "tried to induce her husband" to get rid of his typist.[39] Reports of Ethel appearing at the Benevolent Society Ball on Crippen's arm while wearing Belle's diamonds only worsened matters. Some of the most censorious statements came from Ethel's mother, Charlotte Neave. In an interview with the *Daily Mail*, Mrs. Neave painted a portrait of her daughter as a vain social climber who had been obsessed with material pleasures since she was a child. Charlotte recounted tales of Ethel's fondness for fine fabrics and talked about her daughter's frequent holidays to the continent. "I am afraid that her love of rare things gave her just a trace of selfishness," lamented her mother, who also added that Ethel "devoted most of her conversation to dress."[40] Interestingly, these identical criticisms—an excessive love of clothing, jewelry and luxury, poor taste, vanity, unrealistic ambitions and sexual immorality—would also be leveled at Belle Elmore in the coming weeks. However, unlike Belle, in Ethel's case these accusations would eventually be replaced by another more captivating narrative.

Shortly after Crippen was ushered off the *Montrose*, a stumbling, fainting, frail "girl" in an ill-fitting dress was half carried down the gangway. The shattered appearance of Miss. Le Neve, with her cropped hair hidden inside a cheap black bonnet and a veil thrown over her face, electrified journalists. Ethel, probably under the influence of sedatives, was whisked away to police headquarters where she and Crippen would spend the night in the cells before being formally charged in the morning.

It was from this point that the two views of Ethel were reduced to a single truth. The public and the press had been shown compelling proof of a weak young woman who had been mentally and physically ruined by a wicked villain. This image of a broken Miss. Le Neve in Crippen's thrall was only reinforced by Inspector Dew's pronouncements to the newspapers that he believed Ethel was innocent and that, owing to her shattered nerves, she was too ill to

withstand prison. Although this was part of his strategy to entice the typist to "turn King's evidence" and provide Scotland Yard with the information necessary to secure Crippen's conviction, Dew's words and her appearance, at least at this stage, were enough to erase any doubt in the public's mind that Ethel Le Neve was a blameless victim. Anything that did not accord with this—stories of a physical fight with the *Montrose's* stewardess, the possible destruction of evidence, the lies she told her parents about her marriage, and her behavior at the Benevolent Society Ball—were all quietly put aside. It was more comfortable for everyone to believe that fragile Miss. Le Neve had no will of her own. As Ethel would soon learn, it would be in her best interest to pretend this too.

27

Homecoming

I SABEL GINNETT WAS WAITING for him in the crowd. She had been in Montreal for that purpose since July 28. As soon as she had read the news that Hawley Crippen and Ethel Le Neve were on the *Montrose*, she had bought a ticket to meet them there. "When a woman gets after a man in real earnest, she usually gets him," she told the New York *Sun.*[1] As the president of the Music Hall Ladies' Guild, she was there to represent its members. She was also there, standing between rows of Canadian police officers in the late hours of the night, because she loved her friend. She was placed beside the gangplank when they dragged Belle's disheveled husband down it. She was certain she had locked eyes with the clean-shaven, stupefied Crippen, but as he wasn't wearing his spectacles, he didn't recognize her.

She had another opportunity the following morning at the courthouse where Crippen was formally charged. After the hearing, he was brought to the judge's chambers along with Inspector Dew and his Canadian counterpart, Inspector Denis. The judge then opened the door to Mrs. Ginnett, who was ushered in and gave him "the surprise of his life." She watched with satisfaction as "the half-contented expression left his face and his ruddy color fled." Crippen could hardly bear to look at her, the *Sun* reported, but "her brown eyes never left him" until she departed.

Isabel was next taken to examine and identify the objects that had been found on the prisoner. Two parcels were unwrapped; one contained Crippen's spectacles, and the other the diamonds she

"had often seen Belle Elmore wear." Observing the rings and the rising sun brooch laid out on the table, devested from their owner's hands and bosom, suddenly filled Isabel with emotion. "It was almost like calling my poor friend back again to handle her jewels," she said. The detective asked her if she recognized them. "A woman remembers the jewels of her friends," Isabel replied.[2]

There was one further favor requested of her. Dew had asked Mrs. Ginnett if she would not mind visiting Miss. Le Neve. He had hoped that the sight of Isabel might elicit some sort of favorable response from the young woman. In the expectation that Ethel would recover from her shock and divulge all of Crippen's secrets, she had been placed in the care of Inspector McCarthy and his wife at their home. The instructions were to treat the prisoner as if she were a guest in their house. She would rest in a comfortable bed and take her meals with them. Her true identity and circumstances, that she was being held on a charge of murder, would not even be disclosed to McCarthy's daughters. Dew explained that Isabel would be brought to the McCarthy home and shown into their sitting room, as if this were a friendly call.

Mrs. Ginnett was somewhat surprised by the appearance of the typist whom she had last seen at Albion House. Far from seeming frail, the Guild president claimed that Ethel looked much healthier and stouter than she had in London. Ethel sat awkwardly before her in a set of clothes purchased with the money found in her possession: a gray jacket and skirt and, rather ironically, a little sailor's hat for her head.

Isabel greeted her, reaching forward and taking Ethel's hand, but found "there was no feeling in her clasp."[3]

"Have you heard from your father?" Mrs. Ginnett inquired. It was a question which Dew would have prompted her to ask.

That morning, Mrs. McCarthy had given Ethel two telegrams that had been waiting for her when she arrived in Montreal. The first, from her father, read simply: "Dear Ethel: Tell all you know. Papa."

The second was a more heartfelt appeal from Charlotte Neave: "With all the love you may have for your husband, don't forget me,

your father, your brothers, your sister. Tell the authorities all you know. Mother."

According to the *Telegraph*, the receipt of these messages distressed Ethel so much that she burst into tears and cried, "Good God, to think of the trouble I have given them. Oh! Dear me, I wish I could die now and end it all!" A doctor had to administer her a further dose of sedatives which rendered her unfit to make a court appearance alongside Crippen that morning. Instead, the judge came to the McCarthys' house to formally charge her.[4]

There was a moment of silence before Ethel answered Mrs. Ginnett's question. "I have received a cable dispatch from him."

Mrs. Ginnett regarded her. "How do you feel, Ethel?"

"I feel very ill," she answered in a weak voice.

"It was an eventful experience."

Ethel shuddered.

"Who cut your hair?"

Miss. Le Neve explained that Crippen had done it.

"You must have made a very pretty boy with your hair cut short and a Fedora hat,"[5] Isabel said, trying to engage her, and she noticed that Ethel smiled faintly, but offered no reply. She then asked if she could do anything for the young woman, to bring her clothing or to communicate with friends or family in London. Ethel told her she did not need anything. Before taking her leave, Mrs. Ginnett stood up and implored her to be guided by the advice of her father. "He is your best friend. He will do what is the very best for you." But this "did not affect her in the least."[6]

Later that day, as she prepared to return to New York, Isabel would tell reporters that, while Ethel Le Neve was obviously shaken by her experience, "she was not in a state of collapse, by any means."[7] Neither was Isabel the least bit convinced that Crippen's typist was a wilting violet. She stated that Ethel had "power of endurance" and cited the occasion when she had "twenty-one teeth taken out and that same evening had a new set of teeth put in without ever complaining."[8] This had become a legend at Albion House. "In my opinion, Ethel Le Neve is still trying to shield Crippen by not telling the

police what she knows," she declared to the *New York Times*. Although she had "never been favorably impressed with Miss. Le Neve," Isabel's overall impression was that the young woman was "innocent of all knowledge of the murder."[9] As the full details of the couple's relationship had not yet been disclosed, Mrs. Ginnett said she believed that the affair had probably begun after Belle's murder.

Following Mrs. Ginnett's departure, Inspector Dew continued to apply pressure to Crippen's "pretty dupe" (as the newspapers were calling Ethel). He made daily visits to both prisoners and did what he could to make them comfortable. His intention, he said, was to spare Ethel "any unnecessary suffering."[10] He conveyed a steady stream of messages to her from Crippen and from her family. Like her mother and father, Nina was also asked to persuade her sister to aid the police: "You have everything to gain from a full explanation. Everyone is certain of your innocence" she telegrammed, but Ethel refused to break her silence. She cabled back to her family: "I had seen or heard nothing until the cruel blow fell."[11]

Ethel had always maintained that she had no indication that a crime had occurred, and no idea of what might have happened to Belle. At the time of her arrest, she had told Captain Kendall that she had "not seen any papers whatever" since leaving London. "I know nothing about it," she had stated to him before turning to Dew and repeating, "I assure you . . . that I know nothing about it."[12] Ethel would continue to claim that even several days into her stay with the McCarthys she had still been unable to read coverage of the story. It was only when Walter Dew visited her that she learned some of the grisly details. By this point, Dew was growing impatient, and decided to confront her. He raised the issue of her father's most recent message to her, which once again begged her to assist Scotland Yard.

"You see what your father says?" Dew urged.

Ethel replied again that she knew nothing. "Neither by word nor deed on the part of Dr. Crippen have I been allowed to guess that anything was seriously wrong."

"Well," said the inspector, "I found human remains underneath the floor of the coal cellar of Hilldrop Crescent."[13]

Ethel would later claim she was "amazed" at this revelation. She would explain that it was the first time she had heard this information and that her response was to "merely stare at him in mystification."[14] Beyond this, the shocking news that she had been living above the dismembered corpse of the former Mrs. Crippen failed to elicit any sort of demonstrable reaction. She never raised the issue again. If Dew had hoped to see her recoil in horror or denounce Crippen, he would be disappointed.

"Despite the allegations against Crippen, Miss. Le Neve still clings trustfully to him," the newspapers had begun to report. "This love element, indeed, proves one of the most pathetic and tragic sides of the story."[15] It was also stated that Ethel had asserted to Mrs. Ginnett that her feelings for Crippen had not been altered by the charge against him. "I loved him deeply, and I still love him," she proclaimed.[16] Recognizing that his efforts to turn the resolute typist against her lover had failed, Dew eventually decided that she was strong enough to be transferred to a prison cell. When learning she was being removed from the comforts of the McCarthy house, she "sobbed" as if her "heart were about to break."[17]

Ethel would not be held at Quebec City's Plains of Abraham Prison for long, nor would she be incarcerated as if she had been found guilty of a crime. Both Crippen and his accomplice were held in accordance with the 1881 Fugitive Offenders Act, which allowed for anyone wanted by warrant in Britain but who had escaped to Canada (or any other part of the British Empire) to be sent back to the United Kingdom. After appearing before a magistrate, it was required that they remain under arrest for fifteen days, should there be an appeal. As they awaited extradition, the prisoners were made to bide their time behind bars but were still permitted a degree of freedom during their stay. Ethel was relieved to find that the experience was not as terrifying as she had imagined and commented that with Crippen on the men's floor beneath her, at least she was in nearer proximity to him. The prison matron fed her from her own

table, and Ethel claimed to have passed her time learning the local French-Canadian style of embroidery from the wardresses. Her one disappointment was that she had never managed to spot Crippen in the exercise yard below. [18]

With his prisoners safely in custody, Walter Dew turned his attention to returning the pair to England as quietly as circumstances would permit. While the press was still hovering, tailing him and sniffing for further morsels of the story, Dew's main concern was the growing sentiment against Crippen in Quebec, which he feared had reached fever point. The inspector had begun to worry about riots, that if the accused murderer was spotted in public, a crowd might be inclined to take drastic measures. Between this and dodging journalists with cameras, Dew's task would be to get them on board a ship without drawing attention to themselves. Arthur Mitchell, his sergeant, was summoned from England to assist. He would be accompanied by Sarah Stone and Julia Foster, two wardresses from Holloway Women's Prison in London, who would be escorting Ethel. The inspector's plan was to have them sail on the *Megantic*, the *Laurentic*'s sister ship, which departed Canada on August 20. As a precaution, only a handful of officials had been notified of this arrangement, and the prisoners were instructed to be ready to depart at six in the morning.

The vicinity of the prison was quiet at that hour as the two sealed carriages appeared. Crippen was taken down first, hurried to the vehicle, and handcuffed to Sergeant Mitchell for the journey. Ethel was led to the second carriage, where she was placed inside with the two wardresses who would be her chaperones for the next week. The blinds were fastened tightly, and the horses whipped into a gallop. They traveled at high speed to a wharf up the St. Lawrence River. Here, they would board a small tugboat bound for the *Megantic* in Montreal. Ethel asked to have a glimpse through the window. She was disappointed that she had seen nothing of the country, but Misses Stone and Foster warned her that Inspector Dew had forbidden it.

After what Ethel described as the longest journey she felt she had

ever taken, they arrived at a small wharf, where their tugboat was waiting.[19] The prisoners, kept separately, were taken below and did not emerge again until the imposing silhouette of the *Megantic* moved into view. Amid a hail of horns, clanking chains and sailors' shouts, the ship lowered its rickety gangway to the tug. It was as the prisoners and their escorts were about to carefully pick their way up the widely spaced wooden planks that Dew realized another craft was approaching with a photographer on board. The inspector attempted to hustle his prisoners on to the ship. Ethel's face was shrouded by a heavy blue motoring veil, but Dew threw his overcoat around her as well. Crippen's hat had been tilted so far over his eyes that he could barely see, and he narrowly avoided tripping into the water.[20] None of this deterred the intrepid Bernard Grant of the *Daily Mail*, who managed to snap a photo of the accused murderer from atop the roof of a tugboat.

The seven-day return voyage to England would be quiet and uneventful for everyone. Wishing to avoid a spectacle, Dew had booked their traveling party under false names. Ethel became "Miss. Mary Byrne," Crippen was "Mr. Cyrus, Field," while the inspector would be known as "Mr. Silas P. Doyle."[21] Dew had placed the prisoners in separate cabins and purchased the surrounding state rooms to ensure absolute secrecy. They were guarded at all times: Crippen by Dew and Mitchell, and Ethel by the two wardresses. They were allowed books, a chaperoned walk on deck in the early mornings and evenings and their choice of meals from the first-class menu. However, every precaution was taken with the freedoms they were permitted; their food arrived cut for them, and they were provided with only fish knives and forks. All the tapes on the life vests and the hanging cords in the state rooms were removed. Even the loose wiring on the ventilation fans was stripped out. After all his effort, Dew was intent on Crippen and Le Neve arriving safely back in England to meet justice.

The lengthy journey gave Walter Dew an opportunity to study Crippen at close range and to attempt to understand the man who had possessed his thoughts for more than six weeks. What the in-

spector failed to appreciate was that Crippen, the consummate con artist, was also taking advantage of his proximity to his captor. Within a matter of days, it appears to have slipped the inspector's mind that the person in his custody was not simply a pleasant fellow passenger who enjoyed discussing books and ships, but a highly skilled snake-oil salesman who had spent decades successfully deploying his charm to acquire what he desired in life. Dew marveled at Crippen's serenity, his inexplicable happiness, his conciliatory and gentle demeanor. "The more I saw of this remarkable man, the more he amazed me," he declared.[22]

Dew was especially seduced by his prisoner's "unswerving loyalty" to Ethel, whom he inquired about "several times every day." Like many of the journalists who had begun to paint Crippen and Ethel's flight from a murder scene as a romantic saga, the inspector also found himself sympathizing with the lovers. A fraudster like Crippen with a keenly honed sense for weakness would have scented this on Dew, and began to harness it for his own purposes. As Ethel was the keeper of his secrets, Crippen's concern would have always been to demonstrate his enduring devotion to her, even at a distance. As long as she was content and did not feel disregarded or betrayed by the man she loved, their pact held. Dew remained unaware that he was being played, and in later years marveled that his gallant prisoner "never seemed to care much what happened to himself, so long as . . . [Ethel's] . . . innocence was established."[23]

On several occasions, Crippen made a spectacular performance of his love for the woman, who only weeks earlier he had proposed abandoning. When many on the *Megantic* were felled by seasickness as the ship hit a patch of rough weather, Crippen began to fret about the fragile Miss. Le Neve. When learning she had been struck down, he pleaded with Walter Dew to tell her to lie flat and to give her some champagne to settle her stomach. As Dew observed his "little prisoner" pledging his eternal gratitude to him for this favor, the inspector claimed that he could not help but be touched; Crippen was able to forget all his worries "for the comfort of the woman he loved." After learning that his remedy had been a success, Dew

wrote that "Crippen was like a dog in his gratitude. He could have scarcely expressed greater pleasure had I told him that he could go free."[24]

The accused murderer had the detective who had pulled his wife's shredded remains out of his cellar eating from his hand. On one evening, as they walked handcuffed to one another on deck, Crippen turned to Inspector Dew with an inquiry.

"I hope you won't mind, Mr. Dew, but I wanted to ask you a favor."

"Not at all," the detective replied, "you know I will do anything I possibly can."

Having intrigued Dew, Crippen then, with his charlatan's sense of timing, hesitated. No, it could wait until Friday, he said, but Dew encouraged him to unburden his mind then and there.

"When you took me off the ship . . . I did not see Miss. Le Neve. I don't know how things may go. They may go all right or they may go all wrong with me. I may never see her again, and I want to ask you if you will let me see her. I won't speak to her. She has been my only comfort for the last three years."[25]

Dew admitted he was "touched" by Crippen's plea. Discreet arrangements were made so that the two could glimpse each other from afar. While Dew records that he enabled this meeting on board the *Megantic,* Ethel recalled that it happened later, as they were en route to London.[26] On both occasions, the couple stood at a distance from one another, smiling contently. Crippen gently raised his manacled hand to greet her, and she reciprocated. Dew was swept up in the romantic drama, claiming that he felt like an interloper in this moment between lovers. "It confirmed what I already guessed—that in the heart of the little man I was holding for murder there was a very deep and real affection for the girl who had supplanted the wife he was alleged to have killed."[27]

If Dew had been persuaded by Crippen's act, then he had also allowed himself to be duped by Ethel. From his very first encounter with her, Crippen's meek typist had lied to him and been obstruc-

tive. She had lied again when giving her statement at Albion House. Her loud and violent outburst upon arrest, before the charge of murder was even read, and her lack of surprise when she was told about the remains at Hilldrop Crescent, failed to raise his suspicions. Dew was intent on viewing Ethel as Crippen's collateral damage, a foolish, easily led little office girl, who obviously had nothing to do with this terrible business. In the time that he had spent with her on the ship, taking her for evening strolls around the top deck, he was impressed that she had "bore herself bravely." He was surprised there had been "no weeping, no hysterics."[28] However, in Ethel's state room, there was another story to be told. Former barrister Cecil William Mercer, writing under the name Dornford Yates, related an anecdote purported to come from Dew himself. It seemed that while Crippen was locked away in his cabin lamenting the fate of Ethel, the "poor girl," as Dew called her, was enjoying herself.

She was a wag, and her flow of quips and back-chat reduced to helpless laughter the crowd of stewards, cooks and others so often as found time to collect outside her door. The thing became such a scandal that Dew approached the purser and had Le Neve moved to a cabin which was less accessible.[29]

The story appears to be borne out in Ethel's own accounts of the voyage. She and her two wardresses chatted freely during their passage and seemed to spend a fair amount of time mocking Walter Dew. They jokingly referred to him as "Father" and when he came to check on Ethel before going to dinner, they used to laugh at him in his formal evening dress. "Dear me, Father is very grand tonight," they would tease once the door had been closed behind him.[30] Their mirth was not even tempered by the storm which sent them grabbing for their chamber pots. Ethel and her guards all suffered equally, but when they learned that "Father" also had been stricken, the ladies sniggered from their sickbeds that "a big man like Inspector

Dew should be no better than three weak women."[31] Whether help-less Ethel was ever given the champagne that reportedly cured her is never mentioned in her memoirs.

Ethel's "good spirits" came to the attention of many, including the journalists who awaited the *Megantic*'s return at Liverpool Docks. An enormous crowd had gathered there on the morning of August 27. As they were coming into port, Dew had gone out on deck to survey the quayside, which he would later describe as "one vast concourse of people."[32] The public were desperate for a glimpse of the wife-murderer and his "boy-girl" accomplice whose stories they had been consuming for more than six weeks. The police had cordoned off the arrival area to make room for disembarking pas-sengers, which included a troop of Canadian soldiers who had come to England on exercise. As the band on the quayside played "God Save the King" and "The Maple Leaf Forever" to welcome the trav-elers, Dew had his prisoners and their guards ready to depart from a hidden side door near the stern. Crippen could hear the commotion of the gathered masses and began to grow nervous. Ethel, whether from anxiety or a sense of relief at seeing her homeland, was re-ported as "laughing heartily."[33] While a further decoy gangplank was set down to distract the crowd, the group hurried from the ship and through a series of sheds to an awaiting train. As the spectators had spread themselves across the quay, Dew and his prisoners were spotted and chased to the railway platform. It was not until they were inside the carriage, with the blinds pulled down, that they felt safe.

Their arrival in Liverpool had left a frightening impression on Ethel. She had shielded her face beneath a large hat and her heavy blue veil, which made it difficult for her to see or to be seen. As they were being pursued to the train, Ethel had been temporarily sepa-rated from her wardresses. The crowd booed and jeered and fought against the police restraints as they pushed nearer to the prisoners. Ethel feared "they would tear us limb from limb," if permitted any closer.[34] This initial experience would offer but a taste of the hostil-ity they would encounter when their train pulled into London's

Euston Station. Recognizing the feverish temperature of public sentiment, the police had taken every precaution to prevent a scene of disorder. Scores of officers were on duty in preparation for Crippen and Le Neve's appearance, but this did not deter angry and curious Londoners from coming to the railway station in their thousands. Ethel commented that it was one of the largest crowds she had ever seen. When the prisoners were taken off the train, "a roar went up like the sound of thunder."[35] The entire station was packed with men, women and children, standing on benches and clinging to ledges. Ethel, handcuffed and with her veil hanging over her face, was shaking as she was led to one of the waiting taxicabs. "The women were the worst," she recalled. "Every evil epithet they could think of was hurled at me."[36] She remembered the shrieking mob and how they clung to the side of the car, pulling at the locked doors while hissing and booing. As they drove away, they were chased across the Euston Road, past St. Pancras New Church, and as far as Southampton Row.

The progress to Bow Street Magistrates' Court in Covent Garden, through Bloomsbury, would have made an uncomfortable homecoming for both Ethel and Crippen. Their route inadvertently took them on a tour of many of the sites which had brought them to this very point in their lives. The buildings along it, the memories produced by certain corners or shopfronts, the sight of a regularly used tram, must have taunted them as harshly as the shouted abuse of the crowds. They drove directly past the entrance to Pitman's College and around the edge of King Edward's Mansions, where the Martinettis lived. For a moment, the red-brick turrets of Albion House came into view. Then, the cars would have turned toward Bow Street.

Ethel claimed she was filled with "a nameless dread" when the cab stopped at the "big gloomy building." Her heart was pounding with fear as she was ushered down the long corridor to a room and left standing and ready to meet a senior police representative who would read the official charges. After a few moments, the door opened again, and Crippen was shown in. He was led to stand beside

her, and then his handcuffs were removed. It was the first time since July 31 that they had been in each other's company. His features appeared haggard, but his mustache had grown back. He could not turn to look at her but was able to utter a few words. "Don't worry," he said, "just try to keep your mind off things, and whatever happens, nobody will hurt you."[37]

It was at this point that Ethel "broke down completely." Unnerved by the entire experience, "she wept bitterly" and had to be assisted by one of the wardresses. She was crying so audibly that one journalist speculated that she would not even have been able to hear the charges read.[38] While Crippen was facing those of "Murder and Mutilation," Ethel was accused of murder as well as "receiving, comforting, harboring and assisting Hawley Harvey Crippen" while knowing that he had murdered his wife. Neither made any response to the charges.

They were led away to separate "special attention" cells, described as "scantily furnished rooms," from which they could be observed.[39] As the court did not sit on a Sunday, they would be held for two nights until Monday, the date of their hearing. During the time of their detention, they were permitted visitors. Ethel had barely been shown to her cell before Nina arrived with her infant daughter, Ivy. Mrs. Brock had been desperate to see her sister and had written to Scotland Yard pleading to meet her in Liverpool. Given the circumstances, a reunion at Bow Street had been agreed instead. She was allowed only a few minutes in the cell in the presence of the police. They were "both too full of emotion for words," she told *Lloyd's Weekly Newspaper*.[40] "She came into my arms and lay there for a minute or two while we kissed each other." She worried that Ethel looked pale, her cheeks sunken. The strain was evident in her voice and manner, Nina noticed, and she attempted to raise her sister's spirits by placing her goddaughter in her arms. For a brief moment, all three held one another in an embrace.

Ethel had no interest in seeing her parents, especially not her father, who, against her wishes, had proposed selling his daughter's life story to the press to raise money for her legal fees. In her ab-

sence he had engaged the solicitors Ingpen and Armitage to represent her at the coroner's inquest in July. They were later dismissed, and replaced by James Welfare of Welfare and Welfare, whom Nina and Horace Brock had hired on Ethel's behalf. Shortly after Nina departed her sister's cell, Ethel was visited by another lawyer, Arthur Newton.

Newton had been waiting on the platform at Euston Station to greet Crippen as he was hustled from the train. Although it was not the ideal occasion to shake hands with his manacled client, Arthur Newton, in his sharply tailored suit with large gold pocket watch, was keen to make his presence known. At the turn of the century, few solicitors had garnered a reputation as notorious or a practice as large as his. His clientele ranged from some of the most powerful aristocratic families in the country to brothel-keepers, music hall performers and an American jockey. Over the years, he had acquired a specialism in making the embarrassing problems of influential men disappear. On one occasion, he even made an influential man himself disappear. In 1889 Newton had been retained by Lord Arthur Somerset to defend him after he was implicated in the Cleveland Street Scandal, when an all-male "house of assignation" frequented by members of the elite and possibly even a member of the royal family was discovered by the police. Newton warned his client that he was to be arrested for gross indecency and Somerset promptly fled the country, an obstruction of justice which sent the solicitor to prison. When it came to his work, Newton regarded laws and ethics as flexible. His pursuit of clients was aggressive and based exclusively on the prospect of financial gain. He was just the sort of man with whom Hawley Crippen was accustomed to doing business.

Not wishing to miss out on the brief of the century, Newton cabled Crippen when he was arrested in Canada: "Your friends desire me to defend you and will pay your necessary expenses. Will undertake your defense, but you must promise to keep absolute silence and answer no questions and don't resist extradition. Reply confirmation as a good deal must be done at once."[41]

The friends to which he referred were himself and Horatio Bottomley, MP, the owner of a newspaper known as *John Bull*, who like Newton would one day end his career in prison for fraud. Both saw Crippen and his case as an exciting commercial opportunity. Bottomley had stumped up the initial expenses to engage Newton, and Newton had promised Bottomley exclusive access to Crippen's story.

Crippen was content to place his case and his life in Newton's hands. It would become Newton's objective for Ethel to do the same. Eventually, it was decided—whether through Newton's persuasions or Crippen's own machinations—that their interests were best served by a single legal representative rather than two separate solicitors. Two lawyers ran the risk of dividing the defense, of Ethel accidentally saying something she might regret, or being compelled to turn against Crippen. The couple had come this far in complicit silence. Ethel had held firm against Dew and even against the impassioned pleas of her family. The lies and inconsistencies had gone unquestioned; however, the true challenge was to come. How well their story was to weather the next few months, including a judge and jury, was yet to be seen.

ACT V

"Nothing to tell but the truth"

28

Spectacle

O N Tuesday, September 6, the *Times* newspaper printed its
usual list of public events, meetings and spectacles in its "To-
day's Arrangements" column. There was a music festival in Glouces-
ter which was to run for four days. A farewell for missionaries
departing for China was being held in the City of London. There
was a cricket match at Scarborough, a lawn tennis tournament in
Brighton and horse racing at Doncaster. A new play, *A Bolt from the
Blue*, was to debut at the Duke of York's Theatre in the evening, and
that morning, the Crippen case began at Bow Street Magistrates'
Court.

Like the theater, the courtroom was open to the public and offered
a similar form of amusement. For centuries, society had viewed the
proceedings of justice, whether in the criminal or civil courts, as a
type of spectacle with which they could engage. The flamboyance
and histrionics of a trial, with its bewigged and robed barristers,
shame-faced defendants, stern judges and weeping witnesses, enticed
everyone into the visitors' gallery, regardless of rank or status. At
the start of the twentieth century, the insatiable appetite for this
type of entertainment showed no sign of abating. George R. Sims,
writing in 1906, was struck that such "a large portion of spectators"
still found murder trials, where the defendant faced the possibility
of execution, "an interesting and sometimes thrilling form of enter-
tainment."[1] Percy Hetherington Fitzgerald commented that every-
one from "fine ladies and gentlemen" to "the unwashed crowd"
clamored for a seat near the magistrate's bench and were willing to

endure "inconvenience of all kinds" including "a stifling, almost fetid atmosphere . . . in the hope of dramatic 'bits' occasionally turning up." Of course, what made it even more appealing was that the entire show was "provided gratis."[2]

Spectators had begun to gather around 6 a.m., as the dawn light awakened the late-summer sky. Ethel would later be told that the crowd was one of the largest ever seen at the door of a magistrates' court. The pavement and the street were clogged with bystanders. Most of those able to gain admission were journalists, but this did not deter others from lingering outside the building. They had come in the hope of snatching a glimpse of the infamous Dr. Crippen or his accomplice, the scarlet Miss. Le Neve, as they were hauled to and from the prison vehicles. Amid the eddying flow of people, an operator of a motion-picture camera set up their tripod to capture the remarkable scene. Photographers squeezed through the crush, and many managed successfully to sneak their apparatuses into court, which they hid beneath notebooks.[3] That day, a few society ladies were able to procure seats. So too had Labour MP Victor Grayson, and the dramatist W. S. Gilbert (of Gilbert and Sullivan). Some members of the public were so desperate to hear the proceedings that they scaled the building and peered in from the skylight.

This was not to be Crippen and Ethel's first appearance. A similar but smaller frenzy had taken place on the 2nd, at the couple's hearing. The pair had leaned on the rail of the dock, standing elbow against elbow as they faced the magistrate. Ethel stared straight ahead, anxiously twisting her black gloves in her hands, while Crippen, contained as ever, maintained his usual blank expression. This had been only a brief encounter with the formalities of justice, during which time the charges against them were confirmed and a date for the committal proceedings was fixed for the following week.

The committal, which commenced on September 6, would run for five days over the next three weeks. It would serve as a dress rehearsal for Crippen and Ethel's trial at the Old Bailey. Its purpose was to assess the evidence, and for a magistrate to determine

whether it was of sufficient quality and quantity to merit a criminal trial before a jury. In anticipation of this, the two teams of barristers had already been assembled. The Home Secretary, Winston Churchill, and Charles Willie Matthews, the Director of Public Prosecutions, had both taken a keen interest in the case. Given the resources that had been spent on the capture of the fugitives, both were intent on securing a satisfactory outcome.

Richard Muir, Senior Counsel to the Treasury, was appointed to lead the prosecution. Muir had a terrifying reputation as "a man who never permitted his feelings to err on the side of mercy."[4] He had a dour disposition and possessed an almost monastic dedication to his work. His case preparation was rigorous, his manner in the courtroom when presenting evidence, or in cross-examination, was like a hunter stalking his prey: slow, exacting, precise, methodical, and then suddenly unexpected. Muir rarely smiled. Even Scotland Yard feared him. He would be assisted by Travers Humphreys, his "junior," who had made a name for himself in the prosecution of several high-profile cases including Oscar Wilde's libel suit against the Marquess of Queensberry. As the case was such an important one, Muir was allowed another younger junior (or a "devil"), Samuel Ingleby Oddie, a barrister who had medical training, which would prove essential when evaluating the scientific evidence. Finally, Cecil Mercer was employed to assist Travers Humphreys.

In an era before publicly funded legal aid was available, the defense, with their limited resources, were already at a disadvantage. While Arthur Newton was busy auctioning off the contents of 39 Hilldrop Crescent and striking a lucrative deal for Crippen to embark on a lecture tour in the United States if acquitted, he had also engaged Alfred Tobin, KC, to lead the case. Tobin, who was described as a "clever, industrious and experienced" barrister, would be able to hold his own against Muir.[5] The funds raised for Crippen also allowed for two juniors: Huntley Jenkins and Henry Delacombe Roome. However, as legal convention dictated, none of these men would be representing their client at the committal in September. That honor would fall exclusively to Arthur Newton.

The first day of the committal would be the most significant. The prosecution, on this occasion led by Travers Humphreys, would put forth to the defense "the evidence which was to be called in support of the charges that had been laid against their clients."[6] All the facts known to the prosecution would be described, and witnesses would be called to substantiate their claims. That morning, Humphreys rose to his feet and presented Crippen and Ethel's entire narrative. He covered Crippen's early career, his relationship with Belle and with Ethel, as well as all the events leading up to his wife's disappearance, his flight with his typist, the discovery of the remains and their arrest. While the epic had been covered extensively in the newspapers, until this time no one had been privy to the details known only by Scotland Yard. Crippen and Ethel were present for this mortifying recitation and would watch as witness after witness came forward to pull their skeletons from the closets.

Some of the most important information disclosed that day pertained to the discovery of hyoscine hydrobromide in the remains. When the inquest had begun in July, the five stoppered jars filled with the remnants of Belle Elmore had been sent to Dr. William Willcox, the senior scientific analyst at the Home Office. While Inspector Dew and the press had been puzzling over the whereabouts of the two fugitives, Willcox had been in his lab testing the preserved viscera for traces of poison. His experiments indicated the presence of an alkaloid that when probed proved to be hyoscine. He had found what had amounted to just under one-third of a grain. This was a significant amount to be retained in the viscera for such a long period, which caused Willcox to conclude that a lethal dose had been administered. It was believed that this poison would have been ingested rather than injected and would have sent the victim into a delirium before she succumbed to paralysis and slipped into a coma. The entire agonizing process would have taken an hour at least, and twelve hours at most. Unbeknown to Hawley Crippen, Scotland Yard had also managed to track down the vendor of this poison. Lewis & Burrows chemist's in New Oxford Street, just over the road from Albion House, had Crippen's name on their poisons

register for an astonishingly large purchase of five grains of hyoscine on the January 19, 1910. That Dew had discovered Belle's remains under the cellar bricks was miraculous enough, but that the entire extent of his dastardly crime had now been unveiled stunned Crippen. Cecil Mercer watched as the normally unperturbable doctor reacted to this revelation:

> The blood rose into his face, as I had never seen blood rise into a face before. It was like a crimson tide. It rose from his throat to his chin in a dead straight line . . . from his chin to his cheeks . . . from his cheeks to his forehead and hair . . . till his face was all blood-red, a dreadful sight. And then, after two or three moments, I saw the tide recede. Down it fell, as it had risen, always preserving its line, until his face was quite pale.[7]

Ethel had been standing beside him as he took in the news. According to her *Life Story*, it was only during the committal that she had "heard the full details of the discovery at Hilldrop Crescent." To her, the evidence seemed "utterly unreal and past belief," though these feelings were not apparent in her fixed and sullen expression. The press had been keenly scrutinizing her in the courtroom: the pallor of her skin, the graceful, composed manner in which she held herself, the way she looked at Crippen or whispered to him. The pair squeezed as close to one another as was dignified and fleetingly held hands. On several occasions, Ethel was seen to laugh at a comment or two, which Cecil Mercer remarked did not leave a favorable impression. Each day she dressed in what would become her trademark uniform: a dark blue jacket and skirt and a wide flat hat. She could make her face vanish entirely beneath her heavy midnight-blue veil, which she lowered like a shade against the impertinent, rowdy crowds. Ethel said that being the object of such censorious attention made her uneasy. She felt the intrusion of the cameras; the boxes with their snapping lenses were ever-present. However, it was the presence in the courtroom of the Music Hall Ladies' Guild members that she claimed upset her the most.

This was the first time both Crippen and Ethel were made to face the women who had seen through the patchwork of lies and been instrumental in their arrest. Clara Martinetti's testimony of the events of January 31, was essential to the case, but those who joined her in this final part of their crusade was to be determined by matters of circumstance. Professional commitments in the United States meant that Lillian Nash was not available to take the stand, and neither was Lottie Albert, who was due to give birth that autumn. While Annie Stratton gave evidence at the coroner's inquest, her husband, Eugene, otherwise forbade her to discuss the case in public.[8] The star performer, an influential member of the all-male Vaudeville Club, was "especially keen on keeping the 'profession' out of it" and worried that "if any of us get mentioned in this case it'll do the profession a terrible lot o' harm."[9] It was likely on account of this that his wife was not called as a witness in the trial. However, Melinda May and Louise Smythson had no such concerns and stepped forward to offer their assistance. As the coroner's inquest was running concurrently with the committal, this became an emotionally intense and deeply taxing experience. Throughout the month of September, Clara, Melinda and Louise shuttled between the two venues at Bow Street and the Islington Central Library, repeating their performances, speaking the same lines to two sets of rapt audiences. On numerous occasions, their deceased friend's remains were passed under their eyes. Again and again, they were called to identify her belongings, her curlers, her scar, her torn strands of dyed hair.

At the committal, the testimonies they gave were primarily intended to present a picture of the Crippens' marriage and Hawley Crippen's behavior; however, it was Ethel who claimed to feel persecuted by their words. She could hear the murmuring around her when any of the Guild ladies stepped into the witness box. "Not content with seeing me in the dock, humiliated, worried, perhaps in danger of losing my liberty, they went out of their way to say all sorts of nasty things about me. The women were the worst," Ethel said. "I could hear them talking about 'the innocent little typist'

sometimes, words that were a thousand times more hard, a thousand times crueler, fell from their lips with a laugh and cut my heart like a knife."[10]

It can only be imagined how she felt when Emily Jackson, her former friend and landlady, took the stand. Mrs. Jackson, like everyone who suddenly found themselves embroiled in this "crime of the century," had been broadsided by the newspaper headlines. She had scarcely read the details when the police had arrived to question her. The woman whom Ethel had once called "Ma" was eager to assist Scotland Yard, and divulged all she could recall about her former lodger. Emily Jackson had been entrusted with some of Ethel's ugliest secrets, and surely the younger woman, not knowing what mortifying revelations were to be unleashed, must have trembled at the sight of her. Although the worst of it was withheld, what did emerge did not paint an entirely irreproachable picture. Emily described Ethel's acquisitiveness, her naked desire for the dead woman's diamonds and how she said she aimed to get "a nice brooch up at the house . . . by a little coaxing and persuasion."[11] This, in addition to Ethel's nervous collapse around the end of January or early February on account of a person she named as "Miss. Elmore," failed to entirely dispel suspicion. Ultimately, the magistrate, Sir Albert de Rutzen, would decide that on the face of it, Miss. Le Neve was not as blameless as some would have her portrayed. While the charge of murder against her had been dropped due to insufficient evidence, the charge of "accessory to murder after the fact" would stand. Her counsel had also applied to have Ethel released on bail, but as she had consistently refused to assist the police inquiry, the judge took a hard line: "the woman might very well have said what her evidence was. She might have been called. She is not called . . ." Under the circumstances, he refused to grant bail.[12] Ethel and Crippen would both stand trial.

In the wake of the committal, Richard Muir and Travers Humphreys had begun to have second thoughts about trying Crippen and his mistress together. On the evening of October 5, Muir picked up the phone and called the office of the Director of Public Prosecutions.[13]

He expressed his concerns that having them both on the same indictment was likely to confuse matters and possibly weaken the prosecution's case. Crippen would have Alfred Tobin, but Ethel too would be entitled to her own defense barrister. The result would be that the witnesses called by the prosecution would be subjected to two separate rounds of cross-examination by the two counsels. This could lead to a situation where contradictions and uncertainty were introduced into an otherwise fairly strong case for Crippen's guilt. Neither Muir nor the DPP wished to draw out the case any longer, but a decision was arrived at to hold Ethel's trial as an accessory separately, and naturally only on the condition that Crippen was found guilty.

As preparation for Crippen's trial proceeded, a hunt was under way to locate two key witnesses who had not appeared at the committal. Bruce Miller, the man for whom Crippen suggested his wife had abandoned him, and Belle's sister Teresa Hunn were to be summoned from the United States.[14] Scotland Yard used the Pinkerton National Detective Agency to trace Miller in Chicago, where they discovered him working in real estate. The former conductor of the "Pneumultiphone Orchestra" had been living quietly with his church-going wife, Edith, and their two children when this scandal erupted into his life and dragged him into the news. Miller was annoyed at being asked to drop everything and come to London for a trial. He argued that he had not seen Belle since 1904 and did not think his testimony could add any value to the case. More importantly, he was about to close on a major property deal worth a $25,000 commission. Reluctantly, it was agreed to pay Miller a sum of $400 and $25 per diem, in addition to all expenses and a first-class passage aboard the SS *Deutschland*. By comparison, Belle's sister, who was offered a second-class passage on the same ship, $10 per diem and a sum of $100, did not fare as handsomely.

As early as August, there had been concern from the Music Hall Ladies' Guild that Belle's working-class family would be in no position to afford the expense of a funeral in London, let alone the cost of transatlantic travel to testify in any trial. Isabel Ginnett had deli-

cately broached the matter with Teresa. Belle's sister requested that when the remains were no longer required by the police, the Guild should arrange and fund the burial of them. Teresa pledged to reimburse the organization once Belle's "affairs were settled," though given the charitable nature of the MHLG's work, it is unlikely the executive board would have asked her to do so.[15] Teresa would not know that in the time she had boarded the ship and was sailing for England, the authorization would be made for burial. The funeral held on October 11, just three days before she arrived.

The MHLG was determined to give their former treasurer an honorable final tribute. Both the police and Leverton's, the undertakers, were given explicit instructions that the ceremony was to be carried out "in as private a manner as possible and without the press knowing anything about it, so as to avoid demonstration."[16] However, knowledge of the event soon leaked down Fleet Street and it became necessary to put further restrictions in place. Orders were given to keep reporters outside the gates of the cemetery and to admit only the mourning party. The journalist Joseph Meaney managed to bypass this measure by attiring himself in black, pretending to be a relative and boarding one of the coaches in the cortège. The procession wound its way somberly through the autumnal streets of North London to the St. Pancras Roman Catholic Cemetery in the quiet outer suburb of Finchley. The press peered through the iron bars of the gates, watching as a train of music hall personalities filed through the doors of the chapel. Hundreds had turned out to pay their last respects. The mourners were each handed leatherette-bound copies of the burial service, which was to be performed in Latin and English. A profusion of floral wreaths and arrangements decorated the polished oak and brass coffin: white chrysanthemums, white carnations, lilies of the valley, oak leaves, ivy and fern.[17] Melinda May spoke affectionate words about their departed sister to the veiled and black-gloved crowd. Father Powell, a Catholic priest, officiated and sprinkled holy water on the coffin before it was lowered into the ground. Joseph Meaney seemed almost disappointed to find everything so earnest and decorous,

and the off-duty performers so sober and dignified. "They were a nice, friendly crowd of women" and "there was no scene at the graveside. The music hall artistes behaved as they always behave in the presence of Death—deeply reverent."[18]

From the day they had received notice of Belle's unexpected "departure" in February, and throughout all the strange, circuitous events of that year, the women of the Music Hall Ladies' Guild had remained staunchly determined to pursue this matter to the end. Now, as the days began to darken and the leaves began to fall, the long-awaited denouement approached. The trial of *Rex* v *Hawley Harvey Crippen* was set to begin on October 18 at the Central Criminal Court, known as the Old Bailey. Clara Martinetti, Louise Smythson and Melinda May, along with Teresa Hunn, were each scheduled to appear as witnesses for the prosecution on that day. This at last would be their opportunity to have their truth heard in its entirety; and this truth, along with every other gathered fragment, paper, diamond, and hair curler as well as all the scientific analysis, the observations of the police, of tradesmen, colleagues and doctors, would be pushed through the filter of justice. This compilation of evidence would be screened by a judge and jury in order to produce an absolute conclusion: a verdict on Hawley Crippen's guilt or innocence.

In February 1907, while Crippen and Ethel were frolicking in hotel bedrooms and Belle was dreaming of returning to the stage, Edward VII opened the newly reconstructed Old Bailey building. It had risen from the ruins of the demolished eighteenth-century Newgate prison and its adjacent sessions house. A court had occupied the site from at least the sixteenth century, but this new gold-topped temple of justice, with its skyward-reaching dome and its echoing grand hall of Sicilian marble, was designed to signify a modern society's hopes for a fair and merciful twentieth century. In his speech marking the occasion, the King referred to the "barbarous legal code" of the previous century and expressed his wishes to see more offenders rehabilitated.[19] However, by 1910, those like Crippen who were accused of murder could still find themselves facing the death penalty.

It was with the full appreciation of this that Clara, Melinda, Louise, Teresa and indeed all the witnesses in the case made their way through the arched stone entrance of the Old Bailey, passing beneath the ominously hooded stone figure of the "Recording Angel" on the pediment. Each of the women adorned themselves in mourning for the occasion. They wished the world to remember their loss, to stop and note that, while this circus of lawyers and photographers reeled around them, their friend, their sister, was dead.

A crowd gathered outside the court building. Officials had predicted an unprecedented crush for this staging of the grand finale. In an effort to manage the onslaught, half-day tickets (red or blue) for either the morning or the afternoon were issued. More than 4,000 people applied for 700 slots, wrote the *Daily Mirror*, though the majority of the court would be filled by lawyers, witnesses and members of the press.[20] Still, on October 18 they came in their hundreds to mill about outside, to gawp at the faces of famous music hall performers, or to catch sight of the leading counsel at a time when barristers and judges were minor celebrities in their own right. Throughout the proceedings, notable guests also turned up—Sir Arthur Conan Doyle, the actor and manager Sir John Hare and the star stage actress Phyllis Dare, who, distractingly, was given a seat beside the judge.

At around 10 a.m., the oak-paneled courtroom had begun to fill with spectators and black-gowned legal counsel. The judge, Lord Chief Justice Alverstone, in his full-bottomed wig and scarlet robe, assumed his seat next to the wall-mounted sword of justice, which hung just above the Lord Mayor of London, who sat beside him. Hawley Harvey Crippen, as unruffled as ever, would have a direct view of it and of Alverstone's unflinching expression. The jury, composed entirely of property-owning men, sat strategically positioned between the judge and the prisoner, with an immediate view of the prosecution and defense counsel ahead of them.[21] Beyond the judge's dash of bright red, "There was scarcely a touch of color in the court," wrote the *Daily Mirror*. Within the visitors' gallery, the "women had wisely chosen small hats with little ornament," so as

not to obstruct the views of those around them. It was observed that a hush overcame the room, which fell into "perfect stillness."[22] Spectators took out their opera glasses and monocles and squinted at the wiry little man enclosed in the dock. One observer wrote that Crippen seemed to bask in the attention and "returned the curious stares of the brilliant assemblage with a faint smile."[23]

Then the show began. The court clerk broke the thick silence.

"Hawley Harvey Crippen, you are indicted and also charged on the coroner's inquisition with the willful murder of Cora Crippen on the first of February last. Are you guilty or not guilty?"

The slight figure in the central box spoke crisply: "Not guilty, my lord."

This was Richard Muir's cue. After weeks of arduous preparation, honing his argument for the Crown, he rose to his feet, drew breath and began his opening speech. He retold the epic story, which by now had been printed in nearly every newspaper in the northern hemisphere and had entered into the annals of criminal legend. Muir plainly stated that the prosecution believed Crippen's motives for the murder of his wife were both financial and romantic. "His affection fixed upon Ethel Le Neve, and himself desirous of establishing closer relations with that young woman; the physical presence of his wife was an obstacle to those relations; the fact that he had no money [was] another obstacle. If Belle Elmore died, both those obstacles would be removed . . ." and Belle's money and property could enable him to keep Miss. Le Neve.[24]

At the end of his oration, he asked the jury to hold in their minds a few essential questions: "What had become of Belle Elmore? Whose remains were those in that cellar? If they were Belle Elmore's, what explanation of their being found in that place was there, mutilated as they were?" These questions could help guide the jury through the evidence and eventually to make their decision about a verdict.[25]

On this first day of the trial, an impressive sixteen witnesses were to be called. Each would be escorted from one of the waiting rooms, one for men and the other for women. There was a third for ladies

and gentlemen of "the better sort." The polite, class-sensitive Edwardian mind could not conceive of a common space which might be shared by a gentlewoman and the man who delivered her coal.

On the prosecution's list for October 18 was the doctor's landlord, Frederick Lown, who would be questioned about Crippen's tenancy and his plans to vacate Hilldrop Crescent. A series of witnesses would also be called to attest to Crippen's movements and financial transactions in the days and weeks that followed his wife's disappearance: Fredrick Pedgrift, who, under Crippen's instructions, placed Belle's death notice in *The Era*; Ernest Stuart of Messrs Attenborough & Co., to whom he pawned Belle's jewelry; the banking staff, Charles Williams and Frederick Hayles, who had traced banknotes cashed by Crippen in early February. In a bitter twist of irony, Edgar Brett, the manager of the Charing Cross Bank, which held the £600 joint savings deposit that Belle had given notice to withdraw in December 1909, was also to appear. The evening before, it had been announced that the bank had collapsed. Although Brett was still able to provide information about the Crippens' finances, the £600 on account, which the doctor had planned on retrieving, was now an irrelevance.

Muir hoped to have Crippen's colleagues, Marion Curnow, Gilbert Rylance and William Long, testify to his professional habits and concerns, to dig into the events surrounding his wife's disappearance, his flight from the police and any inconsistencies in his behavior. Rylance and Long helped to tease out the details of what had transpired at Albion House between February and July, while regurgitating the verbal and written lies Crippen had fed to them. The jury was also made aware that neither Rylance nor Long entirely understood the nature of the doctor's business affairs. He had a room in which he compounded medicines for private patients, and he underwrote the dental practice. As far as the prosecution's case was concerned, the most useful of the three witnesses proved to be Marion Curnow. The Munyon's "manageress" revealed to the courtroom that in the wake of Belle's disappearance, her employer had asked her to hide two envelopes of jewelry and financial

319

documents in her safe, which she was instructed to give to Miss. Le Neve in the event that something happened to Crippen. She also confirmed that when Crippen had purchased the five grains of hyoscine hydrobromide from Lewis & Burrows, it had not been for Munyon's, as he had written on the poisons register. "Munyon's do not make any of their remedies in this country, nor do they purchase any drugs in this country. All remedies are imported ready from America," she told Muir.[26]

At this early stage in the proceedings, Alfred Tobin and his defense team had little at which to push back against in cross-examination. It was their intention to have every witness who knew or worked with Crippen to agree that he never seemed "hunted or worried" after his wife's disappearance. Nothing irregular could possibly have occurred if he had remained his usual affable, diligent self, always at ease and never "abrupt." One of their strategies had centered on the issue of character. Those who took the stand were asked to agree with the statement that "he was a kind-hearted and amiable man." Emily Jackson, who spoke about Ethel's movements in February and March, the jewelry she acquired and the clothing she gave away, was also asked to confirm this.

"He always gave me that impression," Emily answered, but the defense wanted more.

"I think you said at the Police Court that he was one of the nicest men you ever met," Mr. Roome insisted.[27]

In contrast, by playing on the jury's ingrained early-twentieth-century prejudices and sexism, they sought to subtly construct an image of Belle that was precisely the opposite: obstreperous, lazy, covetous and ethnically inferior. Dr. John Herbert Burroughs, who had acted as the Music Hall Ladies' Guild's honorary physician and who, along with his wife, had befriended the Crippens when they lived on Store Street, was called to provide an account of Belle's general health and the relations that existed between the couple. His commentary was overwhelmingly favorable. He referred to Belle as "vivacious," "bright and cheerful" and "a very pleasant woman generally." She was fond of dress and jewelry and she and

Crippen "always seemed on good terms." She was in fine health as well, which is why he and Mrs. Burroughs had been so shocked to receive news of her death. Crippen had even written to them on black-edged mourning paper.

When Huntley Jenkins stood up to cross-examine Burroughs, he sought to throw question on as much of his favorable account of the victim as he could. He asked Burroughs to confirm that Crippen was a "kind-hearted, well-mannered man" and that he was always of service to his wife.

"Yes," the physician answered.

"I just want to put this one question to you: would you describe Mrs. Crippen as a well-dressed woman?"

"Oh yes, certainly."

"Always tidily and neatly dressed?"

"Yes, at all events outside. Not so much indoors, of course."

"I mean, when she is dressed would you call her a smart woman and a woman of neat appearance?"

"Yes."

"Have you noticed at times that she was somewhat hasty in her manner toward Dr. Crippen?"

"Yes, at times somewhat hasty."[28]

When Teresa Hunn was invited to give evidence, she took her place in the witness box dressed "in deep black" and wearing "a mourning streamer on her hat."[29] As she told the jury about the early years of Belle's marriage, the operation her sister had in Philadelphia and the scar it left on her abdomen, those in the courtroom puzzled over her manner of speech. In the decades before Hollywood film and television introduced the world to the working-class New York accent, the average Briton would have had no exposure to it. She was described by the *Daily Mirror* as having "a mixed American and foreign accent" which was so thick that the judge asked her to raise her voice so she might be better understood.[30] Teresa's foreignness seemed to play into the defense's hands. Here was an opportunity to stoke xenophobia among the English jurymen, in an era deeply suspicious of ethnic difference. Tobin asked

her if she was "the half-sister or whole sister" of Belle Elmore. Teresa clarified that she was the "full sister."

"What was your father's surname?" Tobin inquired.

"Mackamotzki," she replied.

"Was your father a Pole?" he asked.[31]

In forensic terms, the question served no obvious purpose; it did not challenge or forward any immediate argument.[32] Instead, Tobin was deliberately poking about in the victim's background, hoping to dislodge something unsavory. Anti-Slavic sentiment and "Polonophobia" (antipathy toward the Polish) was common in a London which had been rapidly filling with "swarthy Eastern Europeans": poor, ill-educated, brutish immigrants with the same dark hair and eyes as Belle Elmore. Belle had been revealed to be Catholic, and this would have aroused a further set of English prejudices which associated the religion with ignorance, slothfulness and peasantry. Of course, the majority of the new arrivals from Poland were Jewish, fleeing the pogroms, and Tobin was undoubtedly attempting to toy with whatever antisemitic sentiments might also be lingering among the jury.

This underhand attack on Belle (which would become increasingly blatant as the trial progressed) was a move played by a defense who could not have been entirely confident in their greater strategy. Tobin and his team were taking their instructions from Crippen, whose story had not budged from his original statement to Dew. They could only make the best of a bad hand and, in order to do this, were also artfully laying a plan should their client be found guilty. If they could paint Belle in such an unfavorable light, capitalizing on the complaints Crippen had made against her, demonstrating that she was venal, slovenly, greedy, argumentative, a bad wife and impossible to share a home with, the men of the jury might be likely to believe Crippen was pushed to take the course he did. With enough pity, there would be room for a mitigated sentence, one which did not lead to the executioner's noose.

While this was a murder trial, the character of the victim as well as that of the alleged killer was the subject of constant question.

Which party might be considered the more morally objectionable became a type of sub-argument tucked into the cases presented by both the defense and the prosecution. Unfortunately for the defense, other than Crippen's defamatory words about his wife, Tobin could produce little actual evidence to substantiate his client's assertions. Not a single witness would take the stand to cast aspersions on Belle; rather, the prosecution had many who were willing to champion her and enumerate her husband's failings.

Clara Martinetti, "dressed in the deepest black," was the third witness to be called on that day.[33] As with many of the other women and men who had found themselves embroiled in this dreadful case, the long, torturous experience had leveled a toll on their health. Clara had fallen ill before the funeral and been too unwell to attend, but had recovered enough to take the stand the following week. As one of Belle Elmore's closest friends and also one of the last people to see her alive, she was a key witness for the prosecution. As she entered the box, a glass of water was placed on the ledge before her. Perhaps sensing that she was not at her strongest, the judge asked her to take a seat. This would be a lengthy examination in which Muir walked her through the events of the potluck supper and the ensuing months. Clara, with her slight lisp and trace of a German accent, was an animated witness, a storyteller who remembered dialogue and performed it compellingly to the courtroom. The newspapers reported that she was "obviously much affected" by having to recall the experience.[34] Alverstone wished her to describe her friend to the jury. "Was she always bright and in good spirits?"

"Oh yes, she was very jolly," she replied.

"Full of spirits, you mean?" rejoined Travers Humphreys.

"Yes, she was nice."

"On this evening did she appear to you to be well?" Humphreys said, prompting her to recollect the events of their supper.

"Oh yes, quite well."

With that, Clara began to weep openly.

"Did you ever see her again . . . after that night?"

"No."[35]

With Humphreys' guidance, Clara peeled away the layers of lies Crippen told and laid bare his deceptions to the jury. The Martinettis were very close to the Crippens and this betrayal of trust offered a shocking insight into Hawley's character. His audacity in bringing Ethel to the Benevolent Fund Ball, in allowing her to wear Belle's jewels, flouting her before Belle's friends, was abominable.

An adjournment for lunch was called, and then a beleaguered Clara returned to the stand to identify jewelry and furs and to endure a cross-examination by Tobin, where he asked about Belle's hair color (natural and dyed), and if she had seen Belle's scar. Once more he encouraged her to agree that Crippen was "a kind-hearted man." When, finally, Clara was relieved of her ordeal, she was asked if she would like to remain and "take a seat in the portion reserved for the witnesses," but the strain of the experience had been too much. "No, I can't bear it," she was heard to murmur, "I want to go out." She disappeared as quickly as she could through the courtroom door.[36] The next day, the *Evening News* reported that Clara had been too ill to return to court and was "confined to her bed."[37]

Louise Smythson, also attired in "black velvet with a long neck chain and a mourning hat," followed her fellow Guild member to the stand.[38] Her mood was defiant. She too was asked to elaborate on the falsehoods Crippen had fed them. Travers Humphreys wanted to glean all the details from her, the lies about Belle's death, the unfair involvement of Otto Crippen in this sticky web, and how Ethel was always seemingly lurking about in Belle's jewelry. If nothing else, the jury was made to see that this was appallingly bad-mannered, insensitive and contemptuous of the hallowed Edwardian conventions of mourning. Crippen was no gentleman.

Finally, Melinda May was called to fill in the final segments of the story not covered by her two Guild sisters. She gave her testimony while fanning herself with her handkerchief in the now stuffy afternoon courtroom. The mysterious resignation letters, purported to have been from Belle, were presented to the jury, along with Melinda's identification of her friend's belongings and her hair samples.

Melinda would later describe the process of the trial as "long and awful." In the weeks beforehand, Arthur Newton had done "all he could . . . to damage the evidence of members of the Guild," but the secretary of the MHLG claimed that he had failed in his attempts. "We knew exactly what we were saying—we had nothing to tell but the truth . . ."[39]

Of the sixteen witnesses who came before the jury on that day, it is significant that six who provided evidence were women. A seventh, Adeline Harrison, would take the stand the following day. They had been the eyes and ears of this case, in part because so many of them had been able to enter the professional sphere, to work in offices, to earn their own incomes alongside men. Women had gained confidence in the public arena, they had learned how to live independently, how to organize themselves, and how to stand up and call out injustice. For some in 1910, a time when women could not sit on juries, become a barrister, a judge, a solicitor or even a police officer, this meant joining the suffrage movement and agitating for political rights. For others it meant having their voices heard in one of the most important courtrooms in the land, when they would have been otherwise excluded from any participation in the justice system.

Having said that, the star of the day was undoubtedly Bruce Miller, who gave his testimony between that of the female witnesses. The press was anxious for Miller to tell his potentially salacious story, which no one had heard prior to that day. What he might reveal on the stand could prove explosive. He was the prosecution's weapon, but the defense planned to turn him to their own advantage. Miller did not want to be there and appeared at the Old Bailey wearing a scowl. Muir's strategy was simple and required no more than a few questions:

"Has there been any proposition at all that Belle Elmore should come out to you?"

"Never."

"Never heard of such a thing?"

"No."

Miller declared that he had not seen her since April 1904. She certainly did not go to Chicago to be with him and was not with him currently.

As Crippen's assertion that Belle had left him for this man had clearly been demolished, Tobin's only use for Bruce Miller was in the deconstruction of Mrs. Crippen's character. If he could prove that Belle was sexually unfaithful, that she had debased herself with another man, who was to say that she had not dallied with numerous men, and might have absconded to live with one of them? Although this was a bit of a stretch, the men of the jury would be able to see how unfaithful and libidinous she was, and how intolerable it must have been for her poor husband.

Tobin circled around Miller's suggestions, attempting to draw him out more fully about his "friendship," as he called it, with Belle Elmore.

"Did you ever tell her that you loved her?"

"Well, I do not know that I ever put it in that way."

"Then you did love her, I presume?"

". . . I did not exactly love her; I thought a great deal of her . . . She was a married lady, and we let it end at that. It was a platonic friendship."

Tobin continued to pull at this thread. "You know the difference between friendship and love, I suppose?" he inquired.

"I do."

"Were you more than a friend?"

"I could not be more than a friend, she was a married lady and I was a married man."

"Were you more than a friend, sir?"

"I could not be more than a friend—I was not," Miller stated.

"Answer the question whether you were or not," Alverstone interjected, suspecting Miller was playing games.

"I was not more than a friend."

"Were there any improper relations between you and her?"

"No."

There was also the letter Miller had sent to Belle signed "Love

326

and kisses to Brown Eyes," the only flimsy piece of evidence suggesting a flirtation that Crippen was able to produce. While the jury would have seen this as an inappropriate way to carry on with a married woman, it was by no means proof of a sexual affair. Tobin cornered the witness into disclosing that he had kissed Belle but was unsuccessful in procuring an admission of anything else. He asked him again, "Were you her lover, sir?" and again, Miller answered, "I was not." Neither had he gone "to any house with her in London for the purpose of an illicit relationship," or ventured beyond the front room of the house where she lived while Crippen was abroad. Worse still for Tobin, Miller then turned the tables on him by stating that Crippen knew all about their relationship and was not concerned in the least by it. Muir was quick to capitalize on this. He asked if Miller had ever visited Belle when her husband was at home.

"I always went to the house any time I thought I would," he answered.

"You visited her during the time her husband was in London?" the judge inquired, incredulously.

"Yes."

Miller even described the photographs of him that Belle kept openly in their parlor.

"Were your relations with her, whatever they may have been, intended to be kept secret from her husband?" said Muir.

"Not at all."

For a final time, both Alverstone and Muir each asked Miller to confirm if "there were any improper relations between you and Mrs. Crippen?"

"There never were."[40]

As the author Max Constantine-Quinn would later write, although Tobin had failed to construe Miller's association with Belle Elmore as a "guilty" one, it "at least never was proved to be innocent."[41] Tobin had sewn a seed of doubt, but if he had hoped to find something truly damning in the Chicago real estate agent's testimony, he would have been sorely disappointed. Over the next two days, the prosecution would produce a further fourteen witnesses,

marching out an impressive procession of pathologists, scientists and doctors, each of whom Muir believed would lend their expertise to securing the prosecution's case. By comparison, the defense's list appeared embarrassingly sparse. Tobin had only four witnesses; however, there was one name among them who stood out. He who had the greatest chance of turning the tide was the accused himself.

29

"A kind-hearted man"

F OR ALL THE EXCITEMENT in the courtroom, the tears, anger
and nerves in the witness box, or the lightning-quick cross-
examination from counsels' row, there was nothing that gripped
the public's fascination with the same intensity as the man who sat
in the dock. The jury, the press and the ticket-holding spectators
studied his every move, as if he were a rare species of animal cor-
ralled in a pen. They watched him every morning as he was ushered
into court. He wore a black overcoat, which he folded and hung
over the back of his chair. He would arrange himself and smooth
his mustache. The papers called him "very prim and neat." He sat
perfectly motionless for long periods; then occasionally he tilted his
head to listen. He laced his fingers together and leaned forward,
"watchful as a lynx . . . and cool as ice."[1] At times he appeared totally
disinterested. Once, as a witness was giving evidence, Crippen pro-
duced some letters and a postcard from his pocket and began to
read them, as if he were waiting for a train, as if this were someone
else's trial.[2]

On the 20th and 21st, the medical and scientific evidence was to be
presented to the court. This was the fulcrum on which the prosecu-
tion's case rested. Richard Muir and his team hoped to convince the
jury beyond reasonable doubt that the remains in the cellar were
indeed those of Belle Elmore and that she had been murdered with
a fatal dose of hyoscine hydrobromide. After Inspector Dew had
been examined for more than two hours about his hunt for and ar-
rest of Crippen, Richard Muir called Dr. Augustus Pepper into the

witness box. Pepper, whose initial assessment of the remains had played a fundamental role at the inquest, would reaffirm his findings. The pathologist was certain that the level of decomposition indicated clearly that the body parts had been buried in the cellar shortly after death and could not have been put there before the Crippens assumed residence in 1905. Pepper was equally confident that the mark on the skin was a scar, and that the skin itself had formed part of the lower front abdomen, where it was later confirmed that Belle had an operation scar.

The various glass specimen jars containing the items from the grave site had been arranged near the witness. Then the truly horrifying task of displaying the skin sample to the jury began. It was removed by a court usher and placed on what resembled "a large white pudding dish" before being passed beneath the noses of each of the men. Perhaps hoping to demonstrate that this peculiar gruesome specimen had nothing to do with him, Crippen "rose to his feet and leaned over the rail to look at the piece of skin," before resuming his seat with indifference.

The debate over the scar tissue was to become what Justice Alverstone called "the battlefield on which the case was fought."[3] In his cross-examination, Tobin hoped to unravel the pathologist's certain identification of the mark. If he could seed doubt that this was part of Belle's body, then there would be room for the jurors to acquit the prisoner. The suggestion was put that it might be a fold in the skin. The mark was slightly wider than usual for a surgical scar, but Pepper would not be moved on this. Belle had gained weight in the years after her surgery and the scar had expanded. This was common, and as a doctor he could attest that he had seen this many times. "Even I could see it was a scar—a scar which had stretched," wrote Cecil Mercer who had also peered inside the dish.[4]

It was universally agreed among the prosecution's scientific witnesses, who were some of the most respected experts in their field, that the mark was a scar on the lower part of an abdomen. Pepper's assertions were supported by another pathologist from St. Mary's Hospital, Bernard Spilsbury. The self-assured and chisel-featured

Spilsbury had been trained by Augustus Pepper and would eventually succeed him as a Home Office pathologist. He would also attain a type of celebrity status working on some of the most sensational murder cases of the early twentieth century. Spilsbury, like his mentor, was calm, precise, and made his pronouncements with an air of absolute certainty.

Under cross-examination, it emerged that he disagreed with Pepper on one issue. Whereas the more senior pathologist believed that the person responsible for the dismemberment need not have possessed anything more than a basic understanding of anatomy to have performed such an act, Spilsbury thought that the perpetrator would have required "considerable" knowledge and practical experience to have accomplished the task. In fact, Crippen's level of aptitude would have resided somewhat nearer to the latter. Although he would later declare that he possessed no surgical experience, that he had only received "theoretical" instruction in the subject, this was a lie. As medical journals reveal, Crippen did have training as a surgeon. At the very least, he had assisted Dr. Phil Porter in his operations and was appointed to the New York Ophthalmic Hospital as a surgeon. As a practitioner qualified to undertake surgery, Crippen would have owned a set of surgical tools and knives, at least during the first part of his career. The tools used on this dismemberment were never found, though Pepper believed that a set of common kitchen knives would have sufficed. Whether Crippen had sold his professional tools in the past or still possessed them at the time of the murder is unknown. Whatever the case, they were not to be found at Hilldrop Crescent.

Dr. William Willcox, the Senior Scientific Analyst to the Home Office, he who had set Crippen's pulse racing at the committal by announcing that he had tested the remains and discovered them to contain a fatal dose of hyoscine hydrobromide, was called to provide evidence. He took the judge and jury through his method of testing for the alkaloid substance and also pronounced that he "did not know of any medicine existing in which such a quantity as two-sevenths of a grain [that] could have been used internally."[5] He

believed that the poison had been administered to Belle in a drink such as stout, beer, sweetened tea, coffee or spirits, which would have disguised the bitter flavor. A second practitioner, Dr. Arthur Pearson Luff, a physician at St. Mary's Hospital and also the Honorary Scientific Adviser to the Home Office, was then called. Luff described how he had repeated Willcox's tests and could verify his conclusions, which would leave the jury little room for doubt as to the findings. The prosecution's line of argument was effectively sealed with the appearance of Charles Hetherington of Lewis & Burrows, who proved absolutely that Crippen bought the poison from him.

The defense's challenge would be to puncture this watertight evidence, a feat which would prove near impossible. They could not disprove that Crippen had purchased the hyoscine or that it had been found in the remains, though Arthur Newton believed there was a possibility of casting doubt on the identification of the scar.[6] He then deployed his cunning to find a scientist who would not be afraid to take issue with the experts from St. Mary's Hospital. Many years later, Bernard Spilsbury would relate how such a person had been located.

Shortly before the trial, Spilsbury's old university friend Dr. Gilbert Turnbull, who was then director of the Pathological Institute at the London Hospital, phoned him for advice. Turnbull was angry and anxious. He revealed to Spilsbury that he had been at a party playing bridge with Arthur Newton when the solicitor asked him if he'd like to have a look at "the disputed piece of skin" in the Crippen case. Newton knew that Turnbull, for reasons of professional jealousy, did not have a high opinion of St. Mary's Hospital and used this to his advantage. Newton told Turnbull that Drs. Pepper and Spilsbury thought it was a scar, but he wanted to know Turnbull's opinion. He agreed to look at the specimen, as did his colleague Dr. Reginald Wall. After an initial twenty-minute examination of it, both suggested that the mark was probably a fold rather than a scar. Turnbull had done this on the explicit understanding that he would not be made to testify to this in court. Newton agreed, but then re-

neged, and both Turnbull and Wall were summoned to the Old Bailey to give evidence for the defense. Turnbull declared to Spilsbury that he had been tricked but, ultimately, he felt compelled to testify. It would be a decision that both he and Wall would live to regret.

Under cross-examination, Turnbull was backed into a corner. He openly admitted that he did not want to be a witness, that when he was "asked to undertake this," he "had hoped it would not mean having to give evidence."[7] His answers became contradictory and confused. He grew surly and argued with Richard Muir and the Lord Chief Justice. At one point, he suggested the skin had come from the thigh rather than the abdomen and Muir invited Turnbull's friend, Bernard Spilsbury, to come forward and show Turnbull the exact location of the abdominal tendon. It was a humiliating affair for Turnbull, whose damaged ego would not allow him to concede that he had been mistaken. His colleague Reginald Wall faced a similar battering, though Wall eventually relented and stated that he thought the skin "probably" came from the abdomen.

The prosecution rested their case on day three of the trial. Alfred Tobin would take up the gauntlet that afternoon. Muir, with his thirty witnesses, would be a difficult act to follow, but the defense would be putting Crippen in the witness box and giving him the opportunity to account for himself. Mercer wrote that he did not think Tobin had much of a choice. If the defense had decided not to subject the accused to examination, the jury would have been more inclined to find him guilty. This was Crippen's last hope.

Before the curtain rose on the penultimate act of this drama, Alfred Tobin, like a narrator taking center stage, rose to his feet and began his speech for the defense. It was an argument that wobbled and sagged as he presented it.

From the outset, Tobin proclaimed that Dr. Crippen's reputation as a "kind-hearted," "good tempered," and "amiable" man would suggest it was impossible for him to suddenly become "a fiend incarnate."[8] Such a man would have been incapable of committing the heinous murder and dismemberment of his wife.

Tobin had hardly begun speaking before Sir Edward Marshall

Hall, King's Counsel and one of the most eminent defense barristers in England, rose and walked out of the courtroom. Marshall Hall had turned down the brief to defend Crippen and had come to observe the trial, but when he saw the futile and absurd line of defense Tobin was running, he could bear to hear no more.[9]

Tobin continued, making much of Crippen's character and behavior, suggesting that his conscience must have been clear because his demeanor remained calm and constant. He was the same person after Belle's disappearance as he had been before it. "He showed no sign of agitation, no sign of fright," and he made no effort to avoid his wife's friends.[10]

As for a motive, there seemed to be none. It was not true that he was in want of money, and if he had wanted to get rid of his wife to marry his mistress, why did he wait so long to do it? More to the point, why, when given the chance to marry his mistress, didn't he?

When it came to explaining the disappearance of Belle Elmore, Alfred Tobin suggested that the jury should consider Belle Elmore herself, "who she was, what she had been, her characteristics," and what she was like at home with Crippen. "Belle Elmore was the daughter of a Pole," he proclaimed once more. She had married Crippen when she was nineteen and he was thirty, and they (the jury) "could not and ought not forget that she had been living under the protection of someone in New York at the time she married him, and he knew it."[11] In other words, Belle was physically and morally compromised. She was unchaste, another man's toy, and Crippen had taken this tarnished second-hand woman, for better or for worse. The Crippens' marriage had deteriorated, largely on account of Belle's "ungovernable temper" and because there had been "an illicit intimacy between Mrs. Crippen and Bruce Miller."[12] Neither of these accusations had been proven, but Tobin pressed on. Now, no one knew where she was. No one knew if she was here, or abroad. It would also be correct to say that no one knew for certain if she was dead or alive, or whether the body found in the cellar was actually hers, he asserted. In a case of murder, Tobin reminded the

jury, they needed to be certain beyond a reasonable doubt, that those remains were hers—and could anyone be sure of that? A man's life was balanced on their decision.

The name of Hawley Harvey Crippen was called through the court. The curious creature who had been caged at the center of the room was released. He ambled across the floor and took his place in the witness box. The jury leaned forward to stare at him. The wooden benches and tip-seats of the Old Bailey creaked amid the expectant hush of the room.[13]

The story that had been told countless times since it was first committed to paper by Sergeant Mitchell on July 6 was recited again. It was sung as a type of duet between Crippen and Huntley Jenkins, who led his examination. In the months that had passed, Crippen had recanted none of it. Not a word or accusation had been altered. Belle was "quarrelsome" and always found fault with him. After she met Bruce Miller, she no longer wished "to be familiar with Crippen" or share a bedroom with him. When she left him, she had been "in a rage." She instructed him to contend with the scandal as best as he could, and that was it. She was gone when he returned from work on the evening of February 1.

Crippen was asked to explain his purchase of hyoscine on January 19. It was true that he had never ordered hyoscine before, but this was for a new homeopathic "nerve remedy" he was preparing. He described in detail how he had made the dilutions and applied the formula to 300 small sugar discs, which he then packaged. He claimed he had used two-thirds of the hyoscine in creating this product; however, he could not account for how he dispensed with all of it. He had a mailing list of over 200 people, but there was no proof he had advertised the "nerve remedy" and beyond one name, "Sweeny" or "McSweeny," he could not recall a single regular patient to whom he had sent it. It was stated that the remaining portion had been left in one of his cabinets in Albion House, but when Newton had gone to look for it, it was not to be found.

The lies fell out of him with nonchalant ease. They came as readily

in the witness box as they had at any other time in Crippen's life. Tobin had described Crippen's flight to Canada as an act of "folly." He had been faced with "clouds of suspicion" and "a mountain of prejudice" and so he ran and took Ethel with him. He claimed that: "Inspector Dew was very imperative in pressing upon me that I must produce my wife, or otherwise I would be in serious trouble. He also said that if I did not produce her quickly, the statements I had made would be in the newspapers the first thing I knew."[14]

None of this was true. Later, Dew would flatly deny he had said such a thing, nor would he have ever dreamed of threatening a possible suspect by publishing their statements in the papers.[15]

According to Crippen, there was an innocent explanation for everything, especially for those utterances which seemed the most incriminating. The comment he had made upon his arrest, "I am not sorry; the anxiety had been too much," was easily dismissed. "I expected to be arrested from all the lies I had told," he said. "I thought probably it would cast such a suspicion upon me, and perhaps they would keep me in prison—I do not know how long, perhaps for a year—until they found the missing woman." The remark to Dew which followed it, that Ethel knew "nothing about it" and that he "never told her anything" was also waved away.

"What were you referring to when you made use of that observation?" Huntley Jenkins asked.

". . . I had told her that my wife had gone away, and I told her afterward that she was dead. These were the only two things that I told Miss. Le Neve. Consequently, she never knew anything about all these letters and lies that I had disseminated."[16] Crippen said further that he believed Belle never knew about his relationship with Ethel, as his wife "always treated Miss. Le Neve with the greatest courtesy when she came into my office." She never prevented him from seeing his mistress. He went on to disclose that "I told Miss. Le Neve that if ever my wife went away and got a divorce I should marry her certainly."

"Was she perfectly satisfied with the position she occupied?" asked Huntley Jenkins.

"She seemed to be very happy," he replied, though he (and Ethel's friends and family) knew that she had been miserable.[17]

Huntley Jenkins then gave Crippen another opportunity to account for himself. "Did you ever at any time administer any hyoscine to your wife?"

"Never."

"Those remains that were found at your house in Hilldrop Crescent—have you any idea whose they were?"

"I beg your pardon?" Crippen responded, as if this were the first time this shocking discovery had ever been mentioned.

"The remains that were found in the cellar at Hilldrop Crescent?" his barrister reminded him.

"I had no idea," Crippen feigned confusion. "I knew nothing about them till I came back to England."[18]

With that, the court was adjourned for the day.

That final extraordinary exchange of questions and answers had been left to linger in the air, priming the court for Muir's cross-examination the following morning.

Crippen had played the role of a persecuted innocent, a quiet, harmless, withdrawn little man who had inexplicably found himself at the center of a murder investigation. He could offer no substantial explanations for anything he did or said. Neither had he any alibis. Each of his statements had exposed a weak point, which Muir and his team had duly noted. They would know precisely where to attack. Muir would pick repeatedly at these slack spots. He would tear down everything Tobin had spent the past day painstakingly constructing. "It was a dead case," Cecil Mercer wrote, and Muir "fairly screwed down the lid."[19]

Richard Muir opened with a swift strike.

"On the morning of February the first you were left alone in your house with your wife?"

"Yes."

"She was alive?"

"She was."

"And well?" Muir persisted.

"She was."

"Do you know of any person in the world who has seen her alive since?"

"I do not," answered Crippen plainly.

"Do you know of any person in the world who has ever had a letter from her since?"

"I do not."

"Do you know of any person in the world who can prove any fact showing that she ever left that house alive?"

"Absolutely not . . ."[20]

Muir danced him through all the steps of the story he gave to Dew. Crippen admitted that he at no point made any inquiries to see if his wife was living. He never placed Dew's advert in the newspapers, but he also never bothered to ask the neighbors or the milkman, or the boy who delivered the bread, if they had seen his wife leave. It never occurred to him to ask the cab drivers who waited at the stand around the corner if they had assisted her with her luggage or taken a woman of her description to the train station. Muir asked him how he knew that his wife was not going to write to him and request her furs and jewels when she arrived at her destination? Crippen responded bluntly that he did not know. At any rate, he claimed he would have kept all her jewelry and furs because he had paid for them.

He was questioned closely on his wife's relationships with her friends and family members. Muir stated that she had many intimate companions with whom she corresponded and socialized frequently: the Martinettis, the Nashes, Isabel Ginnett, Louise Smythson, Annie Stratton. She was close to these people, and he saw them too, often several times a week, dining with them, hosting them in his home. Muir asked him if he had dressed in mourning attire after he had placed her death notice in *The Era*. Crippen, echoing exactly what Ethel had said to Dew in her statement, claimed he did not recall if he wore mourning. Muir had to remind him that he did wear it.

"Did you not think of the pain you would give to your wife's friends?" he put to Crippen.

"I was not considering them at all."[21]

Belle was also "very fond" of her sisters, Mrs. Mills and "Tessa," with whom she corresponded regularly, Muir stated. Crippen had written letters to her family and friends on mourning paper, announcing her death and playing the role of a grieving husband. Crippen had admitted that when his wife disappeared, he had no idea where she went, but how was he so certain she would not write to her friends? Muir inquired. How could he be so sure she would not have gone to see Mrs. Ginnett or her family?

". . . If Cora Crippen were alive, might she call at any moment on her sisters?" the barrister posed.

"I did not think she would," he answered. "If she had gone off with some other man, I did not think she would have the face to go there."

"This was a very elaborate series of representations to a large number of persons?"

Crippen agreed this was so, and then continued, "I did not wish the friends here to think that I had treated her so badly that she had gone away and left me."

"Is that right?" Muir responded.

"Yes, so far as my part of it was concerned."

"Going about as you were with Ethel Le Neve?"

Abashed, Crippen insisted it was not "so open as you seem to imagine" and that by doing this, he was saving himself and Belle from scandal.

"Now, you had treated your wife well?"

"Yes."

"And given her money?"

"Yes."

"And jewels?"

"She had them to wear."

"And clothes?"

"Clothes," Crippen confirmed.

"And kept an establishment for her for four years after you ceased to cohabit with her, and then she treated you with ingratitude and went away and left you for no cause at all?"[22]

"Yes."

"Why should you seek to cover up a scandal for such a wife as that?"

Crippen seemed dumbfounded. "I do not think I can explain it any further than I have."

Muir was stalking him, letting him run, tiring him out.

He asked the accused to confirm that he had been a tenant at 39 Hilldrop Crescent for five and a half years.

"Had the floor of the cellar of that house been disturbed during the whole of that time?"

"Not to my knowledge." Crippen added that he had no reason to think it had ever been disturbed. Well, he prevaricated, there were times when he was out of the house, of course, and when Belle was out of the house too.

Alverstone could not believe what he was hearing. "Do you really ask the jury to understand that your answer is that without your knowledge or your wife's at some time during the five years that the remains could have been put there?"

"I say that it does not seem possible . . . but there is a possibility."

Muir wanted to get as near to a confession out of the accused as was possible. He would continue to push him on the events surrounding his arrest. Crippen reiterated his fears that he would be put in jail and kept there for months on grounds of "suspicion." Again, the judge was incredulous at Crippen's answer. Was he really trying to suggest that he would be kept in jail for an indefinite period on nothing more than "suspicion"?

"Suspicion of what?" Muir asked.

"Suspicion of—Inspector Dew said this woman has disappeared, she must be found."

"Suspicion of what?"

"Suspicion of being concerned in her disappearance."

Crippen was finding it difficult to say the word "murder." Neither could he bring himself to speak his wife's name. Throughout his entire time in the witness box, he never once pronounced the name Belle Elmore or Cora Crippen. His disassociation from the crime

was such that Belle was simply referred to as "the woman," "this woman," "that woman." "If I could not find the woman, I was very likely to be held . . ."; "If I did not produce the woman . . ."[23]

The problem was, as Muir pointed out, he never did attempt to find "that woman." He asked Crippen to describe what had occurred aboard the *Montrose,* when Inspector Dew appeared and read out the charge of murder.

"I realized I was being charged."

"With what?"

"Well, I realized I was being arrested for murder; I remember hearing that."

"The murder of your wife?"

"Yes."

"Up to that time did you believe she was alive?"

"I did."

"Did you put any question to Inspector Dew as to whether she had been found?"

"I did not put any question at all."

"As to how he knew she was dead?"

"No."[24]

Muir reminded him that if his wife were to have been located, there "would be no foundation for this charge at all" and he would be acquitted of it. He asked Crippen what steps had been taken to find his wife since his arrest. Crippen replied that he had "not taken any steps" and neither had anyone else, not even his solicitor. Muir confirmed that Crippen had seen Mrs. Ginnett in Quebec, and he had not asked her to find his wife. Neither had he suggested to Inspector Dew that he might attempt to locate Belle, nor had he applied for help from Belle's sisters or stepfather. Crippen never tried at all, nor did he offer a plausible excuse for his reasons why.

Muir touched on the question of Ethel's culpability, how much she could possibly have known. At every turn, Crippen stuck to his original story, that she knew nothing beyond what he had told her, that Belle had left him and then that she had died. According to him, Ethel tamely accepted everything, even his explanation that

they had to flee or there would be a scandal which "would turn her folks against her." She asked no questions about his insistence that she dress in boy's clothing, cut her hair, and pretend she was his son. He said that, initially, he thought she would only wear her disguise until they had safely left London, but never elucidated as to why they maintained their false identities throughout their journey. However, Muir would not let him slip away without explaining his declaration to Dew that Ethel "knew nothing about it."

"What was *it?*" Muir asked repeatedly. "What did she know nothing about?" Crippen insisted he was referring to the lies he told and the letters he wrote, but Ethel did know about the lies and had even helped to perpetuate them. On the day they fled, she had also admitted to Nina that Crippen had told her that Belle was alive.

As Muir attempted to strip back the layers of falsehoods, Crippen laid others in their place, repeatedly and carelessly perjuring himself each time. He had now spent months in jail and had sufficient time to strategize and fabricate elaborate cover stories for his missteps.

The card discovered on him when he was arrested, in which he claimed he could not "stand the horror" he went through every night and declared his intention to throw himself overboard, consumed a fair amount of the prosecution's cross-examination time. Crippen insisted that there had been a quartermaster on board who had heard that he was to be arrested and formulated a plan to smuggle him off the ship. This member of staff suggested that Crippen leave the note and fake his suicide. The accused was asked to describe the quartermaster, as there had been four working on the *Montrose*. Crippen had offered only a vague description of a medium-sized man with a dark mustache. The *Montrose* had been into port in Britain twice since Crippen's arrest, and Muir asked if any effort had been made to locate the quartermaster to substantiate the story.

"No, not so far as I know," answered Crippen, untroubled.[25]

The prosecution's cross-examination had lasted an exhausting 3 hours and 48 minutes. Crippen had chosen to stand the entire time, lingering back from the bar, with his hands folded behind him. He "made a very poor witness," wrote Mercer.[26] He played dumb

throughout. As a fraudster, this had always been his modus operandi: lie low, do precisely the opposite of what they expect you to do, wrong-foot them. Behave humbly. Prevaricate. Obfuscate. But Muir and Alverstone saw through all of it. Perhaps for the first time in Crippen's life, his strategy did not work.

On the fifth and final day, before the closing speeches, a late witness for the Crown was called. Muir had produced Crippen's pajamas, both the fragments of the jacket from the grave site and the matching pair of trousers from under Crippen's bed. There had been a dispute about the date of their purchase. The prosecution insisted that the Jones Brothers pattern did not exist before 1908, and that Crippen or Belle had bought them at some point after that. Crippen affected confusion. He was not sure if they were from the same set. William Chilvers of Jones Brothers was called to confirm the date of manufacture and purchase. Jones Brothers sales records showed that they had been bought and delivered to 39 Hilldrop Crescent on January 5, 1909. There was no innocent explanation to be had for how the jacket found itself entangled with the remains beneath the cellar floor. The evidence was so damning that the Lord Chief Justice wanted to make absolutely certain that the accused had an opportunity to comment on it. He addressed Crippen directly and asked him, as Muir had done previously, "how they got into your cellar . . . ?"

". . . I have no idea," Crippen answered.[27]

In the wake of this, Alfred Tobin had the painful task of cobbling together the scraps of the defense's tattered arguments. He presented the thin remnants to the jury. He wished them to remember that "the burden of proof rested with the prosecution and if anything was in doubt, they should not convict for a capital crime."[28] He suggested that his client never searched for his wife because he was pleased she was gone. He explained Crippen's flight as "an act of folly" rather than guilt. He had simply panicked. Once more, Tobin pleaded that Crippen was "a kind-hearted, good-hearted, amiable man." All his friends attested to this, he reminded them, but somehow, even the Edwardian jury and those present in the courtroom

struggled with this line. There has long been a tradition of calling middle-class men who murder their wives "nice."

Muir, in his closing remarks, was excoriating about the suggestion that Crippen was "kind-hearted." He reminded the jury that "over a long series of months" the accused had "led a life of studied hypocrisy, utterly regardless of the pain which the lies he was telling . . . would inflict upon a friend or sister of his wife."[29] He mocked the grief of their friends and displayed deep contempt for the conventions of mourning. He lied that his wife was having an affair with a man on whom she had not set eyes for six years. All the while, he was openly carrying on with Ethel Le Neve. In Muir's opinion, the jury could see what sort of man he was just by observing him in the witness box. He displayed no remorse, no emotion at all. "If you are going to acquit him, do not let it be on the grounds that he is too kind-hearted," Muir declared in disgust.[30]

Muir continued his speech, leaning into the dramatic and emotional, but also urging the jury to be pragmatic. He wanted them to hold a few questions in mind, foremost among them: "Where is Belle Elmore?" "Whose remains were in the cellar?" "Who mutilated her body and put the remains there?" "How did she die?" Muir wished the jury to consider the evidence of the pajamas, the hyoscine found within the remains, and who purchased that deadly drug. He was satisfied that all of this amounted to the murder of Belle Elmore by Hawley Harvey Crippen. Now, it was left for the jury to be satisfied of that fact.

Before Alverstone sent the jury into retirement, he addressed them, reminding them of the gravity of their obligations. They had been presented with a dizzying amount of evidence and two complicated, competing arguments. His task was to guide them to their decision. At the heart of the case lay the issue of whether the remains found at 39 Hilldrop Crescent were those of Belle Elmore. If the jury concluded they were not, then Crippen must be acquitted. If they were, the jury must then consider if her death was occasioned by a willful act committed by her husband. On this, his guilt or innocence rested.

The jury was asked to retire, and the judge made his way out of the door. A murmur of voices rose through the courtroom, like a theater at intermission.

It took twenty-seven minutes. The twelve men in possession of Crippen's fate filtered back into the room. The October afternoon light streamed in through the windows, casting a mellow orange glow along the walls.[31] The absolute, church-like silence returned. The clerk of arraigns asked the jury foreman if they had agreed on a verdict. They had.

"Do you find the prisoner guilty or not guilty of willful murder?"

"We find the prisoner guilty of willful murder."

It had been unanimous.

There were gasps from the spectators, and even a sob was heard in the gallery. Journalists hastily rose from the benches and pushed their way to file their stories.

The face of the man in the dock turned ashen gray. A nerve began to twitch in his throat, but his expression remained as placid and inscrutable as ever. Only his blue eyes, bulging behind his spectacles, revealed his thoughts. They stared at the jury, hard with resentment.[32]

"Prisoner at the bar, you stand convicted of the awful crime of willful murder; have you anything to say why the Court should not give you judgment of death according to the law?"

"I am innocent." Crippen spoke in a low, hoarse voice.

Alverstone placed the fateful black cap upon his head and a court usher called out for silence.

The Lord Chief Justice leaned forward and looked steadfastly at the prisoner.

Hawley Harvey Crippen, you have been convicted, upon evidence . . . that you cruelly poisoned your wife, that you concealed your crime, you mutilated her body, and disposed piecemeal of her remains . . . On the ghastly and wicked nature of the crime I will not dwell. I only tell you that you must entertain no expectation of hope that you will escape the consequences of your crime, and

I implore you to make your peace with Almighty God. I have now to pass upon you the sentence of the Court, which is that you be taken from hence to lawful prison, and from thence to a place of execution, and that you be there hanged by the neck until you are dead, and that your body be buried in the precincts of the prison where you have last been confined after your conviction. And may the Lord have mercy upon your soul![33]

"I still protest my innocence," Crippen said, but it no longer mattered.

As the warders prepared to take him from the dock, he did not break down. He did not scream or become violent. He did not even cry. Ingleby Oddie, one of the prosecution counsel, would later claim that any reports in the press that he did were fabricated. "He was a fatalist," wrote Oddie. ". . . He knew he was doomed" and "that it was no use getting excited about it."[34]

He was strangely serene as he was led away. The public, gathering their hats and belongings, lingered in the gallery to observe him, this "little man," this "kind-hearted" murderer, as he was escorted out of the courtroom.

Three months of running and hiding, of lying, of keeping silent, of evidence gathering and argument building, of press scoops and headlines were finally over—for Crippen, at least.

★★★

It was well after 1 a.m. when the Martinettis had left Hilldrop Crescent. Belle had shut the door. The house was locked for the night. Used dishes and plates, glasses and cutlery were stacked, left in the breakfast room and in the kitchen. At some point, Belle would have to tidy it all up, but tomorrow, after Hawley went to the office. The Crippens headed for bed. Perhaps they argued, perhaps not. The only man left to tell the story of what occurred was a proven liar. What is known is that her husband brought her a drink, perhaps a nightcap of brandy to help her sleep, or a glass of health-giving stout, as Cecil

Mercer suggested. Crippen took the secreted packet of hyoscine from where it was stashed and dropped it into the liquid.

Belle was engaged in her bedtime toilette. She had begun to put in her hair curlers when she took the glass from him. Her dress, petticoats and jewelry were off, but she was in her underwear: her combinations, with a vest for extra warmth beneath it, her corset and a corset cover (or camisole) above it. Perhaps she was in a dressing gown too. Crippen had changed into his striped pajamas by the time the hyoscine took hold.

Crippen had obviously imagined that everything would have occurred differently. Samuel Ingleby Oddie, who went on to become a coroner after his involvement in the trial, suggested that Crippen's original plan had been to make Belle's death appear as if it were a natural one, that she had suffered a heart attack in her sleep. The hyoscine had been chosen specifically because it was intended to work silently, slowly shutting down the victim until her heart stopped altogether. After the death, Crippen would have then sent for a doctor. Oddie wrote that "the facile way in which some general practitioners issue certificates of death leads me to think that in all probability Crippen could in this way have got a death certificate showing syncope and fatty disease of the heart as the cause of his wife's death."[35] The murderer likely had their friend Dr. John Burroughs in mind for this task, someone who knew the couple and would not have doubted Crippen's sincerity in the face of such a tragedy. After all, Crippen had done this before. Charlotte's death had been the rehearsal, demonstrating to him just how easy the process was. On a cold, late January day in 1892, he had called his friend Dr. Dart to certify that his wife had died of an apoplexy, at the curiously young age of thirty-three. Crippen would later say she had died of heart trouble. Whatever the story, it was all soon forgotten. Charlotte was buried, and by the end of the year, he had married Belle.

Oddie believed that no one would have been likely to raise the alarm, and even if there had been some suspicion and a post-mortem was held, "no sign of the hyoscine poisoning would have been

observed, for there are no such signs visible to the naked eye."[36] Crippen would have thrown himself into mourning for some respectable but brief period and then, with an official death certificate in hand, married Ethel. The new wife replacing the old, just as it had happened before.

Oddie was not the only person to have arrived at these conclusions. On July 16, long before Belle's cause of death had been determined, Crippen's 75-year-old father, Myron, gave an interview to the *Los Angeles Herald* in which he expressed his thoughts:

> If my son had wanted to rid himself of his wife, he, with his superior education and knowledge of medicine, would have employed some means to put her out of the way without exciting suspicion . . . He could very easily have trumped up circumstances to make it appear that she had died of natural causes, and his signature on the death certificate perhaps would have been sufficient to close the case. There are subtle poisons that give no trace, and he could have easily used one of them.

Myron was evidently proud of his son's cunning, and one wonders if he had not let slip some insight into the previous occasion when he had lost his daughter-in-law.

Crippen had been strategizing and laying the groundwork for at least a month. From what Belle's friends observed, Mrs. Crippen did not seem to be in the best of health in January. She had two strange "turns." The first of these took place on the night of the 6th when she woke up unable to breathe. She believed she was dying and told Crippen to call for a priest. She was so distressed by this episode that she recounted it to Louie Davis the next day when she saw her at the Guild office, and then raised it a second time afterward, as they were sitting in Lyons having tea. She put her hand to her throat and said, "I shall never forget it, it was terrible." Crippen dismissed it as "the worry of the Guild" and suggested she should resign her position, but Belle said she "did not think that was it."[37] The second occasion was on the 18th. Belle had begun to feel unwell. Her head

hurt and she became so dizzy that she fell. This was recalled to Lillian Nash who had the Crippens over for dinner the following night.[38] Belle refused an offer of a brandy and soda, because she still had a headache and because Crippen had given her something for it. Belle's friends agreed she was in generally good health, so this was unusual. If Crippen's plan was to make Belle's death appear to be a natural one, then it would also make sense for others to witness her health faltering shortly before her heart attack. Slipping her something in a drink to bring on these symptoms was easy enough and it was probably no coincidence that both of these "episodes" occurred just before pre-arranged gatherings.

Crippen would have counted on everything happening seamlessly, but that was not how it unfolded. The murder of Belle Elmore was a poisoning that went wrong. Oddie believed it was down to Crippen's inexperience with hyoscine, which in large doses "sometimes produces wild delirium." Instead of drifting into a stupor, and then experiencing paralysis followed by a coma and death, it is likely Belle grew agitated and violent. She may have even realized that her husband was attempting to kill her. She may have fought back. There was most likely a struggle of some description, or an accident in her disorientated state. When interviewed by the police, several neighbors reported hearing disturbances at night "at the end of January or the beginning of February." Franziska Hachenberger at 36 Hilldrop Road believed she heard "one long scream" which "ceased suddenly" coming from "the back of Hilldrop Crescent." Her father had heard the noise too, at around 2 a.m.[39] Miss. Isaacs, who lived in the house that backed on to the Crippens', also claimed that she had heard "a loud scream," as did Louisa Glackner, who said she was awakened by a shriek and then opened the window to hear a woman cry, "Oh don't! Oh don't!"[40]

Oddie believed that, in a panic, Crippen was likely to have taken his gun and shot his wife. Interestingly, Lena Lyons and her lodger, Mrs. May Pole, both told the police that they were awakened one night in late January or early February by the sound of what Lyons described as "two shots" which came "from the direction of 39 Hill-

drop Crescent." Both believed they had heard the noise sometime between 7 and 8 a.m., before dawn had broken. Mrs. Pole, who was pregnant, said she was especially frightened and ran into Mrs. Lyons's bedroom. That was when they heard the second shot. Later, they speculated that it may have been the backfiring of a motorcar but felt certain at the time that sounds had come from a revolver.[41]

Although none of these witness reports proved substantial enough to be used by the prosecution, Oddie's theory is a logical one. Belle's body sustained some sort of injury, whether marks of a physical assault, a tumble down the stairs resulting in broken bones, a bump on the head, or a gunshot wound. This would have made it impossible to pass the death off as natural. Suddenly, in the early hours of the morning, Crippen had to rethink everything. He now had to dispose of a body.

On the evening of January 31, the temperature in Central London sat at roughly 1 degree Celsius.[42] In a suburban coal cellar, it would have been much colder still. It might have been that he placed her there at least until he could devise a plan. This way, he could go about his day without raising suspicion. He could visit the Martinettis and go to his office. Crippen needed time to hatch a story, and a very complex one, to account for Belle's absence. It was probably that evening that he began the horrific task of taking apart her body, of utterly obliterating the woman with whom he'd shared his life.

Oddie believed it had happened in the bathtub. Cecil Mercer thought it would have been done in the kitchen. At some point during the previous night, he had used the pajama jacket to help maneuver her into the cellar. This, along with a handkerchief which served some use, and the curlers which had been ripped out in the laborious process of shifting and disposing, were left there. The disorder, the blood, the hideous mess would have been indescribable, unimaginable, inhuman.

In *Supper with the Crippens*, David James Smith interviewed Dr. Richard Shepherd, a modern forensic pathologist, regarding the time it might have taken Crippen to accomplish this task. Shepherd explained that an experienced pathologist might be able to perform

the dissection in an hour. Although Crippen's level of skill is unknown, he would not have possessed this sort of expertise. The act of stripping out the bones would have made this yet more arduous—"that would have taken much, much longer . . ."[43] Even after the dissection had been performed, Crippen would still be faced with the problem of disposing of the remains discreetly and then cleaning away the evidence of the crime. This was not an undertaking that could have been accomplished overnight, and considering that Crippen was at Albion House and visiting the Martinettis and pawnbroker on the 1st and the 2nd, he was not able to devote entire days to it.

How precisely Crippen discarded his wife's bones and her head has never been agreed. Walter Dew thought he might have disguised them (perhaps in brown paper, as a fragment was found in the cellar) and thrown them into nearby Regent's Canal, then a polluted, industrial waterway filled with detritus. Hilldrop Crescent was also just up the road from the Metropolitan Cattle Market with its vast slaughterhouses, which may have presented some other possibilities under cover of darkness.[44]

This very naturally leads to the question of February 2nd and Ethel's whereabouts on that afternoon or night. During his trial, Crippen insisted on more than one occasion that Ethel slept at Hilldrop Crescent on that date.[45] Ethel, in her statement to Dew, claimed she went to the house the week after Belle had left to put the place straight; however, in her 1910 memoirs she shortens the time frame to "three or four days" after February 2nd. She recounts a tale about how she had gone to the house to feed the pets which had been locked in the kitchen. During her errand, one of the cats escaped and ran up the stairs, which permitted her to snoop in Belle's bedroom and nose her way through other parts of the house. By 1920, this narrative had changed entirely and she coyly remarks that she "thinks but cannot be certain" that she stayed over on the 2nd.[46] If this is indeed true, then there is no doubt that Ethel knew about the murder. Even if she had gone to the house during the day and not stayed over, the evidence of the act would have been everywhere

and unavoidable. Crippen would have needed her help with the clean-up, at the very least, and from the statements given by the Crippens' rubbish collectors and their neighbors, it appears that the scrubbing away of Belle and her husband's crime continued through to March. It is likely that he never intended to involve Ethel so directly in the deed itself, especially if he believed her to be so delicate and easily unnerved, but the unexpected course of events changed everything. Whatever horrors she witnessed in that first week of February would work to bind them together like nothing else. She had been initiated into the secret, and now their lives and their future together were dependent on keeping it.

Ethel had known the murder was coming at least since the beginning of January. So certain was she that Belle would soon be gone, she could not resist—while Crippen was ordering the poison—showing everyone her engagement ring. The timing of the hyoscine purchase with the date of Ethel's twenty-seventh birthday and the murder itself on the last night of that month presents a sense of an ultimatum. It had to happen by the end of January. She had to be gone, or else.

Crippen had spent years promising Ethel that she would be something more than his mistress. He undoubtedly loved her, but, as he expressed to Belle quite early on in their affair, Ethel was also "indispensable to the business."[47] She knew where the bodies were buried, so to speak. Crippen was running a series of swindles, his associates were fraudsters, gamblers and convicted criminals. Ethel managed all of it. They had their systems and schemes. Presumably she also knew enough to send him to prison, if she wished. Ethel was known to play games. She could make him jealous by courting other men. She could disappear to Brighton. She could get pregnant. Ethel had much more influence over Crippen than most were willing to acknowledge. One thing is for certain: if Hawley Harvey Crippen had never met her, Belle Elmore would not have died the way she had.

30

"A little hysterical"

W HEN ETHEL WALKED DOWN the steps of 39 Hilldrop Cres-
cent on the morning of July 9, it is unlikely she imagined
herself returning to the neighborhood any time soon. However, by
the end of August, she was back, and incarcerated at Holloway
Women's Prison, not seven minutes from her front door. Ethel used
to catch glimpses of the castellated Victorian building when she
shopped on Camden Road. Its austere high walls were an unavoid-
able presence in the area, a reminder to women of the fate that
awaited them if they failed in their roles as good, law-abiding daugh-
ters, wives and mothers. The prison filled its chilly, damp cells with
the drunk and disorderly, the violent, those who sold sex, thieves,
abortionists, forgers and murderers. By 1906, it also housed suffrag-
ettes, those who sought political equality with men and who were
prepared to destroy property and raise havoc in order to achieve it.[1]

Ethel was driven through the gates of the prison while still "trem-
bling" and "dazed" from her ordeal at Bow Street Magistrates'
Court. She was interviewed, weighed, had her possessions removed
and was taken to the cold, grim prison bath. As she was there on
remand, she was allowed to wear her own clothing, to receive visi-
tors and to write letters. Upon admission she was given a prison
number, fifteen, by which she would be known.[2] She was then lined
up in the hall with the collection of fellow inmates who had also
been processed that day. They were each "given a Bible, a card of
prison rules, a diet card showing the meals for each day, two blan-
kets, two sheets, a pillowslip, a spoon, a knife made of tin, a slate

and a slate pencil." She observed the collection of "poor, miserable women" who surrounded her. They "were women of all ages, some of them well-dressed, some of them tattered and battered and broken. One or two of them bore the traces of the crimes that had landed them in prison." Ethel was intrigued that several of the prisoners "laughed and joked and greeted the wardresses as if they were old friends."[3] She was taken to a cell where she spent the night behind a locked iron door. In the morning, she was told that for a sum of 3s. 6d. she might be provided with a better sort of prison accommodation containing a washstand, a dresser and a proper bedstead, but whether she was able to afford this luxury was never revealed. Instead, it was decided that Ethel was too frail and shaken from her ordeal to withstand the cells and was transferred to the infirmary for the duration of her stay. This was a calmer, more comfortable place, decorated with potted ferns and flowers, where the inmates were allowed to sit together and embroider or patch prison garments.

Each day during Crippen's trial, Ethel was taken to the Old Bailey and placed in a cell. This may have been done in a final attempt to encourage her to testify, which she continued to refuse to do. She was never permitted to see Crippen, nor was she informed of what was transpiring in the courtroom above her, but she was allowed to read the newspapers and pore over the details of the previous day's proceedings. On the day the verdict was announced, Ethel made the journey back to Holloway in the prison van, riding in complete ignorance of the jury's decision. It would not be for at least another day before she was told the disturbing news by the prison governor. She was also informed that her trial would begin on that Tuesday, the 25th.

Ethel never described her response to hearing the verdict, only that at the approach of her own trial she was "in a state of collapse."[4] She remembered little beyond swimming in a dream-like daze. On the morning her trial began, in the same court at the Old Bailey, she required two wardresses to assist her into the dock. To the reporter from the *Morning Leader* watching from the gallery, she seemed "in-

different and pitiably lifeless to everything that was going on." In her usual court attire, her blue skirt and jacket and dark blue motoring veil, she appeared "a weary, tragic little body sitting there so frail and timid."[5]

She claimed she had spent a week imagining her lover in that strange, glass-enclosed pen at the center of the courtroom. Now it was her turn, and the critical, piercing eyes of the spectators, press and jury scrutinized her face, her expressions, her movements. Ethel remarked at how the benches seemed to be filled with "richly dressed" women eager to see how she endured the ordeal. However, when compared with the furor and sense of occasion that Crippen's trial inspired, Ethel's moment in court drew far less interest. Although the curious still turned out, packing the street outside the court and vying for seats inside it, the trial of the murderer's mistress had acquired a sense of anticlimax after the main event. To a degree, this was to be a condensed rehashing of Crippen's trial, with none of the dramatic revelations, and featuring most of the same faces. Lord Chief Justice Alverstone would once more be presiding, while Richard Muir and his team would again be presenting the case for the Crown. They would be calling no new witnesses, but reconfirming the case as it was presented in Crippen's trial, which proved that Belle Elmore had been undeniably murdered by her husband. Walter Dew, Melinda May, Drs. Burroughs, Pepper and Willcox, William Long and Emily Jackson would all be reprising their testimonies, but this time without the participation of Clara Martinetti, who was struggling with influenza. The only difference would be that these witnesses would be cross-examined by Ethel's own barrister, the acclaimed Frederick Edwin Smith, King's Counsel.

The strikingly handsome F. E. Smith, known later as Lord Birkenhead, was noted for his quickfire mind and devastating wit. Although a lover of louche living and addicted to alcohol, he performed like an Olympian in the courtroom. Smith was a wunderkind, a man who had come from a relatively ordinary middle-class background to

scale the heights of social and political influence. He counted among his closest friends Winston Churchill, who was present that day in the courtroom. Smith's political ambitions would see him become Lord High Chancellor and Secretary of State for India. In October 1910, he was dividing his time between preparing Ethel's defense and performing his duties as Conservative MP for Liverpool Walton. Ideologically, he was adamantly opposed to women's rights. After the passing of the Sex Disqualification Removal Act in 1919, which allowed women to enter into law-making, Smith objected to every attempt to allow women to sit in the House of Lords. He was an opponent of Irish Independence, but strongly supported British colonial rule in India. In every way, Smith was a product of his time and class, and as such he would speak directly to the sympathies of the twelve jurymen.

Ethel did not meet her barrister on the day he had come to defend her. She was left to guess his identity from among the line of black-robed men sitting on counsels' row. She was given no guidance as to the order of events, or any understanding of what to expect. As the barristers and court clerks huddled together, shuffling papers and conferring, she was made to feel as if no one took any interest in her.[6] Suddenly, the charge was read out and Ethel, her gloved hands gripping the rail in front of her, was asked to respond. "Not guilty," she said in a barely audible voice.

The next thing she knew, a barrister, who she assumed to be Richard Muir, began his "merciless speech" against her. She shrank as she listened to the serious accusations, fearing "there was no hope of escape."[7] What Ethel, trembling in the dock, didn't know, however, was that she was poised at the center of a great charade. Her fate had been decided weeks, if not months earlier. Muir might have sounded thunderous and threatening, but his arsenal of evidence, which had been so well stocked for Crippen's trial, was now virtually empty for Ethel's.

From the day Inspector Dew knocked on the door at Hilldrop Crescent, it was Hawley Crippen he had had in his sights. A wife had gone missing, and the husband who had been lying to her

friends was the chief suspect. Dew had observed "the little typist" living as the man's mistress, blushing and stammering, pretending to be his housekeeper, and written her off. She was simply a lower-middle-class office girl, flitting about in the background, saying nothing, eyes always on the floor, young, silly, unexceptional, not even pretty (in his opinion). She also bore none of what the era's social scientists might identify as the hallmarks of criminality. These sorts of women were easily spotted from their physiognomy; they were ugly, small-eyed, strong-jawed and masculine-looking. Their manners were uncouth; they were untidy and lazy.[8] A quiet girl like Ethel was surely incapable of malfeasance. Dew stepped right over her, dismissing her obstructive behavior, uninterested in challenging her lies. Crippen—the man—was what he wanted. As a result of these prejudices and choices, Dew narrowed the case. He chose to follow leads if they helped to build an argument for a husband acting alone, not for a murderer and an accomplice.

Dew, Mitchell and another officer, Sergeant Cornish, had interviewed Ethel's sister Nina, her father, Mrs. Jackson, Ethel's dressmaker Caroline Elsmore, and both the elder and younger Lydia Rose. Each of the statements they provided exposed Ethel's manifold lies, stories that were as twisted and as incongruous as those from Crippen. Nina, who was not called for questioning until July 21, revealed that Ethel had sent her a postcard from Dieppe and that she knew about Belle's supposed death much earlier. She also stated that Ethel and Crippen had left the country in an attempt to find Belle, or the person responsible for the telegram announcing her death. Similarly, the police had no interest in pursuing accounts of Ethel's suspicious engagement prior to the murder. They never questioned Mrs. Benstead, who had been privy to Ethel's confidences, nor did they probe Mrs. Jackson on the statement she gave to the newspapers that she had confronted Ethel on her plans to marry a man whose wife was still alive. Finally, no attempt was made to interview Freida Heer, the stewardess aboard the *Montrose* who allegedly fought with Ethel and witnessed her destroy evidence. There seemed to be no appetite to build a case against Ethel,

and after a certain point it made no sense to do so. Scotland Yard and later the Crown never abandoned hope she would turn King's Evidence on her lover and confess all. Dew's early declarations of her innocence had always been an invitation for her to do this. Unfortunately, everyone had underestimated Ethel Le Neve.

Without a confession and with a lack of evidence against her, the murder charge was dropped. By early October, when it was decided that Crippen and Ethel should be tried separately, it was far too late to gather further statements and build a case against Ethel as an accessory to murder. "The great point was to secure a conviction of Crippen, and . . . the result of the proceedings against Le Neve was of very little importance," the DPP's office determined.[9] Ethel's case was to be processed through the justice system, but it would be waved through in the most cursory way.

Muir knew he had nothing of any substance to present to the jury. All he could do was pose questions, many of which would never be answered: how much did Ethel really know? Did she not think it suspicious that a woman would leave behind all her clothing, her diamond jewelry and expensive furs when going abroad? Why would Ethel have a breakdown on that specific night at Mrs. Jackson's? Did she not think that wearing boy's clothing, cutting her hair, pretending to be mute and traveling under an assumed identity was an extreme set of measures to take? Why was she not surprised at being arrested for murder? Why did she never protest her innocence? "Unless and until you get from her, or from somebody else, some explanation, the only interpretation you can put upon these acts is the interpretation that she knew of Crippen's crime and she assisted Crippen to escape," Muir concluded.[10]

Of the witnesses that the prosecution called into the box, it was only Emily Jackson who was capable of lending some heft to the Crown's case. Travers Humphreys examined her and asked her to describe Ethel's behavior in January and early February, particularly what she said and did on that night and morning when Ethel had a nervous collapse. Once he had finished, F. E. Smith set about unraveling her testimony.

He did not dispute that Ethel had taken ill and cried "Oh, it is Miss. Elmore" to Emily Jackson; nor did he question Ethel's sudden change in demeanor a week later when she proclaimed joyfully, *"Somebody* has gone to America." What he skillfully contested was the date when all of this occurred. He asked her repeatedly if she remembered the precise dates. She could not. He asked if the police investigation had influenced her memory of events. She denied it had. He began to confuse her, to muddy her recollection. He inquired if Ethel seemed uneasy and depressed for most of January. Yes, Mrs. Jackson concurred, she appeared haggard and troubled for quite some time. Bearing all this in mind, he pressed Emily once more if she was certain of her dates. "Would you be prepared to say on oath that it may have been as far back as the 25th of January?" Emily Jackson hesitated. To be so aggressively questioned on such an important matter by a man in authority must have been extremely daunting to the wife of a mineral-water salesman.

"I could not fix a date," she answered.

"It may have been as early as that?" the Lord Chief Justice interjected.

"It may."[11]

All Smith needed was to sow doubt. The jury would draw the conclusions themselves.

The defense called no witnesses. There was no need. The only argument Smith would provide came in the form of a dramatic and memorable closing speech. In it, he would draw upon the biases and preconceptions of the property-owning male jury to construct an image of perfect Edwardian feminine innocence. He summarized Ethel's life experience as a type of parable, an age-old tale of "virtue in peril." Here was "this girl, little more than a child," completely "defenseless" when she entered "the steep and dangerous road of life" to "earn her own living as a typist."[12] More fortunate girls at sixteen or seventeen were kept safe under their fathers' roofs or sent to finishing schools. Instead, this "gentle, retiring and sympathetic girl" who was undoubtedly "chaste during the first seven years of her struggle with the world" was made to live an existence "of drab

and dreary toil by day as a typist" and stay at night in "a gloomy lodging house."[13] When she came to board with Mrs. Jackson, her character bore "no wickedness, no dissolute habits, no levity or wantonness of conduct."[14]

Ethel was also unwell, but unwell in a pleasant and harmless manner. She was "nervous," "neuralgic, delicate, and a little hysterical."[15] The brand of hysteria to which Smith alluded was the passive sort, known as neurasthenia. Described as "a more prestigious and attractive form of female nervousness," it encompassed a range of symptoms which included neuralgia, depression, headaches, insomnia and menstrual problems.[16] It often affected single women "of a highly nervous stock." The afflicted tended to be thin and frail, they did not possess much of an appetite or were anorexic. They were known to be hypochondriacal, to take to their beds and suffer from a variety of neuroses.[17] Ethel's "hysteria" was not the sort of female malady that would land a woman in an asylum. Those who suffered from it were not wild, violent, highly sexed and socially inappropriate, but "cooperative, ladylike, and well-bred." The neurasthenic quietly exhibited "a proper amount of illness."[18] Nevertheless, as Ethel was "nervous and hysterical," Smith reminded the jury that she was not entirely in command of herself.[19] If she had known that there had been a murder, she could have never kept it a secret.

Ethel's great misfortune was that she crossed paths with "one of the most dangerous and remarkable men who have lived in this century."[20] Crippen took full advantage of this girl's innocence and acquired "enormous power over her." This type of unequal, manipulative relationship between a more senior man and a young woman would have struck a distinct chord with the jury. In 1894, George du Maurier had published his sensationally popular novel *Trilby*, which told the story of Trilby O'Ferrall, a poor laundress and artist's model in bohemian Paris who came under the hypnotic influence of Svengali, a nefarious and unprincipled older man. In the year of Ethel's trial, the same story appeared again, respun as Gaston Leroux's novel *The Phantom of the Opera*. Smith argued that Crippen was an "imperturbable, unscrupulous, dominating . . . insinuating, attrac-

tive and immoral" man, who commanded Ethel for seven years.[21] He corrupted her physically and morally, turning her into his mistress and controlling her to such an extent that she never thought to ask questions. She accepted everything he told her, so when he lied to her about fleeing the country, she docilely followed him, agreeing to every part of his scheme. Today, such a legal argument is known as a "Svengali defense." It posits that after coming under the spell of "a malevolently charming and persuasive figure," an individual of otherwise sound mind can be "manipulated and dominated to a point where that person is effectively no longer in control of his or her actions."[22] While undoubtedly Crippen did use his influence to induct Ethel into the world of white-collar criminality, she seemed content to remain in his employment, even when fully cognisant of the nature of his business. Similarly, although Crippen used his position of authority to court and even to groom Ethel while she worked under him, by the standards of the era such behavior would not be considered unusual or abusive for a man in his position. Only his choice as a married man to pursue an eligible young woman would have been considered irregular and immoral.

In running this defense, Smith sought to remove every shred of Ethel's agency. By extension, he extinguished any possibility of her culpability. He also created an avatar of Ethel Le Neve that bore little resemblance to the real Ethel, and would make her more palatable to the jury. For all her demureness and frail health, Ethel was a uniquely determined and independent woman. In every version of her ghostwritten memoirs, she pushed back angrily against the manner in which she had been depicted during her trial and by the newspapers. She boasted of challenging Inspector Dew when he came looking for Crippen. She claimed she enjoyed dressing as a boy, and strongly objected to the absurd suggestion that she had fallen under Crippen's spell. She declared that she fled abroad with him because she wanted to support him. She proclaimed that she had been a rambunctious tomboy as a child, that she and Nina were highly competitive about their achievements, and that she had been eager to acquire qualifications and earn her own living. Her parents'

accounts concurred with these descriptions. Ethel used to sneak off to dances at night, and punched boys who teased her. She was proud of her income, enjoyed her professional responsibilities, and the freedom of not living in her father's home. Ethel used her allure to flirt with men. She rebelled against her family, she lied to them, she indulged in a clandestine affair and had been pregnant out of wedlock. Ethel knew precisely what she wanted from life, and she was committed to having it. The "real" Ethel was the embodiment of the era's New Woman, someone who had worn trousers, flouted the established feminine norms and posed a threat to the patriarchal order. Smith understood that if the jury had seen the real Ethel, they would not have regarded her kindly.

Society was suspicious of the New Woman and her perceived degeneracy. Increasingly, the New Woman's identity had become fused with that of the suffragette: shameless, strident, masculine women, who aggressively demanded the vote. Both of these types, with their education, their assertive ways and their confidence in the public realm, presented a demonstrable threat to the "natural order." Three weeks after Ethel's trial, on November 18, the contempt and hostility society had been harboring for "this sort of woman," erupted violently. As 300 women marched to the Houses of Parliament to insist on their voting rights, they were set upon by the police and groups of male bystanders. For the next six hours, they were brutally assaulted: kicked, punched, beaten and thrown. Limbs were dislocated, noses broken, eyes blackened. Women were dragged down side streets, hurled in front of horses, pushed down steps. A large number were sexually assaulted, their breasts were grabbed, twisted and pinched. The police stuck their hands up their skirts and shoved their knees between their legs, often while making sexually suggestive comments. Black Friday, as it came to be known, was a lesson intended to humiliate and punish women who did not conform to social expectations, who exhibited courage, boldness, and a desire to determine their own lives.

It was better that the jury saw weak, hysterical, childlike Ethel than the alternative. F. E. Smith very purposefully steered the twelve

men toward the conclusions he wished them to make. There would be no room to consider anything but the possibilities he put before them. "How could Le Neve have known about the murder?" he asked. There could be "two ways only. The first would be that she found out, and the second that Crippen had told her," he concluded. "No one would suggest that she found out . . ." Smith stated, because if she had, Ethel would have reacted with "aversion, revulsion and disgust."[23] By the same token, Crippen would not have been so foolish as to have told her, thereby making himself "a hostage to fortune." Sweet, quivering Ethel could not have known of the hideous deed. It was nonsensical, impossible, Smith affirmed. But in Canada, Inspector Dew *had* informed Ethel that Belle had been murdered and that remains had been found in the cellar. She never once exhibited the vaguest hint of horror or surprise, and, if anything, grew more devoted to her lover. Smith then posed to the jury another important point: why would Ethel have gone to live at Hilldrop Crescent to share Crippen's house, "knowing that its last tenant had been murdered by the man she was going to live with?"[24] The answers to which he guided the jury were not the most logical ones. He could not risk them contemplating that there might be a third way in which Ethel could have known about Belle's murder, one which would have made it easy for her to live at Hilldrop Crescent afterward—she had been a party to it from the beginning.

After Alverstone's summing-up, the jury were sent out. They spent twenty minutes in deliberation and returned with a verdict of "not guilty."

Ethel, who had been weeping into her handkerchief, was approached by her solicitor, Arthur Newton. He patted her hand reassuringly.

"It is all right," he said.

A wistful smile appeared on her pale face.

It was over.[25]

31

Darling Wifie

NINA HAD BEEN WAITING for her sister near the cells below the court. Ethel, with the help of the wardresses, pushed through the crush to the stairs. People were congratulating her, shaking her hand, but Ethel was still in a state of shock—both relieved and dazed. They had been warned that getting away without causing a sensation would be difficult. Ethel had already spotted the photographers with their "flash lights" poised in the corridor. Nina had been advised to organize a decoy pony and trap which had been parked outside the court's main entrance. Word had been spread that Miss. Le Neve was to depart in it. She had brought Ethel a change of clothing. Her signature blue jacket and skirt were exchanged for something less recognizable. Then a police officer led them through a series of corridors to a side exit and they were free. A moment later, they leaped into a waiting taxi. They were off, just as the seething crowd had caught sight of them.

Her sister had arranged to take Ethel directly to Southend-on-Sea, to recover her nerves, and to remove her from the public eye. They escaped on a train from Fenchurch Street Station without a single person noticing. Nina booked them into a hotel under a false name and, after laying down her belongings, they proceeded to the dining room where Ethel rejoiced in "the finest meal" she had partaken since her arrest on the *Montrose*: a plate of bacon and eggs and a cup of tea all consumed as a free woman. Then she retired to her room to write to Crippen.[1]

Nina had suggested that her sister forget him entirely and start

her life afresh. She took her for a walk along the windy seafront and suggested they go for a ride in the country, but Ethel remained despondent. She could think of nothing beyond writing to her lover and scouring the newspapers for coverage of her trial. By the 27th, Ethel decided she could no longer bear to be away from Crippen and asked to return to London.

As Ethel was now without a home, Nina assisted her in searching for lodgings along the roads adjacent to Pentonville Prison. No sooner had Ethel been settled with a landlady than she went directly to the gates of the prison to apply for a pass to see her lover. On the 29th, a fifteen-minute visit was arranged. For whatever reason, Pentonville's governor, Major Owen Mytton-Davies, permitted the couple to meet in a special waiting room. Crippen was shackled but was allowed to wear his overcoat over his prison uniform. The pair were instructed not to touch or kiss. Ethel was told to keep her hands above the table and a warder stood by, monitoring their interactions.

Ethel trembled throughout, and Crippen would later write that he "struggled to be composed" and "nearly broke down." He had longed to touch her hand and to hold her.[2] Their discussion was mostly about her, and Ethel would later say that "he did most of the talking."[3] He explained that his thoughts were for her well-being. She was certain to encounter prejudice and prying if she kept her surname, and he urged her to call herself by one of his names: Mrs. Hawley or Harvey, and for her to "wear my [or our] wedding ring as before." Crippen knew that Ethel's acquittal would not sit easily with many of his wife's friends, and he inquired whether she had been "annoyed" by any of their "former acquaintances."[4] Ethel assured him that, so far, she had managed to elude everyone. They also both remained quietly hopeful that there might be a chance of a future life together. Newton had been busy organizing his appeal, which would be heard on November 5. In the coming weeks, Ethel would do everything in her power to assist Crippen's cause. The real Ethel, bold and dauntless, she who had been hidden from public view, would come forward with a roar.

Following her acquittal, Ethel had a major asset to sell: her story. The newspapers were hungry to publish the confessions of the innocent girl who had loved a murderer and whose account of events had yet to be heard. She could name her price, which would be useful in paying off the legal bills Nina and her husband Horace had accrued after her arrest.[5] The *Daily Chronicle* and its sister publication, *Lloyd's Weekly Newspaper*, eventually won the contest, but not before agreeing to pay the Brocks' debts and installing Ethel in a furnished flat in Chelsea. For the next several days Ethel was interviewed by two journalists, Philip Gibbs and J. P. Eddy, who followed her about like a pair of smitten suitors. They came to her home and listened to her entertaining stories. She met them in a Soho restaurant where they would buy her meals. In return, Ethel drip-fed them her secrets, or at least those tales she wished to represent her, whether true or imagined. Gibbs thought her "quite a pretty and attractive little creature," while Eddy was taken by her "slight figure," "finely chiseled nose and expressive eyes."[6] Ethel greatly enjoyed the attention and would later claim that it gave her satisfaction to know she had "presented the facts as she wanted them to be presented."[7] On more than one occasion, she allowed Eddy to follow her on her visits to Crippen. The journalist knew he was not allowed to accompany her inside. The story was only ever going to be about the sad, pining mistress. He "remained outside the great green, studded door of the prison" so that when she returned, he could study her "very subdued" mood and document her deep anxiety for her lover, who she hoped would "escape the gallows."[8]

Far from being shy and timorous, Ethel Le Neve possessed an enormous store of confidence, especially when it came to managing men in positions of authority. She had no problem challenging Chief Inspector Walter Dew, even lying to him, and she seemed equally fearless in her dealings with journalists, doctors and later the governor of Pentonville. According to her 1920–21 memoirs, she began visiting medical experts in the hope that she, personally, could find someone willing to contest the prosecution's evidence. "I argued that I might blunder upon some loophole of escape if I refused to be

discouraged." Unfortunately, she found herself going "from doctor to doctor . . . All of them sympathized with me but all of them shook their heads and told me that I was trying to achieve the impossible."[9] With Crippen's encouragement, she also wrote to medical men in Philadelphia asking if they might provide information about the nature of Belle's surgery. It is possible that two of the men she contacted were James Munyon and his son Duke, who went on record to defend Crippen and offer a $12,000 reward for anyone who could prove that Belle Elmore was still alive.

Crippen, the inveterate grifter, had only fellow grifters as champions. Most of them, including Arthur Newton, were not genuine defenders, but people who stood to make money from his troubles. While he awaited his trial and later his appeal, one of Crippen's most ardent correspondents was a woman who called herself Lady Mercia Somerset. Initially, she had been mistakenly identified by a prison official as Lady Henry Somerset, a woman known for her charity work among dispossessed girls and female alcoholics. "Lady Mercia" was in fact a notorious con artist named Ada Alice Fricker, aka Lady Gypsy Rogers, Avis Fitzroy and Roma Cholmondeley. Fricker inveigled her way into Crippen's confidence by promising to provide him and Ethel sanctuary at her Huntingdonshire home, Broom Lodge, once they had been acquitted. Her actual design was to winkle out a confession from Crippen. She also set to work on Ethel, whom she managed to visit at Holloway Prison. If this scheme failed, her contingency plan was to sell Crippen's letters. It does not seem entirely coincidental that Fricker had been a client of Arthur Newton, and until that time Newton had been unsuccessful in acquiring the confession he had promised his friend Horatio Bottomley at *John Bull*. For whatever reason, Crippen appears, at least superficially, to have fallen for her ruse and faithfully replied to her letters. Ethel, on the other hand, was never taken in. "There was something . . . that I did not like about the woman," she announced. Her expression, her ordinary manner of dress, the questions she asked and the transparently false story about her friendship with Crippen made Ethel instinctively suspicious.[10] Although Crippen

continued to advocate on behalf of Lady Mercia's friendship, Ethel refused to have anything to do with her. One of the first letters she wrote after her acquittal was to Major Mytton-Davies at Pentonville, warning him "of a person who is trying to sell . . . [Crippen's] letters to the papers." She asserted "this, Sir, should not be allowed to continue as she is not a desirable person." She took an officious tone with the governor, questioning him for allowing Nina to visit Crippen more frequently than she, herself, was permitted, especially when she had "so many things . . . to arrange for him."[11] Ethel possessed a clear understanding that above anyone else, it was she who best represented her lover's interests.

As November 5 approached, those interests had become exigencies. Ethel believed she had done what she could to assist his appeal, but the execution of it would rest with Alfred Tobin, who would face Judges Darling, Channell and Pickford at the Royal Courts of Justice. While Crippen had hoped to have the medical evidence disputed, none of the justices was remotely prepared to entertain that the remains were not those of Belle Elmore. They felt this had been sufficiently proven to the jury by science. Tobin then suggested that the late submission by the prosecution of the pajama evidence had not allowed them to prepare an adequate defense. This too was shot down. Tobin was left with one last feeble card to play. In the course of Crippen's trial, a juror had fainted and had to be removed for a short spell while the medical evidence was being presented. Three doctors had been on hand to attend him and proceedings had been temporarily adjourned until he recovered. Tobin argued that this disruption was grounds for a retrial; however, as the juror had not discussed any aspect of the trial while he was separated from the jury, this point was also dismissed.

Crippen had sat in court watching as the three justices, Tobin and Muir slowly pulled the shade on his fading hope. The *Daily Mail* wrote that "it was a very pitiable sight" and that "his nervousness was painful to see . . ."[12] In the end, he was simply led away, back to the prison van and the cells of Pentonville.

Ethel had not been present to hear the verdict. Her "friends"—probably Newton, as well as Nina and Horace—had advised her that she was likely to be spotted by the press, which would "create a sensation." Such a distraction would not have been welcome. Instead, Ethel claimed that she rose very early that morning and stood on the corner of Carey Street so she "might catch a glimpse of him as he was being taken into court."[13] Sadly, she had been unable to. Later that day, as she was walking along the King's Road, she spied a newspaper stand displaying the headline that Crippen's appeal had been dismissed. But for the kindness of a bystander, who found her leaning against a wall, she would have collapsed with grief upon the street.

That was one version of events. As is frequently the case with Ethel's life story, there are many. The actor-manager Seymour Hicks happened to be visiting a detective friend at Bow Street on the day the appeal result was announced. His friend told him that Ethel had just been there attempting to borrow the suit she had worn on the *Montrose*. The *Daily Mirror* had offered her a nice sum for a set of photographs if she were to pose in male clothing and display her shocking cropped hair. Apparently, she had heard the news "that Crippen was to hang" as she was speaking with the detective. "The only comment she made was 'Oh!' "[14]

According to Ethel, she would spend that evening at home, attempting to recover. Crippen had written to her:

> *The Appeal has decided against us. Hope has completely gone, and your hub's heart is broken. No more can he hold his wifie in his arms, and the life he planned to devote to making your life comfortable is rapidly drawing to its end . . . I have not been able to keep the tears back tonight, the bitter news of the disappointment has been so terrible, and my longings for my wifie have been so intense. But I shall soon be brave again and keep up to the end.*[15]

In an attempt to forestall the inevitable, it was decided that a petition to the King should be drafted, requesting that Crippen's sentence

be commuted to one of life imprisonment. According to Ethel's memoirs, she spent that Sunday afternoon, November 6, with a lawyer and his wife at his home, discussing the matter. This was likely to have been Arthur Newton, who was organizing it. Ethel suggested that she see the Home Secretary in person and "endeavor to intercede with him on behalf of the doctor," but Newton persuaded her otherwise. She was told that she "would never get any further than a private secretary."[16] The petition would be the best and only possible remedy. As it happened, Newton's campaign would become quite popular. He distributed several hundred copies of the petition throughout the country. Winston Churchill would eventually be presented with over 15,000 signatures, though it has been argued that this probably reflected the growing opposition to the death penalty, rather than support for Crippen.[17]

With the date of Crippen's execution announced for November 23, and the days rapidly dwindling, Ethel turned to the American Embassy as a last possible avenue. She claimed to have met with an official and pleaded that Crippen, as an American citizen, did not believe the medical evidence in his trial had been presented correctly. This suggestion had undoubtedly been her lover's. While sitting behind bars, he had become obsessively fixated on the scientific evidence and how it might be disproven. The American gentleman, though very sympathetic, "did not think there was the slightest loophole of escape." He believed that Crippen had been given a fair trial, and informed Ethel there was nothing more he could do.[18]

In a final act of desperation, two days before her lover's scheduled execution, Ethel turned to Major Mytton-Davies. According to Tom Cullen, author of *Crippen: The Mild Murderer*, which takes many liberties in recounting the affair, Ethel paid a visit to the prison governor's home. Cynric, Mytton-Davies's son, revealed to Cullen that when Ethel appeared unannounced at the door, his father was not there. His mother, who did not know the protocol in such cases, showed Miss. Le Neve inside, at which point Ethel begged Mrs. Mytton-Davies "to use her influence" with her husband "to obtain

Crippen's reprieve." The idea was that the governor would then "use his persuasive powers with the Home Secretary to this end." In the middle of this, Major Mytton-Davies returned home and "furious at finding Le Neve . . . ordered her out of the house." The family were aghast at Ethel's "gall."[19]

It is difficult to determine where among these anecdotes and ghostwritten memoirs Ethel's true experiences lie. Each account seems to contain at least a germ of truth, but the poetic license surrounding it makes it challenging to discern where the reality ends and the tall tale begins. In the first half of the twentieth century, as the bookshop shelves filled with autobiographies of performers, policemen and journalists, there was an imperative to prove that one's life had been interesting; that the author had rubbed shoulders with a range of notable and notorious characters. Ethel and the Crippens commonly feature in such annals. Some of the alleged interactions are nothing more than often-repeated legends lifted from earlier publications, while others are more likely to be offering genuine insights. Although it may be difficult to confirm Ethel's movements and thoughts during her lover's imprisonment, two sets of Crippen's letters—one written to "Lady Mercia Somerset" and the other addressed to Ethel, allow for a clearer view of events.

As the couple's prospects grew bleaker, Crippen's concerns turned to Ethel. His letters overflow with the effusive, fervent ardor of a man who feels abandoned by everyone but the woman who maintained their secret—the only soul in the world he could still trust. His words to her are desperate, grateful and needy. After her acquittal he wrote:

> *You can imagine what my feelings are to have before me your dear handwriting again. I have longed so passionately for a letter to sustain me through the long and weary separation, and, although I have been able to subdue my nerves and preserve my outward control, my heart has been bursting and throbbing with the pain of longing for you and even for a few written words from my ever-loving darling. I knew my*

darling's heart and love for me would never waver in the slightest, and hope sustained me, and that our union has not only been for life but for all eternity.[20]

Then again in the week before his appeal:

Probably you did not have time to write to me last night, as I have had no letter yet . . . In the meantime, wifie, I must now content myself with those you have sent me up to now—four of them, and all treasured more than diamonds. I read them over and over again, and get great comfort from your loving words and the thought that, though we are separated, your love is all mine for always, as my love is yours to eternity . . .[21]

Although deeply passionate, these love letters were never composed for Ethel's solitary consumption. They are performatively intimate, written with an eye to publication. Ethel gave them to Gibbs and Eddy to read. They totalled 40,000 words in length, the size of a short novel, all ". . . written on prison paper in neat little writing, without a blot or a fault," Gibbs recalled. They were a quietly dispatched piece of propaganda from a man who understood the art of advertising, which is not to suggest that his feelings were not genuine and powerful, but that he knew the letters would work to soften his monstrous reputation. No soul capable of such poetry could tear his wife's body to shreds. His ardent yearnings, his sensitivity and selflessness would transform his and Ethel's sordid story into a romantic tale of doomed love, where the villains were eventually recast as the victims. The plan worked. After spending time with Ethel and reading the correspondence, Gibbs thought their relationship "extraordinary." He marveled at the ". . . deep, sincere, and passionate love between the little weak-eyed, middle-aged quack doctor, and this common, pretty little Cockney girl" and that "These two people from the squalor of a London suburb might have been medieval lovers in Italy of Boccaccio's time, when murder for love's sake was lightly done."[22]

Crippen's letters are not all flowery prose and pledges of undying devotion. At times they gallop along in a sort of frantic stream of consciousness. At one moment he is planning how to recover his losses from the Charing Cross Bank, at the next he is recounting what was on his prison dinner plate (roast mutton, vegetables, soup and fruit . . .); then he is once more lyricizing on his love for Ethel, before discussing how he plans to write his life story and sell it. He fretted constantly over Ethel's financial situation. He must have spent hours staring at the walls, scheming. He decided that whatever money he would be given for his manuscript would go to her.[23] He also imagined a possible future for her where she would take over his homeopathic remedy business. He scribbled down the prescription for Sans Peine and reminded her that she could try to sell this, along with Ohrsorb, to Munyon who "would take it up for America, and perhaps pay you to manage it . . ."[24] However, what most consumed his thoughts was his will and ensuring that Ethel received all his "personal property" after his death. This would include not only his "watch, chain, plain-band ring, clothes, etc." but "all of the baskets of things taken from the house" (by the police). He was adamant that she should have Belle's belongings too—the furs and the diamonds, which he wanted her to wear for as long as she could afford to keep them.[25] Under English probate law in 1910, it was entirely permissible for a man to bequeath his dead wife's personal property to another party, but it seems that Crippen's unique circumstances were raising a few eyebrows.

Hawley Harvey Crippen had murdered his wife so that his mistress could replace her; the same mistress who had adorned herself in Belle's diamonds, had her dresses remade to fit her, and flounced about town in her furs. It seemed wrong to Teresa Hunn and to Belle's friends that, in the end, Ethel, who had inspired the ghastly deed, should profit by it. Much to Crippen and Ethel's outrage, the Music Hall Ladies' Guild engaged their solicitor, Harold Seyd, to investigate the grounds for contesting Ethel's right to benefit from the murder of her love rival. "I told my solicitor to notify Scotland Yard that all property outside your own was to be sent to his office,

and that no one has claim on it but myself. This is to keep off those 'harpies' you mention," Crippen wrote angrily. "Legally, no matter what happens, *all* comes to me, and then I have instructed my solicitor you *must* be allowed to select what you want, and the balance to be sold for you."[26] But this was not exactly how it came to pass.

In February 1911, the case would be heard in the probate court, where it was decided that "a convicted felon had no right to receive any benefit from his own felonious act" and "neither can his representative, claiming under him, obtain or enforce such rights." The judge added that "The human mind revolts at the very idea that any other doctrine could be possible in our system of jurisprudence."[27] Belle's property, valued at £175, and the money that remained in bank accounts at the Charing Cross and Birkbeck banks were assigned to her sister Teresa. It proved to be a landmark case, which fundamentally changed inheritance law in England.

Ethel, somewhat chagrined, would at first claim that she "at no time intended to touch the articles belonging to the late Mrs. Crippen," and later that her "only desire was to see that Dr. Crippen's wishes were carried out in every detail."[28]

Hawley Crippen's inevitable end inched closer.

The vultures circled around him in the week of November 23. In death, he would be eaten by his own kind. Newton, on whose bent guidance Crippen came to lean, would eventually sell him out. On the 21st, Horatio Bottomley, who had paid more than £200 upfront in Crippen's legal fees, had yet to receive the exclusive confession from the prisoner that he had been promised in exchange. Bottomley had gone so far as to publish an open letter to Crippen in his newspaper *John Bull*, inviting him to explain how the murder had been conducted. The publication, which had been sent to the prisoner, was duly withheld by Mytton-Davies, who was disgusted at the plan. Two days before the execution was scheduled, Newton felt he had no choice but to attempt to extract a confession during his

final visit. This, Crippen not only refused to give, but the solicitor found himself being cautioned by the prison guards for attempting something so audacious. When he appeared at Bottomley's office empty-handed, the editor decided to take decisive action; he and Newton would compose a statement themselves. While not an outright confession, it was a letter which promised one in the following week's edition of *John Bull*.

Newton was about to lose his golden goose, and, wishing to squeeze every penny out of the opportunity before it was too late, he quietly approached another newspaper, the *Evening Times*, and offered them an exclusive confession too. They agreed to pay him £500 for it. Crippen's fabricated final words were dictated by one of Newton's employees to two journalists at 2 a.m. on the 23rd. In this confession, "Crippen" unburdened his troubled mind fully, and admitted to killing Belle by putting the hyoscine in her indigestion medicine. He then dismembered her with a surgeon's knife which he later hid in the garden of another house on Hilldrop Crescent.

The *Evening Times* went to press with this sensational scoop, only to discover that another newspaper had interviewed officials at the Home Office and at Pentonville and confirmed that Crippen had made no confession at all. Bottomley was in a rage. The *Evening Times* was mortified, and Newton denied any knowledge. Eventually it would catch up with him, and the following year, the solicitor would be penalized with a six-month practice ban for unethical behavior.

Crippen would strenuously protest his innocence to his dying day.[29] In place of a confession, he would repeat yet again the story of his tragic circumstances, which Ethel sold with his approval to the editor of *Lloyd's Weekly Newspaper*. His "Farewell Message" appeared in print on the 20th, alongside a photograph of Ethel posed in boys'clothing, wearing a fedora hat. Much of the writing in the columns he produced is dedicated to melodramatic proclamations of his love for Ethel Le Neve. His parting gift to her was to assert her innocence and pure-hearted goodness to the world. She loved him "as few women love men" and the only crime she might be consid-

ered guilty of is "yielding to the dictates of the heart absolute." He celebrates her for remaining faithful to him: "However vile I am, whatever faults I may have committed . . . never once has she turned against me for all that unwittingly I have made her bear. Is that not a wonderful woman's love?" After all, "She put her trust in me, and what I have asked her to do, she did, never doubting." He continues:

> I make this defense and this acknowledgment—that the love of Ethel Le Neve has been the best thing in my life—my only happiness—in return for that great gift I have been inspired with a greater kindness toward my fellow beings, and with a greater desire to do good.[30]

And with that, the swindling, duping, lying Crippen, a confidence trickster to the very end of his life, makes the now damp-eyed reader forget in an instant that he is a murderer, condemned to death for ruthlessly killing his spouse.

At nine o'clock on the morning of November 23, the noose was placed around Hawley Harvey Crippen's neck. The lever was pulled. The slack rope suddenly snapped tight.

They buried his body in the grounds of Pentonville Prison, along with those of other men who had met the same death, sanctioned by the Crown.

By the afternoon it was in the newspapers, shouted across the rumbling roar of London's roads, written on posters propped up against the smutty brickwork. Men lit their pipes and folded back their broadsheets to read about it. Women exchanged their thoughts across their laundry basins or their iced buns at Lyons. Some thought it terrible; others believed that the correct punishment had been meted out.

Richard Muir had heard the news that afternoon too. Of course, none of it came as a surprise, but according to his biographer, it did make him pause. "Full justice has not yet been done," he commented. "Exactly what he meant by that cryptic remark need not be explained."[31]

32

"Mad for me"

O N T H E E V E O F the execution, Ethel took to her bed. She had been too distressed and ill to do anything else. She watched as the blue light of dawn emerged, and the hours ticked steadily forward to the fated time.[1]

Nina had been staying with her and had gone out to buy the papers. Ethel claimed she was still under her covers when her sister brought her the news that Crippen had confessed. This struck alarm in her. She rose, put on her mourning clothes, and went immediately to see Major Mytton-Davies at Pentonville. The story, as his son recalled it, was that Ethel appeared at their family home pale-faced and "very frightened" by this revelation. She asked if it was true that Crippen had confessed all.

The prison governor was said to have drawn "himself up to his full height and icily replied": "You, if anyone, should know."[2]

Ethel omits the details of this exchange but claimed that Mytton-Davies had always treated her and his prisoner with kindness. On that sad visit, he had entrusted into her care Crippen's personal effects, which included his watch, watch chain, a "fox head pin" and his wedding band. He told her how Crippen had spent his final hours—that "the poor little victim" wept when he read her farewell telegram, that he could eat no breakfast, and that he had sat pensively while the Catholic priest had administered the last rites.[3]

As she left Pentonville for the final time, she hurried past a crowd of people who had gathered to read the announcement of Hawley

Harvey Crippen's execution, which had been posted outside the prison gates.

She had determined that this would mark the end of the affair, and although still ill "and haunted by the shadow of all that had taken place" on that day, she "went out into the Metropolis to begin a new life."[4]

It would not prove easy.

With *Lloyd's Weekly Newspaper* no longer paying the rent on her Chelsea flat, Ethel moved back to North London to be nearer to Nina. She took a small room in a three-bedroom flat above a shop belonging to a family on Hornsey Road.[5] It was a considerable demotion from Hilldrop Crescent, and far less comfortable than even Mrs. Jackson's residence. As Crippen had left her virtually nothing, and with her source of employment now gone, Ethel also needed to find a job. According to her memoirs, she was fortunate enough to be taken on without references by a business not far from Albion House. Her prospective employer merely asked her a few questions, tested her typing speed, and hired her to join a large, bright room filled with ladies tapping away on their machines. She did not use the name Ethel Le Neve. Since her acquittal, she had become Miss. Ethel Hawley, which she later changed to Harvey.

Like many of Ethel's stories, there are two variants of her experiences in the typing pool. In one, she becomes reacquainted with a young woman she knew when she lived in Hampstead, who promised to keep her identity a secret. In another, she maintained her anonymity, but occasionally her colleagues, over their typewriters, would mention the Crippen case in passing. Ethel had to bite her lip, keep her head down and laugh along with their jokes.

There must have been a hollowness inside her. Nothing she had seen or felt could ever be acknowledged, and yet what she had experienced had been cataclysmic: traumatic, transformative, and perhaps profoundly thrilling too. She had to tamp it down, deaden all of it. If she were to survive, Ethel Le Neve had to be smothered.

"At the luncheon hour, I used to make my way out into Oxford Street and have a cup of coffee and a roll and a bun in a restaurant I

frequently visited when I was working with Dr. Crippen," she re-called. "Over and over again, people that I knew and people who had known me in the old days used to come and sit quite close to me. Some of them even looked me straight in the face, and one or two now and again looked puzzled."[6] Never once did anyone say a word to her. Ethel assumed that her ordeal had rendered her un-recognizable from the woman she had once been.

Nevertheless, Ethel remained fearful that she would be discov-ered and unmasked, and along with this would come some form of persecution. In the wake of Crippen's execution, she had begun to consider leaving England altogether. Her thoughts turned to Can-ada, "the one bright oasis of my dreams."[7] She had come so tantaliz-ingly close to starting a new life in that country that it haunted her. The few Canadians she had encountered, with their "open hearts" and "kindly ways," had also left a warm impression. Somehow, she had convinced herself that Quebec would offer her shelter, and that upon arriving there she could "throw off the shackles of the past."[8]

She was still in England in mid-February 1911 while Crippen's will was being disputed in court. It is likely she expected the ruling to go in her favor and would have put her inheritance toward her travels, but on the 18th of that month she found herself left with nothing. The diamonds and furs, along with ambitions she had fastened to them, were gone for ever. The passage to Quebec would have to be purchased with her savings, and perhaps a sum from *Lloyd's Weekly Newspaper*, who on the 26th of that month published her farewell letter to England. Quietly dressed, Ethel "stole unobserved away from the scene of the wonderful life drama in which she had filled a leading role."[9] It had been a performance grander than any Belle Elmore might have even imagined for herself.

Ethel's journey to Canada appears to have been about more than simply a fresh start. For some reason, she felt compelled to retrace her movements across the Atlantic with Crippen. In 1921 she claimed that the period up until her arrest had been "one of the happiest . . . of [her] life." Oddly, those to whom she attached some of her fondest emotions were the wardresses of the Plains of Abraham Prison and

Chief Officer McCarthy and his family. Her first business after disembarking and finding a hotel in Quebec City was to go directly to the McCarthys' home. Ethel admits that when she mentioned her intentions to her sister, even Nina thought it peculiar. The McCarthys, who discovered her standing unannounced at their door, must have found it stranger still. One can imagine the stunned, awkward smiles of Mrs. McCarthy and her husband couched in the description Ethel gives of their greeting. She claimed they were "overjoyed" at her visit, as "They had never dreamed that they would see me again in Canada . . ." They reiterated that they were "surprised but full of admiration at my coming out . . . to the very place where I had been arrested . . ." The following day, she went out to the Plains of Abraham and repeated the experience. Ethel knocked at the gates and asked for the matron, who was "amazed" to see her. "She told me, with a smile, that I was the first prisoner who had ever made the long journey of her own accord to pay a visit to the place where she had been incarcerated . . ." The wardresses, too, "could scarcely believe their eyes." According to Ethel, they then lavished her with gifts and affection. "You never saw such a fuss made of me!"[10]

After the excitement, Ethel spent several days exploring Quebec City and then visiting Montreal. Although Quebec City with the rambling Château Frontenac perched above its narrow streets was picturesque, Montreal was Canada's metropolis: a vibrant, growing North American city filled with billboards, businessmen, broad streets and towering buildings. She chose to settle there and found lodgings with a Scottish woman in the suburbs, amid an ever-expanding population of British immigrants. There seemed to be an abundance of work to be had, especially in real estate, as Canadians and settlers from across Europe scrambled to carve out a piece of the country for themselves. On a freezing day in the early spring, as she passed along a row of office fronts, she noticed a card in one of the windows: "Stenographer wanted." She was quickly given the job managing the administration of the business.

It is here where Ethel's narrative of her life once more splits into two versions. The story she provided *Thomson's Weekly News* in

1920–21 charts her movements in the wake of Crippen's demise, but the account she gave to that same publication in 1928 explores a much darker side of her experiences. In both tales, she mentions how her ordeal had changed her into a more reticent, withdrawn person. When she arrived in Canada, she had no intention of ever marrying. The idea of revealing herself to a prospective husband, or to anyone, filled her with dread, but after a short while in a completely new city, Ethel grew lonely.

With 400,000 people from Britain alone emigrating to Canada between 1911 and 1913, Canadian churches felt compelled to create clubs and programs of activities to accommodate the social needs of large numbers of isolated, homesick young men and women.[11] Ethel, finding herself among them, was drawn to a local nonconformist church. The Methodist churches in particular were known for their wide range of events, and although Ethel had been raised as an Anglican, she felt there was "more fellowship and progress" to be had in Canada among this community.[12] Soon she was attending formal tea parties and amateur dramatics, and learning to forget the worries she harbored about forming friendships. Ethel explained that all of this continued quite happily until the church's preacher, an eloquent young man with curly hair, began courting her.

They had been introduced by an older couple in the congregation, who knew that both Ethel and the clergyman were unmarried. Their acquaintance was made over regular Sunday dinners at the couple's home and soon the pleasant chats across the table had become walks in the outlying countryside. The months seemed to pass pleasantly, and summer became autumn. On one early evening, with the moon rising behind them, Ethel's beau stopped and sat down on the stile of a gate. He began talking to her about "companionship" and "the influence of a good woman." She knew where this was headed and suddenly became anxious. "Here was a chance such as I had been waiting for and dreaming about . . ." she said, but in order to have it, she would need to open her heart to him, "and what the end of it might be, I could not fathom." Ethel went home, sobbed, and spent time reflecting on her course of action. She was

bitterly torn. Ultimately, she decided that "the only thing was to pack my trunk and to leave Quebec before things went any further."[13]

She made her escape to Toronto, and into anonymity once more.

Toronto she found was much like Montreal: another city crowded with immigrants and strangers. Its neighborhoods of recently built clapboard houses pushed further and further outward from its dense center of electric signs, trams, cars and imposing stone office blocks. As before, she had no trouble gaining employment and "secured a place in one of the largest banks," but what at first appeared to be a solid new start, rapidly began to give way. The job was well paid, Ethel admitted, and she had earned the commendation of the bank's manager, but she was feeling less certain of herself than ever. She could not identify the sensation as it gradually overcame her but described herself as losing all grip. She was certain that there were customers coming into the bank who knew who she was. The fear that she was going to be discovered gnawed at her. "This feeling played havoc, not only with my nerves but with my brain," she claimed. She believed that it was only a matter of time before someone from England would walk through the door, point at her, and exclaim, "Why, that's Ethel Le Neve. What is she doing in a position of trust—a place where money is handled?"[14]

The paranoia intensified and then consumed her:

One day in the middle of the city—I don't know why—I suddenly had the feeling that someone was following me, and then my head began to swim. Before I knew what was happening, I had fainted and when I came to myself, I was surrounded by a small and sympathetic crowd. They asked me where I wanted to go and for the life of me, I could not tell them. I did not know myself. I did not even know who I was. I was suffering from a complete loss of memory.[15]

Ethel described how one woman took her to have a cup of tea, and after a while she recalled her real identity and then "the name I

went by at the bank and where I lived." The kind stranger took her home, but Ethel was gravely shaken. She began to panic that she would have another episode and that "it might be a long time before my memory returned." Worse still, it was possible that next time "I would be taken to the police station where they would soon find out who I was." She feared that she would blurt out her name, Ethel Le Neve.[16]

If Ethel's story is true, it is a curious one. Could she have been suffering from what today is known as dissociative amnesia, a disorder which often follows extremely stressful or traumatic experiences? It includes what is described as periods of abnormal memory loss which may last for a few minutes or for an entire lifetime. During such episodes, the afflicted are unable to recall key autobiographical details about themselves and frequently report a sense of detachment from their identities and their emotions.[17] It seems significant that Ethel's sense of paranoia was triggered by her employment in a bank, reminding her perhaps of the eight acts of forgery she had committed while posing as Belle Elmore and stealing money from her Post Office account. It would not be until the end of that year that the Treasury Department was made aware of her crimes. As Ethel had already been acquitted of charges on the basis that "what she had done was under the domination of a will stronger than her own," the DPP decided that they would not rearrest her.[18] None of this was ever made known to her, and for the rest of her life, Ethel must have silently feared that one day there would come a knock at the door, for this or perhaps for other criminal acts.[19] Shortly before she left for Canada, the press had come uncomfortably close to blowing the whistle. While Crippen's will was in probate, an attempt had been made to trace all of Belle's assets. It seems that during this process, Belle's Post Office bank book was located among her husband's papers. Someone must have mentioned the anomalous dates of the withdrawals to Horatio Bottomley at *John Bull*. On December 3, 1910 an open letter to Ethel Le Neve was published in which it was asked ". . . did you ever hear anything about a sum of £200 which was deposited in a certain savings bank,

and was drawn out, on somebody's signature, within a few days of Belle Elmore's disappearance?"[20] Reading those words in print must have struck terror in her.

Nine months into her new life in Canada, Ethel decided she could no longer cope. She resigned her job and cabled Nina that she would be returning home.

Her "nervous breakdown," as she referred to it, had rendered her so anxious and "ill" that she confined herself to her cabin for the entire journey to England. Her sister met her off the train at Euston Station and took her to their house in Tooting, South London. Here, Ethel would remain for the better part of a year, rarely moving from a chair beside the fire in the Brocks' sitting room. "My nerve was completely shattered, my mind a blank," she recalled. She would jump "at the sound of a footstep" and shrank "at every knock which came to the door." Nina arranged for Ethel to be examined by several doctors, which must have proved expensive for a lower middle class family of four, who now had taken on the additional burden of an invalid sister. Ethel said that most of the experts she saw were puzzled by her case, or more likely, they dismissed her troubles as a form of hysteria. "Is the poor girl worried?" asked one. "She hasn't had a disappointment in a love affair, has she?" inquired another. They recommended that Nina take Ethel out to dances or to the theater, but socializing only made her recoil further into her shell. After a time, Ethel "refused to come downstairs at all."[21] Her existence shrank to that which could fit between the four walls of her bedroom. She claimed to feel as much a prisoner in her sister's house as she had been in her cell at Holloway, but at least there she amused herself with embroidery and needlework. In her current state, she could not even do that. Ethel said that Nina was always patient with her and never scolded, but one day, Horace Brock felt it necessary to have a word with her.

Nina had recently become fatigued, and her health had begun to suffer. How long after this she would be diagnosed with tuberculosis is unclear, but the family would recall that the onset of symptoms—usually a fever, night sweats, weight loss and a persistent

cough—would not become obvious for another year or so. While mortality rates had decreased somewhat from the late 1880s, when one in every seven cases proved fatal, by 1912 a cure still had not been discovered.[22] Medical professionals recommended bed rest, fresh air and a nourishing diet. In the recent past, Nina and Horace had made enormous sacrifices for Ethel; the hurricane of troubles that she had landed upon the Neaves tore apart their immediate family and also laid waste to the Brocks' finances. Now, it was Nina who required assistance. She would need help with the children, with managing the house and paying the bills. Ethel would have to return to work.

It was with trepidation that Ethel began her search for a job. She felt uneasy about the prospect of returning to an office in the West End where she might be recognized, so instead sought employment in the East End of London, an area with which she was unfamiliar. She was hired by a factory in Poplar, near the docks, where she would be assisting with bookkeeping and payroll. As the office was small and she had little interaction with the mostly female factory workers, she felt fairly secure, until one day when she was cornered by a group of several young women. Somehow, word had spread that the reserved, dark-haired Ethel Harvey was actually Ethel Le Neve. The workers wanted to know if it was true. "The question staggered me," she said, "it cut me like a knife."[23] Naturally, Ethel vehemently denied it and believed she had snuffed out the rumor completely. A short while after this incident, she was approached discreetly by one of the young women of the group. The worker confided that she had not managed to earn her full pay that week, and wished to know if Ethel could assist her by fudging the accounts. Ethel refused, but the woman pulled out an old newspaper article featuring Ethel's photograph and laid it on her desk: "You've been in trouble yourself and you might do a little kindness to help me when I'm in a hole."[24] Stunned and terrified, Ethel loaned the woman four shillings. The worker handed over the photo, but this was by no means the end of it. She continued to "borrow" sums from Ethel, which she never repaid. The young woman also took

enormous pleasure in confirming Miss. Harvey's true identity to everyone in the factory. Ethel felt her position and her confidence completely undermined. Her former anxieties began to pluck at her nerves.

One day, when she arrived at work, she noticed a local police officer standing at the factory gate with "a man in plain clothes with the unmistakable stamp of a detective upon him." Ethel became panic-stricken. "At noon, without a word of explanation to anyone, I left the office by a back way, went home . . . and never returned to my work."[25]

After this, Ethel struggled openly with paranoia. Once more, she became certain she was being watched. At the time, she had started a new job working as a typist for a firm of solicitors in Piccadilly. She commented that whenever she left her home she saw "the same men and women hanging about." These strange individuals seemed to travel with her on the trains and then, alarmingly, she would "see them again in the lunch hour in the West End." Although she pretended not to notice them, they appeared to be waiting for her. There was one particular day when she boarded a bus in Hackney and rode it to her workplace near Piccadilly Circus. A gentleman had sat with her for the entire route and alighted at her stop. After stealing a few stealthy glances at him she had convinced herself "he had the look of a detective."[26] She grew worried and decided to tail him, thinking he might turn on to Vine Street, where there was a police station. Instead, he walked toward Glasshouse Street and entered a wine shop. To be absolutely certain that he was not spying on her, she returned fifteen minutes later and was relieved to find the unassuming object of her suspicions dressed in a shop apron and sweeping the floor.

Ethel's anxieties appeared to impact every aspect of her life. By 1913, she felt it necessary to move out of the Brocks' home and into lodgings with a landlady. As she worried incessantly about being discovered, she never felt comfortable remaining anywhere for too long, and in July of that year found a flat of her own at 19 Coalbrook Mansions in Balham.[27] Every time she stepped out on to the street,

she claimed that she "tried to put up a strong fight" against her panicked instincts.[28] Eventually, she turned to a doctor who prescribed "Just a little bromide with a touch of strychnine with it" to put her "nerve right."[29] He also cautioned her against allowing herself to believe these delusions, warning her that such behavior was "the first sign of insipient insanity." "Why should anyone follow you about?" he asked. "After all, you've done nothing terrible."

According to Ethel's account, the doctor's advice and his curative tonic seemed to work, or perhaps she would grow accustomed to an existence of two halves, where one persona remained locked away while a second self engaged in the performance of life. It became the responsibility of the functional, socially appropriate new Ethel to ensure that reminders of the old shadow Ethel never intruded into the present. Maintaining this would require a succession of sacrifices.

One of these was a job she loved, working in the mail order department of "one of the big London stores."[30] After several months of diligently managing checks and money orders, her employer announced his intention to promote her to head of department. It was to be the most important and highly paid position she had ever held, but before she was permanently added to the payroll and the pension scheme, company policy dictated that she present them with her birth certificate. Realizing that this was likely to cause a stir, Ethel explained her situation to her manager and resigned her position. Fortunately, he knew that a rival business was not so particular with their paperwork, and so recommended her for a similar vacancy there. The store was likely to have been Hampton & Sons, a vast furniture, interiors and real estate empire based off Trafalgar Square. Their departments included building, surveying, antique and modern furniture sales, upholstering, plumbing and electrical works. Some of their most famous commissions included the design and installation of the interiors of the Drury Lane Theatre and Cunard's steam liners, as well as the palaces of the Nizam of Hyderabad and the Maharajah of Kashmir. It was while working here, on the eve of the First World War, that Ethel would meet her husband, Stanley William Smith.

Ethel's children would agree that their father bore an uncanny physical resemblance to Hawley Harvey Crippen. He was a bespectacled and fair-haired man of a medium to slight build, with a substantial mustache. When he joined the Territorial Army in 1909 at the age of eighteen and two months, he was described as being 5 feet 6 inches tall. Stanley had lost his father at the age of four and he and his younger brother Robert were placed into the care of the Wanstead Infant Orphan Asylum, a charity school for the "fatherless children" of otherwise "respectable families." His father had managed a fishmonger's shop; in the wake of his death, his mother found work as a barmaid and later entered domestic service. There were many advantages to placing a boy in a charity school, but primarily it offered a guarantee that he would be trained in a trade which would make it easier to earn an income. Stanley was taught upholstering and given an apprenticeship with one of the large London furniture makers. By 1911, he was working and living at Maple & Company as an upholsterer's clerk at their enormous Tottenham Court Road showroom, headquarters and employee residence. As a clerk, rather than as a craftsman, this provided him with an entrée into more financially promising roles in administration and sales. However, Stanley retained his interests in furniture-making and pursued a love of art. He painted landscapes, "was a keen photographer," tried his hand at calligraphy, reupholstered his own furniture, made tables and rocking chairs, sewed curtains and even embroidered. His children would describe him as an honest, practical, "easy-going sort" whom everyone liked.[31]

There is nothing known about their courtship. Neither Ethel nor Stanley discussed such things with their children. They were married on January 2, 1915, in the early months of the First World War, at a register in Wandsworth, South London. Nina acted as a witness. Ethel was nearly thirty-two and her husband eight years her junior. She was also three months pregnant with Stanley Robert, her first child.

Stanley William's regiment, the London-based Queen Victoria's Rifles, was one of the first Territorial battalions to be sent to France,

landing at Le Havre on November 5, 1914. The timing of Ethel's pregnancy makes it likely that "Bob" (as he would be called) was conceived as the couple bid each other farewell. It was a risky roll of the dice for Ethel, but one which many young women at the outbreak of war were willing to take. There was no guarantee that Stanley would return from the front or would be there to marry her and quietly cover up the shameful "stain of illegitimacy" and unwed motherhood. What allowed her to take this perilous gamble with her future? Had her travails anesthetized her against the fear of being shamed? Or at thirty-one, as she watched the possibility of a child and a husband slip away yet again, did she instinctively grab for what she wanted? As her children would one day attest, Ethel had always been a strong-willed woman.

The public would never know about any of this. This was Ethel Smith's life, and she was now a different woman from Ethel Le Neve.

Bob recalled that his mother rarely had guests at their home, but he did remember one exception. When he was about six years old, two people whom his mother "used to do work for" visited her regularly. This would have been around 1920 to 1921, the time that *Thomson's Weekly News* was putting together their first series on Ethel's life. Readers wanted to know what had happened to Ethel Le Neve, how she had weathered the events of the war and where she was now. Ethel must have felt there was no harm in coyly revealing her adventures so long as they did not stray too close to the real experiences of Ethel Smith. To keep Ethel Smith safely hidden behind the facade of Ethel Le Neve, it was necessary to create a fanciful diversion. It would read something like this . . .

At the outbreak of the Great War, Ethel Le Neve had felt an intense yearning to assist the nation. When she learned that French translators were needed to help process and settle refugees arriving from war-torn Belgium, Ethel answered the call. While engaged in this, she met a woman who had joined the VAD, the Red Cross Voluntary Aid Detachment. During the First World War, these volunteers offered their services for no or low pay as nurses, cooks, kitchen

maids, clerks, housemaids, ward maids, laundresses and motor-drivers. "At the back of my mind I had the feeling that if only I could make some sacrifice . . . it would help to purge whatever sins I had committed," Ethel allegedly told *Thomson's Weekly News*.[32] So, she joined the VAD and volunteered for service at a hospital in Tottenham, North London. At 7 p.m., after working a full day at Hamptons, she would spend the next four hours eagerly throwing herself into "the less spectacular and less romantic work" of cleaning crockery and scrubbing the hospital floors. Ethel claims she also enrolled in a nursing course. She read and attended lectures while working weekends, before passing her examination and receiving a nursing certificate. It was "this little bit of paper" which allowed her to meet her husband.[33]

She called him Corporal Jim Brown, though admitted it was not his real name. While he was convalescing on her ward, he took a shine to her. She was quite smitten with his dark eyes—or his blue eyes—depending on the version one reads. The courting pair used to sit under the chestnut trees on the hospital grounds and he would regale her with stories of his home on a fruit farm in Australia. He was wholesome and honest. When he asked her to marry him, she knew she would have to reveal her true identity. It took all her courage to tell him that she was Ethel Le Neve; however, much to her surprise, he had never heard the name before. He did not care. "We're just going to forget about that now," Jim Brown said to her. "You've had your share of trouble and this day forward you are just going to forget about Ethel Le Neve."[34]

The war ended. The couple got married and the Browns went to live on Jim's Australian fruit farm somewhere "between Perth and Kalgoorlie." She told her readers that she had two children: a boy, born a year and a half after she left England, and a girl, born in 1921, who was "the living image of my sister." For a time, it was a perfect idyll, what seemed a sweet and tidy ending to a terrible story, but whispers of Ethel's past always seemed to intrude. Occasionally, her anxiety and paranoia would re-emerge and "make me do strange things, so that my husband began to look at me in a puzzled sort of

way and to ask if there was anything wrong."[35] When her daughter's health began to decline, a doctor suggested that the girl's condition had been caused by Ethel's history of nervous complaints. The answer was to take her to England where there was better treatment for children with such cases. The decision was made, and the Brown family returned to London.

As convincing as Ethel's First World War narrative sounds, if she had joined the VAD, worked as a translator, or earned a qualification as a nurse, no evidence of this survives in the Red Cross's records. Neither was there ever a strapping Australian husband or a fruit farm near Perth. During the first part of the war Ethel was pregnant, and then raising Bob. In the final part of it, she was looking after Nina, whose condition was rapidly declining. Horace was in the Territorial Army and Stanley was abroad, fighting in France and Germany. Bob recalls that Nina lived with them at their house at 107 Harrington Road in 1917 for a spell, but that she died on December 1, 1918, at the Croydon Union Infirmary. The loss of her beloved sister must have been a ferocious blow to Ethel. Nina had been the one constant point in her life; she had known Ethel better than anyone. They had been best friends, as much as blood relations. It is difficult to imagine how Ethel ever recovered.

Ethel's post-war adventures, although wildly fantastic, frequently skirt quite close to the truth in their finer details. On October 25, 1920, Ethel gave birth to her daughter, Nina Margaret Smith. If Bob had been Stanley's parting gift to his wife, then Nina was to be his homecoming present. In Ethel's eyes, the baby girl must truly have been the living image of her sister. After the war, Stanley returned to work at Hampton & Sons, and Ethel retired from the office to maintain the home. The family settled into a quiet interwar suburban existence among the identical rows of squat, four- and five-room houses near Croydon.[36] It was not until Bob was almost ten that he met his maternal grandparents and his mother's brothers. Ethel had been estranged from them for fifteen years. What had encouraged them to finally lay aside their differences is unknown, but it meant that, after Ethel's mother's death in 1938, Walter came

to live with them during the Second World War. The children re-
called a very stiff sort of grandfather, who insisted on wearing spats
and a top hat and listening to choral hymns on the wireless on Sun-
days. The family almost never took holidays. They went to Brigh-
ton once and stayed with an aunt. Stanley frequently cycled to work
to save on the train fare. Times were lean. It seems a rather colorless
existence, a world washed with gray, lived under London's fogs and
backyard laundry lines, the passage of the days tapped out to milk
deliveries, children's teatimes and Stanley's return from work. Ethel
darned socks and sewed on buttons in the evenings. She also took
up smoking. It was certainly not what Miss. Le Neve had had in
mind for herself in 1910.

In the interviews Bob and Nina would give in the 1980s and 90s,
they would describe their mother as "a strange lady" with "strange
ways."[37] She expressed no affection for her husband. Their marriage
was not obviously unhappy, they never quarreled, but neither was
there much joy in it. Bob believed they were opposites: Stanley was
an open book; Ethel was deeply secretive. They never once saw her
kiss him. Neither did they ever see her cry. There was no emotion
when Stanley died in 1960.[38] "She wasn't all that loving," Nina said,
even toward her children. She "never touched them" and "rarely let
them touch her."[39] Which is not to say she wasn't "a darn good
mother" to them. She raised them well and was very patient, Bob
recalled. As a very young boy, during the First World War, he re-
membered sitting on her lap during a Zeppelin raid. Ethel distracted
him by drawing pictures of trains. However, in her later years, she
became less charitable toward her adult children and much angrier.
"She was tough-minded" and "had an ingrained suspicion of men,"
said Nina.[40]

After Stanley died in 1960, Ethel moved in with Nina and her hus-
band, Colin Campbell.[41] Her daughter found it to be a very difficult
arrangement. Ethel constantly complained, was rude to Colin, and
made hurtful accusations to the neighbors that Nina was starving
her.[42]

From the age of fifty-five, Ethel had developed a panoply of health

problems: arthritis, bronchitis, asthma and angina. It was her heart that took her in the end. On the last day of her life, August 9, 1967, the family gathered around her deathbed. She refused to speak with them, or even to hold Nina's hand. Nina always regretted this, and that she did not come to understand her mother better.[43]

The realization that neither Nina nor Bob truly knew their mother struck particularly hard when they were contacted in 1985 by the true-crime writer Jonathan Goodman. Goodman had found Bob's address on Ethel's death certificate and wrote to him that he was researching their mother, Ethel Le Neve. He wanted to interview them about her. Bob and Nina were initially perplexed and thought Goodman was a crank—their mother had nothing to do with any of this. However, they soon realized that he hadn't been joking. They were completely stunned; their mother had managed to hide everything from them. They were sure their father had known her identity, and of course so had their maternal grandparents and uncles and aunts. Suddenly, pieces started to fall into place: odd incidents in the past, gaps in their knowledge, strange conversations—all began to make sense. Nina remembered finding books with the name "E. Harvey" written inside the cover. "Who is E. Harvey?" she had asked her mother. "Oh, that's a friend," Ethel had responded.[44]

Ethel Smith never mentioned her past, but the internal battles she fought to keep Ethel Le Neve bound and gagged within her occasionally intruded into their lives. Bob recalled one bizarre incident where suddenly his mother began telling him about a train journey she had made across Canada and how she had seen wolves, forests, and wheat fields that seemed to stretch to the horizon. And then that was it. She clamped shut. At another time, she mentioned being at sea, on a steam liner in a storm. Somehow, he knew she had visited continental Europe, that she had learned how to lay a proper table, that there had been some sophistication in her life. He had been a child at the time these stories were told to him, and once the words had been spoken, they vanished. He never thought to inquire again.

Then there was Nina and the "dark blue scarf" she used to play with as a girl. Ethel used to watch her wrap herself in it and disappear into a childish reverie. It was only after she saw the photographs of Ethel in court that she recognized the long piece of chiffon as the motoring veil her mother had worn throughout the grueling days of her trial. It was an odd gift to bequeath one's daughter, especially when she had purged every other memento from the past. Bob and Nina remember that their father had photos and letters, many bits of ephemera from his earlier days, but Ethel had not one slip of anything—not a postcard, an old train ticket, a pressed posy of flowers. The only two items of true value she had given to Stanley: Crippen's wedding ring and his pocket watch. Her husband had no idea to whom the objects had once belonged. According to a friend in whom Ethel confided, Stanley had imagined they were "normal family trinkets" which had been handed down and awarded to him "with some affection." She allowed him to believe this, but in reality, observing the band around Stanley's finger, and hearing the gold vermeil watch tick in his pocket, provided her with an indulgent, secret pleasure. The "spectacle of the watch and the ring, still 'alive,' as it were, on the person of the husband, served strangely to symbolize and stimulate a profound and enduring love still nurtured in her heart for the dead lover!" she had confessed.[45]

The friend to whom she had unburdened herself was Rex Manning. It was a peculiar relationship, which, according to Nina and Bob, seemed to have blossomed out of nowhere. Their mother had no companions until she met Rex and Doris Manning. Neither of her children knew exactly how this came about—it was either a chance encounter while they were shopping in nearby Addiscombe, or at a social event. Whatever the case, Rex Manning seemed to be a near relation of the Reverend Charles Upwood Manning who had christened Ethel so many years ago in Diss.[46] There was nothing exceptional about Rex: he was a big, bald man with a warm smile, an accountant for London Transport. For some reason, she came to trust the Mannings even more than her own family, or perhaps the

Mannings became the safety valve which helped her release the internal pressure that Ethel Le Neve exerted upon Ethel Smith. What did not become apparent until after her death was that Rex Manning seemed to know everything, and did not judge. He was empathetic, bought into her entire narrative and allowed himself to be swept up in the romantic story of her affair with Crippen. She even confided that she never loved her husband, but rather that she "came to like and respect" Stanley. It was Crippen whom "she loved . . . to the day she died."[47]

In 1957 Manning gallantly offered to act as an intermediary after the novelist Ursula Bloom had developed an obsession with Ethel. Three years earlier, while working for the *Weekly Dispatch*, Bloom had been inspired to write a novel about her, entitled *The Girl Who Loved Crippen*. She had thrown herself into the project, stalking the streets of Holloway and eventually establishing a correspondence with Ethel's brother Sidney. It was through him that she learned Ethel's address and pestered her for an interview. Ethel relented and the two met once, while Stanley was at work.[48] Bloom became enchanted, confusing the fictionalized character of her romantic imagination with Mrs. Smith, now in her seventies. She was positive that both Ethel and Crippen were innocent and became Ethel's unsolicited mouthpiece whenever a film or stage adaptation of the story appeared. Although she had pledged discretion when publishing their interview, after Ethel's death Bloom would spray the details of her private life all over the papers. She was not to be trusted, and the ever-wary Ethel understood this. However, Bloom became increasingly persistent, begging to renew their friendship, asking to come and see her, inquiring why she had failed to respond to her letters, warning her that there was a "scheme afoot" to turn Crippen's story into a film. Ethel asked Rex Manning to manage the situation: "I certainly, as you know, do not want any more *publicity* in any shape or form . . ."[49] Rex, the bulldog who guarded her secrets, effectively saw off the novelist. For all of his fidelity and kindness, Ethel rewarded him with Crippen's pocket watch and wedding ring

when Stanley died. It would not be until later that Bob understood why his mother had chosen to give his father's personal possessions away to a friend and not to him.

Without the Mannings, Ethel Smith might not have succeeded in hiding Ethel Le Neve from her children for as long as she did. After they were born, nothing in her life became more important than keeping her past concealed from them. She had expressed this to Rex, and even to Ursula Bloom. When Nina and Bob finally learned the truth, they spent a good deal of time reflecting on their mother's decision. Eventually, they came to terms with it, and understood and forgave. "I think it would have taken an awful lot of courage on my mother's part to have told us," said Nina; ". . . she was running quite a risk of alienating us . . . we might have turned around and thoroughly despised her, which would have hurt her dreadfully."[50] When they were young, they simply would not have understood, added Bob, and if other children had learned of the connection with Crippen, they would have been teased, at the very least.[51]

Ethel had considered all of this as early as 1928. "I sometimes wonder if I am right in withholding the truth from them and I suppose this also is part of the cross I have still to bear," she said at the end of her *Thomson's Weekly* series.

> It is not difficult to visualize that a secret like mine would be a powerful lever in the hands of a blackmailer and might cause tragedy in the lives of my children after I am dead and gone. But on the other hand, it might give my bairns endless pain to learn that their mother was the central figure in a world tragedy . . . the one reward for all my mental agony and physical suffering that my mother's heart craves is that the children she bore will revere her memory.[52]

When the 1928 series ran it was splashed with large professionally posed photographs of Ethel, with her hair fashionably bobbed and her lips lacquered with red. At the time, her son would have been thirteen and her daughter eight. They were old enough to have ac-

cidentally picked up a copy of the newspaper and recognized their mother, as might have any of their schoolfriends or neighbors. For someone so determined to preserve her anonymity, Ethel could be extremely reckless with it. There must have been times when Ethel Le Neve squirmed and kicked within Ethel Smith, desperate to come out. Ethel Smith made the children's sandwiches and spent her evenings listening to the wireless with her crochet work. Ethel Le Neve wore diamonds, holidayed in France and drank cocktails with music hall stars. Talking to a journalist about it, watching their eyes sparkle with wonder, must have been tantamount to reliving it: the thrill, the glamour and even the horror. Afterward, it would have been a struggle to pack Ethel Le Neve away again, but it was necessary. Nineteen twenty-eight would be the last interview she gave before the children were adults.

Ethel had a dangerous weakness—she was easily charmed by journalists. Her initial game of hard-to-get soon fell away when they sat beside her, pencils in hand. Invariably, she was asked about Crippen—was he guilty? Did she ever suspect anything? What were her theories? She liked to think that her stories all joined together seamlessly, without gaps and inconsistencies, but they did not. It was perhaps on account of this that she was never allowed to enter the witness box in either trial. After her acquittal, no reporter would dare insinuate that she was anything other than innocent, and once granted this latitude, she would ramble carelessly about her theories. Across the years she would forget what she had said in previous interviews and so her assertions would vary from one occasion to the next. In one interview she would concede that Crippen was guilty, while in another she would insist he was innocent, or that Belle might possibly be alive. In another still, she supposed that Belle's death had been an accident which her husband had tried to cover up. Ethel even suggested that on the night Belle died she had asked Crippen for something to calm her nerves. She demanded that he give her the hyoscine, but he had got the dose incorrect. It was practically her own fault she was dead.

The journalist Philip Gibbs had studied Ethel closely while writing

her biographical story for *Lloyd's Weekly* in 1910. He found her to be an "astonishing" and "unusual" woman. She was particularly "astonishing" in her ability to disassociate from the grim reality of her circumstances. As they sat together with J. P. Eddy in a Soho cafe, Ethel was remarkably light-hearted. "Many times she was so gay that it was impossible to believe she had escaped the hangman's rope . . . and that her lover was . . . lying under sentence of death." She had "a childish sense of humor" which "bubbled out of her." It was only when reminded of her current troubles that she "used to weep, but never for long." To Gibbs she seemed as careless of Crippen's crime "as any woman of the Borgias when a rival was removed from her path of love." Earlier, Ethel had confessed to him that she had "no doubt" of her lover's guilt. That he had slaughtered his wife "made no difference to her love for him." "He was mad when he did it," she said, "and he was mad for me."[53]

After the interview, the journalist wrote that he was "sickened at the squalor of the whole story" and "was glad to see the last of her."[54]

Gibbs appears to have sensed something in her character that others of his profession were afraid to express: that Ethel might have been capable of the crime of which she had been accused. In all the interviews she gave, in the many ghostwritten articles and memoirs, she offers not the faintest note of remorse. Neither can there be found a single hint of compassion for Belle, her family or her friends. They are replaced with praises for her killer. And in Ethel's candid remarks to her own relations and friends, there is a barely disguised disgust for Crippen's murdered wife. In Ethel's eyes, *she* was the victim. The "harpies," the Music Hall Ladies' Guild and Belle's bereaved sisters, had come for *her*. *She* was meant to have been Crippen's wife. *She* should have inherited Belle's possessions. Belle and those women had destroyed *her* life.

Although no one could be absolutely certain of what Ethel did, she knew, and she would never be able to forget. Neither would others.

On March 24, 1913, a train pulled into Eastbourne Station. Melinda May, who was still presiding as the secretary of the Music Hall

Ladies' Guild, was returning from an Easter holiday spent at the seaside. She opened the door to her compartment and arranged her bags and boxes before taking her seat. As she settled herself, she noticed there was a woman sitting directly opposite her. Her dark hair was styled atop her head, her mouth was turned down at the corners: ". . . to my amazement I recognized her as Ethel Neave." Melinda began to stare. She could not help herself. After a while Ethel saw her too, "and knew who I was." She did not dare meet her gaze, and "hung her head" in deliberate avoidance, if not a touch of shame. They sat in silence, in a type of checkmate, Melinda holding her there in an unseen grip. For the rest of the journey, all the way to London Bridge Station, "I could not take my eyes off her . . ."[55]

Epilogue

The Final Word

I N THE SUMMER OF 1910, the world became obsessed with a little, balding, short-sighted man who had murdered his wife and stolen away with his attractive typist. The international press rolled out thousands of printed pages devoted to this compelling whydunnit. Readers from Newcastle upon Tyne to Boise, Idaho, and Adelaide, Australia, opened their papers each day to read about the manhunt, the motives, the body parts found in the cellar. When they had exhausted these stories, newspapers reached for peripheral subjects: interviews with the poor typist's family and friends; commentary about Mrs. Crippen's character from the Music Hall Ladies' Guild; or anything which would throw light on the killer's life or motives. Not only was his history probed and recounted, but every aspect of his personality and his habits were discussed: the clothing he wore, the interior of his home, the newspapers and periodicals he read, the restaurants he frequented. Neighbors, colleagues—past and present— were pursued for comment. The local shopkeepers and even the laundry company who washed his shirts were interviewed. The murder of Belle Elmore was selling newspapers, but so too was the killer himself.

Day after day between July and November, they printed the words he used in his defense. First it was the statement he gave to Inspector Dew, and then it was his testimony in the dock where he adamantly protested his innocence, lying and perjuring himself in the process. Even once convicted, the papers gave him a platform to proclaim the injustice of the verdict. Crippen, a con artist and a

murderer, was provided with a screen on which to project an image of himself: a sensitive poet and devoted lover, a romantic who ached for the woman he adored, a kind and generous soul who had been wronged by the world, but who, nobly, was prepared for death. In the end, Ethel too was led into the spotlight to perform her aria—a lament for her misunderstood lover. It made for tremendous copy; it held readers spellbound and sent newspapers flying from the stands. In the wake of Crippen's trial, interest in any other angle shriveled away. Kind words which had once been spoken in favor of Belle Elmore, praise for "a bright, bonny and beautiful woman of sweet disposition" who was "popular everywhere," were soon lost and forgotten.[1] Long after Crippen's demise at the hands of a hangman, the potency of his possible innocence would continue to linger in the air.

At a time when men's and women's characters were judged on their outward manners and comportment, it remained difficult for some to accept that such an inoffensive man could have committed such a dastardly deed. The author Alexander Bell Filson Young was one such individual. No one would do more to commit the story of Crippen and his murderous love triangle to legend than he. Filson Young was by no means an expert in the law. He wrote novels and nonfiction on a variety of subjects: art, motoring, music, Christopher Columbus, and the *Titanic*. In 1920 he was asked to contribute to the Notable British Trials series, in which transcripts of high-profile cases were prefaced by introductory essays. His volume, *The Trial of Hawley Harvey Crippen*, appeared that year and offered his particular insights on the case. Like many others, Filson Young had been swept up in the romance of the Crippen story and its pathetic runaway lovers in 1910. He had even written to the *Saturday Review* disparaging the censorious coverage of the couple's relationship while they were aboard the *Montrose*. ". . . No matter what they had done, their love for one another was worthy of respect . . ." he reminded the editor. Ten years later, his feelings about the case had not changed. When writing his introduction to the edited transcripts, Filson Young was determined to say something he believed

was both "sympathetic and balanced," but what he created was neither of those things.[2]

In addition to proffering his theories about the motives for the killing, his essay framed the case as a tale about star-crossed suburban lovers. Crippen and Ethel were both polite and gentle souls caught in an impossible situation. The problem with such a trope is that thwarted love requires an obstacle, something or someone to frustrate it. In Filson Young's version, that was Belle Elmore—the dragon that had to be slayed.

Working from what he described as Adeline Harrison's "notes," the author sketched out his monster. His Belle Elmore was a grotesque, overblown caricature of a woman devoid of any redeeming features. The author's depictions drip with misogyny. At various times, he describes her as extravagant, shrewish, "robust and animal," "loud," "aggressive," inordinately vain, talentless, tasteless, parsimonious, "excitable," "irritable" and "quarrelsome." He presents unsubstantiated anecdotes detailing how Crippen, "a man with no apparent surface vices, or even the usual weakness or foibles of the ordinary man," had his spirit slowly crushed by his "plump little" wife.[3] Her demands for material comforts were incessant, her habits were slovenly, and she was sexually unfaithful. She emasculated him by choosing his clothing and forcing him to do the housework. She also humiliated him in front of their friends. "We must remember what she had been and what she was," the author sneers, and that when it came to "Mrs. Crippen's relations with other men . . . it is obvious that the avenue to her affections was not very narrow or difficult of access."[4] Ultimately, when Crippen could no longer bear to live with her, "He went and bought the hyoscine— always considerate, you see, even in the weapon he used to kill his wife."[5]

Filson Young's *Trial of Hawley Harvey Crippen* became a standard text for anyone wishing to read about the case, from law students to those simply curious about the crime. Although the author denied that he was an apologist for Crippen's deeds, by choosing to tell the murderer's story, by extending sympathy to him while withholding

it from the woman he killed, Filson Young granted Crippen a form of absolution. His interpretation of events acted as a template for other authors writing about the case and would lay the foundation for the way in which Belle would be depicted and remembered throughout the twentieth century.

Like a gang of bullies following their leader, the writers who learned from Filson Young felt compelled to match, if not to exceed, his cruelty. The result was an astonishing hail of malicious abuse by authors who had never so much as met Belle Elmore. Edward Marjoribanks in his biography of the barrister Edward Marshall Hall calls Belle Elmore "a peacock and a slut," while Captain Kendall in his memoirs describes her as "a flashy, faithless shrew, loud-voiced, vulgar and florid."[6] "This overweight and overbearing female allowed her intimates to call her Belle, and never for a moment suspected the name could be comic in the circumstances. But then she had no sense of humor . . ." writes Leonard Gribble in 1954, before continuing that she "was extravagant and without taste . . . she spent money recklessly . . . on clothes and jewelry to deck her gross body."[7] Horace Thorogood, in his book *East of Aldgate*, goes even further:

The home life of this quiet, likable man was made wretched by an uncongenial wife who treated him with contempt. She was a worthless creature. She filled his house with people whom he despised and who despised him. Here, if ever was an excusable crime. The woman had no known relatives and no children. There was no one to mourn for her loss.[8]

Female authors too joined in the assault, heaping scorn on what they had internalized as unacceptable manifestations of womanhood. Adeline Harrison had thrown the first stone, but Dorothy L. Sayers and Ursula Bloom followed suit. Bloom claimed to be "disgusted" by Belle Elmore, whom she described as a "hysterical and blowsy . . . music hall lady with a large bust and bottom" who had "worked as a prostitute," while Sayers just about forgave Crippen

for ridding himself of a wife who was "noisy, over-vitalized, animal, seductive and intolerable."[9] Ultimately, many of those who chronicled the Crippens' tale came to agree that the offensive Belle merited her fate. Like the proverbial drunk woman in a short skirt, she brought it on her outlandish, hyper-sexualized self.

It is no coincidence that Filson Young created his female monster when he did. In the two years immediately prior to the publication of *The Trial of Hawley Harvey Crippen* in 1920, women had achieved the right to vote and stand for election to Parliament. They had been permitted to sit on juries, become barristers and solicitors, to join professional bodies and have academic degrees conferred upon them. Women had entered the police force and had stepped into traditionally male jobs during the First World War, working as bus and tram conductors, in munitions factories and as farm laborers. Against a background of this, Marie Stopes and Margaret Sanger openly campaigned for accessibility to birth control, so married women could secure ownership of their reproductive rights. In 1920, women bobbed their hair and began shortening their hemlines. Wearing cosmetics and smoking became more widely acceptable. For as objectionable as the New Woman had been at the turn of the century, she and her "modern ways" were now here to stay. The increasingly educated and financially independent woman of the twentieth century had been unhappy with her lot. So began the slow but steady expansion of women's rights and the social and cultural changes that accompanied them in the decades to follow.

For many, the empowerment of women was a terrifying and unnatural prospect. The rightful place of a man was as a breadwinner, a lawmaker, a leader. Men were strong, aggressive, bold, sexual, independent. Women were weak, passive, submissive and modest. To envision a future where educated, autonomous, outspoken and sexually liberated women stood equal to men, or worse still made laws and ruled over them, was a nightmarish scenario—and from nightmares emerge monsters.

A monster is born "as an embodiment of a certain cultural moment," explains the theorist Jeffrey Jerome Cohen.[10] It is emblematic

of the fears and anxieties of its time and place. Monsters are invented during periods of cultural crisis and exist to police the boundaries of a society's norms. Filson Young created a Belle Elmore that symbolized everything the early twentieth century found horrifying about the modern woman—a female who couldn't be controlled by a man, who dwarfed him; her desires, her voice, her material needs, her physicality were excessive and repulsive. Belle drains her husband, emasculates him, shames and diminishes him. She is the quintessential female monster of ancient fables, who "oversteps the boundaries of her gender role."[11] She is the dreaded "Vagina Dentata," the luridly sexual creature who tricks and seduces her male victim before castrating him. Belle's foil is the "quiet, ladylike, unassuming" and "obedient" Ethel, the object of Crippen's noble and selfless affection.[12] Monstrous Belle had to be defeated and, according to Filson Young's parable, Crippen's act of killing her is honorable because he did it "in order to give his life to the woman he loved."[13]

The fear of the empowered woman certainly did not fade with the advance of the twentieth century, and with a handful of more recent exceptions, Filson Young's tale of Monstrous Belle and the tragic Crippen continues to persist, weaving its presence into twenty-first-century examinations of the case.

In 2008, *"Executed in Error,"* an episode of the documentary series *Secrets of the Dead*, was broadcast on PBS in the US and Channel 5 in the UK.[14] In it, toxicologist John Trestrail sought to make a case for Crippen's innocence by having a microscope slide of Belle's skin, which had been created for the trial in 1910, DNA tested. The sample, which was part of the archives of the Royal London Hospital, was sent to a lab at Michigan State University to be tested by Dr. David Foran and a team of assistants. Much to everyone's surprise, the mitochondrial DNA reading did not match with that of Belle Elmore's living relatives. Not only that, but a newly innovated test for determining sex was carried out on the sample, which revealed the remains were in fact male. The findings were startling and, much like Crippen's story nearly a century earlier, made their way into the

news. The documentary asserted that it was clear Crippen did not kill Belle Elmore, or at least that the remains Dew uncovered in the cellar were not hers. An attempt was then made to construct a case based on a letter, proven in 1910 to be a forgery, that Belle was still alive at the time of Crippen's execution. According to the documentary, she was in the United States and refused to come forward to spare her husband from the noose. In this way, the story has reached its apogee; not only was Monstrous Belle Elmore never murdered, but the true victim has become the killer, and the killer, the victim.

According to the geneticist Professor Turi King, director of the Milner Centre for Evolution at the University of Bath, and a key member of the team who identified the remains of Richard III in 2012, questions remain regarding the findings of Dr. Foran and his team. After consulting the scientific white paper they produced, Professor King does not believe a case has been definitively proven.[15]

One of the problems with historic true crime, particularly those cases which occurred a century or more ago, is how these stories are told to us and how uncritically we are willing to receive them. With the passage of time, events like the North London Cellar Murder evolve from news events into cultural legends. The lines between fact and invention, supposition and opinion begin to disintegrate. Filson Young's misogynistic parable becomes the established account of events because it makes for a good story, because it is still considered acceptable for a man to claim he killed a "difficult woman" under duress. She was asking for it.

The process of rarefying a crime into legend removes all nuance. That which is left is easily digestible—established fears and prejudices, and neat binaries: good and evil; heroes and villains. Legends speak to us in shorthand, but real murder stories are infinitely complex, their implications wide-ranging. They are bigger than a narrative about a killer or a detective; there is more to understand about a crime than a motive or a method, and the capture of a suspect by no means signals the conclusion of a case. No matter how guilty a suspect might appear, judges and juries decide the ultimate outcome; and even then, a crime which is about people—a criminal, a

victim, their family, their friends, their community, our society—never entirely ends.

It feels uncomfortable to acknowledge nuance in something so atrocious as a murder, but human beings are morally ambiguous creatures and therefore nothing is ever as straightforward as we would like it to be. People are flawed, weak, sometimes courageous, self-interested, frightened, kind and capable of love. Ethel was a devoted sister and mother; Crippen was once just a young man who wanted to be a doctor; and Belle was not perfect. However, she does not deserve to be depicted or remembered in the manner that she has been. Her murderer should not have the final word.

Belle Elmore, or Cora Crippen or Kunegunde Mackamotzki, was loved. Her family and loyal friends made that abundantly clear, both while she lived and after her death. She was an extraordinary character: resilient, strong, undaunted by adversity. Belle Elmore had mastered reinvention; there seemed to be no challenge which frightened her. When stripped of her ability to become a mother, she embraced her dreams of performing opera. While some women might have wilted in sadness, Belle would never accept defeat. When opera seemed impossible, there was the music hall. When those aspirations began to falter, there was the Music Hall Ladies' Guild. There was always a route to happiness. Belle was generous, devoted to her charity work and to her faith, as well as to her friends and family. She learned to overcome loneliness and disappointment, and to forbid those things from darkening her life. She was creative and resourceful. Her effervescence filled a room. Perhaps what surprised people the most was her audacious self-belief. Belle had no fear of revealing herself to the world—she dressed flamboyantly and sang from her heart. She loved openly and unashamedly—friends, family, children, animals—no matter how much it annoyed others. She was simply Belle Elmore, a woman who lived her truth. Amid all the spite and malice that has made its way into print, if anything deserves to be remembered and repeated, it is that.

Notes

1. CHARLOTTE

1 *New York American*, July 16, 1910.

2 *Farmer's Gazette and Journal of Practical Horticulture*, February 13, 1862.

3 *Leinster Express*, June 27, 1863.

4 National Library of Ireland: MS 39, 027: de Vesci estate papers, letter from Arthur Bell to Viscount de Vesci, May 9, 1860.

5 Ibid.: June 24, 1867.

6 Ibid.: June 30, 1860.

7 James Kelly (ed.), *The Cambridge History of Ireland, Vol. III, 1730—1880* (Cambridge, 2018), pp. 664–7.

8 John Clarke, *Victorian Brackley* (Stroud, 2018), cited at https://www .magdalen.northants.sch.uk/general/welcome-and-introduction /history/.

9 Ibid.

10 Oscar Wilde, *Impressions of America* (Sunderland, 1906; Project Gutenberg, 2013, https://www.gutenberg.org/files/41806/41806-h /41806-h.htm).

11 *New York Times*, September 22, 1881.

12 By way of comparison, in 1879 rent at the Smithsonian, a modern apartment block in midtown Manhattan with six to seven rooms and a bath, could be had for $33—$40 per month (*New York Daily Herald*, October 30, 1879).

13 *Trow's New York City Directory* (1886).

14 Arlene W. Keeling, John Kirschgessner and Michelle C. Hehman (eds), *History of Professional Nursing in the United States: Towards a Culture of Health* (New York, 2017), p. 53.

15 *Brooklyn Daily Eagle*, June 16, 1889.

16 Ibid.

17 Mary Roberts Rinehart, *My Story* (New York, 1931), p. 43.

18 Ibid., p. 53.

19 *Brooklyn Daily Eagle*, June 16, 1889.

20 *New York American*, July 16, 1910. In the interview, William suggests that Charlotte either began her nursing studies in 1885 or completed them in that year.

21 *American Homeopathist*, vol. 13 (April 1, 1887), p. 157.

2. THE CRIPPENS

1 State of New York Marriage Certificate for Myron Augustus Crippen and Ardesee Crippen, September 28, 1891.

2 Chapman Bros. (ed.), *Portrait and Biographical Album of Branch County, Mich.* (Chicago, 1888), p. 277.

3 *Los Angeles Evening Post-Record*, November 18, 1910.

4 *Los Angeles Herald*, October 23, 1910.

5 Ibid.

6 Ibid.

7 Michele Aaron, "The Historical, the Hysterical and the Homeopathic," *Paragraph*, vol. 19, no. 2 (July 1996), pp. 114–26, p. 116.

8 John S. Haller, *The History of American Homeopathy: The Academic Years, 1820—1935* (Binghamton, NY, 2005), p. 15.

9 *San Francisco Call*, August 3, 1910.

10 *Catalog of the University of Michigan: 1882–83* (Ann Arbor, 1882), p. 116. Crippen is listed in the 1882–83 catalog as a student with Breyfogle as his preceptor.

11 "Personal Points," *American Homeopathist*, vols 11–12 (1885), p. 205.

12 An oophorectomy and an ovariotomy were interchangeable terms at this time. Both involved the removal of a woman's ovaries.

13 Crippen would later suggest that he had first visited London in 1883, but this date may have been given in error.

14 "Personal Points," p. 192.

15 *American Homeopathic Journal of Obstetrics and Gynaecology*, vol. 1 (1885). See Crippen's contributions during his European trip: "Our Berlin Letter," p. 242; "Our Paris Letter," p. 192; "London

Notes—Methods—The Hospitals," p. 141; "Diseases of Women as a Case of Insanity," p. 42; and "Foetal Nutrition," p. 164.

16 Ibid., pp. 44–5.

17 Ibid., pp. 46–7.

18 "On the Relation of Diseases of the Ear to Abnormal Conditions of the Female Generative Organs," *American Homeopathic Journal of Obstetrics and Gynaecology*, vol. 8 (Detroit, 1886), pp. 429–33.

19 "Another New Hospital," *The Chironian*, vol. 3, no. 9 (March 11, 1887), pp. 129–30.

20 Rinehart, *My Story*, p. 46.

21 *New York Tribune*, July 12, 1899.

22 Ibid.

23 The photographer N. L. Merrill's photo of young Crippen appears in Roger Dalrymple's book, *Crippen: A Crime Sensation in Memory and Modernity* (Woodbridge, 2020), p. 50.

24 *Detroit Free Press*, August 3, 1910.

25 *Cincinnati Medical Advance*, vol. 20 (1888), p. 80. The journal gives the date of their marriage as December 13, but the date of the marriage license is given as the 12th (Ancestry.com: Michigan, US: County Marriage Records, 1822–1940 [database online], Lehi, UT, USA). How Charlotte was related to John Butler is open to question. His name is not immediately obvious in either the Bell or Madden family trees.

26 *Journal of Obstetrics and Gynaecology*, vol. II (1889), p. 313.

27 *Los Angeles Evening Express*, December 20, 1887.

28 *San Diego Union and Daily Bee*, December 22, 1887.

29 Coronado Historical Association, www.coronadohistory.org. As the Crippens were residing at the Hotel Josephine, what would become the famous Hotel del Coronado was being built a bit further down the beach.

3. PARALYSIS OF THE SYMPATHETIC

1 *Medical News and Abstract*, vol. 42 (1883), p. 452; T. S. Van Dyke, *County of San Diego: The Italy of Southern California* (National City: 1887).

2 Based at 845 5th Street, as well as selling eyeglasses, glass eyes, opera, field and marine glasses, it advertised as "the largest and finest selected stock of watches, clocks and jewelry in Southern California." Crippen was listed as "MD and surgeon in charge" (*San Diego Union and Daily Bee*,

March 14, 1890). In 1888, Crippen advertised himself in the *California Homeopathist* as having an office at 1248 5th Street and 5th Avenue.

3 *Monteith's Directory of San Diego and Vicinity: 1889–90.*

4 According to Philo H. Crippen's will, Myron appears to have been living in Chicago at the time.

5 "The Insanity of Pregnancy," *Homeopathic Journal of Obstetrics, Gynaecology and Paedology*, vol. 10 (1888), p. 33.

6 *New York American*, July 16, 1910.

7 *Times-Picayune* (New Orleans), April 7, 1890; *Memphis Avalanche*, April 8, 1890.

8 *105th Annual Report of the Regents for the Year Ending September 30, 1891* (Albany, 1893), p. 578. (Crippen was appointed for the academic year starting October 1, 1890). Also announced in the *Medical Era*, October 8, 1890.

9 New York City Police Census, 1890.

10 *New York Daily Herald*, September 30, 1879.

11 *New York American*, July 16, 1910.

12 Ancestry.com: Michigan, US: Wills and Probate Records, 1784–1980, case files 3117–3207, 1833–1923, Philo H. Crippen, 1890.

13 Samuel H. Williamson, "Seven Ways to Compute the Relative Value of a US Dollar Amount, 1790 to present," *Measuring Worth* (April 2024), www.measuringworth.com/uscompare/.

14 Crippen signed the promissory note in October 1890.

15 Crippen arrived at Liverpool on July 1, 1891 (Ancestry.com: The National Archives in Washington, DC, USA: London, England, UK; Board of Trade: Commercial and Statistical Department and Successors: Inwards Passenger Lists; Class: Bt26; Piece: 12; Item: 39). He departed on July 24, 1891, traveling via Amsterdam (ibid.: Washington, DC, USA; Passenger Lists of Vessels Arriving at New York, NY, 1820–1897; Microfilm Serial or NAID: M237; RG Title: Records of the US Customs Service; RG: 36).

16 *New York American*, July 16, 1910.

17 *Dundee Courier*, July 22, 1910.

18 *Salt Lake Tribune*, November 8, 1891.

19 Dart lived at 533 East Second South, and the Crippens were at 565 South First West. As Salt Lake City's extremely confusing historic street plan has been renamed and numbered, it is difficult to identify exactly where these addresses were. James Dart was also an amateur musician with a large collection of violins, which undoubtedly impressed Hawley Crippen, a dedicated fiddler.

20 *Salt Lake Tribune*, July 16, 1910.

21 *Reno Gazette-Journal*, January 16, 1911.

22 *New York American*, July 16, 1910.

23 *Southern Journal of Homeopathy*, vol. 11 (February 1892).

24 By 1910 Crippen had long given up practicing as an ob-gyn and made an effort to hide that he had once been an expert in this field of medicine. William Bell was the only person to disclose this information to the press in relation to what he believed was the true cause of Charlotte's death.

25 *Reno Gazette-Journal*, January 16, 1911.

26 *Salt Lake Tribune*, July 16, 1910.

27 *New York American*, July 16, 1910.

4. KUNEGUNDE

1 Theodore Dreiser, *Sister Carrie* (New York, 1900).

2 Betty Smith, *A Tree Grows in Brooklyn* (New York, 1943), p. 43.

3 The Mersingers attended Most Holy Trinity Church in Williamsburg, where a baptismal record can be found for Katie. This is the same church attended by Betty Smith, author of *A Tree Grows in Brooklyn,* and her protagonist, Francie Nolan.

4 *St. Louis Post-Dispatch*, July 16, 1910.

5 *Times-Union* (Brooklyn), August 1, 1910; *Sun*, July 15, 1910.

6 *New York Times*, July 15, 1910.

7 Ibid., June 17, 1894.

8 KSU: Special Collections and Archives: Jonathan Goodman papers: Series 1: Publications by Goodman: Nonfiction, 1685–2005: Sub-Series 8: The Crippen File, 1845–1999: box 2, folder 3: Letter from Louise Mills to Filson Young, December 8, 1952.

9 *Detroit Free Press*, July 16, 1910.

10 KSU: Goodman papers: box 2, folder 3: Mills.

11 *Detroit Free Press*, July 16, 1910. Other family members said she "went to work for a family" as a servant, but not in what capacity.

12 *Brooklyn Daily Eagle*, March 20, 1887.

13 *New York Times*, September 29, 1896; Ancestry.com: Norfolk County, MA: Probate File Papers, 1793–1900 Page(s): 28814:2 Volume: Norfolk Cases28000-29999, "Estella H. Lincoln."

14 On the weekend before Easter in 1892, the Lincoln brothers appear to have been out of town and Cora had been allowed to have her sister

Katie to stay with her for several days. For some unknown reason, her fourteen-year-old sister left the house on Lafayette Avenue on Easter Sunday morning but did not immediately return home to the Mersingers. A Mrs. M. Turner then went to the police to report a missing person. Eventually, Katie did return home but where she had disappeared to remains a mystery (*Standard Union* (Brooklyn), April 20, 1892; *Brooklyn Citizen*, April 20, 1892).

15 Smith, *A Tree Grows*, pp. 227–34.

16 The Comstock Act made even advertising an abortifacient, or an "instrument of contraception," punishable by law.

17 Ivy Anderson and Devon Angus (eds), *Alice: Memoirs of a Barbary Coast Prostitute* (Berkeley, 2016), p. 152. Alice's story was serialized in 1913 in the *San Francisco Bulletin*, a campaigning newspaper. Under a promise of anonymity, Alice told her story to journalists, who turned it into an exposé on prostitution. The series was so successful that it encouraged other women who had had experience of sex work to write letters to the newspaper, relating their stories.

18 Ibid., pp. 166–8.

19 *Standard Union* (Brooklyn), December 13, 1894.

20 NA: DPP 1/13: *Rex* v *Crippen* trial transcripts.

21 Filson Young (ed.), *The Trial of Hawley Harvey Crippen* (Edinburgh and London, 1920).

22 Ibid.

23 See also the *Medical Century: The National Journal of Homeopathic Medicine* (January 1893).

24 Ibid.

25 *Chicago Daily Tribune*, "Marriage by Wholesale," June 2, 1890.

26 *Detroit Free Press*, July 16, 1910. If Cora did appear on the stage of the Star Theater, it is more likely to have been the Star in Brooklyn, with its associations with German-language performance.

27 *Sun* (New York), July 15, 1910.

28 *Medical Century*, vol. 1, no. 2 (February 1893).

29 Ibid. (April 1893).

30 *Champaign Daily Gazette*, December 19, 1891.

31 *St. Louis Globe-Democrat*, July 16, 1910.

32 *St. Louis Post-Dispatch*, July 16, 1910.

33 *St. Louis Globe-Democrat*, July 16, 1910.

34 *Brooklyn Citizen*, August 1, 1910.

35 Ibid.

36 *St. Louis Post-Dispatch*, July 16, 1910.

37 *Los Angeles Herald*, July 15, 1910.

38 *Weekly Dispatch*, February 15, 1920.

39 Ibid.

5. GRAND OPERA

1 Phil Porter, "Ovariotomy," *American Journal of Obstetrics and Gynaecology* (Ann Arbor, 1885); Phil Porter, "Double Ovariotomy," *Ann Arbor Medical Advance* (1884).

2 William Goodell and W. Constantine Goodell, "Diseases of the Ovaries and Tubes," *Annual of the Universal Medical Sciences*, vol. 4 (Philadelphia, 1888), p. 94.

3 Phil Porter, "Ovariotomy," p. 201.

4 Sally Frampton, "Defining Difference: Competing Forms of Ovarian Surgery in the Nineteenth Century," *Technological Change in Modern Surgery: Historical Perspectives on Innovation*, ed. Thomas Schlich and Christopher Crenner (Rochester, NY, May 15, 2017), ch. 3; Ornella Moscucci, *The Science of Woman: Gynaecology and Gender in England, 1800–1929* (Cambridge, 1990), pp. 148–9.

5 Phil Porter, "Neurasthenia-Oöphorectomy," *American Homeopathic Journal for Obstetrics and Gynaecology*, vol. I (1885), p. 90.

6 *The Medical Advance*, vol. 14 (1884), p. 673; H. H. Crippen, "From Our London Correspondent," *The American Journal for Obstetrics and Gynaecology*, vol. 1 (1885).

7 NA: HO 144/1719/195492: Crippen's explanation of his wife's scar, 1910.

8 Ibid.

9 NA: DPP 1/13: Teresa Hunn police statement, November 1910.

10 KSU: Goodman papers: box 2, folder 3: Mills.

11 NA: DPP 1/13: Anonymous "Friend" police statement, n.d.

12 Ibid.: Adeline Harrison further police statement, n.d.

13 Ibid.: Hunn statement.

14 Ibid.: Antonia Jackson, boarding-house keeper in Bath, police statement, August 18, 1910.

15 Ibid.: Maud Burroughs further police statement, September 16, 1910.

16 Elinor Cleghorn, *Unwell Women* (London, 2021), p. 144.

17 NA: MEPO 2/10996: Gifts to the Metropolitan Police "Black" Museum: translated letter from Paul Martin, "Crippen on Board," *Sun* (New York), July 15, 1910. Crippen's employer Munyon remembers Cora as weighing "160 pounds" when they lived in Philadelphia.

18 Thomas Spencer Wells, *Modern Abdominal Surgery: The Bradshaw Lecture Delivered at the Royal College of Surgeons of England, December 18th, 1890* (London, 1891), p. 43.

19 H. H. Hahn, "Electricity in Gynaecology," *Journal of the American Medical Association*, vol. 20 (1893), p. 328; Lawrence D. Longo, "Electrotherapy in Gynaecology: The American Experience," *Bulletin of the History of Medicine*, vol. 60, no. 3 (Fall 1986), p. 351.

20 *Daily Telegraph*, July 16, 1910.

21 Charles Morris (ed.), *Men of the Century: An Historical Work* (Philadelphia, 1896), p. 193.

22 *New York Times*, March 11, 1918.

23 Samuel Hopkins Adams, "The Great American Fraud: The Patent Medicine Conspiracy Against the Freedom of the Press," *Collier's Weekly*, November 4, 1905.

24 *Philadelphia Inquirer*, July 15, 1910.

25 NA: DPP 1/13: Teresa Hunn, further statement, October 15, 1910.

26 Probably intended to be the *Journal of Ophthalmology, Otology and Laryngology*, of which Crippen was an assistant editor.

27 *Philadelphia Inquirer*, March 3, 1895.

28 *Philadelphia Times*, March 25, 1894.

29 William Armstrong, *Lillian Nordica's Hints to Singers* (New York, 1922), pp. 88–9.

30 NA: DPP 1/13: Hawley Harvey Crippen statement to Inspector Dew, July 8, 1910.

31 *New York Times*, July 15, 1910.

6. LADY TYPEWRITER

1 E. T. Cook, *Highways and Byways in London* (London, 1920; Project Gutenberg, 2012, https://www.gutenberg.org/files/39875/39875-h/39875-h.htm).

2 "Female Clerks and Book-keepers," *The Girl's Own Paper*, vol. 1, May 15, 1880, p. 309.

3 Gregory Anderson (ed.), *The White-Blouse Revolution: Female Office Workers Since 1870* (Manchester, 1988), p. 34, table 2.3.

4 Michael Heller, *London Clerical Workers, 1880—1914: Development of the Labour Market* (London, 2010).

5 Walter Neave said he performed at St. Andrew's Hall, a concert venue in Norwich, in "The Life Story of Ethel Le Neve, by Her Father," *Answers*, August 27, 1910.

6 "I nursed Le Neve: Chesterfield man's story," *Derbyshire Courier*, October 29, 1910.

7 Neave, *Answers*, August 27, 1910.

8 *Ethel Le Neve: Her Life Story: With the true account of their flight and her friendship for Dr. Crippen; also startling particulars of her life at Hilldrop Crescent, told by herself* (London, 1910).

9 Nancy Jackman and Tom Quinn, *The Cook's Tale* (London, 2012), p. 22.

10 Ethel's brother Bernard was born in 1890.

11 *Hampstead & Highgate Express*, January 21, 1888.

12 Le Neve, *Life Story*.

13 Ibid.

14 Neave, *Answers*, September 3, 1910.

15 Le Neve, *Life Story*.

16 Neave, *Answers*, August 27, 1910.

17 *Musical Times*, March 1 and May 1, 1901. Walter was also advertising himself as both an alto and soprano soloist in the 1902 *Musical Times*: "Sacred and Ballad songs a speciality." His performances were reviewed favorably in the *Paddington Times* and the *Church Times*.

18 *Daily Mail*, August 1, 1910.

19 Neave, *Answers*, August 27, 1910.

20 Ibid.

21 Deborah Gorham, *The Victorian Girl and the Feminine Ideal* (Oxford, 2013), p. 52.

22 Neave, *Answers*, September 17, 1910.

23 Clara Collet, *Educated Working Women* (London, 1902), p. 53.

24 B. C., "Stenographers—not 'Type-Writers': A Protest," *Shorthand Review* (August 1892).

25 It seems that Christ Church School, where Ethel attended, was already offering lessons in shorthand by 1891 and increased demand for lessons meant that an outside teacher had to be hired in 1895. Contrary to her story, it may be that her first exposure to this subject was through school (NA: ED 21/11578: Correspondence from Christ Church School).

26 *Thomson's Weekly News*, September 18, 1920.

27 Neave, *Answers*, August 27, 1910.

28 *Thomson's Weekly News*, September 18, 1920.

29 Neave, *Answers*, September 10, 1910.

30 *Thomson's Weekly News*, September 18, 1920.

31 Ibid.

32 Neave, *Answers*, August 27, 1910.

33 *Thomson's Weekly News*, September 18, 1920.

7. BELLE ELMORE

1 Mary H. Krout, *A Looker On in London* (New York, 1899), pp. 9–10; T. C. Crawford, *English Life Seen Through Yankee Eyes* (New York, 1889), pp. 7–8.

2 NA: DPP 1/13: Crippen statement.

3 William Archer, *The Theatrical World: 1895* (London, 1896), p. 100.

4 *National Review*, vol. 17 (1891), p. 258.

5 Adeline Harrison, "Belle Elmore, a Character Study," *John Bull*, December 10, 1910.

6 Ibid.

7 Ibid.

8 Ibid.

9 Ibid. In the *Music Hall and Theatre Review*, September 9, 1909, Adeline, writing her column "Frocks and Fancies" under the name of "Marjorie," describes selfitis as "a very prevalent disease, which if not checked in time becomes chronic. The majority of people are absorbed in self, dream self and worst of all constantly talk self."

10 *Weekly Dispatch*, February 15, 1920. Adeline Harrison enjoyed a very short stint on the stage in the 1890s performing her own work, but appears to have given up after receiving lukewarm reviews suggesting she was still young and had "time to improve" (*The Referee*, April 4, 1897).

11 Harrison, *John Bull*, December 10, 1910.

12 Ibid.

13 Ibid.

14 Ibid.

15 NA: DPP 1/13: Crippen statement.

16 Adeline later claimed she had written *An Unknown Quantity* for Cora, but it seems she first debuted the piece at the Bayswater Bijou on March 29, 1897 and played the female lead herself. The music was composed by her then lover, Denham Harrison (*The Era*, March 20, 1897).

17 Harrison, *John Bull*, December 10, 1910.

18 *Melbourne Argus*, August 20, 1910.

19 *Daily Mirror*, August 3, 1910.

20 *London Evening Standard*, September 24, 1898.

21 *North American*, July 15, 1910 and *Nottingham Evening Post*, July 30, 1910.

22 *Strand Magazine*, vol. 19 (1900), pp. 340–44.

23 The date of when precisely Miller met Belle changes from statement to statement. During his cross-examination, he insists it was December 1899, but in his official police statement he claims that he and Belle celebrated the night of their meeting on January 6, when "their friend" left for the United States. Crippen claims he departed in November 1899.

24 NA: DPP 1/13: *Rex* v *Crippen* trial transcripts, cross-examination of H. H. Crippen.

25 Ibid.

26 NA: DPP 1/13: Bruce Miller police statement, n.d.

27 The Crippens first lived at 34 Store Street and later at number 37.

28 NA: DPP 1/13: Miller statement.

29 On the 1901 census, Miller was living at 18 Colville Place, a small street of Georgian housing on the opposite side of Tottenham Court Road from the Crippens on Store Street.

30 NA: DPP 1/13: Miller statement.

31 Ibid.: *Rex* v *Crippen* trial transcripts, cross-examination of Bruce Miller.

32 Ibid.

33 This was based out of an office at 13 Newman Street, off Oxford Street.

34 *Daily Mail*, July 30, 1910.

35 *Daily Mirror*, July 19, 1910.

36 NA: DPP 1/13: Melinda May police statement, August 3, 1910.

37 NA: DPP 1/13: Crippen statement. An anonymous former clerk to Crippen's solicitor wrote an article for *The People* that appeared on April 23, 1933 in which he told an apocryphal story about seeing Belle one night in a pub with some entertainment friends who commented:

"Calls herself Belle Elmore . . . thinks she can dance too. Holy Pete! We've got a lot of outside competition on the halls but we haven't sunk to that. They did put her on for a few shows and she got the bird— feathers, beak and spurs."

38 *Melbourne Argus*, August 20, 1910.

39 *Music Hall and Theatre Review*, January 23, 1902; *The Era*, September 29, 1900.

40 *Portsmouth Evening News*, December 8, 1903 and January 5, 1904; *Derbyshire Times and Chesterfield Herald*, August 23, 1902; *Ealing Gazette and West Middlesex Observer*, October 11, 1902; *The Stage*, September 13, 1900.

41 *Weekly Dispatch*, February 15, 1920.

42 *Daily Mirror*, August 3, 1910.

8. "THE BUSINESS WITH DR. CRIPPEN"

1 Evan Yellon, *Surdus in Search of His Hearing* (London, 1906), pp. 6–7.

2 Hepar sulphuris calcareum appears in the *Materia Medica* as a homeopathic remedy for various types of hearing loss and afflictions of the ear. The Drouet plasters were found to contain iodine, cantharides and mustard powder. Physicians who testified at the libel trial of a former Drouet doctor, Hanna Nasif Dakhyl (*Dakhyl* v. *Labouchère*, 1907), stated that a sticking plaster placed behind the ear would effect no treatment at all but was likely to cause skin irritation.

3 *Truth*, June 21, 1900.

4 Ibid., February 18, 1904.

5 *The Times*, November 5 and November 8, 1907.

6 Ibid., November 9, 1907.

7 *Truth*, February 18, 1904.

8 *Thomson's Weekly News*, September 18, 1920.

9 Le Neve, *Life Story*.

10 *Thomson's Weekly News*, September 18, 1920.

11 *Daily Mirror*, July 21, 1910.

12 *Detroit Free Press*, July 16, 1910.

13 KSU: Goodman papers: box 2, folder 3: Mills.

14 *Thomson's Weekly News*, September 18, 1920. The assertion that Crippen had forged a close relationship with Ethel's father is also confirmed in Walter Neave's own version of events as related to the police in 1910, in

which he confirms that he had "known Dr. Crippen for 8 to 10 years" in 1910 (NA: DPP 1/13: Walter Neave police statement, July 14, 1910).

15 NA: DPP 1/13: Neave statement; ibid.: Adine True Brock police statement, July 21, 1910.

16 Le Neve, *Life Story*.

17 Neave, *Answers*, August 27, 1910.

18 *Dundee Evening Telegraph*, August 5, 1910.

19 Lt Col. Nathaniel Newnham-Davis, *Dinner and Diners: Where and How to Dine in London* (London, 1899).

20 James Tyson, *The Practice of Medicine: A Textbook for Practitioners and Students with Special Reference to Diagnosis and Treatment* (Philadelphia, 1897), p. 67.

21 *Southland Times*, August 26, 1910.

22 KSU, Goodman papers: box 2, folder 3: typescript "Notes of post-tape talk, March 1985" with Ethel Le Neve's children.

23 J. C. Ellis, *Black Fame* (London, 1928), p. 318.

24 Tom Cullen, *Crippen: The Mild Murderer* (London, 1988), p. 214.

25 Neave, *Answers*, September 3, 1910.

26 *Thomson's Weekly News*, September 25, 1920.

27 Le Neve, *Life Story*.

28 *Thomson's Weekly News*, September 25, 1920.

29 Ibid.

30 Ibid.

31 Le Neve, *Life Story*.

9. THE GARDEN OF EDEN

1 George H. Duckworth's Notebook: Police District 2 [Strand and St. Giles], Booth/B/355, p. 57, https://booth.lse.ac.uk/notebooks/b355.

2 NA: DPP 1/13: John Herbert Burroughs police statement, n.d.

3 Ibid.: Maud Burroughs police statement, n.d.

4 *Daily Express*, July 15, 1910.

5 Ibid.

6 *Islington Daily Gazette*, July 15, 1910.

7 George H. Duckworth's Notebook: Police and Publicans District 10, Booth/B/349, https://booth.lse.ac.uk/notebooks/b349.

8 Jessica H. Foy and Thomas J. Schlereth (eds), *American Home Life, 1880–1930: A Social History of Spaces and Services* (Knoxville, TN, 1994), p. 70.

9 Young, *Trial*, p. 13.

10 Ibid.

11 Various inventories of the Crippens' furniture sold at auction in 1910 and comments about the items can be found in numerous newspapers, including the *Daily News*, September 21, 1910, and the *Daily Chronicle*, September 21, 1910.

12 Foy and Schlereth, *American Home Life*, p. 54.

13 Le Neve, *Life Story*.

14 Harrison, *John Bull*, December 10, 1910.

15 NA: DPP 1/13: *Rex* v *Crippen* trial transcripts, testimony of Maud Burroughs; KSU: Goodman papers: box 2, folder 3: Mills.

16 *Daily Express*, July 15, 1910.

17 Ibid.

18 NA: DPP 1/13: Rhoda Ray police statement, n.d.

19 *Daily Express*, July 15, 1910.

20 "With the Men and Women of the Twice a Day," *New York Times*, May 6, 1906.

21 Harrison, *John Bull*, December 10, 1910.

22 Ibid.

23 KSU: Goodman papers: box 2, folder 3: Mills.

24 *Evening News*, July 15, 1910.

25 KSU: Goodman papers: box 2, folder 3: Mills.

26 Patricia Cornwell Private Collection: Letter from H. H. Crippen to "Lady Henry Somerset," October 7, 1910.

27 *Weekly Dispatch*, February 15, 1920.

28 NA: MEPO 2/10996: Gifts to the Metropolitan Police "Black" Museum: Reinisch correspondence and article.

29 *Daily Telegraph*, August 6, 1910.

30 Ibid.

31 NA: MEPO 2/10996: Reinisch correspondence and article.

32 KSU: Goodman papers: box 2, folder 3: Mills.

33 Ibid.

34 Ibid.

35 Filson Young. Young invented many anecdotes about the Crippens and how Belle misused her husband which have gone on to become

accepted "fact." The assertion that Crippen had to carry the coal upstairs is proved untrue by Crippen himself during his cross-examination. The couple had gas fires upstairs at Hilldrop Crescent and they only used coal for the kitchen range. Crippen said he "very seldom ever carried it."

36 KSU: Goodman papers: box 2, folder 3: Mills.

10. PETTY RAT SWINDLERS

1 *Truth*, August 4, 1904.

2 Ibid., June 4, 1903 and April 6, 1905.

3 *John Bull*, April 11, 1908.

4 Yellon, *Surdus*, pp. 4–5.

5 In a separate case, Kennedy was also found guilty of writing fraudulent checks and served concurrent sentences for this crime as well as for the American and Parisian massage scam.

6 *John Bull*, December 17, 1910; *The Globe*, July 8, 1902.

7 *The Dental Annual* (London, 1906), pp. 290—96.

8 NA: BT 31/11768/91259: Chemical Blood Manufacturing Company Ltd.

9 *Truth*, July 24, 1907; *Cornubian and Redruth Times*, March 21, 1907.

10 *Western Mail*, April 6, 1925.

11 *Daily Mail*, July 16, 1910.

12 NA: DPP 1/13: Gilbert Rylance police statement, September 19, 1910.

13 Ibid.: *Rex* v *Crippen* trial transcripts, testimony of Marion Curnow.

14 Ibid.: Edward Marr police statement, n.d.

15 *Evening Star* (Washington DC), July 16, 1910.

16 W. Buchanan-Taylor, *Shake the Bottle* (London, 1946), p. 91.

17 *Western Times*, July 29, 1910.

18 *Detroit Free Press*, July 16, 1910.

19 Ellis, *Black Fame*, pp. 113–14.

20 Neave, *Answers*, September 10, 1910.

21 *Buffalo Commercial*, April 22, 1915.

22 Patricia Cornwell Private Collection: Letter from Crippen to "Lady Somerset," October 5, 1910.

23 Neave, *Answers*, September 10, 1910.

24 Ellis, *Black Fame*, p. 318.

25 Royal Commission on Population, 1949, in Robert Jütte, *Contraception: A History* (Cambridge, 2008), p. 186.

26 NA: DPP 1/13: Brock statement.

27 Ibid.

28 Ibid.

29 NA: DPP 1/13: William Burgh police statement, n.d.

30 *New York Tribune*, July 16, 1910.

31 *Detroit Free Press*, July 16, 1910.

11. 80 CONSTANTINE ROAD

1 NA: DP 1/13: Emily Jackson police statement, July 15, 1910.

2 Ibid.

3 *Los Angeles Herald*, July 15, 1910.

4 Barbara Brookes, *Abortion in England: 1900–1967* (Oxford, 1988), p. 4.

5 In 1916, in the city of York, it was estimated that "at least seven and probably eight in ten" working-class women used abortifacient drugs at least once in the course of their reproductive lives. Prosecutions for abortion were also on the rise throughout England between 1900 and 1910 (Brookes, *Abortion*, p. 5 and p. 28).

6 Le Neve, *Life Story*.

12. LADIES OF THE GUILD

1 *Music Hall and Theatre Review*, March 8, 1907.

2 Pony Moore was a celebrity noted as much for his "generous nature" as he was for breaking speeding laws and beating up waiters and tram operators. Michael Bennett Leavitt calls him a foul-mouthed rough diamond. See Michael Bennett Leavitt, *Fifty Years in Theatrical Management* (London, 1912), and George Robert Sims, *My Life: Sixty Years of Recollections of Bohemian London* (London, 1917).

3 *The Stage*, November 26, 1908.

4 *Music Hall and Theatre Review*, September 9, 1909.

5 Ibid.

6 Andrew Lamb, *Leslie Stuart: Composer of Florodora* (Abingdon, 2020).

7 *Weekly Dispatch*, February 15, 1920.

8 The Crippens had become so close to Pony Moore and Eugene and Annie Stratton that in October of that year, they were listed among the chief mourners at his funeral.

9 *Weekly Dispatch*, February 15, 1920.

10 NA: DPP 1/13: Maud Burroughs statement.

11 *Weekly Dispatch*, February 15, 1920.

12 Walter Wood, *Survivors' Tales of Famous Crimes* (London, 1916), pp. 263–4.

13. PROMISES

1 *Daily Mirror*, March 3, 1910.

2 NA: DPP 1/13: Emily Jackson coroner's deposition, n.d.

3 *Staffordshire Sentinel*, July 18, 1910.

4 NA: DPP 1/13: John William Stonehouse police statement, n.d.

5 Censuses, 1901 and 1911. Stonehouse eventually remarried in 1914, though there is no record that he ever divorced, and his first wife, Dorothy Ann Graham (whom he married in 1893), was still alive at the time. His second wife had been a fellow lodger at the house where he had lived after leaving Mrs. Jackson's.

6 NA: DPP 1/13: John Young Sellar police statement, n.d.; NA: MEPO 3 /198: Police report July 28, 1910 re. John Young Sellar.

7 David James Smith posits this theory in his book *Supper with the Crippens* (London, 2005).

8 NA: WO 363: Soldiers' Documents, First World War: Horace George Brock conscription records; Ivy Ethel Brock birth certificate (Ancestry. com: London, England, UK: Church of England Births and Baptisms, 1813–1923 [database online]).

9 NA: DPP 1/13: Stonehouse statement.

10 NA: MEPO 3/198: C. J. Thompson of Harvey & Thompson Ltd police statement, n.d.

11 *Sheffield Evening Telegraph*, July 16, 1910 (originally printed in the *Daily Mail*).

12 *Staffordshire Sentinel*, July 18, 1910.

13 The date of Crippen's order varies—Hetherington says he recalled it being the 17th, but the British Drug Houses Ltd., the wholesaler from where he sourced the hyoscine, had a record of the order being made on the 15th.

14 NA: DPP 1/13: Pre-trial Brief to Counsel: Charles Hetherington statement.

15 Ibid.

16 *The Daily Chronicle*, July 18, 1910.

17 Ibid.: Lydia Rose describes a different engagement ring, "a lovely diamond ring, with four nice-sized stones in it, set on the cross in

pairs." It's possible that Crippen had bought Ethel more than one engagement ring, though Ethel later showed the solitaire to Mrs. Jackson and said, "That is my proper engagement ring." (DPP 1/13: Emily Jackson further police statement, July 21, 1910.)

14. POTLUCK

1 NA: DPP 1/13: *Rex* v *Crippen* trial transcripts, cross-examination of H. H. Crippen.

2 NA: DPP 1/13. The entire account of events is documented in a detailed letter written by Clara Martinetti on July 20, 1910 and addressed to the police (Inspector Dew).

15. RISING SUN

1 NA: DPP 1/13: Letter from Clara Martinetti to Inspector Dew.

2 *The Era*, February 22, 1892.

3 NA: DPP 1/13: *Rex* v *Crippen* trial transcripts, cross-examination of Melinda May.

4 Ibid.

5 *Bristol Times and Mirror*, September 7, 1910.

6 http://kurtofgerolstein.blogspot.com/2020/07/cartesians-murder-she-said.html.

7 NA: DPP 1/13: John Nash coroner's deposition, July 18, 1910.

8 *Bristol Times and Mirror*, September 7, 1910.

9 NA: DPP 1/13: Clara Martinetti coroner's deposition, July 18, 1910.

10 NA: DPP 1/13: Paul Martinetti police statement, July 4, 1910.

11 Ibid.: Paul Martinetti further police statement, July 18, 1910.

12 Ibid.

13 Ibid.: *Rex* v *Crippen* trial transcripts, cross-examination of Clara Martinetti.

14 Ibid.: *Rex* v *Crippen* trial transcripts, cross-examination of Louise Smythson.

15 NA: T 1/11282/6329: J. E. Nash application for compensation in respect of losses incurred by himself and his wife.

16 NA: DPP 1/13: Annie Stratton police statement, n.d.; ibid.: *Rex* v *Crippen*, cross-examination of Clara Martinetti.

17 *Morning Leader*, July 18, 1910.

18 NA: DPP 1/13: John Nash police statement, June 30, 1910.

19 *Daily News*, July 18, 1910.

16. "BRAZEN THE WHOLE THING OUT"

1 *Thomson's Weekly News*, October 9, 1920.

2 Ibid.

3 Ibid.

4 Le Neve, *Life Story*.

5 *Thomson's Weekly News*, October 9, 1920; Le Neve, *Life Story*.

6 *Thomson's Weekly News*, October 9, 1920.

7 Ibid.

8 NA: DPP 1/13: Paul Martinetti further statement, July 18, 1910; Buchanan-Taylor, *Shake the Bottle*, pp. 92–3.

9 *The Era*, February 26, 1910.

10 *Thomson's Weekly News*, October 20, 1920.

11 Ibid., October 9, 1920.

12 Ethel gave four "official" versions of her story: one to the police in July 1910; another for the publication of her memoirs (her *Life Story*) in the second half of that year; a third one to *Thomson's Weekly News* in 1920, which ran as a serialization between September 1920 and January 1921; and a fourth to *Thomson's Weekly News* again in 1928, in which much of her narrative from 1920 is repeated. Other versions of her story have appeared, including one by Ursula Bloom (1954), which was fictional.

13 *Thomson's Weekly News*, October 1, 1920.

14 Le Neve, *Life Story*.

15 NA: DPP 1/13: Emily Jackson further police statement, July 18, 1910.

16 Ibid.

17 Ibid.: Emily Jackson coroner's inquest statement, n.d.

18 Ibid.: Jackson further statement, July 15, 1910.

17. MRS. CRIPPEN

1 NA: DPP 1/13: Jackson further statement, July 18, 1910.

2 Ibid.

3 Ibid.: Jackson coroner's deposition.

4 Ibid.

5 Ibid.: Pawn slips from Jay Richard Attenborough & Co.

6 Despite the enormous publicity the case received in the press, only Attenborough & Co. came forward with items of Belle's property. No more than a fraction of her jewelry was ever recovered.

7 NA: DPP 1/13: Jackson further statement, July 21, 1910.

8 *Nottingham Evening Post*, July 16, 1910.

9 NA: DPP 1/13: Caroline Elsmore police statement, n.d.

10 Ibid.: Jackson further statement.

11 Ibid.: Brock statement.

12 Le Neve, *Life Story*.

13 NA: DPP 1/13: Brock statement.

14 Ibid.

15 *Staffordshire Sentinel*, July 18, 1910.

16 *Daily Mail*, August 1, 1910.

17 NA: DPP 1/13: Neave statement.

18 Ibid.

19 Arthur Symons, *Cities and Sea-Coasts and Islands* (New York, 1919), pp. 228–9.

20 NA: DPP 1/13: Brock statement.

18. OBSERVATIONS AND INQUIRIES

1 NA: DPP 1/13: *Rex v Crippen*, testimony of Clara Martinetti.

2 Ibid.: Clara Martinetti statement.

3 Ibid.

4 Ibid.: Paul Martinetti further statement, July 18, 1910.

5 Ibid.: Clara Martinetti statement.

6 Gilbert Rylance in fact did know that Mrs. Crippen was unwell, as he later confessed in his witness statement, but for whatever reason chose not to reveal this knowledge to Mrs. Martinetti.

7 NA: DPP 1/13: Clara Martinetti statement.

8 Ibid.

9 https://www.playingpasts.co.uk/articles/football/and-i-mean-that-most -sincerely-theater-and-the-birth-of-womens-football/.

10 https://pasttopresentgenealogy.co.uk/2019/06/12/pioneers-of-the-fifa -womens-world-cup-the-first-football-internationals/.

11 NA: DPP 1/13: Clara Martinetti statement; ibid.: Louise Smythson police statement, July 14, 1910.

12 Ibid.: *Rex v Crippen*, cross-examination of Clara Martinetti.

13 Ibid.: Clara Martinetti statement.

14 *Los Angeles Herald*, July 15, 1910.

15 Ibid.: Smythson statement.

16 *The Performer*, July 21, 1910.

17 NA: DPP 1/13: Smythson statement.

18 Ibid.: Marion Curnow coroner's deposition, September 26, 1910.

19 Wood, *Survivors' Tales*, p. 271.

20 *The Performer*, July 21, 1910.

21 NA: DPP 1/13: Clara Martinetti statement; also ibid.: *Rex* v *Crippen*, testimony of Clara Martinetti.

22 *Lloyd's Weekly Newspaper*, July 17, 1910.

23 NA: DPP 1/13: Michael Bernstein police statement, July 17, 1910.

24 *Lloyd's Weekly Newspaper*, July 17, 1910.

25 *The Globe*, July 15, 1910.

26 Wood, *Survivors' Tales*, p. 272.

27 Ibid.

28 *Lloyd's Weekly Newspaper*, July 17, 1910.

29 NA: MEPO 3/198: Walter Dew Missing Person's report, July 6, 1910.

30 NA: DPP 1/13: *Rex* v *Crippen* trial transcripts, testimony of Louise Smythson.

31 *Lloyd's Weekly Newspaper*, July 17, 1910.

19. THE BAD GIRL OF THE FAMILY

1 NA: DPP 1/13: Jackson statement.

2 Ibid.: Letter from Ethel Le Neve to Emily Jackson, n.d.

3 Ibid.: Brock statement.

4 Ibid.: Elizabeth Burtwell police statement, July 29, 1910.

5 Ibid.: William Curtis police statement, August 19, 1910.

6 Symons, *Cities*, p. 227.

7 *The Graphic*, July 23, 1910.

8 NA: DPP 1/13: Letter from Ethel Le Neve to Emily Jackson, n.d., probably mid-June 1910.

9 A Post Office clerk who discovered the withdrawal slips among the files in 1911 and recognized the name Belle Elmore noted that the signatures had been made after her death. An investigation was made by the Post Office and the Treasury Office, who determined that the handwriting

seemed closest to Ethel Le Neve's specimens, but "the forgeries were very good." The Treasury decided not to press charges (NA: T 1/11335).

10 NA: DPP 1/13: Curnow coroner's deposition. Mention of the piece of blotting paper with Belle's signature designed for Ethel's use was omitted from Marion's deposition statement and deliberately avoided during her cross-examination on the witness stand.

11 Ibid.; also MEPO 3/198: Sergeant Arthur Mitchell's report. On July 11 Sergeant Mitchell found a sheet of paper with Belle Elmore's name written on it several times, as if somebody had been practicing writing it.

12 Old Bailey Sessions Papers Online: Gwendoline Howell, Deception; forgery, October 16, 1905. Annie Warner, Deception; forgery, October 8, 1912.

13 The DPP decided when charging Crippen with murder that they would not further investigate the possibility he forged her signature on these checks, as it would require an additional set of charges to be brought and possibly a further trial.

14 *Staffordshire Sentinel*, July 18, 1910.

15 *Strabane Chronicle*, July 23, 1910.

16 NA: DPP 1/13: Neave statement.

17 Neave, *Answers*, September 3, 1910.

18 Ibid.

19 NA: DPP 1/13: Paul Martinetti further police statement, August 1, 1910.

20 Ibid.: Paul Martinetti further statement, July 18, 1910.

21 *Daily News*, September 20, 1910.

22 NA: DPP 1/13: Jackson statement.

20. "SOME LITTLE TOWN IN SAN FRANCISCO"

1 *Camden Courier-Post* (New Jersey), October 25, 1910.

2 *Boston Globe*, August 16, 1910.

3 NA: DPP 1/13: Letter from Frank Wiggins to Mr. Van S. Roosa, n.d.

4 *Daily News*, July 18, 1910.

5 NA: DPP 1/13: Nash coroner's deposition.

6 NA: MEPO 3/198: Dew, Missing Person's report.

7 Probably a misspelling of Alamo, California, 22 miles from San Francisco.

8 NA: MEPO 3/198: Dew, Missing Person's report.

9 Ibid.

10 NA: T 1/11282/6329: Nash application for compensation.

11 Nicholas Connell (ed.), *The Annotated I Caught Crippen: Memoirs of Ex-Chief Inspector Walter Dew, C.I.D.* (London, 2018).

12 Ibid.

21. SERIOUS TROUBLE

1 *Thomson's Weekly News*, October 16, 1920.

2 NA: DPP 1/13: Walter Dew investigation report, September 5, 1910.

3 Connell, *I Caught Crippen*.

4 *Thomson's Weekly News*, October 16, 1920.

5 Le Neve, *Life Story*; *Thomson's Weekly News*, October 16, 1920.

6 NA: DPP 1/13: Walter Dew "Information" laid for arrest warrant, July 16, 1910; Walter Dew deposition, July 18, 1910; Arthur Mitchell investigation report, "Crippen and Le Neve wanted for murder," July 25, 1910.

7 Connell, *I Caught Crippen*; *Thomson's Weekly News*, October 16, 1920.

8 Le Neve, *Life Story*.

9 Connell, *I Caught Crippen*.

10 Le Neve, *Life Story*; *Thomson's Weekly News*, October 16, 1920.

11 Le Neve, *Life Story*.

12 Dew later covered for his error by claiming, "I am quite sure Miss. Le Neve had no ulterior motive in forestalling us in this way. All she was thinking of was Dr. Crippen and his business." (Connell, *I Caught Crippen*.)

13 Connell, *I Caught Crippen*.

14 NA: MEPO 3/198: Dew Missing Person's report.

15 Connell, *I Caught Crippen*.

16 Ibid.

17 NA: DPP 1/13: Crippen statement.

18 Ibid.

19 Connell, *I Caught Crippen*.

20 NA: DPP 1/13: Crippen statement.

21 Ibid.

22 Ibid.

23 Dew in his memoirs claims it was 6 p.m., and Ethel in her 1910 account claims it was nearly 4 p.m. If Dew had spent five hours with Crippen,

and had begun his interview around 12 noon, 5 p.m. would be more accurate.

24 Connell, *I Caught Crippen*.

25 Ibid.; NA: DPP 1/13: Crippen statement.

26 Le Neve, *Life Story*.

27 NA: DPP 1/13: Le Neve statement.

28 Ibid.

29 Le Neve, *Life Story*.

30 *Thomson's Weekly News*, October 16, 1920.

31 Le Neve, *Life Story*.

32 *Thomson's Weekly News*, October 16, 1920.

33 Connell, *I Caught Crippen*.

34 Ibid.

35 In Dew's memoirs he imagines that Crippen had a revolver in his pocket which he would have been prepared to use should Dew have discovered anything suspicious (Connell, *I Caught Crippen*).

36 NA: DPP 1/13: Dew investigation report.

37 NA: DPP 1/13: Wanted ad.

38 *Daily Mail*, July 18, 1910.

39 Le Neve, *Life Story*.

40 Ibid.

22. "JUST A LITTLE SCANDAL"

1 Ibid.

2 Ibid.

3 *Evening Star* (Washington DC), July 16, 1910.

4 *Daily Mail*, July 18, 1910.

5 Ibid.

6 NA: DPP 1/13: Brock statement.

7 NA: DPP 1/13: William Long deposition statement, July 18, 1910.

8 NA: DPP 1/13: Marion Curnow deposition statement, September 26, 1910.

9 Ibid.

10 *Thomson's Weekly News*, October 23, 1920.

11 Ibid.; Le Neve, *Life Story*; *Yorkshire Evening Post*, August 4, 1910.

12 Le Neve, *Life Story*.

13 Ibid.; *Thomson's Weekly News*, October 23, 1920.

14 *Thomson's Weekly News*, October 23, 1920; Le Neve, *Life Story*.

23. PIECES

1 NA: DPP 1/13: Exhibit 16 in *Rex* v *Crippen*, letter from H. H. Crippen to Gilbert Rylance, July 11, 1910.

2 Connell, *I Caught Crippen*.

3 Jonathan Goodman, *The Crippen File* (London, 1985), p. 21.

4 *Manchester Guardian*, July 19, 1910.

5 *Lloyd's Weekly Newspaper*, July 17, 1910.

6 Ibid.

7 Connell, *I Caught Crippen*.

8 Ibid.

9 Ibid.

10 Old Bailey Sessions Papers Online: George Hume Killing, January 12, 1909.

11 In his statement, Mitchell claimed he was the one who dug with the poker and found the loosened bricks (NA: DPP 1/13).

12 Connell, *I Caught Crippen*.

13 DPP 1/13: Dew investigation report.

14 Connell, *I Caught Crippen*.

15 Ibid.

16 NA: DPP 1/13: Augustus Joseph Pepper coroner's inquest statement, September 19, 1910.

17 *British Medical Journal*, Obituary, August 13, 1910, pp. 416–17.

18 *The Times*, July 19, 1910.

19 The Crippen murder inspired a number of experienced police officials and lawyers to offer ridiculous theories about various aspects of the case in their memoirs. Melville Macnaghten suggested that Crippen might have taken his wife's head in a bag with him on his getaway to Dieppe and, eight weeks after the murder, thrown it overboard during the Channel crossing (Melville L. Macnaghten, *Days of My Years* (London, 1914), p. 201).

20 Wood, *Survivors' Tales*, p. 275.

21 Ibid., p. 277.

22 *Bristol Times and Mirror*, September 7, 1910.

23 NA: T 1/11282/6329: Nash application for compensation.

24 "Badgered by the Press," Walter Neave, *Answers*, October 1, 1910.

25 *Daily Mirror*, August 1, 1910.

26 *Los Angeles Times*, July 15, 1910.

27 Ibid.

24. MANHUNT

1 Connell, *I Caught Crippen*.

2 *The Sun* (New York), July 15, 1910.

3 *Brooklyn Daily Eagle*, July 14, 1910.

4 *The Sun* (New York), July 15, 1910.

5 Ibid.

6 *Brooklyn Daily Eagle*, July 15, 1910.

7 Ibid., July 14, 1910.

8 *Brooklyn Citizen*, July 15, 1910.

9 *New York Times*, July 16, 1910.

10 *New York American*, July 16, 1910.

25. TITINE AND OLD QUEBEC

1 *Daily Mail*, July 26, 1910.

2 *Thomson's Weekly News*, October 23, 1920.

3 Ibid.

4 Ibid.

5 Le Neve, *Life Story*.

6 *Daily Mail*, July 26, 1910.

7 Ibid.

8 Le Neve, *Life Story*.

9 *Thomson's Weekly News*, October 30, 1920. In an interview with *Reynolds Newspaper* on July 31, 1910, Madame Henry-Delisse claims that the Robinsons told them they never went to the Exposition, and explained "we are rather eccentric."

10 *Thomson's Weekly News*, October 30, 1920.

11 Ibid.

12 *Daily Mail*, July 26, 1910.

13 *Reynolds Newspaper*, July 31, 1910.

14 Ibid.

15 NA: DPP 1/13: CID/Scotland Yard report on John Robinson and John Robinson Junior, July 24, 1910.

16 Ibid.

17 *Reynolds Newspaper*, July 31, 1910.

18 NA: DPP 1/13: List of jewelry and furs.

19 *Daily Mail*, July 26, 1910.

20 NA: DPP 1/13: Belgian police interviews with Louisa Delisse Henry and Vital Henry, July 30, 1910.

21 *Thomson's Weekly Newspaper*, October 30, 1920.

22 NA: DPP 1/13: Port of Antwerp, Metropolitan Police report, July 25, 1910.

23 *Thomson's Weekly Newspaper*, October 30, 1920.

24 Ibid.

25 Ibid.

26 H. G. Kendall, *Adventures on the High Seas* (London, 1939), p. 155.

27 Ibid.

28 Ibid., p. 156.

29 Ibid., p. 157. By 1910, commercial sanitary napkins were widely available to purchase in shops and by mail order; however, while dressed as a man, Ethel would have raised suspicion and drawn attention to herself if she had walked into a shop in Brussels and bought these necessities. The pair would be on the run for twenty-three days and it is not difficult to imagine that, within that time, Ethel would have had to contend with her period without the appropriate products, and while wearing men's clothing.

30 Ibid.

31 Ibid., p. 160. Interestingly, Ethel's mother later admitted that the photo which appeared in all the newspapers purporting to be of Ethel was actually a picture of Nina. Ethel never liked any photos that were taken of her and destroyed them all. When the police came looking for an image of her they could use, Charlotte and Walter Neave could only offer a photograph of Nina as a near likeness.

32 Ibid., p. 163.

33 Ibid., p. 164.

34 Ibid., p. 165.

26. CRIME OF THE CENTURY

1 *San Francisco Bulletin*, July 30, 1910.

2 *Brooklyn Citizen*, July 30, 1910; *Montreal Daily Star*, July 30, 1910.

3 Kendall, *Adventures*, p. 165.

4 Ibid.

5 Ibid., p. 168.

6 *Daily Mirror*, August 2, 1910.

7 Le Neve, *Life Story*.

8 *Thomson's Weekly News*, November 6, 1920.

9 Le Neve, *Life Story*.

10 Kendall, *Adventures*, p. 166.

11 Ibid., p. 172.

12 Ibid.

13 Ibid., p. 176.

14 Le Neve, *Life Story*.

15 Ibid., p. 178.

16 Ibid.

17 Ibid., p. 179.

18 Connell, *I Caught Crippen*.

19 Ibid.

20 *Thomson's Weekly News*, November 16, 1920; Le Neve, *Life Story*.

21 Connell, *I Caught Crippen*.

22 *Thomson's Weekly News*, November 16, 1920.

23 Le Neve, *Life Story*.

24 *Daily Mirror*, August 2, 1910.

25 *Illustrated Police News*, August 13, 1910.

26 Connell, *I Caught Crippen*.

27 *Illustrated Police News*, August 13, 1910; *Daily Mirror*, August 2, 1910; *Ottawa Free Press*, August 2, 1910; *Lloyd's Weekly Newspaper*, August 7, 1910; *Thomson's Weekly News*, August 6, 1910.

28 *New York Times*, August 1, 1910.

29 *Daily Mirror*, August 2, 1910.

30 Kendall believed differently. As no stranger to the tricks deployed by stowaways, he was convinced that Crippen had planned to leave the card in order to fake his own death. He would then hide on board until they had come into port and, under cover of darkness, creep ashore, thereby avoiding the scrutiny of the Canadian authorities.

31 Connell, *I Caught Crippen*.

32 Ibid.

33 Kendall, *Adventures*, p. 182.

34 *Reynolds Newspaper*, August 7, 1910.

35 The *Laurentic* was fitted with three propellers powered by triple expansion engines for the starboard and port propellers, and a turbine for the central propeller. At the time, this innovation had become the fastest and most economical method of powering a ship. White Star Line used this technology, making slight adjustments when it launched the *Titanic* two years later.

36 *Daily Mail*, July 17, 1910.

37 Ibid., July 18, 1910.

38 *Islington Daily Gazette*, July 15, 1910; *Nottingham Journal*, July 18, 1910.

39 *Islington Daily Gazette*, July 15, 1910; *The Globe*, July 15, 1910.

40 *Daily Mail*, July 31, 1910; *Staffordshire Sentinel*, August 1, 1910.

27. HOMECOMING

1 *Sun* (New York), August 2, 1910.

2 *San Francisco Examiner*, August 2, 1910.

3 Ibid.

4 *Daily Telegraph*, August 2, 1910. Interestingly, the *New York Times* on that same date reported that Ethel had read the messages "without comment."

5 *New York Times*, August 2, 1910.

6 *San Francisco Examiner*, August 2, 1910.

7 *New York Times*, August 2, 1910.

8 *Daily Mail*, August 2, 1910; *Sun* (New York), August 2, 1910.

9 Ibid.; *New York Times*, August 2, 1910.

10 Connell, *I Caught Crippen*.

11 *Lloyd's Weekly Newspaper*, August 7, 1910.

12 As David James Smith points out in *Supper with the Crippens*, pp. 177–8, these were also the precise words that Crippen used upon his arrest: "She knows nothing about it."

13 *Thomson's Weekly News*, November 20, 1920.

14 Ibid.

15 *Lloyd's Weekly Newspaper*, August 7, 1910.

16 Ibid.

17 *Thomson's Weekly News*, November 20, 1920.

18 Ibid.

19 Ibid.

20 Moments before, Crippen had had a mishap and walked into a ship's rope which would have thrown him from the gangway had Dew not caught him.

21 Contrary to Dew's assertion, the surviving passenger list has them under their actual names. NA: BT26/422.

22 Connell, *I Caught Crippen*.

23 Ibid.

24 Ibid.

25 Ibid.

26 Le Neve, *Life Story*. Ethel also claimed in her 1920 interview in *Thomson's Weekly News* (November 27) that she asked Dew if she could see Crippen and he said that it would prove difficult as he didn't want to alert other passengers to their presence on board. He suggested they might see each other once they were off the ship.

27 Connell, *I Caught Crippen*.

28 Ibid.

29 Dornford Yates, *As Berry and I Were Saying* (Cornwall, 2001), p. 258.

30 Le Neve, *Life Story*.

31 *Thomson's Weekly News*, November 27, 1920.

32 Connell, *I Caught Crippen*.

33 *Reynolds Newspaper*, August 28, 1910.

34 *Thomson's Weekly News*, November 27, 1920.

35 Ibid.

36 Ibid., December 4, 1920.

37 Ibid.

38 *Reynolds Newspaper*, August 28, 1910.

39 *Lloyd's Weekly Newspaper*, August 28, 1910.

40 Ibid.

41 *New York Times*, August 3, 1910.

28. SPECTACLE

1 George R. Sims, *The Mysteries of Modern London* (London, 1906; Project Gutenberg, 2015, https://www.gutenberg.org/files/49701/49701-h/49701-h.htm).

2 Percy Hetherington Fitzgerald, *Chronicles of Bow Street Police-Office*
 (London, 1888), pp. 214–15.

3 According to *Thomson's Weekly News*, December 4, 1920, this was the
 first time in the history of Bow Street Magistrates' Court that a
 filmmaker was present to record the day. How much they caught on
 camera is unknown. At this time photography was not yet banned in
 the courtroom, but was also not encouraged.

4 S. T. Felstead and Lady Muir, *Sir Richard Muir: A Memoir of a Public
 Prosecutor* (London, 1927), p. 1.

5 Nicholas Connell, *Doctor Crippen: The Infamous London Cellar Murder of
 1910* (Stroud, 2013), p. 133.

6 *The Times*, September 7, 1910.

7 Yates, *Berry and I*, pp. 256–7.

8 *The People*, January 4, 1925.

9 Buchanan-Taylor, *Shake the Bottle*, p. 94.

10 *Thomson's Weekly News*, December 4, 1920.

11 *Reynolds Newspaper*, September 25, 1910.

12 *The Times*, September 22, 1910.

13 NA: DPP 1/13: Note from the Director in *Rex* v *Crippen and Le Neve*,
 October 6, 1910.

14 Louise Mills later stated in her letter from 1952 that originally she had
 been asked to come to London to testify but fell ill and could not make
 the journey (KSU: Goodman papers: box 2, folder 3: Mills).

15 NA: MEPO 3/198: Special Officer's Special Report, C.I.D., concerning
 Teresa Hunn's appearance at Crippen's trial, August 23, 1910.

16 Ibid.: Special Officer's Special Report, C.I.D., concerning the burial of
 the remains of Belle Elmore, October 10, 1910.

17 *The Globe*, October 11, 1910.

18 Joseph Meaney, *Scribble Street* (London, 1945), pp. 58–9.

19 Thomas Grant, *Court Number One: The Old Bailey Trials that Defined
 Modern Britain* (London, 2019), p. 417.

20 *Daily Mirror*, October 18, 1910.

21 Women only became eligible to serve on English juries with the passing
 of the Sex Disqualification (Removal) Act of 1919. It would be a further
 two years before this act was implemented in 1921.

22 *Daily Mirror*, October 19, 1910.

23 *American Law School Review* (1920), p. 557.

24 Young, *Trial*, pp. 43–4.

25 Ibid., p. 53.

26 Ibid., p. 87.

27 NA: DPP 1/13: *Rex* v *Crippen* trial transcripts.

28 NA: DPP 1/13: *Rex* v *Crippen* trial transcripts. When Travers
 Humphreys had put this same question to Burroughs at the committal
 on September 6, he had amended his statement by saying "she was at
 times hasty toward him, but not more so than one often sees in life"
 (*Westminster Gazette*, September 6, 1910). In his police statement,
 Burroughs went further to say that while they were neighbors, he had
 "never heard any quarrels."

29 Black mourning ribbons or "love ribbons" were often worn by poorer
 families who could not afford to purchase full sets of mourning clothes
 when grieving a family member.

30 *Daily Mirror*, October 19, 1910; *London Evening Standard*, October 19, 1910.

31 NA: DPP 1/13: *Rex* v *Crippen* trial transcripts.

32 Tobin would again raise the issue of her ethnic identity during his
 opening speech for the defense, encouraging the jury to "consider . . .
 who she was, what she had been, her characteristics, what was her life
 at home with Crippen. Belle Elmore was the daughter of a Pole."
 (Young, *Trial*, p. 188.)

33 Young, *Trial*, p. 188.

34 *Daily Mirror*, October 19, 1910.

35 NA: DPP 1/13: *Rex* v *Crippen* trial transcripts; *The Globe*, October 19, 1910.

36 *Daily Mirror*, October 19, 1910.

37 *Evening News*, October 19, 1910.

38 *Daily Mirror*, October 19, 1910.

39 Wood, *Survivors' Tales*, p. 279.

40 NA: DPP 1/13: *Rex* v *Crippen* trial transcripts.

41 Max Constantine-Quinn, *Dr. Crippen* (London, 1935), p. 45.

29. "A KIND-HEARTED MAN"

1 *Morning Leader*, October 20, 1910.

2 *Westminster Gazette*, October 21, 1910.

3 Young, *Trial*, "Charge to the Jury," p. 332.

4 Yates, *Berry and I*, p. 261.

5 Young, *Trial*, p. 174. Willcox said that, overall, the total amount of hyoscine extracted from all of the organs was one-fifth of a grain.

6 The defense called Dr. Alexander Wynter Blyth, the author of *Poisons: Their Effects and Detection* (London, 1895), in an attempt to question Willcox's testing methods, but Blyth demonstrated himself to be woefully lacking in the experience of either Willcox or Luff.

7 Young, *Trial*, p. 280.

8 Ibid., p. 186.

9 *Sunday Express*, February 27, 1927. Arthur Newton regularly instructed Edward Marshall Hall in the defense of his clients. Marshall Hall was offered the brief to defend Crippen, but turned it down when Crippen would not allow him to run the line of defense he thought was best. Marshall Hall wanted Crippen to admit to poisoning Belle, but that he did it accidentally. He suggested that Crippen's intention had been to sedate Belle so he could sneak Ethel into the house. Apparently, Crippen refused this out of hand, as he did not want Ethel implicated in any aspect of Belle's death. In reality, this argument would not have withstood much scrutiny, as Mrs. Jackson attested that Ethel was at home that night. Crippen would have found it extremely difficult to have summonsed her on the night of the party, especially as there was no set departure time for the Martinettis.

10 Young, *Trial*, p. 187.

11 Young, *Trial*, pp. 188–9.

12 Ibid., p. 190.

13 *Daily Mirror*, October 21, 1910.

14 Young, *Trial*, p. 208.

15 Connell, *I Caught Crippen*.

16 Young, *Trial*, pp. 209–10.

17 Ibid., p. 211.

18 Ibid.

19 Yates, *Berry and I*, p. 260.

20 NA: DPP 1/13: *Rex* v *Crippen* trial transcripts.

21 Ibid.

22 Crippen had claimed that he and Belle had stopped sharing a bed after they moved to Hilldrop Crescent, though Louise Mills said they were still sharing a bed when she visited in 1907.

23 NA: DPP 1/13: *Rex* v *Crippen* trial transcripts.

24 Ibid.

25 Ibid.

26 Yates, *Berry and I*, p. 260.

27 NA: DPP 1/13: trial transcripts.

28 Young, *Trial*, p. 304.

29 Ibid., p. 319.

30 Ibid., p. 320.

31 *Daily Graphic*, October 24, 1910.

32 Ibid.

33 Young, *Trial*, p. 370.

34 S. Ingleby Oddie, *Inquest* (London, 1947), p. 79.

35 Ibid., p. 80.

36 Ibid.

37 NA: DPP 1/13: Louie Davis police statement, n.d.

38 Ibid.: Lillian Nash (aka Hawthorne) police statement, June 30, 1910; January 19 also being the date when Crippen collected the hyoscine he'd ordered from Lewis & Burrows.

39 NA: DPP 1/13: Franziska Hachenberger police statement, August 9, 1910.

40 *Islington Gazette*, July 18, 1910. In her statement, Lena Lyons cautioned the police that Mrs. Glackner was "an old gossip."

41 NA: DPP 1/13: Lena Lyons and May Pole police statements, July 27, 1910.

42 *Daily Mirror*, January 31, 1910.

43 Smith, *Supper*, p. 300.

44 Engaging in anything beyond this general level of speculation about the details of the disposal of Belle Elmore's body is, for reasons of personal choice, not something I wish to explore.

45 NA: DPP 1/13: trial transcripts.

46 *Thomson's Weekly News*, October 1, 1920.

47 NA: DPP 1/13: Maud Burroughs further statement.

30. "A LITTLE HYSTERICAL"

1 In 1910, when Ethel entered Holloway Prison, a temporary stop was put to the violent practice of force-feeding suffragettes who went on hunger strike.

2 *Thomson's Weekly News*, December 18, 1920.

3 Ibid., December 11, 1920.

4 Ibid., December 25, 1920.

5 *Morning Leader,* October 26, 1910.

6 *Thomson's Weekly News,* December 25, 1920.

7 Ibid.

8 Frances A. Kellor, "Psychological and Environmental Study of Women Criminals, I," *American Journal of Sociology,* vol. 5, no. 4 (January 1900), pp. 527–43.

9 NA: DPP 1/13: Memo to the Director, *Rex* v *Crippen and Le Neve,* October 6, 1910.

10 Young, *Trial,* p. 392.

11 Ibid., pp. 401–2.

12 Ibid., p. 406.

13 Ibid., p. 407.

14 Ibid., p. 408.

15 Ibid.

16 Elaine Showalter, *The Female Malady: Women, Madness and English Culture, 1830—1980* (London, 1987), p. 134.

17 George Henry Savage and Edwin Goodall, *Insanity and Allied Neuroses* (London, 1891), p. 90.

18 Showalter, *Female Malady,* pp. 134–5.

19 Young, *Trial,* p. 411.

20 Ibid., p. 407.

21 Ibid.

22 Michael Arntfield, "Trilby: Forensic Victimology and the Svengali Defense," *Gothic Forensics: Semiotics and Popular Culture* (New York, 2016), p. 217.

23 Young, *Trial,* p. 410.

24 Ibid., pp. 413–14.

25 *Morning Leader,* October 26, 1910.

31. DARLING WIFIE

1 *Thomson's Weekly News,* January 1, 1921.

2 Ellis, *Black Fame,* p. 309.

3 *Thomson's Weekly News,* January 1, 1921.

4 Ibid.

5 When Newton became Ethel's solicitor, Crippen also arranged to pay for her defense along with his own.

6 Philip Gibbs, *Adventures in Journalism* (London, 1923), p. 75; J. P. Eddy, *Scarlet and Ermine* (London, 1960), p. 49.

7 *Thomson's Weekly News*, January 8, 1921.

8 Eddy, *Scarlet*, p. 57.

9 *Thomson's Weekly News*, January 8, 1921.

10 *Thomson's Weekly News*, December 11, 1920.

11 Private Collection: Letter from Ethel Le Neve to Governor Mytton-Davies, October 29, 1910. Contrary to Ethel's advice and perhaps out of desperation, Crippen would continue to correspond with Ada Fricker. However, Pentonville would carefully screen the letters and withhold those which they believed contained coded messages about Ethel. Fricker also tried to entice Ethel "into her protection" directly after her trial.

12 *Daily Mail*, November 6, 1910.

13 *Thomson's Weekly News*, January 8, 1921.

14 Seymour Hicks, *Between Ourselves* (London, 1930), p. 74.

15 Ellis, *Black Fame*, pp. 315–17.

16 *Thomson's Weekly News*, January 8, 1921.

17 Connell, *Doctor Crippen*, p. 180.

18 *Thomson's Weekly News*, January 8, 1921.

19 Cullen, *Crippen*, p. 184.

20 Ellis, *Black Fame*, p. 308.

21 Ibid., p. 312.

22 Gibbs, *Adventures*, p. 76. These letters have disappeared. Extracts from approximately nine of them appear in Ellis's *Black Fame* and in Cullen's *Crippen*.

23 The *New York American* had promised him £500 for his manuscript, but the deal never seems to have been honored.

24 Ellis, *Black Fame*, p. 313.

25 Ibid., pp. 315–16.

26 Ibid., p. 311.

27 *The Globe*, February 13, 1911; Brian Sloan, *Borkowski's Law of Succession* (Oxford, 2017), p. 253.

28 *The Globe*, February 13, 1911; *Thomson's Weekly News*, January 8, 1921.

29 Newton's petition that Crippen should receive a reprieve failed to sway the Home Office and he was notified of this on 21 November.

30 *Lloyd's Weekly Newspaper*, November 20, 1910.

31 Felstead and Muir, *Muir*, p. 117.

32. "MAD FOR ME"

1 *Thomson's Weekly News*, January 22, 1921.

2 Cullen, *Crippen*, p. 184.

3 *Thomson's Weekly News*, January 15, 1921.

4 Ibid., January 22, 1921.

5 The address that appears for her on Crippen's will is 313 Hornsey Road.

6 *Thomson's Weekly News*, February 5, 1921.

7 Ibid., August 18, 1928.

8 Ibid., February 22, 1921.

9 Ibid., January 22, 1921.

10 Ibid., January 29, 1921.

11 Richard Harris, "A Working-Class Suburb for Immigrants, Toronto 1909–1913," *Geographical Review*, vol. 81 (July 1991), p. 324.

12 *Thomson's Weekly News*, August 18, 1928.

13 Ibid.

14 Ibid.

15 Ibid.

16 Ibid.

17 https://www.psychologytoday.com/gb/conditions/dissociative-amnesia.

18 NA: T 1/11335/19725: Savings Bank account of Belle Elmore, forged withdrawals therefrom.

19 Ibid. The Treasury decided they would not prosecute Ethel for these offenses and no action was taken to inform her of the information they held.

20 *Mrs. Bull*, December 3, 1910.

21 *Thomson's Weekly News*, August 25, 1928.

22 https://www.cdc.gov/tb/worldtbday/history.htm.

23 *Thomson's Weekly News*, August 25, 1928.

24 Ibid.

25 Ibid.

26 Ibid., September 1, 1928.

27 Smith, *Supper*, p. 270. Ethel remained at Coalbrook Mansions, moving to 14a (formerly number 13) on February 1, 1914. She remained there at least through March 1916.

28 Ibid.

29 At this time, a strychnine and bromide tonic was recommended by Dr. Paul Bousfield for patients suffering from "nervous diseases" (Paul Bousfield, *The Pathology, Diagnosis and Treatment of Functional Nervous Diseases* (London, 1926), pp. 132–3).

30 *Thomson's Weekly News*, September 1, 1928.

31 KSU: Goodman papers: Series 18: Audio Visual Materials: box 36, folder 16: Audio: Goodman's Interview with Ethel Le Neve's Children, 1985.

32 *Thomson's Weekly News*, September 8, 1928.

33 Ibid., February 5, 1921.

34 Ibid., September 8, 1928.

35 Ibid., September 22, 1928.

36 The family moved several times. They appear on the 1921 census at 107 Harrington Road, on the 1939 register at 28 Shirley Road, and at 10 Parkview Road in 1941, as stated on Walter Neave's death certificate.

37 KSU: Goodman papers: box 36, folder 17: Audio: Interview with Ethel Le Neve's Children, October 4, 1999.

38 Ibid.

39 KSU: Goodman papers: box 2, folder 3: "Notes of post-tape talk, March 1985."

40 Ibid.: box 36, folder 15: BBC Radio 4: "Living with the Legend: Ethel Le Neve," recording.

41 62 Burford Road, Lewisham.

42 KSU: Goodman papers: box 2, folder 3: "Notes of post-tape talk, March 1985."

43 Ibid.

44 Ibid.: box 36, folder 15: BBC Radio 4: "Living with the Legend."

45 Private Collection: Typescript note accompanying H. H. Crippen's watch and ring, written by Rex Manning in 1967.

46 Charles Upwood Manning was the son of Charles Robertson Manning, for whom Ethel's grandfather once worked.

47 Ibid.

48 Smith, *Supper*, pp. 274–5.

49 KSU: Goodman papers: box 2, folder 18: Crippen: Correspondence, undated.

50 Ibid.: box 36, folder 15: BBC Radio 4: "Living with the Legend."

51 Ibid.: box 36, folder 17: Interview, October 4, 1999.

52 *Thomson's Weekly News*, September 29, 1928.

53 Gibbs, *Adventures*, p. 76.

54 Ibid.

55 Wood, *Survivors' Tales*, p. 282.

THE FINAL WORD

1 *Lloyd's Weekly Newspaper*, July 17, 1910.

2 http://richarddnorth.com/archived-sites/filsonyoung/biography/part-6-editor-1919-24/31-attacking-the-admiralty/.

3 Young, *Trial*, p. 14.

4 Ibid., p. 11.

5 Ibid., p. 27.

6 Edward Marjoribanks, *The Life of Sir Edward Marshall Hall* (London, 1929), p. 277; Kendall, *Adventures*, pp. 114–15.

7 Leonard Gribble, *Adventures in Murder: Undertaken by Some Notorious Killers in Love* (London, 1954), pp. 114–15.

8 Horace Thorogood, *East of Aldgate* (London, 1935), pp. 97–8.

9 Ursula Bloom, *The Mightier Sword* (London, 1966), p. 88 and p. 90; *Sunday Times*, October 7, 1934.

10 Jeffrey Jerome Cohen, "Monster Culture (Seven Theses)," *Monster Theory: Reading Culture* (Minneapolis, 1996).

11 Ibid.

12 Young, *Trial*, p. 15.

13 Ibid., p. 7.

14 In the UK the documentary was entitled *Revealed: Was Crippen Innocent?*

15 See appendix for Professor King's response in full.

Appendix

Comment on the Foran et al. paper "The Conviction of Dr. Crippen: New Forensic Findings in a Century-Old Murder"

By Professor Turi King

I think the first thing to say is that the results from the Foran et. al. paper may be right. However, there are a number of issues which stand out for me and other colleagues who have a great deal of experience in the analysis of historical/ancient DNA. These issues, alongside technological advances since 2010, suggest that revisiting the case would be prudent before drawing conclusions based on the single analysis.

The issues are as follows:

1. The entirety of the work was carried out in only one lab. As historical/ancient DNA, if it survives, is highly damaged and fragmented, the risk of contamination from modern DNA during the process, producing false results, is high. As such, it's best practice, especially in high-profile cases, that the work is carried out in two separate labs on two different samples. See the Richard III case and the recent Kaspar Hauser case.

2. The paper states that the analyzes of both the historical (slide) and modern (DNA from the victim's relatives) samples were carried out in the same lab—albeit some time apart. This suggests that the work on the slide was not carried out in a lab dedicated to the analysis of historical/ancient samples. Carrying out such work in a lab dedicated to historical/ancient DNA analysis, with all its contamination controls and workflow protocols, is basic practice.

3. The slide consisted of formaldehyde-fixed tissue which will have gone through a preservation process that may introduce contamination. As a precaution, it's prudent to test for the presence of DNA in the fixant as a control. This was not done in this case.

4. Testing carried out was on mitochondrial DNA, specifically using PCR to amplify sections of the D-loop and then sequence. There are three issues here:

 a) They do not list all the primers used but instead say they "included" F16190/R16410, F15/R285, F15989/ R16207 (the reverse sequence of F16190), F82 (5'–ATA– GCATTGCGAGACGCTGG–3')/R285, F16450/R16, and F256 (5'–CACAGCCACTTTCCACACAG–3')/R484. It is standard practice to list all the primer pairs used.

 b) Some of the primers used amplify quite large fragments (~390bp)—average fragment sizes of historical/ancient DNA are smaller than this. They don't list which primers worked and which didn't work.

 c) They don't state how much of the D-loop they were able to amplify.

5. They found seven polymorphic sites in the D-loop of the mitochondrial DNA of the relatives of Cora Crippen but don't list which sites they are, only mentioning three of them. It is standard practice to give a table(s) of all results, including all polymorphic sites. Furthermore, some polymorphic sites are known to have much higher mutation rates than others and this has to be factored into the analysis.

6. Despite using primers which amplify large fragments of mitochondrial DNA, they couldn't amplify shorter fragments (~110bp) as part of the amelogenin test which tests for presence/absence of X and Y versions of the gene. While this could be due to copy number, there are numerous copies of mitochondrial DNA versus the single copy of the Y chromosome per cell; given the sensitivity of PCR it raises questions as to why this difference occurred.

7. The assay they used to test for presence of Y (DYZ1/Alu real time PCR) cited two PhD theses for the assay, rather than using a

standard, previously published test. Though it may well have been published since, using a test that has yet to be peer-reviewed in a case such as this is, again, not ideal. Furthermore, given the assay is targeting a short fragment of a multicopy segment of DNA on the Y chromosome, and given the sensitivity of PCR, this makes it easier to inadvertently target contaminant DNA.

8. The analysis saw them test three relatives of Cora Crippen. However, these consisted of two sisters and one of their daughters—two grandnieces and one great-grandniece of Cora. Testing three such closely related individuals is completely unnecessary and is essentially maternity testing. I would be curious to know what the aim of this was and what additional information they thought it might add.

9. It doesn't state that all people in the lab had their DNA tested to ensure that the sequences generated from the slide did not originate from a lab member. Again, this is standard in any ancient/historical DNA lab.

Now, fourteen years later, we have numerous techniques used as standard for ancient and historical remains. These would, if sufficient DNA is present, allow us to carry out more in-depth DNA analysis, including potentially sequencing the entire mitochondrial genome and analyzing in more detail a Y chromosome, should the sample indeed originate from a male.

Acknowledgments

At the start of the new year in 2020, I was excitedly looking forward to beginning research on a new book. I had drafted out an ambitious schedule of visits to cities, archives and libraries across two continents. It was going to be a thrilling tour of foreign locations, a true research adventure, and I'd eagerly booked my flights to New York for early April. Then came Covid-19.

Two years of travel restrictions and archive and library closures across the world made this book a challenge to write. My usual way of working went out of the window. When the National Archives at Kew temporarily reopened, readers were given five-hour appointments, often months apart and, at first, were not permitted to bring in any paper or writing implements. I frantically photographed boxes of documents with the panicked haste of a Cold War spy. I had to do everything out of sequence, and in ways that I had never considered. In some cases, I had to call in the auxiliaries, especially overseas.

I'm enormously grateful to those people who had to be my eyes and ears in other cities. Cara Gilgenbach at the Kent State Archives in Ohio became a sort of companion during the dark days of lockdown. Robert Davis in New York has been a stupendous lifesaver, able to access libraries and pull sources when I couldn't. He is a research superhero. Maurice Casey was a brilliant help in Dublin, as were Hayley Seager and Brian Casey. When I finally did get to these places, and after I had left, they lightened my burden, as did Joe Svehlak in Brooklyn, Sandee Wilhoit and Jamie Laird at the Gaslamp Museum in San Diego, and Heidi Stringham at the Utah State Archives in Salt Lake City. In Boston, Mary Daniels and Patricia Cornwell have also both provided assistance in getting this book written. Finally, Jonathan Menges has been generous with his information about Charlotte Bell.

There are also many in the UK to whom I owe a debt of gratitude for their diligence and skill: Dilara Scholz, Lizzie Mackerel and Louise Quick. Thanks

are also due to John Rogers, Matthew Sweet, Lindsey Fitzharris, Professor Turi King, Elinor Cleghorn, Annie Grey, Professor Sarah Churchwell, David Olusoga, Roger Dalrymple and Professor Julia Laite. I am grateful to David James Smith for his preliminary chats about the case and to Kevin Roach at the Central Criminal Court, who allowed me to stand in the Old Bailey's court number one and absorb the weighty silence.

Although I was not able to meet them personally, making contact with some of the descendants of Charlotte Bell's family was an absolute joy. Thank you to Anne Lise Moe Brown and Rebecca Moe, Caroline Mary Raymond, Thomas Brennan and Brian Brennan for their family stories and a few surprising photographs.

This book would have never been born were it not for my stellar team in the UK and in the US: my devoted agents, Sarah Ballard and Eleanor Jackson; my editors, Jane Lawson (Doubleday) and Jill Schwartzman (Dutton), Patsy Irwin, Kate Samano, Richenda Todd, Liane Payne, Liv Bignold and Eli Keren. Thank you for your advice, your skills and for your handholding.

And finally, a thought should be spared for my husband, Frank McGrath, whose patience I must have tried enormously as I endlessly bent his ear about Ethel, Belle, Charlotte and H. H. Crippen. His legal expertise and his loving support have been essential to me as I researched, wrote, agonized over and edited this book.

Picture Acknowledgments

Page 1: *top left* (Hawley Crippen in the early 1880s, photographed by N. L. Merrill) courtesy of Roger Dalrymple; *top center* (Charlotte Jane Bell, photographed by Marc Gambier) courtesy of the Harry Ransom Center; *top right* (photo of Hawley Harvey Crippen) public domain; *bottom* (the Mersinger family with Mr. and Mrs. Crippen) *Los Angeles Herald*, July 21, 1910, Library of Congress, https://lccn.loc.gov/sn85042462.

Page 2: *top left* (Belle, photographed on the night of September 25, 1909) Hulton Archive/Getty Images; *top right* (Belle and Crippen at the 1909 Music Hall Railway Artistes' Railway Association dinner and ball) Trinity Mirror/Mirrorpix/Alamy stock photo; *bottom left* (Eugene and Annie Stratton) courtesy of the author; *bottom right* (Lil Hawthorne) courtesy of the author.

Page 3: *top left* (photo of Ethel taken to accompany the publication of her *Life Story*) *Daily Mirror*/Mirrorpix via Getty Images; *top right* (39 Hilldrop Crescent) public domain; *bottom* (the Neave family) *Daily Mirror*.

Page 4: *top left* (Belle, dressed sumptuously) Chronicle/Alamy stock photo; *top right* (Belle, posing in a variety of her costumes) *Daily Mirror*; *bottom* (front page of the *Daily Mirror*, July 29, 1910) *Daily Mirror*.

Page 5: *top left* (Ethel Le Neve posing in her boy's suit) © Illustrated London News Ltd / Mary Evans; *top right* (photo of Ethel and Crippen on board the *Montrose*) public domain; *center* (Sergeant Ernest Walden of the Brooklyn Police, *et al.*) Fay 2018 / Alamy stock photo; *bottom* (Crippen and Ethel being escorted off the *Megantic*) public domain.

Page 6: *top* (a large and rowdy crowd awaited the arrival of Crippen and Ethel) PA Images / Alamy stock photo; *center left* (Louise Smythson, Melinda May and Clara Martinetti walking to the Coroner's Inquest) Topical Press Agency / Hulton Archive / Getty Images; *center right* (Melinda May testifying at the Coroner's Inquest) Trinity Mirror / Mirrorpix / Alamy stock photo; *bottom* (Clara Martinetti giving evidence at the committal) Mirrorpix via Getty Images.

Page 7: *top* (Crippen and Ethel at their committal) *Daily Mirror* / Mirrorpix via Getty Images; *center* (the dig at 39 Hilldrop Crescent) Shutterstock.com; *bottom* (Crippen's trial at the Old Bailey attracted enormous public interest) Topical Press Agency / Getty Images.

Page 8: *top* (Crippen sitting in the dock during his trial at the Old Bailey) Mirrorpix via Getty Images; *bottom* (Ethel as she appeared in *Thomson's Weekly*) used by kind permission of DC Thomson & Co. Ltd.

Bibliography

PRIMARY SOURCES

THE NATIONAL ARCHIVES (NA), KEW, LONDON
BT: Board of Trade (31/11768/91259)
CRIM: Central Criminal Court (1/117)
DPP: Director of Public Prosecutions (1/13)
ED: Education Department (21/11578)
HO: Home Office (144/1718/19549, 144/1719/195492)
MEPO: Metropolitan Police (2/10996, 3/198, 3/3154)
PCOM: Prison Commission (8/30)
T: Treasury (1/11282/6329, 1/11335/19725)

KENT STATE UNIVERSITY (KSU), KENT, OHIO
jonathan Goodman Collection, Subseries 8: The Crippen File 1845–1999
Box 2: Folders 1, 2, 3, 11, 12, 14, 15, 16, 17, 18
Box 24: Folder 22
Box 36: Folders 15, 16, 17

NATIONAL LIBRARY OF IRELAND, DUBLIN
de Vesci Papers
MS 38,753/1–3, MS 38,755/2–3, MS 39,027, MS 39,026/1–2, MS 39,022/3–6, MS 39,022/1–2, MS 39,021, MS 39,020/1–17

UTAH DIVISION OF ARCHIVES AND RECORDS SERVICE, UTAH STATE
ARCHIVES, SALT LAKE CITY

Series 1471: District Court, Third District, Salt Lake County Criminal Case
Files from 1896: Reel 7, case no. 331: James M. Dart.

Series 3851: Coroner's Inquest Files: Reel 1, Box 1, Folder 11 (1891–92); Folder
12 (1892–93); Folder 27 (1910).

Series 6836: District Court, 3rd District Territorial Criminal Case Files: Reel 9,
Box 5; Reel 10, Box 6.

Series 21866: Salt Lake City Death and Burial Registers: Reel 2 (1888–93):
Charlotte J. Bell.

NEW YORK CITY MUNICIPAL ARCHIVES, NEW YORK

The Records of Mayor William J. Gaynor, 1910–13.

Box 47, Folder 407, Police Department: 1910, July 1–18, Roll 47; 1910, July
19–30, Roll 47.

PATRICIA CORNWELL PRIVATE COLLECTION, BOSTON, MASSACHUSETTS

Letter from Ethel Le Neve to Governor Mytton-Davies, October 29, 1910.
Letter from H. H. Crippen to "Lady Henry Somerset," October 7, 1910.

CAMDEN LOCAL STUDIES AND ARCHIVES CENTRE, LONDON

Hampstead Wells and Campden Trust, Account Books 1891–94.

SECONDARY SOURCES

BOOKS

Grant Allen, *The Typewriter Girl* (London, 1897)

—, *The Woman Who Did* (London, 1895)

Viscount Richard Everard Webster Alverstone, *Recollections of Bar and Bench*
(New York, 1915)

Ann Anderson, *Snake Oil, Hustlers and Hambones: The American Medicine Show
of the Nineteenth Century* (Jefferson, 2000)

Gregory Anderson (ed.), *The White-Blouse Revolution: Female Office Workers
Since 1870* (Manchester, 1988)

Ivy Anderson and Devon Angus (eds), *Alice: Memoirs of a Barbary Coast
Prostitute* (Berkeley, 2016)

Bibliography

William Archer, *The Theatrical World: 1895* (London, 1896)

William Armstrong, *Lillian Nordica's Hints to Singers* (New York, 1922)

Michael Arntfield, "Trilby: Forensic Victimology and the Svengali Defense," *Gothic Forensics: Semiotics and Popular Culture* (New York, 2016)

Max Arthur, *Lost Voices of the Edwardians* (London, 2007)

Peter Bailey (ed.), *Music Hall: The Business of Pleasure* (London, 1986)

Baillière, Tindall and Cox, *The Dental Annual 1906: A Yearbook of Dental Surgery* (London, 1906)

Felix Baker, *Edwardian London* (London, 1995)

Richard Anthony Baker, *British Music Hall: An Illustrated History* (Barnsley, 2014)

—, *Marie Lloyd: Queen of the Music Halls* (London, 1990)

Maude Barker, edited by Helen Allinson, *Growing Up in Edwardian London: Maude's Memories* (Sittingbourne, 2007)

Sandrine Baudry, Hélène Ibata and Monica Manolescu (eds), *Borders in the English Speaking World*, Cristina Laurence, "From the 'Angel in the House' to the Suffragette: How the New Woman Crossed the Border Between the Private and the Public Spheres, 1854–1918" (Strasbourg, 2021)

W. H. Berry, *Forty Years in the Limelight* (London, 1939)

Ursula Bloom, *The Girl Who Loved Crippen* (London, 1955)

—, *The Mightier Sword* (London, 1966)

Paul Bousfield, *The Pathology, Diagnosis and Treatment of Functional Nervous Diseases* (London, 1926)

Barbara Brookes, *Abortion in England: 1900–1967* (London, 1988)

Douglas Gordon Browne and E. V. Tullett, *Bernard Spilsbury: His Life and Cases* (London, 1951)

Bella Burge, *Bella of Blackfriars* (London, 1961)

Edwin G. Burrows and Mike Wallace, *Gotham: A History of New York City to 1898* (Oxford, 1998)

Camden History Society, *The Streets of Bloomsbury and Fitzrovia* (London, 1997)

John Campbell, *F. E. Smith, First Earl of Birkenhead* (London, 1983)

Mary Carbery, *The Farm by Lough Gur: The Story of Mary Fogarty (Sissy O'Brien)*, with an introduction by Shane Leslie (Cork, 1973)

Chapman Brothers (eds), *Portrait and Biographical Album of Branch County, Michigan* (Chicago, 1888)

G. K. Chesterton, *What's Wrong with the World* (London, 1910)

John Clarke, *Victorian Brackley* (Stroud, 2018)

Elinor Cleghorn, *Unwell Women* (London, 2021)

Bibliography

Jeffery Jerome Cohen, *Monster Theory: Reading Culture* (Minneapolis, 1996)

Clara Collet, *Educated Working Women* (London, 1902)

Nicholas Connell (ed.), *The Annotated I Caught Crippen: Memoirs of Ex-Chief Inspector Walter Dew, C.I.D.* (London, 2018)

—, *Dr. Crippen: The Infamous London Cellar Murder of 1910* (Stroud, 2014)

—, *Walter Dew: The Man Who Caught Crippen* (Stroud, 2013)

J. S. Conover (ed.), *Coldwater Illustrated* (Coldwater, MI, 1889)

Max Constantine-Quinn, *Doctor Crippen* (London, 1935)

E. T. Cook, *Highways and Byways in London* (London, 1902)

Janet Elizabeth Courtney, *Recollected in Tranquillity* (London, 1926)

T. C. Crawford, *English Life Seen Through Yankee Eyes* (New York, 1889)

Barbara Creed, *The Monstrous Feminine: Film, Feminism and Psychoanalysis* (Oxford, 1993)

Geoffrey Crossick (ed.), *The Lower Middle Class Britain 1870–1914* (London, 2016)

Duncan Crow, *The Edwardian Woman* (London, 1978)

Tom Cullen, *Crippen: The Mild Murderer* (London, 1988)

Roger Dalrymple, *Crippen: A Crime Sensation in Memory and Modernity* (Woodbridge, 2020)

Caitlin Davies, *Bad Girls: A History of Rebels and Renegades* (London, 2018)

Matilda Alice Powles, Lady de Frece, *The Recollections of Vesta Tilley* (London, 1934)

Frank Dilnot, *The Adventures of a Newspaper Man* (London, 1913)

Hasia R. Diner, *Erin's Daughters in America: Irish Immigrant Women in the Nineteenth Century* (Baltimore, 1983)

Jay P. Dolan, *The Irish Americans: A History* (New York, 2010)

Terri Doughty (ed.), *Selections from The Girl's Own Paper: 1880–1907* (Peterborough, Ontario, 2004)

Theodore Dreiser, *Sister Carrie* (New York, 1900)

George du Maurier, *Trilby* (London, 1894)

Carol Dyhouse, *Girls Growing Up in Late Victorian and Edwardian England* (London, 2012)

J. P. Eddy, *Scarlet and Ermine* (London, 1960)

J. C. Ellis, *Black Fame* (London, 1928)

Daniel Farson, *Marie Lloyd and Music Hall* (London, 1972)

S. T. Felstead and Lady Muir, *Sir Richard Muir: A Memoir of a Public Prosecutor* (London, 1927)

Bibliography

Percy Hetherington Fitzgerald, *Chronicles of Bow Street Police-Office* (London, 1888)

Jessica H. Foy and Thomas J. Schlereth (eds), *American Home Life, 1880–1930: A Social History of Spaces and Services* (Knoxville, TN, 1994)

Gaslamp Quarter Association, Gaslamp Quarter Historical Foundation and San Diego Historical Society, *San Diego's Gaslamp Quarter* (Charleston, 2003)

Philip Gibbs, *Adventures in Journalism* (London, 1923)

Michael Gilbert, *Dr. Crippen* (London, 1953)

William Goodell and W. Constantine Goodell, "Diseases of the Ovaries and Tubes," *Annual of the Universal Medical Sciences*, vol. 4 (Philadelphia, 1888)

Jonathan Goodman (ed.), *The Crippen File* (London, 1985)

Jonathan Goodman and Bill Waddell, *The Black Museum: Scotland Yard's Chamber of Crime* (London, 1987)

Linda Gordon, *Woman's Body, Woman's Right: Birth Control in America* (New York, 1990)

Deborah Gorham, *The Victorian Girl and the Feminine Ideal* (London, 1982)

Bernard Grant, *To the Four Corners* (London, 1933)

Thomas Grant, *Court Number One: The Old Bailey Trials that Defined Modern Britain* (London, 2019)

Leonard Gribble, *Adventures in Murder: Undertaken by Some Notorious Killers in Love* (London, 1954)

George and Weedon Grossmith, *The Diary of a Nobody* (London, 1892)

Hubbard Harris, *Edwardian Stories of Divorce* (New Brunswick, NJ, 1996)

John S. Haller JrJr., *The History of American Homeopathy: The Academic Years, 1820–1935* (Binghamton, NY, 2005)

Janice Hubbard Harris, *Edwardian Stories of Divorce* (New Brunswick, NJ, 1996)

Michael Heller, *London Clerical Workers 1880–1914: Development of the Labour Market* (Abingdon, 2010)

Seymour Hicks, *Between Ourselves* (London, 1930)

—, *Not Guilty, M'Lord* (London, 1939)

—, *Twenty-Four Years of an Actor's Life* (London, 1911)

Travers Humphreys, *Criminal Days: Recollections and Reflections of Travers Humphreys* (London, 1946)

Richard Huson, *Sixty Famous Trials* (London, 1938)

Bibliography

Samuel Hynes, *The Edwardian Turn of Mind* (London, 1992)

Nancy Jackman with Tom Quinn, *The Cook's Tale: Life Below Stairs as It Really Was* (London, 2012)

Stanley Jackson, *The Life and Cases of Mr. Justice Humphreys* (London, 1952)

Naomi Jacob, *Me, A Chronicle about Other People* (London, 1936)

Robert Jütte, *Contraception: A History* (Cambridge, 2008)

Sadakat Kadri, *The Trial: A History from Socrates to O. J. Simpson* (London, 2005)

Arlene W. Keeling, John Kirschgessner and Michelle C. Hehman (eds), *History of Professional Nursing in the United States: Towards a Culture of Health* (New York, 2017)

H. G. Kendall, *Adventures on the High Seas* (London, 1939)

Anne Taylor Kirschmann, *A Vital Force: Women in American Homeopathy* (New Brunswick, NJ, 2003)

Mary H. Krout, *A Looker On in London* (New York, 1899)

Andrew Lamb, *Leslie Stuart: Composer of Florodora* (London, 2020)

Erik Larson, *Thunderstruck* (New York, 2006)

Michael Bennett Leavitt, *Fifty Years in Theatrical Management* (London, 1912)

Victor Lederer and the Brooklyn Historical Society, *Images of America: Williamsburg* (Charleston, 2005)

Ethel Le Neve, *Ethel Le Neve: Her Life Story* (London, 1910)

William Le Queux, *Dr. Crippen: Lover and Poisoner (and Other Stories)* (London, 1966)

Prof. Caesar Lombroso and William Ferrero, *The Female Offender* (New York, 1895)

E. V. Lucas, *Harvest Home* (London, 1913)

John William MacDonald, *A Clinical Textbook of Surgical Diagnosis and Treatment* (Philadelphia, 1898)

Margaret Dixon McDougall, *The Letters of "Norah" on Her Tour through Ireland* (Montreal, 1882)

John Francis McGuire, *The Irish in America* (London, 1868)

Melville L. Macnaghten, *Days of My Years* (London, 1914)

Rohan McWilliam, *London's West End: Creating the Pleasure District, 1800–1914* (Oxford, 2020)

James MaHood and Kristine Wenburg (eds), *The Mosher Survey (Clelia Duel Mosher): Sexual Attitudes of 45 Victorian Women* (New York, 1980)

Edward Marjoribanks, *The Life of Sir Edward Marshall Hall* (London, 1930)

Catherine Meadows, *Dr. Moon* (New York, 1935)

Bibliography

Joseph Meaney, *Scribble Street* (London, 1945)

Sally Mitchell, *The New Girl: Girl's Culture in England 1880–1915* (New York, 1995)

John C. Monteith, *Monteith's Directory of San Diego and Vicinity: 1889–90* (San Diego, 1890)

Charles Morris (ed.), *Men of the Century: An Historical Work* (Philadelphia, 1896)

James Morton, *Gangland Soho* (London, 2008)

Ornella Moscucci, *The Science of Woman: Gynaecology and Gender in England, 1800–1929* (Cambridge, 1990)

Lt Col. Nathaniel Newnham-Davis, *Dinner and Diners: Where and How to Dine in London,* (London, 1899)

Deborah Epstein Nord, *Walking the Victorian Streets: Women Representation and the City* (London, 1995)

Samuel Ingleby Oddie, *Inquest* (London, 1941)

Maeve O'Riordan, *Women of the Country House in Ireland, 1860–1914* (Liverpool, 2021)

Richard Panchyk, *German New York City* (Charleston, 2008)

J. M. Parrish and John R. Crossland, *The Fifty Most Amazing Crimes of the Last 100 Years* (London, 1936)

Erika Diane Rappaport, *Shopping for Pleasure: Women in the Making of London's West End* (Oxford, 2000)

Ciaran Reilly, *The Irish Land Agent, 1830–60: The Case of King's County* (Dublin, 2014)

John Richardson, *A History of Camden* (London, 1999)

Mary Roberts Rinehart, *My Story* (New York, 1931)

George Robb, *White Collar Crime in Modern England: Financial Fraud and Business Morality, 1845–1929* (Cambridge, 2002)

George Robb and Nancy Erber (eds.), *Disorder in the Court: Trials and Sexual Conflict at the Turn of the Century,* Julie English Early, "A New Man for a New Century: Dr. Crippen and the Principles of Masculinity" (London, 1999)

Elizabeth Roberts, *A Woman's Place: An Oral History of Working-Class Women 1890–1940* (Oxford, 1984)

Naomi Rogers, *An Alternative Path: The Making and Remaking of Hahnemann Medical College and Hospital of Philadelphia* (New Brunswick, NJ, 1989)

David Ross QC, *Advocacy* (Cambridge, 2007)

George Henry Savage and Edwin Goodall, *Insanity and Allied Neuroses* (London, 1891)

Thomas Schlich and Christopher Crenner (eds), *Technological Change in Modern Surgery: Historical Perspectives on Innovation*, Sally Frampton, "Competing Forms of Ovarian Surgery in the Nineteenth Century" (Rochester, 2017)

Jonathan Schneer, *London 1900: The Imperial Metropolis* (New Haven, CT, 2001)

Andrew Scull, *Hysteria: The Disturbing History* (Oxford, 2009)

Alistair Service, *Victorian and Edwardian Hampstead: Two Walks Around Its Streets and Buildings* (London, 1989)

Elaine Showalter, *The Female Malady: Women, Madness and English Culture, 1830–1980*, (London, 1987)

Haia Shpayer-Makov, *The Ascent of the Detective: Police Sleuths in Victorian and Edwardian England* (Oxford, 2011)

George Robert Sims, *Living London* (London, 1902)

—, *My Life: Sixty Years of Recollections of Bohemian London* (London, 1917)

—, *The Mysteries of Modern London* (London, 1906)

Brian Sloan, *Borkowski's Law of Succession* (Oxford, 2017)

Betty Smith, *A Tree Grows in Brooklyn* (New York, 1943)

David James Smith, *Supper with the Crippens* (London, 2005)

Harold L. Smith, *The British Women's Suffrage Campaign 1866–1928* (London, 2007)

Henry Reed Stiles, *A History of the City of Brooklyn, Including the Old Town* (New York, 1888)

Marie Stopes, *Married Love* (New York, 1918)

Gillian Sutherland, *In Search of the New Woman: Middle-Class Women and Work in Britain 1870–1914* (Cambridge, 2015)

Arthur Symons, *Cities and Sea-Coasts and Islands* (New York, 1917)

Richard Tames, *Bloomsbury Past* (London, 1993)

W. Buchanan Taylor, *Shake the Bottle* (London, 1946)

Ella Cheever Thayer, *Wired Love: A Romance in Dots and Dashes* (New York, 1880)

Paul Thompson, *The Edwardians: The Remaking of British Society* (London, 1985)

W. Gilman Thompson, *Training-Schools for Nurses: With Notes on Twenty-two Schools* (New York, 1883)

Horace Thorogood, *East of Aldgate* (London, 1935)

James Tyson, *The Practice of Medicine: A Textbook for Practitioners and Students with Special Reference to Diagnosis and Treatment* (Philadelphia, 1897)

University of Michigan, *Catalog of the University of Michigan: 1882–83* (Ann Arbor, 1882)

—, *University of Michigan General Catalog of Officers and Students, 1837–1890* (Ann Arbor, 1891)

University of the State of New York, *105th Annual Report of the Regents for the Year Ending September 30, 1891* (Albany, 1893)

T. S. Van Dyke, *County of San Diego: The Italy of Southern California* (National City, 1887)

Martha Vicinus, *Independent Women: Work and Community for Single Women, 1850–1920* (Chicago, 1988)

Christopher Wade, *For the Poor of Hampstead, For Ever: 300 Years of the Hampstead Wells Trust* (London, 1992)

—, *Hampstead Past* (London, 1989)

—, *The Streets of Hampstead* (London, 1972)

Mike Wallace, *Greater Gotham: A History of New York City from 1898 to 1919* (Oxford, 2017)

Bridget Walsh, *Domestic Murder in Nineteenth-Century England: Literary and Cultural Representations* (Farnham, 2014)

Andrew Watson, *Speaking in Court: Developments in Court Advocacy from the Seventeenth to the Twenty-First Century* (London, 2019)

Katherine D. Watson, *Dr. Crippen* (Kew, 2007)

H. G. Wells, *Ann Veronica* (London, 1909)

Thomas Spencer Wells, *Modern Abdominal Surgery: The Bradshaw Lecture Delivered at the Royal College of Surgeons of England, December 18th, 1890* (London 1891)

Jerry White, *London in the 20th Century: A City and Its People* (London, 2009)

Oscar Wilde, *Impressions of America* (Sunderland, 1906)

Thornton Wilder, *Our Town and Other Plays* (London, 2017)

Philip H. A. Willcox, *The Detective-Physician: The Life and Work of Sir William Willcox* (London, 1970)

Martin Williams, *The King is Dead, Long Live the King! Majesty and Mourning in Edwardian Britain* (London, 2023)

A. N. Wilson, *After the Victorians: The Decline of Britain in the World* (London, 2005)

Walter Wood (ed.), *Survivors' Tales of Famous Crimes* (London, 1916)

Dornford Yates, *As Berry and I Were Saying* (Cornwall, 2001)

Evan Yellon, *Surdus in Search of His Hearing: An Exposure of Aural Quacks* (London, 1906)

—, *Surdus in Search of His Hearing*, 2nd edition (London, 1910)

Alexander Bell Filson Young (ed.), *The Trial of Hawley Harvey Crippen* (London, 1920)

Raleigh Yow, *Betty Smith: Life of the Author of A Tree Grows in Brooklyn* (Chapel Hill, 2008)

CONTEMPORARY PERIODICALS AND NEWSPAPERS

Albion Magazine

Answers Magazine

Boston Globe

Bristol Times and Mirror

Brooklyn Citizen

Brooklyn Daily Eagle

Buffalo Commercial

Camden Courier-Post (Camden, NJ)

Carlow Post

Chesterfield Herald

Chicago Tribune

Collier's Weekly

Coronado Mercury

Cornubian and Redruth Times

Daily Chronicle

Daily Express

Daily Graphic

Daily Mail

Daily Mirror

Daily News

Daily Telegraph

Derbyshire Courier

Derbyshire Times

Derry Journal

Detroit Free Press

Dublin Evening Post

Dundee Courier

Dundee Evening Telegraph

Ealing Gazette

Bibliography

The Era

Evansville Courier and Press

Evening News

Evening Star (Washington DC)

Evening World (New York)

Evening World Herald (Omaha, NE)

Farmer's Gazette and Journal of Practical Horticulture

The Girl's Own Paper

The Globe

The Graphic

Grimsby Daily Telegraph

Hampstead & Highgate Express

Harper's New Monthly Magazine

Harper's Weekly

Hendon and Finchley Times

Illustrated Police News

Islington Gazette

John Bull

Lloyd's Weekly Newspaper

London American

London Evening Standard

Los Angeles Evening Express

Los Angeles Evening Post-Record

Los Angeles Herald

Los Angeles Morning Press

Los Angeles Times

Manchester Courier

Manchester Guardian

Melbourne Argus

Memphis Avalanche

Montreal Daily Star

Morning Leader

Morning Post (Camden, NJ)

Mrs. Bull

Music Hall and Theatre Review

Musical Times

Bibliography

National Review

New York American

New York Daily Herald

New York Times

New York Tribune

Nottingham Evening Post

Ottawa Free Press

The People

The Performer

Philadelphia Inquirer

Philadelphia Times

Portland Daily Press

Portsmouth Evening News

Reno Gazette-Journal

Reynolds Newspaper

St. Louis Globe-Democrat

St. Louis Post-Dispatch

Salt Lake Herald

Salt Lake Tribune

San Diego Union and Daily Bee

San Francisco Bulletin

San Francisco Call

San Francisco Examiner

Sheffield Evening Telegraph

Shorthand Review

Southland Times

Staffordshire Sentinel

The Stage

Standard Union (Brooklyn)

Strabane Chronicle

Strand Magazine

Sun (New York)

Sunday Citizen

Thomson's Weekly News

The Times

Bibliography

Times-Picayune (New Orleans)
Times-Union (Brooklyn)
Truth
Utah Gazetteer
Weekly Dispatch
Western Mail
West Middlesex Observer
Westminster Gazette
Yorkshire Evening Post

MEDICAL JOURNALS

American Homeopathic Journal of Obstetrics and Gynaecology
American Homeopathist
American Journal of Obstetrics and Gynaecology
Ann Arbor Medical Advance
British Medical Journal
California Homeopathist
Canada Lancet
The Chironian
Cincinnati Medical Advance
Hahnemannian Monthly
Homeopathic Journal of Obstetrics, Gynaecology and Paedology
Homeopathic Recorder
Journal of Obstetrics and Gynaecology
Journal of Ophthalmology, Otology and Laryngology
The Lancet
Medical Argus
Medical Century
Medical Era
Medical News and Abstract
Southern Journal of Homeopathy

JOURNAL ARTICLES

michele Aaron, "The Historical, the Hysterical and the Homeopathic,"
 Paragraph, vol. 19, no. 2 (July 1996), pp. 114–26

Bibliography

Anne Digby, "Victorian Values and Women in Public and Private," *Proceedings of the British Academy*, 78 (1992), pp. 195–215

Julie English Early, "Technology, Modernity, and 'the Little Man': Crippen's Capture by Wireless," *Victorian Studies*, vol. 39, no. 3 (Spring 1996), pp. 309–37

David R. Foran, Brianne M. Kiley, Carrie B. Jackson, John H. Trestrail, Beth E. Wills, "The Conviction of Dr. Crippen: New Forensic Findings in a Century-Old Murder," *Journal of Forensic Sciences* (online), vol. 56, issue 1 (January 2011), pp. 233–40

Ginger Frost, "'The Black Lamb of the Black Sheep': Illegitimacy in the English Working Class, 1850–1939," *Journal of Social History*, vol. 37, no. 2 (Winter 2003) pp. 293–322

Jonathan Goodman, "Much Ado About Crippen," *New Law Journal* (May 30, 1997)

H. H. Hahn, "Electricity in Gynaecology," *Journal of the American Medical Association*, vol. 20 (1893), p. 328

Richard Harris, "A Working-Class Suburb for Immigrants, Toronto 1909—1913," *Geographical Review*, vol. 81 (July 1991), pp. 318–32

Annette R. Hoffman, "Lady Turners in the United States: German American Identity, Gender Concerns and Turnerism," *Journal of Sport History*, vol. 27, no. 3 (Fall 2000), pp. 383–404

Ellen Jordan, "The Lady Clerks at the Prudential: The Beginning of Vertical Segregation by Sex in Clerical Work in Nineteenth-Century Britain," *Gender and History*, vol. 8, no. 1 (April 1996), pp. 65–81

Frances A. Kellor, "Psychological and Environmental Study of Women Criminals, I," *American Journal of Sociology*, vol. 5, no. 4 (January 1900), pp. 527–43

Laura Lee, "Strange Bedfellows: The Solicitors and Blackmailers of the Oscar Wilde Case," *The Wildean*, no. 53 (July 2018), pp. 33–45

Lawrence D. Longo, "Electrotherapy in Gynaecology: The American Experience," *Bulletin of the History of Medicine*, vol. 60, no. 3 (Fall 1986), p. 351

Fanny Louvier, "Beyond the Black and White: Female Domestic Servants, Dress and Identity in France and Britain, 1900–1939," *The Journal of the Social History of Society*, vol. 16, issue 5 (2019), pp. 581–602

Jonathan Menges, "Another World and Another Judge: Do New Scientific Tests Clear Crippen?," *Ripper Notes*, issue 28 (2008)

—, "Connective Tissue: Belle Elmore, H. H. Crippen and the Death of Charlotte Bell," *Ripperologist* 158 (2017), pp. 11–16

Bibliography

Christopher G. Ogburn, "Brews, Brotherhood and Beethoven: The 1865 New York City Sängerfest and the Fostering of German American Identity," *American Music,* vol. 33, no. 4 (Winter 2015), pp. 405–40

Judith Rowbotham and Kim Stevenson, "'For today in this arena . . .' Legal Performativity and Dramatic Convention in the Victorian Criminal Justice System," *Journal of Criminal Justice and Popular Culture*, vol. 14, no. 2 (2007), pp. 113–41

PHD THESIS

Carrie Selina Parris, "The Crimes Club: The Early Years of Our Society" (University of East Anglia, 2016)

ARCHIVAL RECORDS ACCESSED ONLINE

Ancestry.com: London, England, UK: Church of England Births and Baptisms, 1813–1923

Ancestry.com: Michigan, US: County Marriage Records, 1822–1940

Ancestry.com: Michigan, US: Wills and Probate Records, 1784–1980, case files 3117–3207, 1833–1923, Philo H. Crippen, 1890

Ancestry.com: National Archives: Court for Divorce and Matrimonial Causes, J77/854/5969, Forrester Kennedy

Ancestry.com: National Archives: CRIM 9: After Trial Calendars of Prisoners 1855–1931, Ref. 42, Forrester Kennedy

Ancestry.com: The National Archives in Washington, DC, USA: Washington, DC, USA; Passenger Lists of Vessels Arriving at New York, NY, 1820–1897; Microfilm Serial or NAID: M237; RG Title: Records of the US Customs Service; RG: 36; New York Passenger and Crew Lists, Roll T715, 1897–1957, 0001–1000, Roll 0377

Ancestry.com: The National Archives in Washington, DC, USA: London, England, UK; Board of Trade: Commercial and Statistical Department and Successors: Inwards Passenger Lists; Class: Bt26; Piece: 12; Item: 39

Ancestry.com: National Archives: MEPO 6: UK Registers of Habitual Criminals and Police Gazettes, 1834–1934, Forrester Kennedy

Ancestry.com: National Archives: WO 363: Soldiers' Documents, First World War: Horace George Brock, UK British Army World War I Service Records, 1914–1920 (Labour Corps, next of kin card for Stanley Smith)

Ancestry.com: Norfolk County, MA: Probate File Papers, 1793–1900 Page(s): 28814:2 Volume: Norfolk Cases 28000–29999, "Estella H. Lincoln"

Bibliography

Ancestry.com: US Civil War Draft Registration Records, 1863–1865, Myron Augustus Crippen, Michigan, 2nd, Class 1 A–K, vol. 1

ONLINE SOURCES

Samuel Hopkins Adams, *The Great American Fraud, A Series of Articles on the Patent Medicine Evil, Reprinted from Collier's Weekly* (1905), https://www.gutenberg.org/files/44325/44325-h/44325-h.htm

The Astounding Record of a Poole Girl (Alice Ada Fricker) (June 19, 2019), https://ww1poole.wordpress.com/2019/06/19 the-astounding-record-of-a-poole-girl/

Thomas Lindsley Bradford (ed.), *Biographies of Homeopathic Physicians, Volume 8: Coombs–Cyriax* (Hawley Harvey Crippen), https://archive.org/details/bradford008-jpg10-mediumsize-pdfx_201410

Centers for Disease Control and Prevention, https://www.cdc.gov/tb/worldtbday/history.htm

Coronado Historical Association, www.coronadohistory.org

"'Dr. Hawley Harvey Crippen' Murderer." (n.d.) Wood Detective Agency Records, 1865–1945: Series VII: Criminal Accounts and Articles compiled by James Rodney Wood, Jr., 1816–1934, box 11, folder 92. Harvard University Law Library: Crime, Punishment, and Popular Culture, 1790–1920, link.gale.com/apps/doc/EUKJOK056527342/CPPC?u=new64731&sid=CPPC&xid=06ab3d65&pg=1.

George H. Duckworth's Notebook: Police and Publicans District 10 [Bethnal Green East], District 15 [South West Islington], District 17 [Upper Holloway], BOOTH/B/349, https://booth.lse.ac.uk/notebooks

George H. Duckworth's Notebook: Police District 2 [Strand and St. Giles], District 3 [StSt. James, Westminster, Soho, All Saints and Tottenham Court Road], District 9 [Bethnal Green, North and South], District 22 [Cavendish Square and St. John's Paddington], District 23 [StSt. Mary Paddington and Kensal Town], BOOTH/B/355, https://booth.lse.ac.uk/notebooks

http://kurtofgerolstein.blogspot.com/2020/07/cartesians-murder-she-said.html

Lindsay McCormack, "Booking for Smoking Concerts Now: A Very Brief History of This Controversial Entertainment," November 16, 2022, https://lincoln.ox.ac.uk/blog/smoking-concerts

https://www.magdalen.northants.sch.uk/general/welcome-and-introduction/history/

James Monroe Munyon's Hotel Hygeia, https://www.scvpalmbeach.com/sub-hygeia-hotel

Old Bailey Sessions Papers Online: Gwendoline Howell, October 16, 1905; George Hume, January 12, 1909; Annie Warner, October 8, 1912

https://pasttopresentgenealogy.co.uk/2019/06/12/pioneers-of-the-fifa-womens-world-cup-the-first-football-internationals/

https://www.playingpasts.co.uk/articles/football/and-i-mean-that-most-sincerely-theatre-and-the-birth-of-womens-football/

https://www.psychologytoday.com/gb/conditions/dissociative-amnesia

Reno, Nevada, Divorce History, https://renodivorcehistory.org/themes/law-of-the-land/how-it-worked/

"Samuel's Sentiments" on Smoking Concerts in the *Cardiff Times*, June 27, 1891, no. 185, https://victorianweb.org/periodicals/cardifftimes/185.html

Samuel H. Williamson, "Seven Ways to Compute the Relative Value of a US Dollar Amount, 1790 to present," *Measuring Worth* (April 2024), www.measuringworth.com/uscompare/

Index

Hawley in the index refers to Dr. Crippen. Ethel refers to Ethel Le Neve. Belle refers to Belle Elmore.

Index

Index

Index

Index

About the Author

Hallie Rubenhold is the number one *Sunday Times* bestselling and Baillie Gifford Prize–winning author of *The Five: The Untold Lives of the Women Killed by Jack the Ripper*. A renowned social historian whose expertise lies in revealing stories of previously unknown women and episodes in history, she is also the author of *The Covent Garden Ladies*, which was the inspiration behind BBC TV's *Harlots*. Her biographical work, *Lady Worsley's Whim*, was dramatized by the BBC as *The Scandalous Lady W*. Her most recent work of nonfiction, *Story of a Murder: the Wives, the Mistress, and Dr. Crippen*, will be published in spring 2025. She has also written two acclaimed novels, *Mistress of My Fate* and *The French Lesson*, which give voice to the women written out by eighteenth-century literature. She lives in London with her husband. Meet her @HallieRubenhold.